THE
ILLUSTRATED GUIDE
TO
COLLECTING BOTTLES

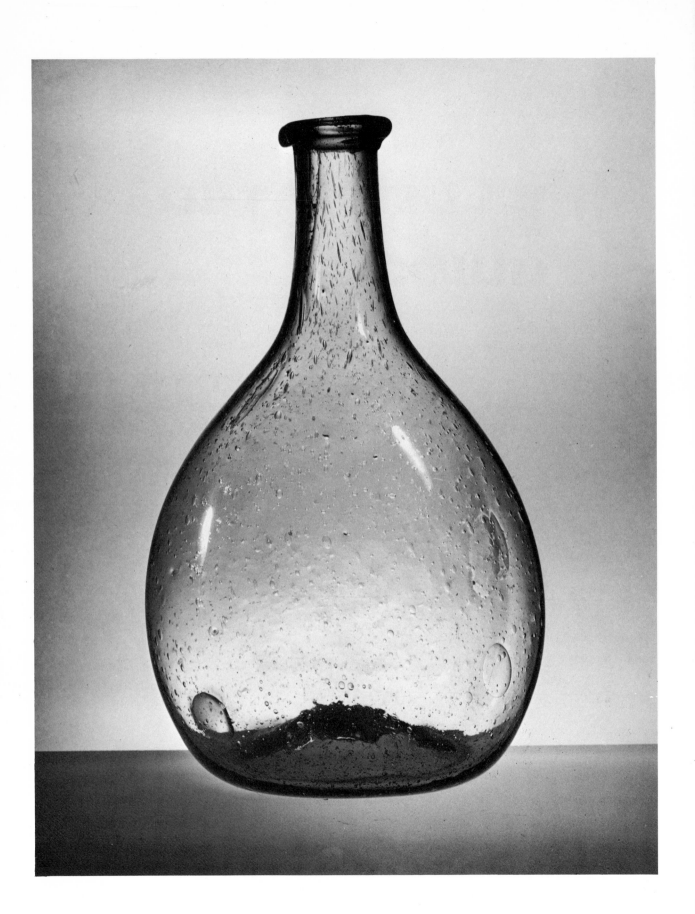

THE ILLUSTRATED GUIDE TO COLLECTING BOTTLES

by Cecil Munsey

Introduction by Charles B. Gardner

Hawthorn Books, Inc. Publishers New York

10

Designed by Harold Franklin

Preface

Less than one hundred years ago most people worked more than ten hours a day and most jobs were done by hand. Such efforts left little, if any, time or energy for leisure activities. Today, most people work eight hours a day and have many machines to make their work easier. Therefore, people are not only provided with more leisure time but have the energy to use it. Much of this spare time and energy is being spent on hobbies. A hobby can be defined as making, doing, or learning something just for the fun involved. It has been said that making a collection is the commonest hobby.

The collecting of bottles is currently one of the most popular and exciting of all the collecting hobbies. The gathering of glass and ceramic bottles has great meaning and significance to thousands of people throughout the world. Bottles are historic, romantic, shapely, beautiful, valuable, and a challenge to acquire.

Current interest in all aspects of the hobby indicates the need for literature devoted to the collecting of bottles. It is sincerely hoped that this effort will be at least a step in the direction of satisfying that need.

This volume represents over four years of research and one year of writing. It is hoped that two years' experience as editor of a bottle collecting supplement in the first magazine to devote space to the bottle collecting hobby on a regular basis has provided the background necessary to present a comprehensive and significant contribution.

This book is divided into eight parts and sixty-two chapters. Many of the divisions are arbitrary but necessary. Most chapters are cross-referenced to aid the reader in locating related material that has been included in other chapters. In addition, an extensive index has been included to facilitate study of specific subjects.

In the first part of this volume a brief history of the bottle collecting hobby is offered; in the second part, several chapters are devoted to glass history as related to bottles and picture some of the oldest bottles in the world. Part III presents a comprehensive study of bottle manufacturing

methods as practiced from earliest times to the present. The fourth part of this work is devoted to discussions of the more than two dozen basic types of relatively old bottles currently being collected. In Part V the reader will find information about several types of unusual bottles that are of interest to collectors. Part VI offers four chapters in which the most popular of the newer bottles are pictured and discussed. Another chapter is devoted mostly to photographs of the hundreds of types of the newer bottles being produced mainly for the collecting market. In the seventh part can be found chapters discussing many aspects of the hobby, including suggestions regarding obtaining, cleaning, restoring, repairing, dating (based mainly on information presented in Part III), transporting, and displaying bottles. In addition there is an in-depth study of the bottle club. In the eighth and concluding part of this book there are several chapters devoted to picturing and discussing the many related articles that bottle collectors include in their collections.

The bibliographies included at the end of most chapters comprise what is probably the most comprehensive listing of books and periodical articles dealing with bottles ever assembled. The reader interested in specializing in one or more aspects of the hobby will undoubtedly find this a valuable reference list. In addition, books meriting special attention are discussed within the text.

The chapters devoted to bottles and related items present as much material as is currently available. Also included are complete histories of some of the most interesting, unusual, and colorful individuals and firms directly related to bottle collecting. Whenever appropriate, these chapters conclude with a general discussion about the size, shape, color, embossment, closures, related articles, rarity, price, and predominant characteristics of the bottles being discussed. Because values change rapidly, general price ranges are offered rather than definite price guides.

The photographs presented throughout the chapters dealing with bottles and related items were selected to give visual examples of the material being discussed. It would be virtually impossible to picture all of the bottles it is possible to collect; they must certainly number in the millions.

In writing this work special attention was given to both the beginning and the advanced collectors. The beginning collector, it is hoped, will find that the material presented is comprehensive, clear, and logically developed. The more sophisticated collector will find that for the first time he will have at his disposal in one book a complete coverage of bottle collecting, specific and previously unpublished histories of many bottles and individuals, and photographs of many persons and things that are offered for the first time in bottle collecting literature.

This book, completely read and properly used, should greatly aid all bottle collectors in enjoying the fascinating hobby centered around the accumulating and preserving of all bottles.

C. M.
San Diego, California

Acknowledgments

A book such as this can hardly be the result of one person's efforts. The hobby of collecting bottles is too large and has grown too fast to allow one person to know everything there is to know about it. The material offered in this work is a result not only of the researching and writing efforts of the author but of the many researcher-writers who have previously recorded information of importance to the hobby; these authors and their works are carefully recorded in the bibliographies offered at the end of most chapters. A club newsletter bibliography is also presented at the end of the book.

In addition to my wife, Dolores, who has helped me in ways too numerous and personal to mention, and my son, Cecil III, who has understandingly done without a father for the year it took to assemble and write this work, I would like to express my deepest gratitude to Louis A. Fournier, who very carefully read the manuscript chapter by chapter as it was written and offered the severe criticism necessary to ensure an accurate, consistent, and logical development of the subjects covered; Dr. Julian H. Toulouse, who provided me with photographs that were invaluable in the discussion of bottle molds and shared technical knowledge about glass manufacturing gained through over thirty years as a glass-industry engineer; and Paul F. Evans, former publisher and editor of *Western Collector* magazine, who encouraged my first writing attempts and whose position with the magazine I have been endeavoring to fill for the past two years. I would also like to acknowledge the following museums, publications, firms, and individuals who either allowed me to take photographs of their collections or supplied me with needed photographs. In addition to mention here, those who actually supplied me with photographs are given proper credit within the text.

I am grateful to the Chase Manhattan Bank Money Museum, N. Y.; the Corning Museum of Glass, Corning, N. Y.; the C. L. David Collection, Copenhagen, Denmark; the Musée du Verre, Liege, Belgium; the Museum of Arts and Sciences, Rochester, N. Y.; the Philadelphia Museum of Art; and the Toledo Museum of Art.

I am also grateful to the Gun Digest Publishing

Co., Northfield, Ill.; *Numismatic Scrapbook,* Sidney, Ohio; *Soft Drinks Magazine* (formerly the *National Bottlers' Gazette*), N. Y.; and especially *Western Collector* magazine (Joseph Weiss, publisher), San Francisco, California.

I am further grateful to the James B. Beam Distilling Co., Chicago, Ill.; Bottles Beautiful, N. Y.; Carl Byoir and Associates (who represent the I. W. Harper Whiskey Co.), N. Y.; the Coca-Cola Co., Atlanta, Ga.; the Jack Daniel Distillery, Lynchburg, Tenn.; the J. W. Dant Co., N. Y.; the Den of Antiquity (Jack Wiseburn, proprietor), Clayton, N. J.; Famous Firsts, Ltd., N. Y.; the Glass Container Manufacturers Institute, N. Y.; Harshe-Rotman and Druck, Inc. (who represent the Ballantine's Scotch Whiskey Co.), N. Y.; J. and B. Antiques (Bill Helton, proprietor), San Diego, Cal.; Lamplighter Antiques (Lloyd and Betty Davis, proprietors), San Diego, Cal.; Lionstone Distilleries, Ltd., Denver, Colo.; McCormick Distilling Co., Weston, Mo.; Numano International, Inc., Los Angeles, Cal.; Old Charter Distillers Co., N. Y.; Paradise Antiques (Lucy Paradise, proprietor), Irving, Texas; Title Insurance Co., San Diego, Cal.; the Wheaton Glass Co., Millville, N. J.; and Wolford's Antiques (Jack and Connie Wolford, proprietors), La Mesa, Cal.

I am very grateful to Lou Alvarado, San Diego, Cal.; Bruce C. Aschenbrenner, San Diego, Cal.; Leslie and Constance Avery, Berkeley, Cal.; Fritz Biemann, Jusnacht, Germany; Kevin Clark, San Diego, Cal.; Hans Cohn, Los Angeles, Cal.; Jim Cope, Orange, Texas; Elton and Barbara Cox, Spring Valley, Cal.; Danny B. Crabb, Los Angeles, Cal.; Tolbert and Vera Duncan, Diboll, Texas; Gary Eichhorn, Missoula, Mont.; Rex R. Elliott, Ewa, Hawaii; Tom and Lyra Elting, Irving, Texas; Buck and Tince Flowers, Mont Belview, Texas; John C. Fountain, Amador City, Cal.; Donald Frace, Escondido, Cal.; Charles B. Gardner, New London, Conn.; Don and Joan Henning, Imperial Beach, Cal.; Don, Mary Lou, and John Hunter, San Diego, Cal.; Rurik and Marjorie Kallis, Costa Mesa, Cal.; Bill and Alberta Kerr, Tulsa, Okla.; Dr. and Mrs. Albert Kies, Tienen, Belgium; Helfried Krug, Mulheim, Germany; Jim and Dale Lafferty, Cameron, Texas; Mack and Alliene Landers, Euless, Texas; William McNeely, Greenville, Texas; Bob and Beka Mebane, San Antonio, Texas; Hardy Montague, Overland Park, Kansas; K. Mooney, Dallas, Texas; Winnie Morris, Dallas, Texas; Pat Omans, San Francisco, Cal.; E. L. Parsons, Guide Rock, Neb.; Fred Rawlinson, Newport News, Va.; Don Robinson, Memphis, Tenn.; James F. Shafer, II, Miami, Fla.; Mrs. M. Sharcott, Victoria, British Columbia; Robert Shipley, Colorado Springs, Colo.; Robert and Norma Silver, Cleveland, Ohio; Alan and Ann Spear, Lockport, N. Y.; Dr. Burton Spiller, Rochester, N. Y.; Wallis Stier, Boise, Idaho; Leroy and Rosemary Stowe, San Diego, Cal.; Robert Terry, Denver, Colo.; and Ramon Willey, Gloucestershire, England.

C. M.

Contents

Introduction

The collecting, preservation, and study of bottles has occupied a major portion of my life for the past forty years. Until the hobby was formally organized in the late 1950's, I was one of only a relatively small number of collectors interested in gathering and studying the glass and ceramic containers that have played an important part in our history. For the past twenty or so years thousands of people have joined with me in this most fascinating pastime.

As the interest in collecting bottles grew so did the need for informative, well-researched, and well-written literature. A number of authors have written books dealing with specific aspects of the bottle-collecting hobby, and a few have offered works of a general nature. In this book, however, Cecil Munsey has produced the most extensive work dealing with bottle collecting in general to date.

It is very apparent that Mr. Munsey has done an incredible amount of research and has produced a volume of tremendous value to *both* the beginning and advanced collectors of bottles.

The book's eight parts and over five dozen chapters deal with: hobby history; general glass history—presented interestingly coupled with the most important dates in the history of civilized man; bottle-manufacturing methods from earliest times to the present; glass and ceramic bottles of *all* types; obtaining, cleaning, restoring, dating, and displaying bottles; bottle-collecting clubs and shows; and collectible articles related to bottles.

Mr. Munsey's style of writing and the book's arrangement are an agreeable change from other books dealing with bottle collecting. Many interesting facts and photographs that have not previously been available to collectors of bottles are presented.

The hundreds of photographs, the thousands of facts, and the end-of-chapter bibliographies combine to make this work possibly the most valuable reference book ever offered to bottle collectors.

Without any question this book is the most interesting and informative it has been my pleasure to read, and I can recommend it without hesitation to every member of the bottle-collecting fraternity.

Charles B. Gardner
New London, Connecticut

PART I

Hobby

History

1

Bottle Collecting

in the

United States

An informal study made in 1968 by Paul F. Evans, while he was editor of *Western Collector* magazine, revealed that the hobby of collecting bottles "is the nation's third largest and fastest growing hobby." Surprisingly enough, collecting bottles as a separate hobby is a relatively new pastime. Although bottles have been saved for thousands of years, their retention was for economic and utilitarian purposes, i.e., bottles until the early 1900s were relatively expensive and were saved for reuse.

As the nineteenth century turned into the twentieth the average one-room schoolhouse could have held the group concerned with the collecting and preservation of bottles. Before the turn of the century, hobbies in general were reserved mostly for the wealthy. As the average American gained more leisure time through higher pay and a shorter work week, he devoted his newly found leisure time to a variety of hobbies including collecting. Coins and stamps seemed to be the most popular collections but glass collecting was an accepted branch of the ever popular collecting of antiques.

Books devoted to glass were few in number and rarely included the common bottle. One of the first devoted in part at least to bottles was A. Sauzay's *Wonders of Glass and Bottle Making,* which was first published in 1871. In 1900 Edwin Atlee Barber wrote *American Glassware.* This 111-page book dealt with a few bottles and flasks but never enjoyed much popularity because relatively few bottle collectors existed at the time. Frederick William Hunter, in 1914, wrote and published the first major work dealing with American glass. His book, *Stiegel Glass,* still is the primary source of information about Henry William Stiegel—one of America's earliest and most successful glass manufacturers (see Chapter 5). William S. Walbridge, vice president of the Owens Bottle Company, released his *American Bottles Old and New* in 1920. This work is mostly a history of the Owens Bottle Company. None of these first books stressed collecting but were written primarily as histories.

Among the earliest of bottle collectors was Stephen Van Rensselaer. As early as 1921 he wrote the first real bottle book, that is, a book devoted to the *collecting* of bottles. This work, *Early American Bottles and Flasks,* was little more than

a pictorial checklist but at least it provides evidence that there were bottle collectors in the early 1900s. In 1926 Van Rensselaer brought out a much revised and expanded edition of his book; this edition featured the first accepted classification system for bottles (flasks) and contained much information about bottle history. In 1927 Charles McMurray, an Ohio collector, added *Collectors Guide of Flasks and Bottles* to the slowly growing bottle collecting literature.

Other pioneer collectors include George S. McKearin, Edwin LeFevre, Charles B. Gardner, and James H. Thompson. During the late 1920s and early 1930s Mr. McKearin gathered the first really impressive collection of American bottles —mostly historical and pictorial flasks. In 1941, Mr. McKearin and his daughter, Helen, wrote a book entitled *American Glass*. This book is one of the most authoritative ever written on glass and features an extensive and almost complete listing of historical and pictorial flasks; the McKearins' classification system for flasks has displaced Van Rensselaer's as the most accepted one in the hobby.

In 1929, as Edwin LeFevre was writing his famous "Why I Collect Bottles" article for the *Saturday Evening Post,* a man who has become the inspiration of organized bottle collecting traded a gun collection to Stephen Van Rensselaer for a collection of bottles. This pioneer collector, the last of the insightful group of early collectors, is Charles B. Gardner of New London, Connecticut. Still very much alive today, Mr. Gardner has after over forty years of collecting the finest collection of bottles ever assembled.

In 1947, James H. Thompson wrote the last major work dealing with bottle collecting before the hobby became organized. This book, *Bitters Bottles,* provided the few interested collectors with the first extensive classification of bitters bottles. Thompson did for these bottles what Van Rensselaer did for historical and pictorial flasks.

The preceding discussion mentions only the most famous of the bottle collecting pioneers; there were others, too, who ran the risk of being scoffed at by their peers. Occasionally their collections come to light at estate auctions and the like.

The era of unorganized bottle collecting, an era of casual collecting of early American bottles and flasks by a relatively small number of collectors, was from about 1900 to 1959. On October 15, 1959, in Sacramento, California, a group of seventeen people led by John C. Tibbitts gathered to form the first bottle collecting club in history. The new group christened themselves the Antique Bottle Collectors Association of California. This group grew rapidly and within several months numbered approximately one hundred. By mid-1962 this fledgling group boasted 257 family memberships in twenty-three states. Other clubs had been formed and John C. Fountain of Sacramento had opened one of the first bottle shops. Mr. Fountain's Ole Empty Bottle House soon became the biggest bottle store in the country.

By 1965 John C. Fountain had convinced Paul F. Evans, publisher of *Western Collector* magazine, to devote monthly coverage to the hobby of bottle collecting. From 1959 until *Western Collector* started its "Bottle World" supplement in 1965 the major means of communication between bottle collectors had been *The Pontil*, the monthly newsletter of the Antique Bottle Collectors Association (the "of California" had been dropped because the club was national in scope) edited by John C. Tibbitts.

In the ten-year period from 1959 to 1969 the hobby of collecting bottles grew until it involved thousands of collectors, over one hundred clubs, and several periodicals. Toward the end of organized bottle collecting's first decade the hobby could also boast a literature consisting of almost a hundred books and a national federation of bottle clubs. As Mr. Evans stated in *Western Collector* magazine in 1968, the hobby of collecting bottles had become one of the nation's largest and fastest growing hobbies.

Bibliography

BOOKS

Barber, Dr. Edwin Atlee. *American Glassware.* Philadelphia: David McKay Co., 1900.

Fountain, John C., and Colcleaser, Donald E. *Dictionary of Spirits and Whiskey Bottles.* Amador City, California: Ole Empty Bottle House Publishing Co., 1969.

Holmberg, Millicent, and Munsey, Cecil. *Western Collector's Handbook and Price Guide to Avon Bottles.* San Francisco, California: Western World Publishers, 1969.

Hunter, A. M. Frederick William. *Stiegel Glass.* New York: Dover Publications, Inc., 1950.

McKearin, George and Helen. *American Glass.* New York: Crown Publishers, Inc., 1968.

McMurray, Charles. *Collectors Guide of Flasks and Bottles.* Dayton, Ohio, 1927.

Mebane, John. *The Poor Man's Guide to Antique Collecting.* Garden City, New York: Doubleday & Co., Inc., 1969.

Sauzay, A. *Wonders of Glass and Bottle Making.* Ft. Davis, Texas: Frontier Book Co., 1969 (reprint).

Thompson, James H. *Bitters Bottles.* Watkins Glen, New York: Century House, 1947.

Tibbitts, John C. *Chips from the Pontil.* Sacramento, California: Heirloom Press, 1967.

————. *John Doe, Bottle Collector.* Sacramento, California: Heirloom Press, 1967.

Van Rensselaer, Stephen. *Early American Bottles and Flasks.* Stratford, Connecticut: J. Edmund Edwards, 1969 (revised edition).

Walbridge, William S. *American Bottles Old and New.* Ft. Davis, Texas: Frontier Book Co., 1969 (reprint).

PERIODICALS

Camehl, A. W. "A Curious Collection of Bottles," *American Homes,* VI (January, 1909), 11–13.

Clark, E. M. "Some Collections of Old Bottles," *Mentor,* XVI (April, 1928), 20–22.

Farrington, F. "Bottle Facts," *Hobbies,* VL (October, 1940), 62.

"History of Bottles," *Harper's Weekly,* LVII (January 4, 1913), 25.

"Imported Glass Wares," *Nile's Register,* XVI (1819), 403.

LeFevre, Edwin. "Why I Collect Bottles," *Saturday Evening Post,* CCII (October 19, 1929), 34–35.

Powers, M. K. "New Pleasures from Old Bottles," *House Beautiful,* LVIII (September, 1925), 292–296.

Roberts, K. L. "Tour of the Bottlefields," *Saturday Evening Post,* CIC (November 13, 1926), 24–25.

Sampson, D. "Collecting Old Bottles," *House and Garden,* LXXX (September, 1941), 58.

Wasson, H. G. "Empty Bottles," *Hobbies,* XLVII (October, 1943), 67-68.

PART II

The

Oldest

Bottles

2

Ancient Glass History

Before meaningful life flourished on earth, nature's combined forces had created glass in two different ways. Long slender glass tubes called fulgurites were formed when lightning struck sand and the immense heat fused it. The subterranean furnaces of volcanoes also fused sand into a glass, called obsidian.

Long before man learned to make glass himself he used the glass that had been provided by nature; he fashioned tools, weapons, and ornaments from this crude metal called obsidian. Some of these manufactured objects have been dated as early as 75,000 B.C.

The exact date that man first manufactured his own glass is not known. It is known, though, that at least 3,500 years ago men knew how to make glass. The first man-made glass was a glaze made from a heated mixture of sand and minerals. The mixture was fused onto the surfaces of stone and ceramic objects in an oven. This form of glass (*pâté de verre*) was used by Egyptian and Mesopotamian potters.

In Egypt early in the eighteenth dynasty (1580–1358 B.C.) glass beads and small vessels were being made. The containers were manufactured by dipping, or rolling, a core of sand in heat-softened glass and wrapping it with softened glass threads while it was still hot (see Chapter 8). After the container was cool the sand was removed. The threads were of varying colors which made the little vessels quite colorful. This method was at its peak when the Israelites made their

"A handful of sand is an anthology of the universe."

—David McCord

flight from slavery in Egypt (1300 B.C.), and they took with them the knowledge of glassmaking.

There has been little change in the ingredients of glass from those early times until today. The few changes that were made were restricted, for the most part, to selection and purification of ingredients. These ingredients, very simply, are sand, soda, and lime. Of the three constituents, sand (silica) makes up the major portion of a batch of glass. The soda is a flux added to promote fusion which takes place at a temperature above 2500 degrees Fahrenheit. Finally, lime is added because soda-silica glass is soluble in water and the lime reduces this solubility.

In 538 B.C. the admirable civilization built up by the Babylonians in the rich land between the Tigris and Euphrates rivers fell to the Persian armies of Cyrus. Meanwhile, history's first major democratic government came into being in Athens, Greece. In 490 B.C. Darius, the Persian, sent a small force to attack Athens; the Greeks not only held off Darius' army but soundly defeated him. As a result the Persians were kept out of Europe and Athens gained first place in the Grecian world. Even during these struggles much trade was carried on; as a matter of fact, these wars were partially over trade routes.

At Arbela, Alexander the Great of Macedonia succeeded in smashing the Persian empire in 331 B.C. The Greek influence his army established continued to dominate Asia for centuries; with the cessation of war, trade flourished. Persian knowl-

edge of glass was brought to Rome by slaves and was added to Roman knowledge. Glass made before 100 B.C. was seldom transparent, but since the craftsmen of that period were interested in colorful glass it mattered little. The advent of the blowpipe extended the use of glass greatly and made glass production in Roman times into a major industry.

The development of glassblowing probably came sometime late in the first century B.C. With this biggest of all innovations in glass history the whole character of glass vessels changed. Thin-walled containers replaced the heavier ones of earlier periods. The new technique made it possible to more or less mass-produce glass items of a utilitarian nature and glass became a household commodity. Clear glass became popular. The average Roman of that period even had crude windowpanes for his home and bought souvenir cups and bottles with the names of his favorite gladiators molded into them.

At the time of the death of Jesus in A.D. 29 or 30 Romans were spreading their knowledge of glass to all ends of the empire and beyond; when Jerusalem was leveled and plowed over by Hadrian's Roman legions in A.D. 135, glass was as much in demand as gold and silver.

It was in the first century A.D. that glass was taken to China from Egypt and Syria by enterprising travelers to the Asiatic provinces of the Roman Empire. In China, too, glass was considered as valuable as gold, silver, and even precious stones.

It was not until the fifth century A.D., however, that glass was manufactured by the Chinese. They practiced the art until their glass was at least equal to that the Venetians were later to produce. For the collector of bottles the acme is the glass snuff bottles produced from the mid-1600s—see Chapter 19.

In A.D. 330 a second capital of the Roman Empire was established at Byzantium, later named Constantinople; the new capital eventually replaced Rome, whose wealth and population shifted eastward. In A.D. 476 the barbarians removed the last Western Roman emperor. The end of the old Roman Empire cut off Constantinople from Western Europe, creating two separate spheres of influence. In the Byzantine Empire, especially in Constantinople, the production of fine glass continued, and was to flourish for hundreds of years. In the West, the art of glassblowing was spread by the barbarians throughout Europe. However, by the end of the fifth century A.D., when the disintegration of the Empire was complete, glasshouses existed only in isolated areas.

In A.D. 800 Charlemagne (King of the Franks) accepted the crown, from the Pope, of the new Roman Empire of the West. By taking the title, Charlemagne strengthened the influence of the Roman Church and culture. While glass continued to be made in the West, it was in Byzantium, in the East, that the art flourished.

In 1066, William of Normandy (France) vanquished Harold of England in the Battle of Hastings. The result was French domination of the English, which meant an influx of French language, culture (including glassmaking), and customs that greatly influenced English thought and life. In 1099 the First Crusade was launched; the Christian armies took Jerusalem from the Moslems in what proved to be only the first of a two hundred-year series of wars between West and East. The chief benefit of the wars was the mingling of peoples and cultures which helped pull Europe out of the Dark Ages into the Renaissance. In glass, much trading of wares and ideas between the Byzantine Empire and the West took place. Toward the end of the eleventh century glassmakers were brought from Constantinople to Venice, beginning the establishment of what was to become one of the finest glass-producing centers in all history. In 1291, the glassmakers of Venice were moved to the islands of the town of Murano (see Chapter 45), where large-scale production could be pursued without danger of fire to the city, and where new techniques and formulas could be developed in relative secrecy. The glassworkers were literally held prisoner in Murano. By the middle of the fifteenth century the Venetians had a virtual monopoly on glass trade in the West.

In 1453 Constantinople fell to the Turks, and Greek and Roman arts and sciences, which had been nourished there for a thousand years, were carried into Europe by fugitive scholars. While the Venetians were rediscovering the art of diamond point engraving, the Grecian glassblowers

who fled from Constantinople introduced them to the techniques of applied decoration, gilding, and enameling (see Chapter 11).

When Columbus sailed to America, the Venetians had already perfected their famous crystal glass (*cristallo*). During the 1500s Italian (Venetian) glassmakers were taken to France and England to help establish glasshouses there.

The Age of Exploration, the establishment of colonies, and the flourishing of trade in the sixteenth century spread the knowledge of glassmaking to many parts of the world.

During the 1500s, Germany began to emerge as a source of fine glass; while other countries were being influenced by Venetian techniques and traditions, the Germans were developing their forest glasshouses (so called, because their glasshouses were, for the most part, built in the forests). The outstanding accomplishments of the Germans during this period were in decoration. Gilding, enameling, wheel cutting, and engraving became the most popular methods of decoration. In the early 1600s the glasshouses of Bohemia in Germany became world famous for their colored wares as well as their masterly execution of many techniques of decoration.

England's major contribution to glassmaking came in 1676 when George Ravenscroft developed lead glass, made by using flint instead of sand, potash instead of soda, and large quantities (25 percent) of lead oxide in the form of red lead. By 1696 lead or flint glass, as it is often called, was being produced in nearly all English glasshouses.

When glasshouses were established in America, they were manned by workers who came from such prominent glass producing countries as England, Germany, France, and Italy. In making glass they followed the methods and styles of their native lands and it was many years before an American tradition evolved.

Bibliography

BOOKS AND PAMPHLETS

Baker-Carr, C. D. T. *Sand and Glass*. U.S.A.: Nelson Doubleday, Inc., and Odhams Books, Ltd., 1967.

Corning Glass Works. *This Is Glass*. Corning, New York: Corning Glass Works, 1962.

————. *Glass from the Corning Museum of Glass*. New York: Corning Glass Center, 1965.

McKearin, George S. and Helen. *American Glass*. New York: Crown Publishers, Inc., 1968.

Maust, Don, ed. *Bottle and Glass Handbook*. Uniontown, Pennsylvania: E. G. Warman Publishing, Inc., 1968.

Robers, Frances, and Beard, Alice. *5,000 Years Of Glass*. New York: J. B. Lippincott Co., 1948.

PERIODICALS

Brill, Robert H. "Ancient Glass," *Scientific American,* CCIX (November, 1963), 120–130.

3

Ancient Glass Bottles

The collecting of ancient glass bottles has not been attempted by the average American bottle collector because of the feeling that most existing specimens from ancient times have already been collected and that the best are now in museums. It must be conceded that many ancient glass bottles do repose in museum collections all over the world. But that it is difficult or even impossible for the private collector to obtain ancient bottles is not true.

Just as digging by bottle collectors in the ruins of the past continues in the United States so does digging continue in foreign countries. Among the items being discovered in these foreign lands are glass bottles. A striking private collection of early Roman glass bottles was displayed at a bottle show staged in Las Vegas not long ago. At the same time, the buyer for an importing firm was selling bottles that had recently been excavated in the ruins of a Roman colony in Phoenicia not far from the present city of Beirut in Lebanon. The bottles dated from the second century A.D. and were being sold for prices ranging from $16 to $75.

In March 1969 an advertisement appearing in *Old Bottle Magazine* offered "ancient Roman flasks" for sale. The advertisement explained that the glass bottles dated from the first to fourth centuries A.D. and had recently been unearthed in Syria. They ranged from pale blue-green to rare deep shades of emerald, olive, and amber. Some of the pieces were mold-blown and featured appliqué or carved decorations (see Chapter 11). These ancient glass containers were offered at prices from $23.50 to $1,000.

Both museums and private collectors of ancient glass have indicated that much buying and selling of ancient glass, including bottles, goes on all the time. Auctions are one of the main sources of ancient glass; another prime source is the people actually digging in the ruins of ancient cities. It is interesting that several private collectors have said that their biggest problem was not locating specimens for sale but rather out-bidding other private collectors. It might be assumed that museums would compete a great deal with the private collector but this is not true; most museums rely quite heavily on donated objects and their buying is usually attempted on a limited budget. Although this is not a universal truth, for the most part it is another private collector who competes for the purchase of available ancient glass.

That most examples of ancient bottles are in museums seems to be untrue. Research shows that a great number of ancient glass bottles are in the hands of private collectors. As partial proof of this the bottles presented in this chapter are mainly from private collections all over the world; only space restrictions prevent the inclusion of many other fine examples from other collections.

The bottles included here were selected primarily to show examples of the various types discussed in the chapter on ancient glass history. Bottles of unusual construction, color, and type were also included to help develop certain concepts presented in other chapters.

Bibliography

PERIODICALS

Hubbard, Clarence T. "The Fascination of Ancient Glass," *The Antiques Journal,* XXIV (September, 1969), 16.

Munsey, Cecil. "Ever Seen a Bottle Made in the Second Century A.D.?" *The Bottleneck,* II (February, 1967), 5.

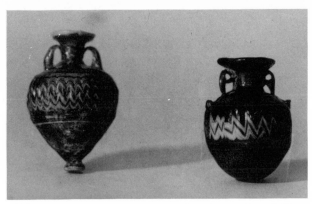

Fifth century B.C., Egyptian amphoriskos and aryballos, blue, green, and yellow. (Dr. and Mrs. Albert Kies, Tienen, Belgium)

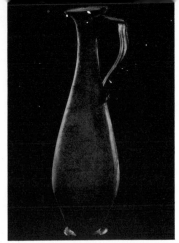

Third century B.C., Roman, H. 12¾ in. (Hans Cohn, Los Angeles, Cal.) Photo by A. P. Verebes.

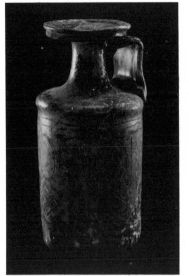

Second century B.C., Syria, H. 10 in. (Hans Cohn, Los Angeles, Cal.) Photo by A. P. Verebes.

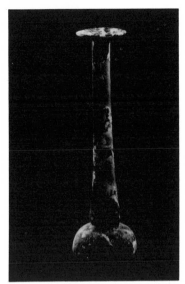

Second century B.C., Syria, H. 7¹⁄₁₆ in. (Hans Cohn, Los Angeles, Cal.) Photo by A. P. Verebes.

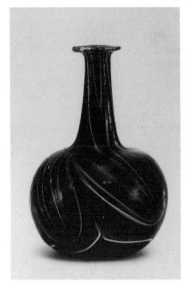

First century B.C., Roman, Milfiori glass bottle, purple and white, H. approx. 4 in. (Hans Cohn, Los Angeles. Cal.) Photo by A. P. Verebes.

First century B.C., Roman, threads and birds decoration, H. 7¾ in., very rare. (Hans Cohn, Los Angeles, Cal.) Photo by A. P. Verebes.

First century A.D., Roman or Syrian, opaque white, double headed flask (man or woman), H. approx. 3 in. (Hans Cohn, Los Angeles, Cal.) Photo by A. P. Verebes.

First century A.D., Roman, globular shape, H. 5¹⁄₁₆ in. (Hans Cohn, Los Angeles, Cal.) Photo by A. P. Verebes.

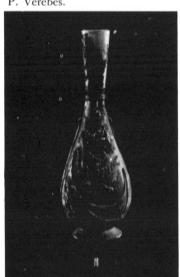

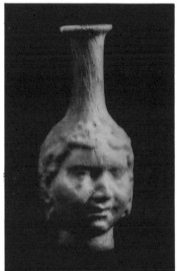

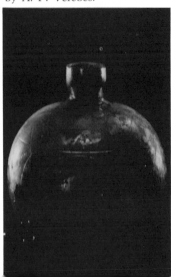

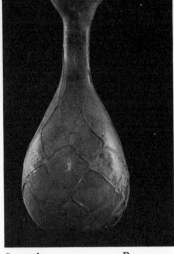

Second century, A.D., Roman or Syrian, H. 8¾ in. (Hans Cohn, Los Angeles, Cal.) Photo by A. P. Verebes.

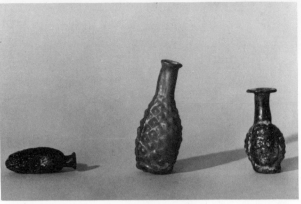

Left to right: (1) second century, Syria, shape of a date, brown, H. approx. 2¾ in.; (2) second century, origin unknown, shape of a fir or pine cone; (3) second century, Syria, "Janus" glass, olive green, H. approx. 3¼ in. (Dr. and Mrs. Albert Kies, Tienen, Belgium)

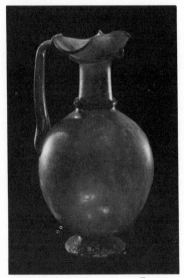

Second or third century, Roman, H. 7⅛ in. (Hans Cohn, Los Angeles, Cal.) Photo by A. P. Verebes.

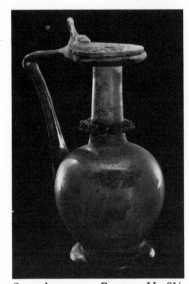

Second century, Roman, H. 8¼ in. (Hans Cohn, Los Angeles, Cal.) Photo by A. P. Verebes.

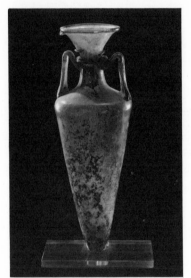

Second or third century, Roman, H. 8 in. (Hans Cohn, Los Angeles, Cal.) Photo by A. P. Verebes.

Second or third century, Syria, H. 5⅛ in. (Hans Cohn, Los Angeles, Cal.) Photo by A. P. Verebes.

Third century, Syria, H. 10 in. (Hans Cohn, Los Angeles, Cal.) Photo by A. P. Verebes.

Fourth century, Byzantine, inscribed "lave" (take), decoration life tree flanked with two crosses, H. 8⅛ in. (Hans Cohn, Los Angeles, Cal.) Photo by A. P. Verebes.

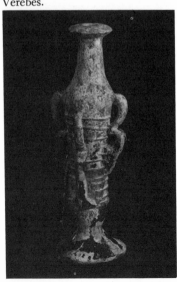

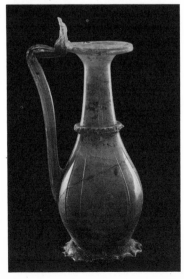

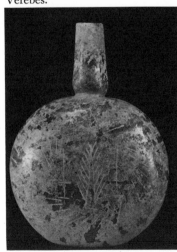

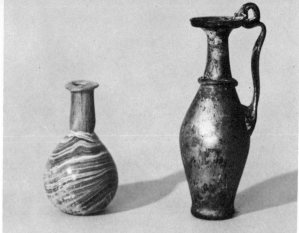

Left to right: (1) fourth to sixth century, Syria; (2) fourth to sixth century, Syria, violet glass, H. approx. 7½ in. (Dr. and Mrs. Albert Kies, Tienen, Belgium)

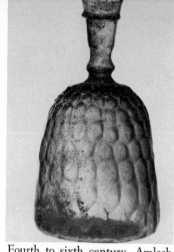

Fourth to sixth century, Amlash, H. 7⅛ in. (Hans Cohn, Los Angeles, Cal.) Photo by A. P. Verebes.

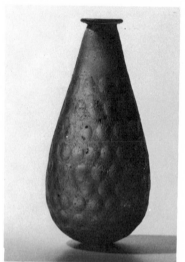

Fourth to seventh century, Persia, greenish, facet cut, H. approx. 8¾ in. (The C. L. David Collection, Copenhagen, Denmark)

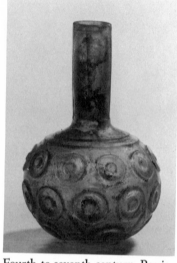

Fourth to seventh century, Persia, colorless, H. approx. 7 in. (The C. L. David Collection, Copenhagen, Denmark)

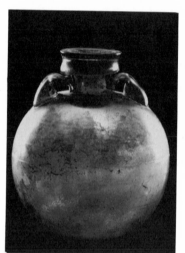

Eighth century, Iran, colorless, globular shape, short neck, H. 5¾ in. (Hans Cohn, Los Angeles, Cal.) Photo by A. P. Verebes.

Eighth century, Iran, H. 7½ in. (Hans Cohn, Los Angeles, Cal.) Photo by A. P. Verebes.

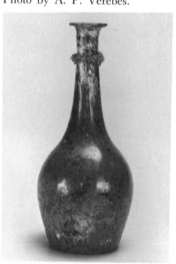

Eighth century, Islamic, iridescent, H. 6⅝ in. (Eugene Fuller Memorial Collection, Seattle Art Museum, Seattle, Wash.)

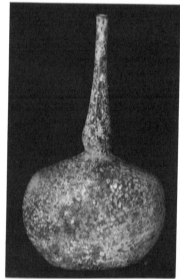

Eighth or ninth century, Iran, H. 2¾ in. (Hans Cohn, Los Angeles, Cal.) Photo by A. P. Verebes.

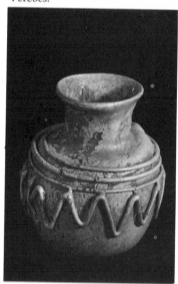

14

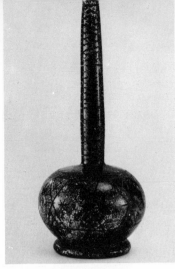

Ninth century, Iran, H. 9½ in. (Hans Cohn, Los Angeles, Cal.) Photo by A. P. Verebes.

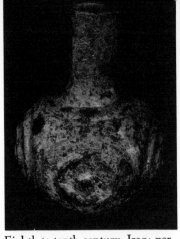

Eighth to tenth century, Iraq: perfume bottle, light green, ground concentric circle decoration, H. 3½ in. (Eugene Fuller Memorial Collection, Seattle Art Museum, Seattle, Wash.)

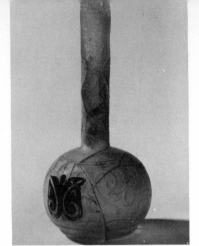

Ninth century, Iran, colorless bottle with overlaid floral decoration in bright green glass, H. approx. 6½ in. (The C. L. David Collection, Copenhagen, Denmark)

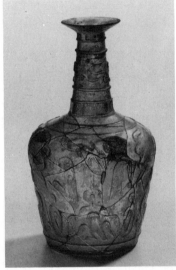

Ninth or tenth century, Iran, colorless, exceptionally fine cut decoration in high relief (birds, animals and wine scrolls) H. Approx. 8½ in. (The C. L. David Collection, Copenhagen, Denmark)

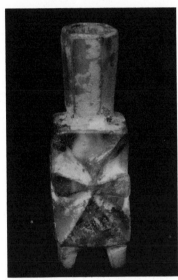

Ninth or tenth century, Egyptian "Molar" flask, ground glass, H. 2½ in. (Eugene Fuller Memorial Collection, Seattle Art Museum, Seattle, Wash.)

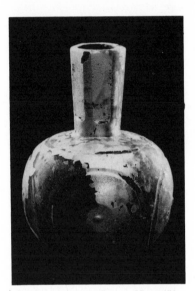

Tenth century, Iran, H. 3¹⁵⁄₁₆ in. (Hans Cohn, Los Angeles, Cal.) Photo by A. P. Verebes.

Ninth or tenth century, Persia, greenish glass, cut decoration, H. approx. 6 in. (The Corning Museum of Glass, Corning, N.Y.)

Ninth or tenth century, Persia, greenish, cut decoration, H. approx. 7 in. (The Corning Museum of Glass, Corning, N.Y.)

Tenth century, Iran, colorless, symmetrical cut plant decoration in high relief, H. approx. 5½ in. (The C. L. David Collection, Copenhagen, Denmark)

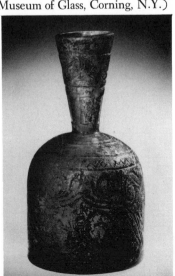

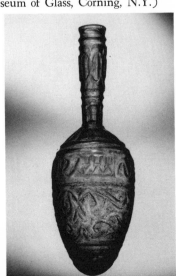

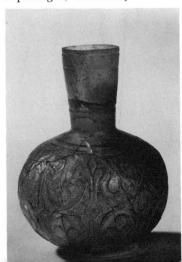

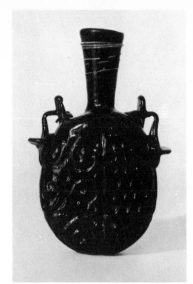

Ninth to twelfth century, Near East, dark green (opaque), mold blown, H. approx. 5 in. (Dr. and Mrs. Albert Kies, Tienen, Belgium)

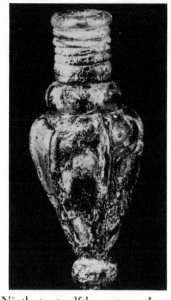

Ninth to twelfth century, Iran, perfume bottle, colorless with molded decoration, H. 3 in. (Eugene Fuller Memorial Collection, Seattle Art Museum, Seattle.

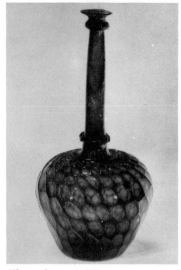

Eleventh or twelfth century, Iran, blue glass with applied net-like decoration, H. 10⅛ in. (Eugene Fuller Memorial Collection, Seattle Art Museum, Seattle, Wash.)

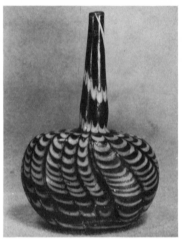

Eleventh to twelfth century, Islamic, dark purplish with white opaque threads, H. 3¾ in. (Eugene Fuller Memorial Collection, Seattle Art Museum, Seattle, Wash.)

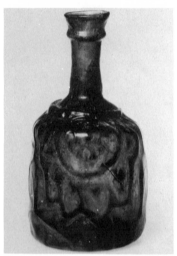

Twelfth century, Persia, blue, mold blown, H. approx. 6¾ in. (Musée du Verre, Liège, Belgium)

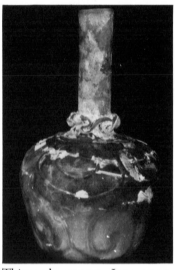

Thirteenth century, Iran, green blown glass, H. 6⅝ in. (Eugene Fuller Memorial Collection, Seattle Art Museum, Seattle, Wash.)

Thirteenth century, Iran, ground S-curved, V-shaped fluted decoration, H. 4½ in. (Eugene Fuller Memorial Collection, Seattle Art Museum, Seattle, Wash.)

Fifteenth century, Germany, double conical shape, yellow-green, H. approx. 6½ in. (Helfried Krug, Mulheim, Germany)

1599, Bohemia, rectangular shape, multicolor enameling, "Christ arising from the grave." (Helfried Krug, Mulheim, Germany)

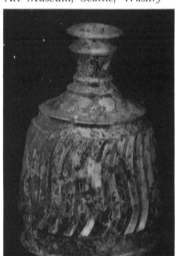

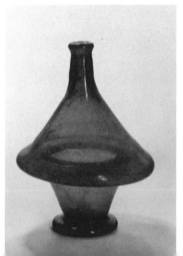

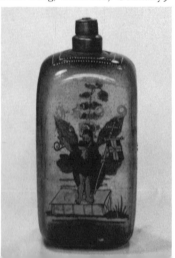

16

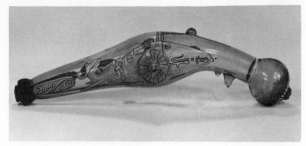

1596, Germany, pistol shape, white and black enameling, pewter top, L. approx. 12½ in. (Helfried Krug, Mulheim, Germany)

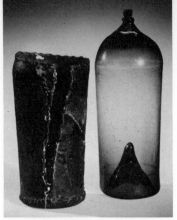

Sixteenth century, Germany, bottle of greenish glass in leather case, H. approx. 7½ in. (The Corning Museum of Glass, Corning, N.Y.)

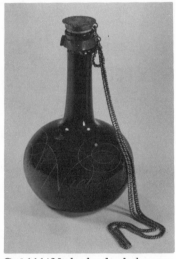

C. 1666, Netherlands, dark green glass, top (consisting of a silver coin dated 1666) fastened to a long silver chain, diamond point engraving on front, H. approx. 7¼ in. (Helfried Krug, Mulheim, Germany)

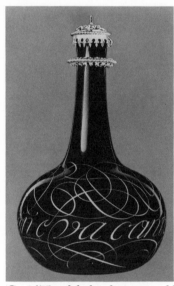

C. 1675, globular bottom, gold inlaid metal top, green with diamond cut design. (Fritz Biemann, Kusnacht, Germany)

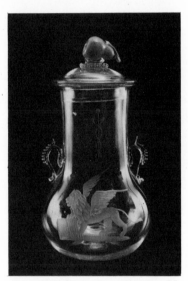

Seventeenth century, Venice, H. 9 in. (Hans Cohn, Los Angeles, Cal.) Photo by A. P. Verebes.

Seventeenth century, India, quadrangular shape, clear glass with multicolored enameling and gilding, H. approx. 5 in. (Helfried Krug, Mulheim, Germany)

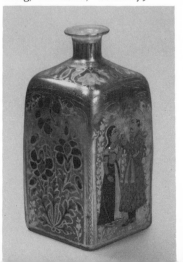

Seventeenth century, Venice, brown and green agate glass, silver top, H. approx. 6½ in. (Helfried Krug, Mulheim, Germany)

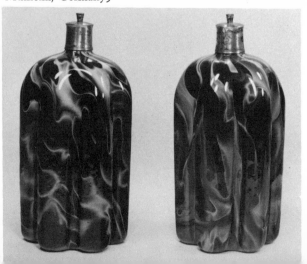

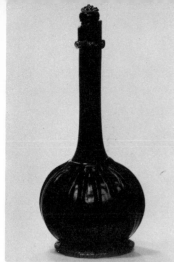

Seventeenth century, Germany, round flattened body vertically banded, long neck, glass screw top, dark violet glass, H. approx. 11 in. (Helfried Krug, Mulheim, Germany)

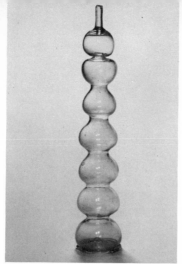

Seventeenth century, Germany, clear, bottle formed by six consecutive bulbs; seventh bulb on top held a cork stopper, H. approx. 15 in. (Helfried Krug, Mulheim, Germany)

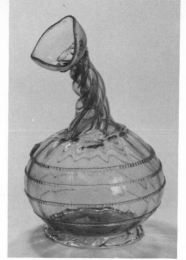

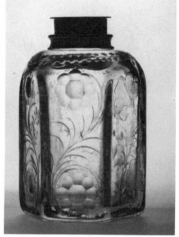

Seventeenth century, Germany, round body with pincered glass rings; neck consists of four winding tubes, H. approx. 6¾ in. (Helfried Krug, Mulheim, Germany)

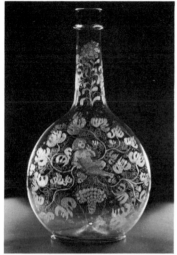

Late seventeenth century, Holland, colorless, diamond cut, "boy sitting in a grapevine." (Fritz Biemann, Kusnacht, Germany)

Seventeenth or eighteenth century, Persia, yellowish, sprinkler, mold-blown rounded body, long S-shaped neck, H. approx. 14½ in. (Helfried Krug, Mulheim, Germany)

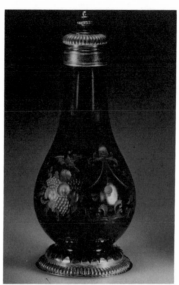

Late seventeenth century, Germany, manufactured by Elias Adam (name stamped on base) who was in business 1685–1709, ruby red, base silver. (Fritz Biemann, Kusnacht, Germany)

Seventeenth or eighteenth century, Spain, violet and white speckled glass, pewter screw top, H. approx. 5½ in. (Helfried Krug, Mulheim, Germany)

Seventeenth century, Germany, clear, six sides, decorated with cut flower motifs, leaf pattern around shoulder. (Fritz Biemann, Kusnacht, Germany)

Seventeenth or eighteenth century, Germany or Netherlands, rectangular, combed blue and milk glass, pewter screw top, H. approx. 9 in. (Helfried Krug, Mulheim, Germany)

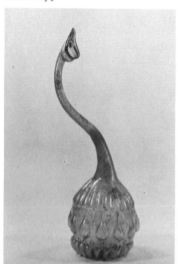

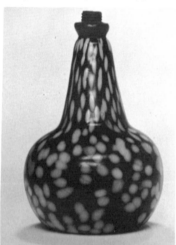

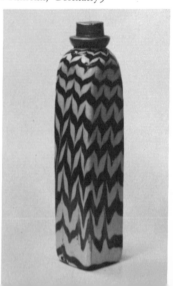

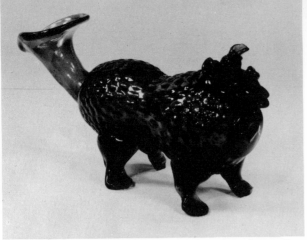

Seventeenth or eighteenth century, Germany, shape of a dog, amber, opening in the form of a trumpet-shaped tail, L. approx. 8¼ in. (Helfried Krug, Mulheim, Germany)

Seventeenth or eighteenth century, Tyrol, apple shape with rounded prunts, dark blue, H. approx. 4 in. (Helfried Krug, Mulheim, Germany)

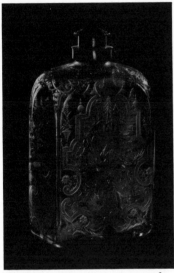

C. 1720, Germany, rectangular, engraving by Anton Wilhelm Mäuerl, silver screw top, H. approx. 7 in. (Helfried Krug, Mulheim, Germany)

Early eighteenth century, Potsdam, thick ruby glass, six sides, gilded silver screw top, H. approx. 6¼ in. (Helfried Krug, Mulheim, Germany)

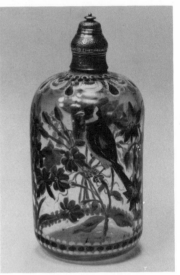

Early eighteenth century, Venice (by Osvaldo and Angelo Brussa), multicolor enameled decorations (bird amidst flowers), H. approx. 3¾ in. (Helfried Krug, Mulheim, Germany)

Eighteenth century, Germany, brownish green, navel bottle, irregular pear-shaped bottle with pressed-in navel in the middle, H. approx. 11¼ in. (Helfried Krug, Mulheim, Germany)

Eighteenth century, Venice, clear, pistol-shaped with pincered decorations representing parts of the pistol, L. approx. 13¾ in. (Helfried Krug, Mulheim, Germany)

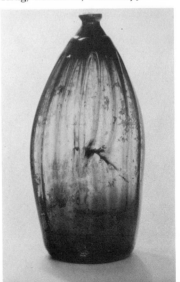

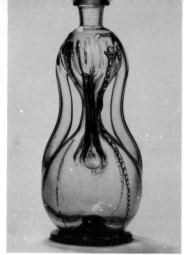

Eighteenth century, Germany, light green, hourglass shape with four separate vertical tubes, H. approx. 10½ in. (Helfried Krug, Mulheim, Germany)

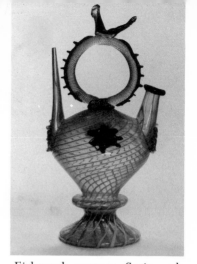

Eighteenth century, Spain, yellowish with latticinio and blue glass decorations, pear-shaped, two spouts, H. approx. 11¾ in. (Helfried Krug, Mulheim, Germany)

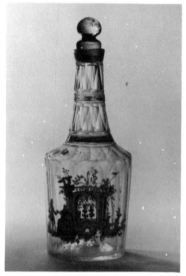

Late eighteenth century, Bohemia, clear, facet cutting and enameling, glass stopper, H. approx. 8½ in. (Helfried Krug, Mulheim, Germany)

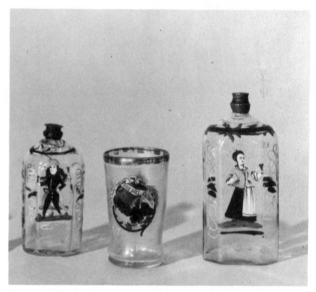

Late eighteenth century, Austria, clear, multicolored enameling. (Dr. and Mrs. Albert Kies, Tienen, Belgium)

Late eighteenth century, Austria, clear, inset medallion in Zwischengold technique (made by J. J. Mildner, Gutenbrunn), H. approx. 7¼ in. (Helfried Krug, Mulheim, Germany)

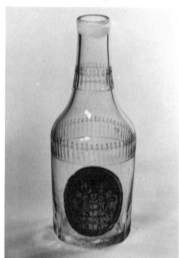

Early nineteenth century, Bohemia, red striated "lithyalin" glass, six sides, pewter screw top, H. approx. 4¼ in. (Helfried Krug, Mulheim, Germany)

4

Ancient American Pottery Bottles

The early European explorers and the colonists who followed introduced the art of glassmaking to North and South America, but long before their coming the aborigines of these two continents were skilled in ceramics. It is not the purpose of this book to dwell on ceramic bottles and it is especially hard to locate ancient types, but no discussion of the major aspects of bottle collecting is complete without at least a brief look at ancient American pottery bottles.

The North American Indian, although advanced enough to have produced ceramic objects, was not prolific in his production of small ceramic bottles. On the other hand, his South American counterpart was not only skilled in the production of clay objects but was an ardent lover and producer of ceramic bottles. Although Indian civilizations existed in various parts of South America during ancient times those groups centered around what is now the country of Peru are among the most studied by modern anthropologists and archaeologists. In addition to an abundance of knowledge about ancient Peruvian cultures there is an abundance of artifacts from these peoples. Many museums and private collections proudly display remains of these early groups; among almost all these displays can be found ancient pottery bottles.

Few countries in the world have as much of interest to the men who study the ruins of the past as does Peru. Though there is considerable controversy as to when the civilizations of Peru began most experts agree that by a few centuries before Christ, major civilizations had been built. By 1500 to 1000 B.C. the art of ceramics had been discovered and perfected. It is mostly from this period on that the collector of ceramic bottles assembles a collection of representative specimens.

The pottery bottles of the North to Central and South American Indians, were for the most part brightly colored and unusually shaped, and ranged in size from several inches to two feet in height. Most of the South American pottery bottles were made in figural shapes (see Chapter 20).

While in the recent past it was relatively easy for collectors in the United States to obtain specimens of ancient South American artifacts, including pottery bottles, currently most governments are unwilling to give permission to collectors to remove historical items from the countries where they are found. The fine collections that do exist outside of countries in which the ancient articles originated were assembled before those countries took a real interest in their cultural history, and passed laws relating to the removal of antiquities. Still, it is not impossible to obtain ancient pottery bottles. Some large antique dealers are able to arrange for the purchase of a few specimens that are duplicates of those included in the growing national collections in many South and Central American countries. Sometimes the American Consulate can be of assistance in helping a visitor get permission to remove art objects from a foreign country.

Needless to say, ancient ceramic bottles are considered rare and command comparatively high prices. Prices in general range from several hundred to several thousand dollars.

Bibliography

BOOKS

Wearin, Otha D. *Statues That Pour*. Denver, Colorado: Sage Books, 1965.

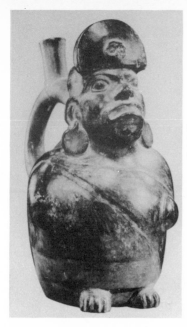

Ceramic Indian-shaped bottle from Peru, c. 100 A.D. (John C. Fountain, Amador City, Cal.)

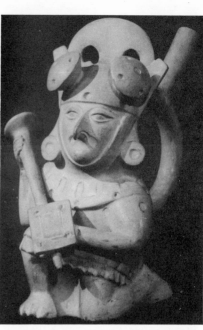

Ceramic warrior-shaped bottle from Peru, c. 500 A.D. (John C. Fountain, Amador City, Cal.)

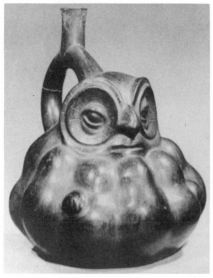

Ceramic human head on a squash-shaped bottle from Peru, c. 600 A.D. (John C. Fountain, Amador City, Cal.)

Stirrup-handled ceramic bottle from Peru, c. 600 A.D. (John C. Fountain, Amador City, Cal.)

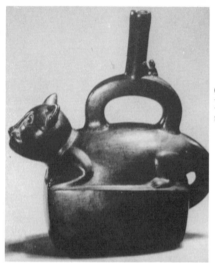

Ceramic puma-shaped bottle from Peru, c. 1300. (John C. Fountain, Amador City, Cal.)

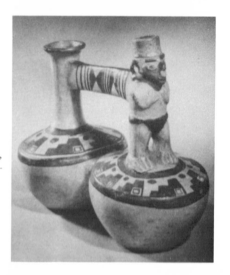

Ceramic double bottle from Peru, c. 1400. (John C. Fountain, Amador City, Cal.)

5

Early American Bottles

The history of glassmaking in America began with the establishment of Jamestown, the first successful English colony in North America, in 1607. In his *Historie of Virginia* (1632), Captain John Smith stated, "We sent home ample proof of pitch, tar, glass. . . ." His statement gives basis to the theory that glass (probably bottles) was the first product manufactured in America and the first product exported. The factory was probably started around 1609 after eight Dutch and Polish glassblowers arrived on the second ship sent to the colony in 1608. It is not known exactly what type of wares were produced because no known specimens have survived. It is safe to assume that the bottles were much like those being made in England at the time (see chapters 2 and 14). At any rate the venture was a failure and by 1617, when Captain Argall reached Jamestown, glass was no longer being manufactured.

A second attempt to blow glass in the English colony was made in 1621 when the London Company sent six Italian glassblowers to Jamestown. It is not known how long this new venture lasted but it too was a failure.

Other early efforts to establish glassmaking in North America included an attempt in Salem, Massachusetts from 1639 to 1643, and the operation of two glasshouses from 1650 to 1674 in New Amsterdam (New York). In Philadelphia a glasshouse was established in 1683 but nothing is known about its products and it is safe to assume that this effort lasted less than ten years.

It was during the early 1700s that America had its first major glasshouse. For forty years, from 1739 to 1779, Caspar Wistar and later his son, Richard, operated their famous glasshouse in Salem County, New Jersey. Again, history is vague about the products of this factory; it is recorded, however, that "most sorts of bottles, gallon, half gallon, and quart, full measure, half gallon case bottles, snuff and mustard bottles" were produced (*Pennsylvania Chronicle,* July 31, 1769). There are no known examples of glass from Wistar's factory that can unquestionably be authenticated.

As with the earlier attempts it has been assumed that this glasshouse followed Continental glassmaking traditions of the period (see chapters 2 and 14). Unlike his contemporary competitor, William Henry Stiegel, Wistar, it appears, did not attempt to produce fine wares, only items that were necessary to colonial life. Because of the supposed difference in their wares, in both glass type and decorative techniques, Wistar and Stiegel have been regarded by collectors as the fountainheads of two distinct traditions in American glassmaking and ornamentation, i.e., the *South Jersey type* and the *Stiegel type,* which were produced in the glasshouses that followed them. (To have but two types represent the wares that many glasshouses produced during the last half of the eighteenth century and the first half of the nineteenth century is not realistic but is traditional and will be maintained in this work; let it remain for a more specific volume to try to make the fine distinctions between the wares of the various early American glasshouses.) Wistar's bottles (and other wares), in the main, were blown from ordinary window glass and green or bottle glass (made from coarser and less pure materials than those used in the production of fine tableware). The colors of the bottles were greens from pale aquamarine to deep olive-greens and ambers of varied hue and tone. Occasionally artificial colors such as blue, deep wine, or maroon were used but probably not by Wistar; it is more likely that these colors belong to the later producers of South Jersey type bottles, who, incidentally, ranged from New Jersey to New York and New England. Ornamentation, with the exception of occasional pattern-molding (see Chapter 8), was accomplished through tooling and manipulation of the bottle in its formative stage. However, such ornamentation was very infrequent on bottles, since Wistar and others of the South Jersey group mainly produced common bottles designed for utilitarian purposes; for the most part they would be plain bulbous containers with sheared necks (see Chapter 6). Because many of the glassblowers in early America were originally trained on the

Continent it must be assumed that they were familiar with and used the so-called German half-post method of bottle blowing (see Chapter 8).

Unlike Wistar, Henry William Stiegel had a dazzling, meteorlike career. Stiegel, who began glassmaking twenty-four years after Wistar and failed five years before Wistar's plant at Wistarberg did, made a significant and perhaps even a magnificent contribution to American glass history. After only a few years in the colonies he married a prosperous ironmaster's daughter in 1752. In 1758 his wife died. Stiegel remarried and assumed ownership of the iron business shortly thereafter. Later he bought another iron business and with the profits from these two firms he went into glassmaking in 1763. By 1765, Stiegel had laid out and built the town of Manheim, Pennsylvania, near his iron business and a second glassworks; it was during this period (a financially unstable one for the colonies) that he built a mansion and began to live in regal splendor. It is reported that he rode to and from his factory in an elaborate coach drawn by eight horses, accompanied by liveried outriders who blew trumpets to attract attention, and followed by a pack of hounds. Such a mode of living earned him the lasting title of "Baron."

During these first years in the glass business it is likely that Stiegel made, among other things, common bottles very similar to those being made by his New Jersey competitor, Caspar Wistar. In 1769, after a trip to England to study the process of making fine English glass, Stiegel built his third glass factory, known today as the second Manheim glasshouse. It was Stiegel's dream that at this plant he would be able to manufacture flint glass as was currently being made in England. While in England, Stiegel must have made the contacts which enabled him to smuggle to this country the master craftsmen necessary to staff his ambitious venture. At its peak, the second Manheim glasshouse employed about 130 men, among them master blowers, engravers, cutters, and enamelers.

When the Townshend Acts were passed by Parliament in 1767, both Wistar and Stiegel thought that the heavy duty imposed on imported glass would cause the colonists to buy more domestic glass. Both were wrong but it was Stiegel who felt the pinches of bad judgment first. Because of his lavish living and poor judgment in financial matters, Baron Stiegel found himself bankrupt and in debtor's prison in 1774 at the age of forty-five. He lived in poverty for the remainder of his life, which ended in 1785.

In a sense it is unfortunate that Stiegel, through his imported workers, succeeded so well in his avowed intention to copy Continental wares because, as a result, it is difficult or impossible to authenticate the literally hundreds of examples of Stiegel glass that must be in collections today.

Characteristically Stiegel bottles are of the pattern-molded and expanded type. After initial blowing into a pattern mold the bottle was removed and expanded to completion by more blowing. Among these bottles is a group called perfume or toilet bottles which are usually about half-pint size, somewhat bulbous in shape with a short cylindrical neck, and feature a plain sheared neck. The most popular design in these bottles is a diamond-daisy, but other designs were used, such as the daisy-in-hexagon and the ogival or diamond diaper where the diamonds appear as grooves on the neck of the bottle and gradually expand to full diamonds on the body of the bottle. These "pocket bottles," as Stiegel listed them, are usually amethyst or sapphire blue in color.

Stiegel decanters were both free-blown and molded and ranged from a half-pint to a gallon in capacity. These bottles were engraved and enameled (see Chapter 11). Popular enameled designs included floral, dove, and dog motifs.

The common bottles made by Stiegel ranged in capacity from a half-pint to four gallons and probably were made at his first two factories. Such common containers were free-blown and were restricted to varying shades of green and amber.

Of necessity this has been a brief discussion of Stiegel and his products; for a most authoritative and complete account of his life and work, *Stiegel Glass* by Frederick William Hunter is recommended.

During the era of Wistar and Stiegel other glass plants were being established in the colonies. In 1771 the Philadelphia Glass Works was erected and operated under several owners until the 1780s. In 1780, Robert Hewes built a glasshouse near Temple, New Hampshire. Another glasshouse was built during the Revolution in New Jersey by the five Stanger brothers. This factory in Gloucester County was later called the Olive Glass Works, and the town, Glassboro. Little is known about the bottles from the Hewes or Stanger operations but it can be assumed that the bottles of the latter were made in the South Jersey tradition.

In the transition period between the end of the war in 1781 and the adoption of the Constitution in 1789, seven to nine new glasshouses were erected in America. One of the most noteworthy

for the collector is the Pitkin glasshouse built in 1783 near Hartford, a few miles from the Connecticut River. This factory operated until the 1830s and produced bottles of all kinds including flasks, carboys, and demijohns. In addition to free-blown flasks it is likely that pattern-molded flasks and molded historical and pictorial flasks were produced. It has been found that many bottles attributed to Pitkin were made at glasshouses in western Pennsylvania, West Virginia, and Ohio. The term Pitkin, therefore, today is a generic one representing bottles that were finely ribbed vertically, spirally, or in a combination of both, and made by the German half-post method. The original Pitkin flasks were made in clear olive amber and olive greens; the most common shape was a tapering ovoid with a slight concavity in the wide sides just above the bottom of the flask. The Pennsylvania, West Virginia, and Ohio Pitkin type, on the other hand, were blown mainly from a brilliant glass in various shades of greens, light to dark amber, and aquamarine. These Pitkin-type flasks were generally heavy and flat as well. It is the considered opinion of many that the majority of the surviving specimens are from the early nineteenth- rather than the eighteenth-century bottle houses.

In 1783 a glasshouse was erected at Peterborough, New York; in 1785 an Albany glassworks was started. Both of these factories produced bottles in the South Jersey style.

After the War for Independence glassmaking in the United States continued to suffer from a lack of both public and private support. State governments were slow in offering loans and tax exemptions which were needed to encourage the industry; the federal government, likewise, was slow in providing protective tariff regulations. Some glasshouses closed and the workers moved to the Midwest (Ohio, Kentucky, and Tennessee), where glasshouses were busy supplying the growing distilling industry with glass bottles for their products. The glass industry in America was not firmly established on a sound financial basis until the development of mechanical means of production in the latter part of the nineteenth century (see Chapter 6).

For the collector of bottles there are several glasshouses of the late 1700s and early to mid-1800s of enough interest to merit discussion here. (The reader who wishes to examine a detailed listing of the approximately one hundred glassworks that existed between 1800 and 1830 or the many that followed that period is referred to *American Glass* by George S. and Helen McKearin; an in-depth history of early American glasshouses can be found in *Two Hundred Years of American Blown Glass* by Helen and George S. McKearin.

A prominent early glasshouse was the Dyottville Glass Works, originally known as the Philadelphia Glass Works in 1771 when it was established. Later, after a series of failures, it became the Philadelphia and Kensington Glass Works and in the early 1820s Thomas W. Dyott bought into the firm. Dyott had started as a bootblack and worked his way "up" to making and selling nostrums (see Chapter 17). By 1812 he had proclaimed himself "Doctor" Dyott. In order to supply his growing need for bottles and avoid the middleman, Dyott bought into the Philadelphia and Kensington Glass Works and by 1830 became the sole proprietor. By 1833 the factory was officially renamed the Dyottville Glass Works. Like the famous "Baron" Henry William Stiegel, Dyott lived lavishly and made one big financial miscalculation. In 1836 he established his own bank, the Manual Labor Bank. Caught in the financial panic of 1838, Dyott improperly juggled the assets of his bank and was convicted of "fradulent bankruptcy." He lost his empire at the age of sixty-seven but lived another twenty-three years and died at ninety.

Thomas W. Dyott was responsible for many of the bottles being gathered today. Besides flasks bearing his portrait on one side and Benjamin Franklin's on the other he manufactured apothecary and patent medicine vials, druggist bottles, carboys, demijohns, confectioners' show bottles, fruit jars, snuff bottles, and many other bottles including ones picturing Washington, Lafayette, Franklin, a ship and Franklin, a cornucopia, the American eagle, agricultural and Masonic devices, and common ribbed pocket flasks (see Chapter 19).

In 1842 at Stoddard, New Hampshire, another important glasshouse was erected. Bottles were the main product of this firm and were manufactured of dark amber-green glass of coarse quality. The Stoddard bottles were usually made in a three-piece mold and displayed a quilted and sunburst design.

In 1814 the New Hampshire Glass Factory was opened in Keene. Bottles were the main product and were made of a glass of coarse quality and dark amber-green color. The most famous of

bottles from Keene are the Masonic and patriotic flasks (see Chapter 19), although it, and other American and European glasshouses of the same period, also made such bottles as gemel or twin bottles, which were very popular in the early 1800s. These bellows-shaped containers were probably made as keepsakes or gifts by the glassblowers in their leisure time, and were used, no doubt, to contain vinegar and oil which has long been a popular salad dressing in America. These bottles, as their name indicates, are two separate bottles fused together. Generally these bottles, after fusing, have the necks pointing in opposite directions; occasionally the necks point in the same direction. These containers featured applied and tooled decorations; frequently glass of a different color than the bottles was looped around them before or after fusing.

Bibliography

BOOKS

Glass from the Corning Museum of Glass. New York: Corning Glass Center, 1965.

Hunter, Frederick William. *Stiegel Glass.* New York: Dover Publications, Inc., 1950.

McKearin, George S. and Helen. *American Glass.* New York: Crown Publishers, Inc., 1968.

McKearin, Helen and George S. *Two Hundred Years of American Blown Glass.* New York: Crown Publishers, Inc., 1950.

Moore, N. Hudson. *Old Glass—European and American.* New York: Tudor Publishing Co., 1939.

Munsey, Cecil. *Would You Believe.* San Diego, California: I.P.S., a division of Neyenesch Printers, Inc., 1968, p. 9.

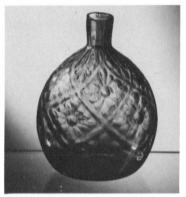

Pocket bottle or flask, amethyst, pattern molded and expanded in diamond-daisy design, Stiegel type, H. approx. 5¼ in., c. 1765–1774. (The Corning Museum of Glass, Corning, N.Y.)

Pocket bottle or flask, amethyst, pattern molded and expanded in diamond design, Stiegel type, H. approx. 5½ in., c. 1770. (The Corning Museum of Glass, Corning, N.Y.)

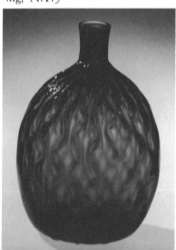

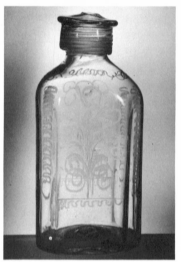

Tea caddy or canister, clear, lightly engraved, glass screw lid, Stiegel type, H. approx. 7½ in., c. 1770. (The Corning Museum of Glass, Corning, N.Y.)

Scent bottle, expanded diamond and rib design, amber, Stiegel, H. approx. 5 in., c. 1774–1790. (Philadelphia Museum of Art, Philadelphia, Pa.)

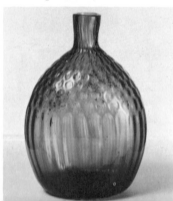

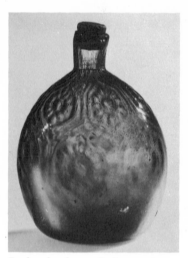

Pocket bottle or flask, amethyst, pattern molded and expanded in daisy-in-hexagon design, Stiegel type, H. approx. 4¾ in., c. 1770. (The Corning Museum of Glass, Corning, N.Y.)

Bottle, amber, midwestern, bulbous, twisted swirl design, H. 6⅝ in., c. 1830–1850.

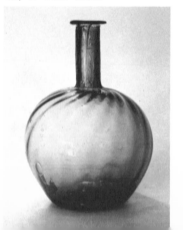

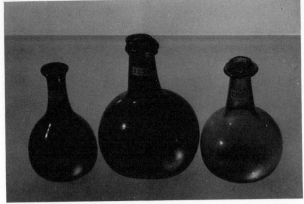

Left to right: small free-blown bottles, green, two globular, one kidney-shaped, H. 3¾ in., 4⅛ in., and 3¾ in., eighteenth century. (Charles B. Gardner, New London, Conn.)

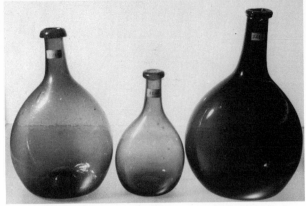

Left to right: flasks, olive-green, chestnut-shaped, free-blown, H. 8 in., 5 in., and 8¾ in., late eighteenth century. (Charles B. Gardner, New London, Conn.)

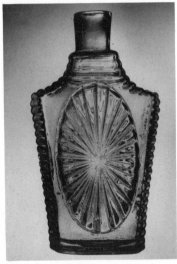

Pint flask, light green, sunburst motif, Keene Glass Works, New Hampshire, H. approx. 8¼ in., 1815–1817. Same pattern was made at the glassworks in Vernon, N.Y., and Coventry, Connecticut. (The Corning Museum of Glass, Corning, N.Y.)

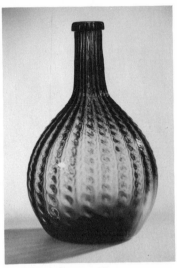

Bottle, amber, midwestern, possibly Zanesville Glass Manufacturing Co., Zanesville, Ohio, H. approx. 7¾ in., c. 1815–1830. (The Corning Museum of Glass, Corning, N.Y.)

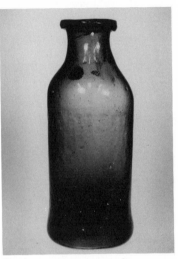

Bottle, transparent olive-green, blown in a cylindrical dip mold, hand finished, probably New England, H. approx. 8¾ in., c. 1825–1860. (The Corning Museum of Glass, Corning, N.Y.)

Preserve jar, light olive-amber, Stoddard, New Hampshire, H. approx. 8½ in., c. 1846–1870. (The Corning Museum of Glass, Corning, N.Y.)

Flask, golden amber, midwestern, H. approx. 6½ in., early nineteenth century. (The Corning Museum of Glass, Corning, N.Y.)

Flask, green, Pitkin type, made by German half-post method, H. approx. 7 in., late eighteenth century or early nineteenth century. (The Corning Museum of Glass, Corning, N.Y.)

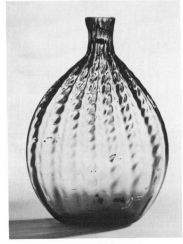

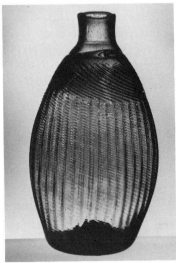

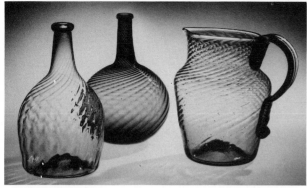

Left to right: (1) bottle, aquamarine, pattern molded in swirl design, midwestern, probably Zanesville Glass Manufacturing Co., Zanesville, Ohio, H. approx. 8 in., c. 1815–1830; (2) bottle, amber, pattern molded in swirl design, midwestern, probably Zanesville Glass Manufacturing Co., Zanesville, Ohio, H. approx. 8 in., c. 1815–1830; (3) pitcher, transparent green, midwestern, H. approx. 7¼ in., early nineteenth century. (All from the Corning Museum of Glass, Corning, N.Y.)

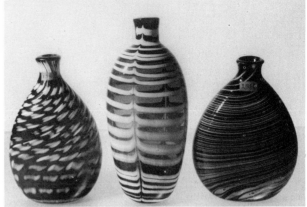

Left to right: flasks, Nailsea glass (olive-green with white striations), H. 5 in., 6¼ in., and 5 in., early nineteenth century. (Charles B. Gardner, New London, Conn.)

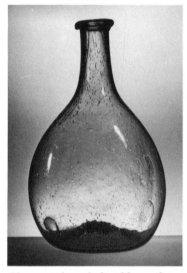

Chestnut-shaped free-blown bottle, green, H. approx. 6¾ in., late eighteenth century or early nineteenth century. (The Corning Museum of Glass, Corning, N.Y.)

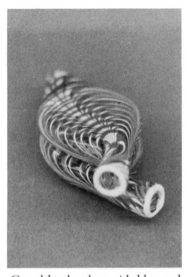

Gemel bottle, clear with blue and white stripes, L. 10 in., probably used for vinegar and oil.

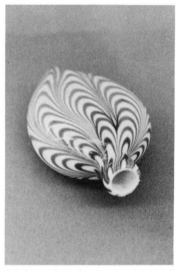

Nailsea glass bottle, opaque red and white stripes, flattened teardrop shape, L. 8 in.

Flasks (left to right): (1) amber, swirled design, midwestern, one quart, early nineteenth century; (2) amber, broken swirled design, midwestern, one quart, early nineteenth century. (Charles B. Gardner, New London, Conn.)

Gemel bottle, clear with red and blue stripes, ground pontil scar, L. 10 in., probably used for oil and vinegar.

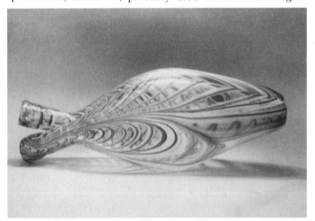

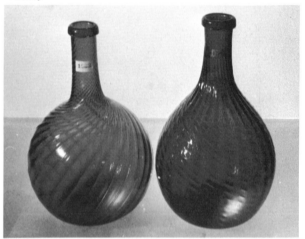

28

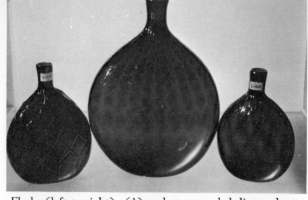

Flasks (left to right): (1) amber, expanded diamond pattern, chestnut shape, midwestern, half pint, early nineteenth century; (2) amber, "grandfather's flask," broken swirled design, chestnut shape, midwestern, one quart, early nineteenth century; (3) amber, expanded diamond design, midwestern, half pint, early nineteenth century. (Charles B. Gardner, New London, Conn.)

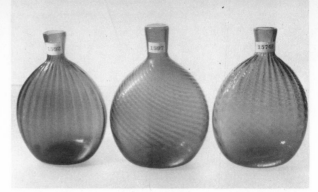

Flasks (left to right): (1) amber, vertical rib design, chestnut shape, midwestern, H. 4¾ in.; (2) amber, swirled design, chestnut shape, midwestern, H. 5 in.; (3) amber, broken swirled design, chestnut shape, midwestern, H. 4¾ in.; all early nineteenth century. (Charles B. Gardner, New London, Conn.)

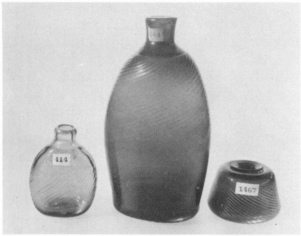

Flasks and ink well (left to right): (1) New England Pitkin, olive-green, H. 2½ in., made by German half-post method, early nineteenth century; (2) New England Pitkin (probably from Keene Glass Works), amethyst, H. 5¾ in., made by German half-post method, early nineteenth century; (3) New England Pitkin, olive-green, H. 1½ in., early nineteenth century. (Charles B. Gardner, New London, Conn.)

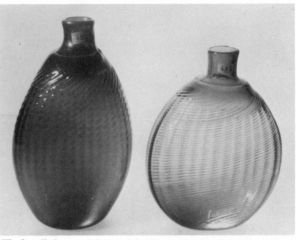

Flasks (left to right): (1) New England Pitkin, olive-green, H. 6⅜ in.; (2) midwestern Pitkin, amber, H. 5¾ in.; both made by German half-post method; early nineteenth century. (Charles B. Gardner, New London, Conn.)

Flask, dense olive-green, vertical ribbed, very heavy, probably Keene, one pint, early nineteenth century. (Charles B. Gardner, New London, Conn.)

Free-blown, paddled, six-sided bottle, straw color, H. 8¾ in., c. early nineteenth century

Early proprietary medicine manufacturer and glassmaker Thomas W. Dyott. (John C. Fountain, Amador City, Cal.)

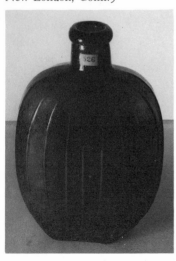

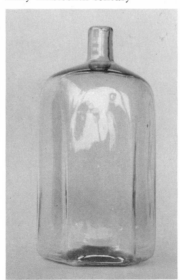

28

PART III

Glass

Production

6

Glassblowing

About one hundred years before the birth of Christ, probably in Syria, glassworkers discovered the art of forming hollow vessels by blowing air through a tube into a blob of hot glass. This was probably the most important discovery in the history of glass; it paved the way for most of the other improvements and inventions that have been made in glassworking to date.

From a twelfth-century manuscript written by a German monk named Rugerus or Rogherus, a glassblower and goldsmith who assumed the name Theophilus, a very interesting description of glass-blowing can be obtained:

At the first hour in the morning, take the iron [blowpipe], plunge the extremity of this pipe into a pot filled with [hot] glass. Turn the pipe in your hand until as much glass as you wish is collected around it, then taking it out, put it to your mouth and blow a little; removing it, immediately you put it to your cheek, so as not to draw the flame [heat] into your mouth while taking a breath. Keep a smooth stone also before the window [of the furnace] on which you can beat the hot glass a little, in order to give it the same thickness all over; you must alternately blow and remove the pipe with great rapidity. When it presents the form of a long hanging bladder, bring the extremity of it to the flame . . . until at last you give it [the finished bottle] to an assistant, who introducing a tool into the opening [probably the mouth], will carry it to the annealing oven, which should be moderately heated.

From Theophilus' time, and before, until the twentieth century glassblowing was accomplished much as in this description. Even today hand blowing techniques are still practiced in some places much in the same way they have been for twenty centuries.

Perhaps the best place to start a specific discussion of glassblowing is with the physical plant and its workers. A traditional glasshouse usually consists of a series of crews, called *shops;* each shop has a master blower called a *gaffer.* The gaffer is responsible for the five or six men assisting him, as well as for the quality of the finished product. (It is interesting to note that glassblowing has been, and still is in some places, carried on in secrecy. The business is so competitive that techniques are revealed as little as possible. Glass-blowers in early times were actually held prisoner and those who attempted to desert were punished severely and sometimes put to death.)

Of the six or seven men to a shop before the turn of the century no more than three were journeymen; the other three or four were boys, apprentices. Child labor was one of the stigmas of glassblowing for hundreds of years. Youngsters in American glasshouses worked ten-hour shifts on the average and in 1870 received only thirty cents a day for such an effort. The children and adults employed were liable to much physical illness, especially damage to the eyes caused by the intense heat of the furnace. Burns, pneumonia, and rheumatism were also prevalent.

Early factories were always located near an abundant supply of fuel; the fires of a glass factory were maintained twenty-four hours a day. Many factories throughout the years have failed because of a lack of fuel. Because the location of early factories was determined by the nearness to the supply of wood for fuel, the factory workers were often obliged to establish their town nearby. The factory was usually cheaply built around a dome-shaped furnace made of either stone or brick. The furnace usually had three chambers. The first level was where the fire burned, the second level was where the pots of molten glass were, and the third level was used as an annealing oven. The furnace had windows, called *boccas,* at appropriate intervals; it was customary to have one bocca per shop.

Clay melting pots, called *crucibles,* were the most expensive single items in the factory. In the 1880s a melting pot cost approximately one hundred dollars, and could be expected to last only a few months at best. (During the same period a master glassblower earned six dollars a day.) Actually it was not the cost of the pots that made them so important to the glasshouse but the time and trouble involved in constructing and installing them, all with no guarantee that a new pot would not crack upon initial use. It took an average of one month to construct a large crucible, sometimes as long as a year to cure (dry), seven to ten days to heat the pot prior to use, and a day to install the

new pot after removal of the old one. Of course, crucibles broke occasionally and spilled out the molten glass in the furnace and throughout the factory. This misfortune caused the factory to close (sometimes permanently) if a replacement pot was not available.

Glass is made from a basic mixture of sand, soda, and lime (see Chapter 2). In order to make the basic ingredients melt more rapidly and to assure smoothness of the mixture, *cullet* (broken pieces of glass) is added to each batch. Depending on the color of glass desired various oxides are also introduced into the basic mixture (see Chapter 7).

As the glass ingredients are melted a scum called *gall* rises to the top of the mixture and is skimmed off with a hoelike tool. Gall is caused by the impurities present in the alkalis of the glass, and, if allowed to remain, would make the resulting glass cloudy and bubbly as well as harm the melting pot. The glass is mixed with the hoe and sometimes a potato or something similar is dunked into the batch; this causes a violent boiling which serves to mix the glass. An entire batch cannot be mixed all at once; it must be done in stages. It takes several days to mix and melt a batch of glass to the point where it is ready to be used. Heat is applied slowly at first and then steadily increased to 2500 degrees Fahrenheit; it is at this temperature that the basic ingredients fuse. The batch is then reduced to 1800 degrees Fahrenheit where it thickens to the consistency appropriate for blowing.

Hand-blown bottles can be either free-blown or mold-blown. Taking a warmed blowpipe, several feet in length, the gaffer's assistant, the *gatherer,* inserts its tip through the bocca into the hot glass and turns it until a sufficient amount of glass has accumulated on the blowpipe. The gatherer then passes the blowpipe with the *gather* (hot glass on the tip of the blowpipe), sometimes called *post,* to the *servitor,* who is the master blower's first assistant; the servitor then rolls the gather on a marble or metal slab called a *marver.* This action gives the gather its basic bottle shape. The servitor then passes the blowpipe to the gaffer. If the bottle is to be hand-blown, the gaffer constantly rotates the gather to keep it from drooping while he makes the initial blow which introduces an air pocket into the gather. From this point the gather is called a *parison.* The parison is then rolled in a *block* (a wooden dipperlike device cut out on one side) which forces the glass into the shape of a sphere; he also blows at the same time to increase

the size of the parison. The block is kept from burning by an occasional splashing with water; the relatively cool block also cools the glass surface which helps the glass retain the desired shape.

At this point the servitor puts the parison back in the furnace for reheating (by the mid-1800s he used a smaller and hotter furnace called the *glory hole*) and then returns it to the gaffer. Through various manipulations and continued blowing the gaffer completes the shape of the bottle. Spinning the blowpipe rounds the parison out like a ball, providing the basic shape of short globular bottles. By swinging the blowpipe back and forth or in a complete circle the parison is elongated, providing the basic shape of long cylindrical bottles. Square free-blown bottles are obtained by slapping the parison on the marver and/or paddling it with a wooden paddle called a *battledore.* To make the bottom of the bottle flat, the gaffer may bang the plastic parison on the marver.

To take the final steps necessary in forming a free-blown bottle the gaffer sits at a workbench called a *chair.* The blowpipe is placed across the arms of the chair, which are tilted downward away from the gaffer, and is gently rotated during the completion period. The most important tool the gaffer uses at this stage of bottle making is the *pucellas,* a tonglike instrument more often called the *tool.* As the blowpipe is rotated the tool is sometimes used to narrow the neck of the bottle in preparation for taking it off the blowpipe for *finishing* (completing the neck and mouth). Shears resembling tin snips are sometimes used to cut the plastic metal—for example, glass to be made into handles. At this stage the bottle is ready for the final manipulations of finishing.

If the bottle is to be blown in a mold, the gaffer receives the blowpipe with the gather on it from the servitor and stands in position over the specific mold to be used. He then lowers the parison into the open mold. If the mold is other than a dip or one-piece mold an apprentice will assist by opening and closing the parts of the mold at appropriate times. After the parison has been lowered into the mold, the gaffer blows steadily into the blowpipe until he feels resistance which signals him that the hot glass has assumed completely the shape of the mold. He immediately ceases blowing and after the mold is opened he removes the bottle from the mold, ready for finishing. For a more extensive discussion of molds and the importance to collectors of the marks they leave, see Chapter 8.

Before either a free-blown or mold-blown bot-

tle can be removed from the blowpipe some arrangement must be made to hold it during the finishing of the neck and lip. This holding process is properly called *empontilling*. Until around the mid-1800s the prevalent method was to take a separate rod or blowpipe tipped with hot glass and stick it to the bottom of the bottle. With the pontil holding the bottle, the blowpipe used for the development of the bottle could be removed to allow finishing. For a more thorough discussion of empontiling, see Chapter 10.

By far the best, and as a result the most popular, method of severing the blowpipe from the bottle is a process known as *wetting off*. Wetting off is merely marking with a wet wooden paddle around the neck of the hot bottle where it is attached to the blowpipe. The cold water weakens the glass in the desired spot and a sharp tap by the gaffer breaks the bottle free of the blowpipe. Another popular method of severing the blowpipe from the bottle is by cutting the neck with shears. There seems to be no way to differentiate between the two methods by examining the bottles; both methods leave the neck in the same condition. There has been some speculation as to whether shearing was a popular or practical method of severing a bottle from the blowpipe. A careful search of early glassblowing literature, however, has revealed several references to the process and at least one photograph (included in this chapter) of it actually being accomplished.

The last step in developing a hand-blown bottle (the *finish*) is the formation of the lip of the bottle. Until about 1840 in America, wetting off and fire polishing was one of the finishing methods used. The technique, very simply, consisted of placing the neck of the bottle that had been severed from the blowpipe by wetting off back into the furnace. The heat from the furnace melted the finish, giving it a polished effect. As previously mentioned, around 1880 a small furnace called a glory hole came into use. The glory hole was kept at a higher temperature than the rest of the furnace and bottles fire polished in the glory hole have an extremely smooth finish.

Another important technique was to lay a string of glass around the outside of the bottle neck; this was appropriately called a *laid-on ring*. This was common on large bottles (demijohns, carboys, etc.) before the eighteenth century and on the smaller bottles early in the nineteenth century. Several laid-on rings were often applied to bottles for decorative purposes.

Until the 1870s, the laid-on ring was crude and rough. With the development of the separate glory hole heated by coal or gas, smoother finishes were more common and after the 1870s laid-on rings were so smooth that they are virtually undetectable—the two glasses appear as one.

Specially designed lipping tools (see Chapter 8) were often used (in America from around 1850) to create specific finishes. As early as 1855 American glassblowers were using a tool designed to make female threads on the inside of the bottle neck. Bottles of this type are often called *inside screws*. The sealing device (*closure*) for this type of bottle is a threaded stopper. Inside screws were used extensively on whiskey bottles from the late 1870s to around 1900 in America (see Chapter 25); in England they were used longer on ceramic bottles (see Chapter 26).

After the finish is developed on the blown bottle and the container is released from the holding device it is essentially completed. But if the bottle is left to cool at room temperature, almost immediately there is a great strain between the molecules of the glass directly exposed to the air (they squeeze together rapidly as the outer surface cools) and the molecules within the glass which is still at a temperature around 1500 degrees Fahrenheit (these molecules are widely spaced). If the bottle is allowed to continue to cool rapidly it is not very long before the strain becomes so great that the bottle explodes. The way to avoid this explosion is to cool the bottle gradually, which allows all of the molecules to contract at a rate tolerable to all of them.

The process of gradual cooling is called *annealing* and is accomplished by placing the hot bottle either in successively cooler parts of the furnace or in a specially built kiln (oven) in which the temperature can be reduced gradually. The proper name for the annealing oven is *lehr*. An estimated ten percent of the completed bottles of the early glasshouses broke in the annealing oven during the cooling period. Today annealing is done scientifically with no appreciable loss.

In America in the very early 1900s, the glass industry abandoned hand blowing in favor of automatic machine blowing. The glass business had finally become a part of the Industrial Revolution when Michael J. Owens invented and perfected the automatic bottle making machine.

The story of Owens's life is typical of the romantic and symbolic figure of American fiction, Horatio Alger, who went from rags to riches by hard work. Born in 1859 in Mason County, West Virginia, Michael J. Owens went to work at the age of ten for a glasshouse in Wheeling called J. H. Hobbs, Brockunier and Company as a firing

boy. (When he showed up barefoot the first day on the job and was sent home to get his shoes he stayed away from the glasshouse for several days until he managed to borrow a pair because he had none of his own.) At the age of fifteen he had worked his way up to gaffer. Later when he went to work for the Libby Glass Company in Toledo, Ohio he was made foreman within three months and factory superintendent two years later. In 1891, Owens patented his first invention, a machine that automatically opened and closed molds. This device eliminated the need for a mold boy and was one of the first steps taken to reduce the use of child labor in the glassblowing industry. Beginning in 1899 he started working on a fully automatic glassblowing machine. The first successful model was in production by 1903. By 1906, Owens's automatic machines were leased to and installed in plants in Pennsylvania, Illinois, and Ohio. By 1910, modified versions of the automatic glassblowing machines were each turning out approximately 33,000 bottles daily. By 1914 there were 172 of Owens's machines in operation; each one capable of producing forty bottles a minute or 57,600 per day. These figures are very impressive when it is realized that in the 1880s it took a shop of three men and three boys to produce approximately 1500 bottles a day.

Basically an Owens automatic glassblowing machine was associated with a melting pot from which a prescribed amount of hot glass was released and cut off. The severed blob of glass dropped into a gathering mold. From the gathering mold the gather was sucked into the closing halves of the finishing mold. The upper part of the mold completely formed the neck and lip of the bottle around a plunger, the plunger being inserted through the top of the parison or gather. As the plunger was withdrawn, the air was forced into the mold; this blew the bottle to its completed form.

The first practical model of the Owens machine had six arms, carrying six gatherings, and six finishing molds. The machine rotated until a completed bottle was released to a conveyor belt that carried it through the annealing oven; after annealing the completed bottles were packaged for distribution.

In August of 1903, Frank M. Gessner, editor of the *National Glass Budget* commented on the Owens machine while visiting the Toledo plant. In his own words:

> The Owens machine stands in a class unapproached by other inventions. It differs radically and fundamentally from all other machines in several epoch-making features, because it gathers its glass, forms its blanks, transfers the blank from the gathering mold to a blow mold with a finished lip and ring, blows the bottle and delivers the finished bottle automatically without the touch of the human hand, eliminates all skill and labor and puts the same amount of glass into every bottle, makes every bottle of the same length, finish, weight and capacity, it wastes no glass, uses no pipes, snaps, finishing tools, glory holes, rosin, charcoal, and requires neither gatherer, mold boy, snap boy nor finisher and still makes better bottles, more of them than by any other process. The Owens machine settles completely the problem of mechanical bottle and jar production, lowers the cost to a vanishing point and cannot fail to revolutionize the industry, displace the can as a fruit package and by providing a cleaner and cheaper vessel will greatly increase the use and demand for glass bottles and packers.

Knowing the techniques of glassblowing, including how to identify bottles made by hand, either free-blown or mold-blown, and by automatic methods, is a valuable help in dating bottles.

Today, almost all glass bottles are the product of automatic machines; to obtain bottles made by hand methods the collector must usually locate bottles of the nineteenth century and before.

Bibliography

BOOKS

Kendrick, Grace. *The Mouth-Blown Bottle.* Ann Arbor, Michigan: Edwards Brothers, Inc., 1968.

McKearin, George S. and Helen. *American Glass.* New York: Crown Publishers, Inc., 1968.

Rogers, Frances, and Beard, Alice. *5,000 Years of Glass.* New York: J. B. Lippincott Co., 1948.

Sauzay, A. *Wonders of Glass and Bottle Making.* Ft. Davis, Texas: Frontier Book Co., 1969 (reprint).

Walbridge, William S. *American Bottles Old and New.* Ft. Davis, Texas: Frontier Book Co., 1969 (reprint).

Page from *De l'Art de la Verrerie,* by Haudiquert de Blancourt, Paris, 1697. Top: (a) Fire compartment—hole in center allowed heat to rise to other compartments; (b) melting chamber where pots were set; (c) annealing chamber; (d) bocca (window) through which hot glass was obtained and pots were set; (e) melting pots or crucibles. Bottom: (a) blowpipes, (b) melting chamber, (c) bocca, (d) annealing chamber, (e) pattern molds. (The Corning Museum of Glass, Corning, N.Y.)

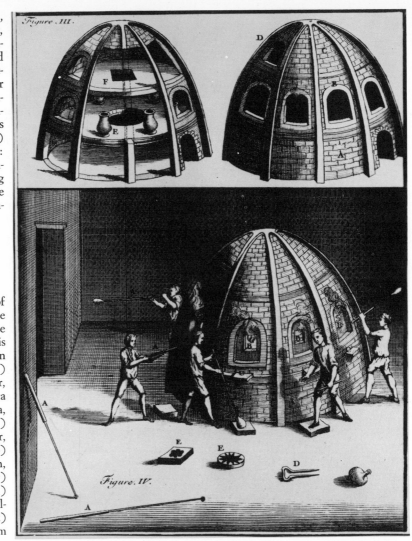

Woodcut showing the interior of a glasshouse. Plate I from the section "Verrerie en Bois" of the *Encyclopédie* edited by Denis Diderot and published in Paris in the mid-eighteenth century. (aa) roof, (a) wall, (c) bocca cover, (d) vent, (e) chimney, (f) bocca cover, (g) worker, (h) bocca, (i) table in front of bocca, (l) fire compartment, (m) gatherer, (n) gaffer or glassblower, (o) gaffer's "chair" or workbench, (p) gaffer or glassblower, (r) door to factory, (t) worker, (u) boy, (x) tub of water for cooling blowpipes, (y) cullet, (z) marver. (The Corning Museum of Glass, Corning, N.Y.)

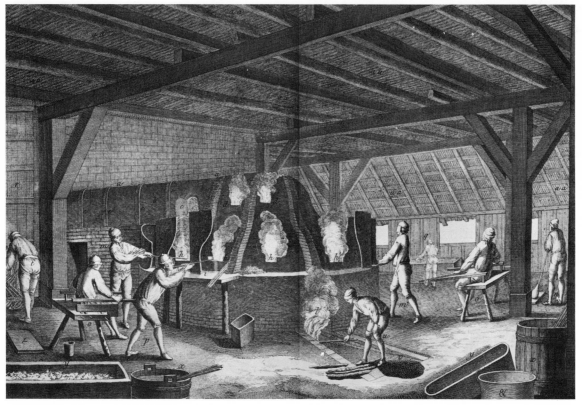

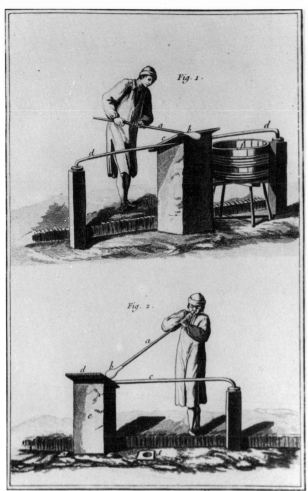

Pucellas (more often called "the tool"), used in all the essential shaping of a bottle in its final stages.

Woodcut showing a glassworker. Plate III from the section "Verrerie en Bouteilles" of Diderot's *Encyclopédie*. Fig. 1: (a) blowpipe, (b) gather or parison, (c) marver, (d) rod, (e) stand, (f) water. Fig. 2: (a) blowpipe, (b) gather or parison, (c) rod, (d) marver, (e) stand, (f) dip mold. (The Corning Museum of Glass, Corning, N.Y.)

Block: wooden dipper-like device cut out on one side and used in the initial stages of blowing to give symmetrical form to the parison. (Dr. Julian H. Toulouse, Hemet, Cal.)

Battledore: a wooden paddle used to flatten the bottoms and sides of objects.

Michael J. Owens

Hand-operated lipping tool for inside screw threads.

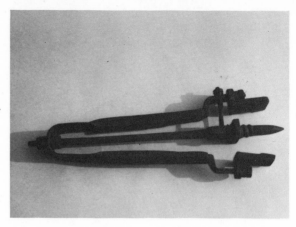

Photograph taken at the Mansfield Glass Works in Lockport, New York, around the turn of the century. The photograph is taken from a book entitled *A Trip Through the Plant,* which was published by the glassworks. The scene pictured is a shop; the master blower has just completed the blowing of a bottle which has been removed from the mold. The caption reads in part: "Boy with *shears* [italics added] ready to snip off the top." This photograph lends evidence that the severing of bottles from the blowpipe with shears was a practical method and was often employed.

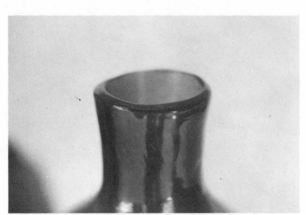

Neck of a flask that has been severed from the blowpipe by either wetting off or shearing. The neck has also been fire polished.

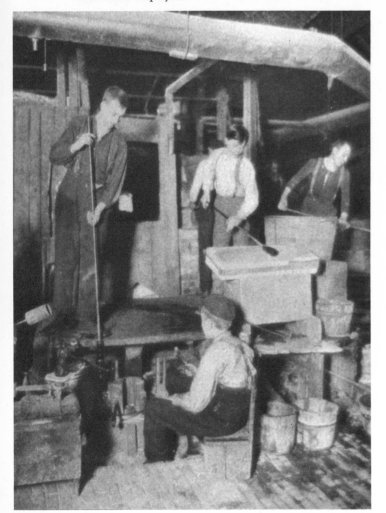

Early glassblower.

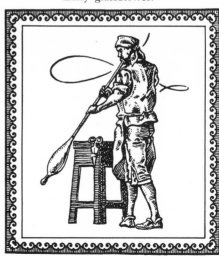

7

Glass Colors

The most common of all colors in which glass bottles are found are varying hues of green and blue, often called aqua. For thousands of years most of the cheap glasses used in the manufacture of bottles were these colors because of iron in the raw materials, mostly in the sand. Glassmakers did know, however, that pure ingredients would produce clear glass; in many cases where clear glass was demanded attempts were made to purify the raw ingredients. Glassmakers even went so far as to crush iron-free quartz crystals to obtain pure silica. Early glasshouses were established with much consideration given to the nearest supply of the purest sand possible, as well as to an abundant fuel supply.

Glass can be produced in all colors of the spectrum. Early glassmakers knew this could be accomplished by adding certain compounds to the basic glass mixture. The following table shows the kinds of materials frequently used and the colors obtained:

copper, selenium, gold	reds
nickel or manganese	purples
chromium or copper	greens
cobalt or copper	blues
carbon or nickel	browns
iron	greens, yellows
selenium	yellows, pinks
tin or zinc	opal or milkglass
iron slag	"black glass"

Some of the compounds are expensive oxides. For example it takes one ounce of gold to create sixty pounds of ruby-red glass. Compounds used in various combinations produce a wide range of colors.

A number of variables can affect the actual color produced, including the amount of the compounds used, the degree to which the basic glass mixture is impure, the temperature and the time-temperature relationship, and the reheating necessary to complete a piece of glass. These and other conditions combine to make the coloring of glass a very difficult task for the glassmaker.

Until approximately the mid-1800s it was believed that dark glass ("black glass") was the best glass. This belief probably stemmed from the demand for dark glass containers by merchants of wine and spirits after they discovered their products would keep better in dark containers. Glassmakers catered to the demand by making a very cheap "black glass," adding iron slag to achieve the extremely dark greenish-amber color. This glass was so dark that at first glance it appeared to be black. Interestingly enough black glass *is* a very durable, and therefore better, glass that can withstand a great deal more exposure to the natural elements than can other colors.

To the bottle collector colored glass has special meaning. Since bottles made before the turn of the century were predominantly greens and aquas, to find nineteenth-century bottles of unusual colors is quite a challenge, and these bottles command fairly high prices.

A careful examination of individual bottles will often reveal color variations within the container itself. Where the glass is thin, possibly throughout the body, the color will be lighter; and where the glass is thick, possibly in the base and/or neck, the color will be darker.

Just as there are specialists in almost every type of bottle, there are collectors who pursue bottles of all types but with unusual colors in mind. A color oriented collection displayed properly, in a window perhaps, is a breathtakingly beautiful sight whether the bottles are randomly placed or arranged by color, imitating a rainbow. Either way the collector of colored bottles enjoys one of the most unique and beautiful aspects of the hobby—his window can rival the most beautiful of stained glass.

Bibliography

BOOKS AND PAMPHLETS

Corning Glass Works. *This Is Glass*. New York: Corning Glass Works, 1962.

Kendrick, Grace. *The Mouth-Blown Bottle*. Ann Arbor, Michigan: Edwards Brothers, Inc., 1968.

Sand and Glass. U.S.A.: Nelson Doubleday, Inc., and Odhams Books, Ltd., 1967.

PERIODICALS

"Making of Colored Glass," *Every Saturday* (Boston), IX (1870), 126.

8

Molds and Mold

and Tool Markings

When a bottle is made in a mold, trapped air must be allowed to escape or the resulting container would be misshapen. Along with other vents, the areas where the various parts of some molds join provide this necessary venting and certain marks, called seams, are the result.

The study of the seams and other markings found on bottles can be of great assistance in identifying the type of molds and tools used in their manufacture. Knowing when the various molds and tools were in common use provides a basis for the approximate dating of bottles (see Chapter 50).

As already pointed out (see Chapter 2), molds were used before the invention of the blowpipe. In a sense the sand cores used by the Egyptians to make the first bottles were male molds; these, as might be expected, left no seams.

With the advent of the blowpipe, about 100 B.C., there came the development of both the open and the closed molds. Some ancient containers display seams that show they were made in molds with as many as six, eight or even more parts.

As to the exact materials of which these ancient molds were made there is room for speculation. One example of a stone mold has been found. In addition it is logical to assume the usage of ceramic, bronze, and wood.

While the advent of the blowpipe led to an increase in the use of molds, the fact that they were crude, clumsy, and without hinges usually made it more expedient to free-blow bottles. With the development of hinged brass molds in the seventeenth century and hinged iron molds in the eighteenth century, mold-blowing bottle manufacturing gradually began to replace free blowing in Europe. In America molds were not used much before the nineteenth century.

When considering mold-blown bottles and mold marks it is useful to keep in mind that free-blown bottles have *no* seams or other similar markings. *Almost* all mold-blown bottles *do* exhibit seam marks.

Non-shoulder molds. Non-shoulder molds were used only in the development of the body of the bottle. Bottles blown in non-shoulder molds may or may not exhibit mold seams.

Dip molds, one of the first types to be used in the blowing of glass, are one piece with the top slightly larger than the bottom so that the bottle could be extracted with ease. When removed from a dip mold a bottle must have been completed from the shoulder up by hand methods which included more blowing.

In some cases the use of this kind of mold will be revealed by seam marks around the shoulder caused by a *blow-over,* but this is not so if the container was lifted out of the mold before it reached the absolute top. It is, therefore, difficult to distinguish certain free-blown bottles from those blown in a dip mold because by either method it is possible to produce a bottle without seams. A distinction that may be helpful is that the bottle developed in a dip mold should have a fairly uniformly shaped body.

Pattern molds are really only a modification of the dip mold. The pattern mold is usually about one-third smaller than the regular dip mold and has perpendicular ridges or grooves cut into the inner walls. The gather or post is blown until it assumes the pattern of the mold and then withdrawn and allowed to cool somewhat. The parison is then redipped in the furnace and covered with a second coating of hot glass; if the second dipping does not extend the full length of the parison it is called *half post.* (Since the method originated in Germany it is most commonly known as the *Ger-*

man half-post.) After the second dipping the bottle is blown to completion and features a ribbed design; if after the second dipping the parison is again blown into a larger pattern mold, withdrawn, and blown to completion, the bottle will display a double pattern. The pattern(s) may be swirled by twisting the bottle slightly during removal from the pattern mold. A characteristic of bottles made by this method is an irregularity in the glass at the shoulder; they look as if the neck had been pushed down and pulled back leaving a wrinkle around the shoulder; the actual cause is the redipping which did not involve the entire bottle. This technique was used in America as early as the second half of the seventeenth century (see Chapter 5) and was very popular during the eighteenth century.

The *hinged shoulder-height mold* dates back to the first century A.D. but the early versions were keyed together rather than being hinged as in later years.

Unlike the one-piece shoulder-height dip mold, this mold did not have to be tapered so that the bottle could be easily removed; thus it could produce a variety of body shapes.

Because of the additional help required to manipulate the mold, this was an expensive one to use. Its main advantage was that, with the development of the brass mold in the late 1700s and the change to iron molds in the 1800s, it could be embossed to fill the demand for lettering and design on commercial containers. This mold was common in two pieces, but elaborate lettering required that more than two mold sections be used.

As with the dip mold, the shoulder, neck, and lip of the bottles were developed by hand tooling by the glassblower. The major characteristic of bottles blown in these molds is the side seam which disappears at or just above the shoulder as a result of the hand tooling.

Full-height molds create a variety of seam markings depending on the specific type of mold employed.

Bottom-hinged molds were used from about 1810 to about 1880. In addition to the seam marks running up the sides, bottles blown in this type of mold have a seam across the bottom. The bottom seams can be found in two varieties. One goes straight across the bottom, and the other type curves around a slight center *push-up*, an indentation in the bottom of the bottle caused by empontilling or mold design.

Across-the-bottom seams may be partially obliterated by a pontil scar. If a snap was used to hold the bottle during finishing, the bottom seam will remain intact.

The *three-part mold with dip mold body* seems to represent an important step from the shoulder-height dip mold, providing more versatility in shoulder design.

Because of the dip mold body, bottles blown in these molds could not have embossments on the lower half. The two-part shoulder portion did allow embossment but it was not popular to do it, so few bottles of this type are found with shoulder letters or designs.

This type of mold was used mostly during the 1870–1910 period.

The *three-part leaf mold* has three body-mold leaves plus the bottom plate, which traditionally is not included in the count. This type of mold could actually employ more than three vertical sections but seldom did.

The three-part leaf mold was very seldom used on the common bottle; it was used mostly on more expensive and highly decorated pieces. The bottom may be either post-bottom or cup-bottom (see below) in design.

The major characteristic of bottles blown in this three-part mold is the seams which run vertically from the base of the bottle to the top.

The *post-bottom mold* gets its name from the design of the bottom plate. The plate is made like a post and extends up to the part of the mold that forms the body of the bottle.

The seams on a bottle formed in this type of mold run down the sides and in a circle around the bottom. The significant seam is the circular one *on* the bottom of the bottle.

The post bottom may be used in conjunction with other mold types, i.e., two-piece, three-piece, and so forth.

In glassblowing the main advantage to using the post-bottom mold lies in the fact that because the base plate extends upward into the other pieces of the mold that form the body, the mold can never be closed incorrectly—it is self-centering.

This form was popular during the hand-blowing period of the nineteenth century.

The *cup-bottom mold* features a cup set into the bottom plate. Bottles formed in this type of mold have a seam mark around the *outside* of the base just above the bottom of the container.

Because of problems in centering the other

parts of the mold this type was not favored in hand blowing but is quite common in machine blowing.

Cup-bottom molds could be used in conjunction with two-piece and other types but generally were not because of the centering difficulty.

The *blow-back mold* was developed in the mid-1800s when glassblowing reached the point where complex finishes could be blown in the mold. An example of such a finish is screw threads (see Chapter 30).

The purpose of the blow-back, a bulb-like formation cut into the neck of the mold, was to make the glass extremely thin just above the finish to allow the bottle to be readily broken from the blowpipe.

In most cases a bottle thus formed was rough and ragged around the top and was usually ground to give a smooth finish.

It is often stated by collectors that the difference between hand-blown bottles and those automatically blown is that the seams on a machine-made bottle go all the way to the top of the bottle. Since bottles formed in a blow-back mold have seams all the way to the top of the bottle, it can be readily seen that the statement is a generalization that cannot be relied upon.

Accessory Molds and Tool Markings. Not all markings on bottles are seams resulting from a junction of mold parts; some markings are caused by particular mold design or use, and by the use of various tools.

The *turn mold* is really more of a process than a mold. Turn-mold bottles can be produced in any of the full-height molds. The normal seam marks were eliminated by rotating the completely blown bottle within the mold before removing it. The term "turn mold" is a misnomer because it was the bottle that was actually turned and not the mold.

To facilitate the turning of the bottle the mold was first coated with a paste of varying composition. (The use of paste has accounted for the term "paste mold" which is sometimes used when discussing the turn-mold process.) Before each bottle was blown the mold was dipped in water which facilitated turning even more by providing a layer of steam between the pasted interior of the mold and the surface of the glass.

Bottles turned in a mold obtained a high polish as a result. They also acquired lines and/or grooves on their surface; these marks were caused by slight imperfections in the mold and were scratched into the surface of the bottle as it was rotated. These horizontal lines are the major characteristics of turn-mold bottles and a definite means of identification.

Because of the turning technique it was impossible for turn-mold bottles to have embossments of any kind. This mold is associated mostly with the manufacture of wine bottles (see Chapter 16) during the period 1880–1910.

It is interesting that several glass companies over the years have incorporated the word "seamless" into their names because of their extensive manufacturing of bottles by the turn-mold method.

The *plate mold,* adopted during the last half of the nineteenth century, made it financially practical for a small buyer of bottles to have a personalized container by the use of insert plates. (Large companies had their own individual molds with the lettering or design cut into the mold itself, in America, as early as 1810.)

In this process the glassmaker had a standard mold made to accept a variety of lettered plates. The cost of making a plate (see Chapter 39) was relatively small compared to making an entire mold with lettering and/or design.

This development was advantageous to both the manufacturer and the buyer. It was also, in part, responsible for the standardization of many bottle shapes for particular uses, e.g., milk bottles.

The use of inserted plates of necessity resulted in marks. These marks are found in circles or rectangles around the embossed lettering or design. Often the plate seams are by design made to coincide with mold seams. Because of this it is sometimes impossible to ascertain whether a plate mold or a regular mold was used on certain bottles.

A very common term used in discussions of plate molds is "slug plate." Mostly because it is redundant this popular name is slowly being replaced by the original and more accurate "plate mold."

Suction machine cutoff scars are irregular circular marks left on the bottom of containers made by the Owens automatic bottle-making machine (see Chapter 6), which was used beginning in 1904. These marks are not seams but rather the result of the severing of the glass after it has been automatically sucked into the mold. Such a mark positively identifies a bottle as being machine made.

A *machine-made valve mark* is frequently

found on the bottom of bottles made during the 1930–1940 period. A circle less than an inch in diameter, the valve mark resembles a seam mark but was caused by the action of a plunger which pushed the fully blown bottle out of the mold for the finishing cycle.

This mark is most often found on wide mouth containers and milk bottles.

The neophyte collector often calls this mark a "pontil mark," which is not correct; it neither resembles the mark caused by the use of a pontil rod (see Chapter 10) nor has anything to do with empontilling.

Finishing or *lipping tool marks* are important because of their relationship to seam marks on the neck of the bottle—they often erased the seams in the process of finishing.

Finishing can be defined as what is done to the bottle to complete it after it has been removed from the mold. The finishing process consists of developing the mouth of the container, and was first accomplished by the use of tongs and other general tools.

Tools specifically for finishing were developed around 1830 in England and around 1850 in America. These devices usually consisted of a rod, which was inserted into the mouth of the bottle, and an associated part that could be clamped to the outside of the mouth and neck. By rotating the device the lip was finished and the seams erased.

Later these specific lip finishing devices were attached to workbenches and operated by hand- or foot-operated presses. If the bottle thus finished was rotated during the process the side seams were rubbed out but if the bottle was merely pressed the side seams were left intact and ran all the way to the top of the bottle.

Until recently seams were considered an easy measure of bottle age: "The further down the side the seam, the older the bottle." While *generally* this is a pretty good rule of thumb, it can be seen that there are exceptions.

Flared or *fired lips* were created when finishing the lips on bottles was completed by reheating them in the furnace or later (circa 1880) in glory holes. The reheating slightly melted the rough finish, polishing the lip and at the same time obliterating the seams. The amount of seam obliteration depended on the extent to which the neck was reheated and how far the bottle was held in the furnace or glory hole.

This process of fire polishing was used a great deal during the early nineteenth century in the United States but originated in the first century A.D.

Automatic machine markings are of importance to collectors who want to be able to identify bottles made by the Owens (and other) automatic blowing machines. Many collectors feel that only bottles made before 1900 (approximately the beginning of machine-made bottles) are "antique" and worthy of collecting.

There is no absolute way of making the desired identification but perhaps the one method that comes closest is the examination of the top of the bottle finish. If one or more seams circle the top of the bottle it can almost always be said that the bottle was produced in an automatic machine. The circles at the top of such bottles are caused by the plunger which defines the inner throat diameter of the finish; of necessity the plunger contacts the glass and when withdrawn leaves a seam marking. To guide the plunger a collar also descends into contact with the glass and produces another seam marking around the neck of the bottle.

The exception in this method of identification is found mostly on beverage bottles. These bottles, because of their frequent direct contact with the drinker's mouth, were often fire polished which, of course, would eliminate one or both of the seam markings resulting from automatic blowing.

Hand-blown bottles were fire polished too, but they would lack the seams on the side of the finish.

Bibliography

BOOKS

Kendrick, Grace. *The Antique Bottle Collector.* Ann Arbor, Michigan: Edwards Brothers, Inc., 1963.

——. *The Mouth-Blown Bottle.* Ann Arbor, Michigan: Edwards Brothers, Inc., 1968.

PERIODICALS

Kendrick, Grace. "Bottles," *Antiques Journal,* XXIV (December, 1969), 18–19 and 23.

Toulouse, Julian Harrison. "A Primer on Mold Seams, Part I," *Western Collector,* VII (November, 1969), 526–535.

——. "A Primer on Mold Seams, Part II," *Western Collector,* VII (December, 1969), 578–587.

42

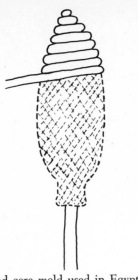

Sand core mold used in Egypt c. 1600–1300 B.C.

Dip mold. (Dr. Julian H. Toulouse, Hemet, Cal.)

Seam marks caused by a blow-over in the dip mold.

Pattern dip mold.

Hinged shoulder-height mold with cup bottom. (Dr. Julian H. Toulouse, Hemet, Cal.)

Rib seams started in a pattern mold and completed when bottle was removed from mold and free-blown.

Mold seams on bottle blown in shoulder-height hinged mold with cup bottom. Dotted line represents possible seams caused by blow-over.

Full-height bottom-hinged mold. (Dr. Julian H. Toulouse, Hemet, Cal.)

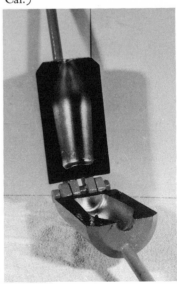

Mold seams on bottle blown in bottom-hinged mold. Dotted line indicates possible alternate seam around center push-up.

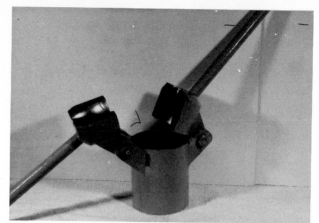

Full-height three-part dip mold. (Dr. Julian H. Toulouse, Hemet, Cal.)

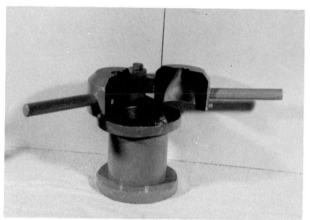

Full-height three-part dip mold. (Dr. Julian H. Toulouse, Hemet, Cal.)

Mold seams on bottle blown in either of the illustrated three-part dip molds.

Full-height three-part leaf mold. (Dr. Julian H. Toulouse, Hemet, Cal.)

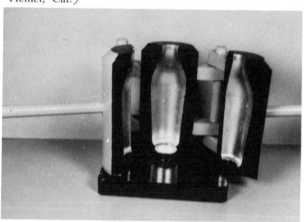

Mold seams on bottle blown in three-part leaf mold with a post bottom.

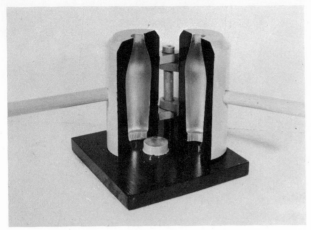

Full-height post-bottom mold. (Dr. Julian H. Toulouse, Hemet, Cal.)

Mold seams on bottles blown in a post-bottom mold.

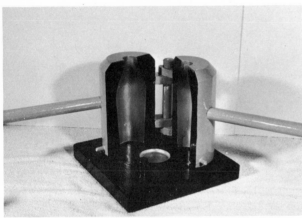

Full-height cup-bottom mold. (Dr. Julian H. Toulouse, Hemet, Cal.)

Mold seams on bottles blown in a cup-bottom mold.

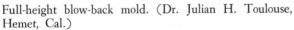

Full-height blow-back mold. (Dr. Julian H. Toulouse, Hemet, Cal.)

Mold seams on bottle blown in a post-bottom blow-back mold.

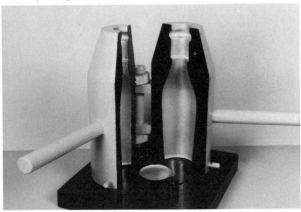

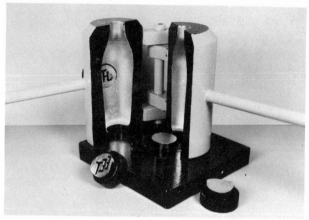

Plate mold. (Dr. Julian H. Toulouse, Hemet, Cal.)

Horizontal score marks found on turn mold bottles.

Mold seams on bottle blown in a post-bottom plate mold.

Bottle with a machine cutoff scar.

Machine-made valve mark.

Machine-blown bottle featuring seams around the top and neck.

Hand-operated lipping tool.

Hand-operated lipping tool.

9

"Whittle Marks"

Bottles made during the nineteenth century make up a good portion of most collections of old bottles in the United States. Many bottles blown during that century are very crude. A typical crudeness is a wavy, dimpled, or hammered appearance on the surface of some bottles. Though inaccurate, the term "whittle marks" is often used to describe this condition.

Early in the collecting of bottles it was discovered that some molds used during and before the nineteenth century were made of wood. It was natural and logical for the early collectors to assume that the marks described above were caused by the blowing of glass into a carved wooden mold—the marks do resemble wood carvings. It is a very romantic story and still clung to by many collectors, and the term "whittle marks" continues to be the one used to describe bottles that are marked in this way.

As the bottle collecting hobby grew, more and more collectors became sophisticated enough to question various "absolutes" that were passed from one collector to another. Whittle marks were investigated by competent researchers and found to be, in reality, marks created when hot glass was blown into a cold mold. Cold molds were found in all glass factories at the beginning of the work day. Since the items to be blown were common bottles, more often than not, very little time was devoted to the proper warming of molds. The master blower and others in the shop were paid according to the number of bottles produced, not by the smoothness of their surfaces.

Glass factories were gradually forced by consumer demand to produce uniformly developed bottles of better quality. Around the turn of the century, as glass plants were automated, whittle marks and other imperfections were eliminated by increased attention to quality control. Competition among manufacturers brought about the near perfect containers that are taken as a matter of fact today.

Bibliography

BOOKS

Kendrick, Grace. *The Antique Bottle Collector.* Ann Arbor, Michigan: Edwards Brothers, Inc., 1963.

PERIODICALS

Toulouse, Julian Harrison. "Whittled Molds," *Western Collector,* IV (October, 1966), 27–28.

10

Empontilling

Before the advent of the automatic glassblowing machine free-blown and mold-blown bottles had to be held by some method so that the neck could be detached from the blowpipe and finished.

The various methods of holding bottles are good keys to approximately when the bottles were made (see Chapter 50).

Recent research has revealed that there were four common methods of holding (*empontilling*) used during the days of hand blowing.

Solid Iron Bar Pontil. Since the invention of the blowpipe solid cylindrical iron bars have been used in the empontilling process. The iron bar generally was slightly enlarged at one end and was four to six feet in length. When the bottle (mold-blown or free-blown) was ready for removal from the blowpipe the iron bar was dipped into the pot and turned to gather a small amount of glass on the enlarged end. The rod was then applied to the bottom of the bottle, which was still attached to the blowpipe. The two main considerations were to see that the pontil was centered and to make certain that it was firmly enough attached to permit finishing.

The glassblower usually was seated in a flat-armed seat called the chair. He rotated the pontil on the arms of the seat to keep the hot glass bottle from sagging; at the same time with various tools he finished the neck and lip of the bottle.

The finished bottle was then broken from the pontil. Breaking the bottle from the iron bar left a *pontil scar* which, on common bottles, was left untouched. It is a solid jagged scar, usually circular. On more expensive bottles (see Chapter 32) the pontil scar was carefully removed by grinding.

The pontil scar or mark just described is often inaccurately referred to as an "open pontil" or simply as a "pontil." A careful study of the description above will reveal that these variations incorrectly describe the pontil scar.

Other accurate, but perhaps archaic, names for the pontil itself are "puntellium," "punte," "pontie" or "punty." By far the majority of writers now in the field prefer "pontil."

Blowpipe Pontil. A blowpipe could be used in the same way as a solid iron bar. The one possible difference is that the use of a blowpipe as a pontil can be accomplished by one person if necessary. The use of the iron bar requires that a second person bring the glass-tipped rod to the master blower, while the blowpipe pontil could be the same pipe used to blow the bottle. If such were the case the master blower would, while the bottle was resting in an angled depression in the floor, have to sever the blowpipe from the neck of the bottle and very quickly attach it to the bottom of the bottle before it cooled.

For the collector, the important difference in the two devices used in this type of empontilling is the resulting scar. The scar left by the blowpipe pontil is not solid but ring-shaped. As with the iron bar the scar is jagged and was left that way unless the bottle was other than a common container. In both cases if the scar interfered with the bottle's ability to stand upright then it had to be modified by grinding or some other means.

Bare Iron Pontil. In about 1845 an improvement in the empontilling was made. This improvement, like others to follow, was probably in part inspired by the need to produce increasing numbers of bottles quickly. Some writers have used the terms "improved pontil" and "graphite pontil" in reference to the use of a bare iron pontil. Although the former is a good term, it is not nearly as descriptive as the term "bare iron pontil" used here. The term "graphite pontil" is completely inaccurate. Except for the fact that the mark left by the bare iron pontil is sometimes black, which is also the color of graphite, there is no justification for the term.

The improved method of empontilling involved the use of a solid iron pontil without benefit of a glass tip. The iron rod was flared so that when pressed against the bottom of the bottle it would force an indentation into the bottle bottom. The pontil rod was heated red hot and applied directly to the bottom of the bottle, where it adhered itself.

When the completed bottle was broken from the bare iron pontil a smooth circular mark consisting of oxidized iron was left on the bottle. The marks are of two colors, i.e., red to reddish black, and white. The color differences are important to note because unlike other glassblowing methods these can be pretty firmly dated; the red to reddish black marks are representative of the period approximately from 1845 to 1870. The white pontil marks are characteristic of the ten-year period from 1870 to about 1880. After this period the snap, described below, was used.

While chemical analysis proves conclusively that the red to reddish black marks are oxidized iron, similar analysis has failed to absolutely identify the exact nature of the white marks. It was discovered, however, that beneath the white coating there is oxidized iron just as in the other type.

Because the white-marked bottles were used for soda and mineral water (red to reddish black pontil marks are found on a variety of bottle types) it has been hypothesized that the white coat was painted on the bottle after annealing for protection. Since these bottles were returned to the bottler to be reused again and again they had to be able to withstand the washing in a hot sodium carbonate solution and rinsing in a cold solution. Bottles with a bare iron pontil mark exposed would be likely to crack during the hot and cold baths because of the different rates of expansion in the iron oxide and the glass. It seems highly probable that the white substance applied over the pontil mark could retard the shock of temperature change and prevent cracking.

Snap. The use of the bare iron pontil was shortlived in glassblowing, not because it was not an effective improvement but rather because of the invention of the more effective snap.

The earliest reference to a snap-type device seems to be from London, where around 1850 a glassblower named Pellatt invented what he called a post (not to be confused with "post" referring to gather). Another early reference comes from Paris, where in 1868 another glassblower named Botemps describes a similar device called a sabot. Both of these devices were spring cradles attached to a pontil; instead of attaching the rod to the glass these devices enabled the glassblower to hold the bottle in the cradle. Botemps claims the sabot was used in France as early as the 1830s. This type of tool has been placed in the United States in the 1850s.

By the mid-1860s most bottles were being made utilizing the snap. The snap differs from the spring cradle-type devices in that a snap is a more mechanical gripping device. A snap is a pontil split down the middle for about a foot. In the center between the two split ends of the rod a cup is placed. The bottom of the bottle fits into the cup and by means of a sliding ring the two split ends of the rod are brought together to grip the body of the bottle and hold it in the cup for finishing.

Machine blowing, of course, did away with empontilling on common bottles.

It is simple to determine which of the early bottles were held by a snap during manufacturing. These bottles have no pontil scars or marks of any kind except an occasional mark where the snap gripped the side of the bottle.

Bibliography

BOOKS

Kendrick, Grace. *The Mouth-Blown Bottle*. Ann Arbor, Michigan: Edwards Brothers, Inc., 1968.

PERIODICALS

Toulouse, Julian Harrison. "Empontilling: A History," *The Glass Industry,* March-April, 1968, p. 137.

Solid iron bar pontil.

Blowpipe.

Blowpipe pontil scar on bottle blown in a full-height bottom-hinged mold.

Ring-shaped blowpipe pontil scar.

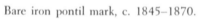

Bare iron pontil mark, c. 1845–1870.

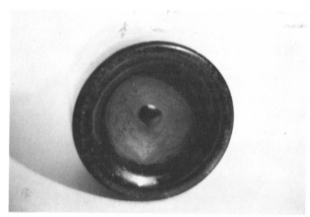

White bare iron pontil mark, c. 1870–1880. (*Western Collector*, San Francisco, Cal.) Photo by D. J. Alverson.

Sabot.

Snap.

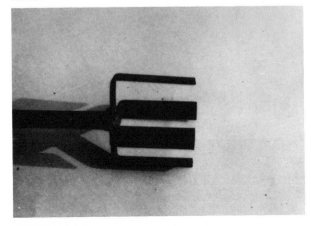

11

Glass Bottle Decoration

Methods of marking bottles for artistic or utilitarian purposes can be called decoration. One of the most popular methods of decorating a bottle is embossing it with lettering and/or design. Embossments are part of the mold-blowing process; lettering and/or designs are cut into the mold and such decoration becomes a part of the bottle as it is being formed. The other popular method of decorating a bottle while it is being formed involves coloring the glass.

Because these techniques are discussed in other parts of this book (see Chapters 7 and 8) this discussion will be limited to the use of materials and techniques foreign to the glass itself, decoration through the use of a second art or craft after the glass has been annealed and is cold. Some of these decorative techniques are quite divorced from the glasshouse and are accomplished in separate locations by independent businesses. All are aids to dating a particular piece of glass.

Cutting. The art of cutting glass was first used by the Romans and after the Dark Ages was rediscovered by the seventeenth-century German glassblowers. From Germany cut glass spread to England and to America in the eighteenth century.

Cutting glass is a three-step process. The first step is *roughing out,* which is accomplished with an iron wheel with sand and water as the abrasive agent. *Smoothing* is the second step and is done with a stone wheel and pumice powder. The third step is *polishing* with a willow wheel and a putty made up of tin or lead.

Overlay. This decorative technique involves the use of different colored glass and glass cutting. In America this method was not used until the mid-1800s but in Europe and other parts of the world the technique had been used for centuries. A notable example in bottle collecting is the use of this technique by the Chinese (see Chapter 19).

Overlay glass is merely layers of different col-

ored glasses blown over each other; the resulting bottle is a series of colors sandwiched together. The decorating is accomplished by glass cutting techniques which cut away those parts of the layers of glass that are not part of the design. The first layer of glass is usually the predominant color of the bottle with the other layers making up the design.

Engraving. There are two types of engraving normally used on glass, diamond point and copper wheel engraving. Diamond point techniques were not used on early American bottles but were and still are being employed on twentieth-century bottles made in this country. Copper wheel engraving was most popular in Germany and was introduced into this country during the seventeenth century by German artisans. Henry Stiegel (see Chapter 5) was probably the first to employ the method in America.

Engraving is a more exacting technique than glass cutting and it can easily be identified by the delicate and intricate designs that were produced.

The technique involved is a scratching of the surface of the bottle by a rotating diamond-pointed object or a series of copper wheels varying from one-eighth of an inch to two inches in diameter. The abrasive agent used with the copper wheels is a mixture of water and oil, and pumice.

Etching. In America etching is mostly a product of the late nineteenth century but is still being used today. Because of the frosted appearance of etched decoration it is often confused with engraving. On the more common bottles it is safe to assume that decoration of a frosted nature was etched because it is less expensive than engraving.

Etching is accomplished through the use of hydrofluoric acid which attacks the glass. Before the acid is applied to the bottle, the parts that are not to be etched must be covered with acid-resisting substances such as beeswax, paraffin, or rosin, through which the design was cut, or by a copper plate into which the design has been cut.

Gilding. This method of decorating is fixing gold to the outside of a glass bottle. Gilding was known to the early glassmakers. It seems not to have been used in America until the early 1800s, but it is still used today.

Gilding is accomplished by mixing an oxide of gold with a flux (potash) and oil of turpentine; the mixture is painted on the bottle and fired in a *muffle,* a small furnace. The firing burns away the

turpentine and leaves the gold fused to the glass. The gold is then polished with a burnishing stone. Gilding will wear or scratch off.

Flashing. This technique is actually a method for overall coloring, but since it was used primarily to decorate it will be included here. Since coloring a bottle can be very expensive (as in the creation of ruby colors by the introduction of gold to the basic glass mixture, for example) the less expensive method of flashing is often used.

Flashing involves coloring only a small amount of molten glass, then dipping a hot bottle into the colored batch. The outside layer of glass provides the desired color at a greatly reduced cost. Flashed colors will wear or scratch off. Flashing should not be confused with overlay, which is not a means of economy; overlaid layers are thicker than a flashed layer and provide permanent coloring.

Staining. Staining was popular in America during the late 1800s. In this process, as in flashing, the prime concern was economy and it was used primarily to produce the gold-based ruby color. Unlike flashing, however, staining was used a great deal to decorate only particular portions of a bottle. The staining compound, which varied with the color, was applied by brush; the bottle was then fired in a muffle. In process, staining resembles gilding, but in appearance is most easily confused with flashing. It is difficult to differentiate between staining and flashing if the bottle is entirely covered but if it is only decorated in selected parts it is safe to assume that staining was the process used. Like flashing and gilding, stain will wear or scratch off.

Bottle collectors have recently discovered that flashing and staining have been used by unscrupulous people to deceive them. Certain common glass bottles such as fruit jars, milk bottles, and soda water bottles as well as some insulators are more valued if they were produced in unusual colors. Flashing and staining have been used to create these unusual bottles and insulators. It would be wise for the collector, if there is any doubt, to ascertain by scratching any item he discovers in unusual colors before acquiring it. If the seller refuses to allow the collector to make this test, then it would be wise not to purchase the object.

Enameling. The Romans were among the first to use this decorative technique on glass after copying the technique from potters. Enameling glass was rediscovered after the Dark Ages by German glassmakers and through them the technique was introduced into America in the eighteenth century. It is definitely known that Stiegel produced enameled wares.

Enamel is a composition of lead (the flux), tin (for opaqueness), and a metallic oxide (for coloring). This mixture is ground to a powder and mixed with oil. The resulting paintlike substance is brushed on the bottle, which is then fired in a muffle which fuses the enamel to the glass.

Applied Color Labeling. This process is a relatively new method of enameling that was developed around 1920 in the United States. It was not until the 1930s, however, that it began to replace the popular mold-created embossments as a means of decoration and identification. Applied color labeling is used almost exclusively today on milk bottles, soda water bottles and other common bottles that are reused. With this innovation, common bottle decorations became more complicated than they had ever been before.

The process as originally developed consisted of powdering a borosilicate with a low melting point and mixing it with an oxide for color, and oil. The resulting paste was then applied to the bottle through a stainless-steel screen similar to the screen used in silk-screening. The screened bottle then had to be slowly dried at about 300 degrees in a muffle before another color could be applied. Since most bottles with applied color labels used two colors the process then had to be repeated for the second color before the bottle was fired in the muffle to fuse the paste with the glass. In the late 1940s it was discovered that by replacing the oil in the mixture with a thermoplastic wax or plastic resin which was solid at room temperature but became fluid and could be screen printed if moderately heated, the drying process was almost completely eliminated. The elimination of the drying step permitted two colors to be printed in rapid succession during a single trip through an automatic printing machine.

Bibliography

BOOKS

McKearin, George and Helen. *American Glass*. New York: Crown Publishers, Inc., 1968.

Reed, Adele. *Bottle Talk*. Bishop, California: Chalfant Press, 1966.

Sauzay, A. *Wonders of Glass and Bottle Making*. Ft. Davis, Texas: Frontier Book Co., 1969 (reprint).

12

Weathering
and Sick Glass

Like everything else bottles are susceptible to the forces of nature. Most common is the adverse reaction bottles have with moisture.

Quite often a bottle collector obtains a container that is opalescent, reflecting a milky play of colors in a rainbow effect. Bottles and other glass that display this iridescence are commonly called *sick glass*.

The name is actually very descriptive—the glass is "sick"; it is dissolving. Glass is often thought to be highly resistant to chemical attack. Glass is, however, subject to slow corrosion by water. Over a long period of time moisture will leach out the soda and lime in glass and leave behind a silicate skeleton.

Depending on the basic color and type of glass the crusts caused by corrosion will vary in color, texture, and thickness. All are formed of extremely thin and transparent layers stacked one upon the other. There are no coloring ions present in the layers. This would seem inconsistent at first because generally sick glass is very colorful. The iridescent colors are in reality merely a reflection as light rays are broken passing through the layers of corrosion.

Dating bottles recovered from the trash heaps and ruins of the past is always a problem. Because the corrosion of bottles appears in layers scientists have hypothesized that the number of layers, like the number of rings in a tree trunk, may be an index of age. The theory is that the layers reflect annual cycles of rainfall and temperature changes. The main requirement in dating bottles by this method would be to ascertain that none of the layers have peeled away as will happen during careless handling or thoughtless cleaning.

From the term "sick glass" the reader may have the impression that bottles that have suffered corrosion are less desirable than those that are in mint condition. That is not necessarily so. What is true, however, is that the more severe the deterioration the more colorful the vessel generally is. A bottle with only a slight amount of corrosion will give the appearance of being stained and for the most part collectors think less of this type. (The restoration of such bottles is discussed in Chapter 51.) Those containers with extensive amounts of corrosion are truly beautiful specimens. The more beautiful a corroded bottle is the higher its value. Collectors who specialize in the gathering of iridescent bottles are owners of some of the most colorful and unusual collections.

In Benicia, California, near San Francisco, in 1968, a cache of what many consider to be the finest specimens of opalescent bottles ever seen was discovered. The bottles were recovered at

low tide from the nearby mud flats. The bulk of the bottles recovered are only a little over one hundred years old, yet in beauty they exceed bottles that have been exposed to the elements for many times that number of years. The value collectors place on Benicia bottles is normally about five times the value of their noncorroded counterparts. No formal chemical analysis has been made but it would appear that Benicia mud must contain some unusual ingredients. There has been speculation that some special combination of wet peat and tule mud, spilled oil from the early ships, and silt that washed down from the Sierra Nevada mountains during hydraulic mining days is responsible for the unusual form of corrosion found on the bottles.

Sand is a prime enemy of bottles. In desert areas long exposure usually results in destruction of the surface of the vessel by the abrasion of windblown sand. The same destruction occurs to bottles that have been thrown into the ocean, where constant rubbing against the sand on the ocean floor destroys the shiny surface. Bottles thus treated have a smooth and very dull finish and are generally reduced in value as a result. There are occasional collectors who find this type of container attractive and specialize in collecting them.

Often, bottles left upright enough to hold water will be cracked by ice during freezing weather. Needless to say, such damaged specimens are of no value and are not collected.

One other common malady caused by the forces of nature is a distortion of the bottle's original shape. Dumping areas were, and still often are, purposely burned periodically, and collectors who retrieve bottles from this source quite frequently discover bottles badly distorted by extreme heat. Usually such vessels are of no interest unless the resulting shape itself appeals to the collector. (For uses for interesting pieces, see Chapter 54.)

Bibliography

BOOKS

Kendrick, Grace. *The Antique Bottle Collector.* Ann Arbor, Michigan: Edwards Brothers, Inc., 1963.

––––––. *The Mouth-Blown Bottle.* Ann Arbor, Michigan: Edwards Brothers, Inc., 1968.

PERIODICALS

Brill, Robert H. "Ancient Glass," *Scientific American,* CCIX (November, 1963), 120–130.

Hansen, Richard. "Nature's Tiffany," *Western Collector,* VII (April, 1969), 187–190.

13

Decolorizing and

Sun-Colored Glass

It was in the final twenty years of the last century that the preservation of food in glass containers became a truly flourishing business. With this method of preserving foods came the consumer demand for containers of clear glass which to the public was associated with purity. What started in food preservation containers soon spread to most other common containers.

The technique of adding small amounts of manganese to a glass mixture to produce clear glass had been known but hardly bothered with since its discovery before the time of Christ.

From around 1880, when the demand for clear glass forced the manufacturers to perfect the technique of decolorizing with manganese, until approximately 1915, at which time World War I cut off the main source—Germany—manganese was America's most widely used decolorizing agent. By 1916 glassmakers were using the more stable but also more expensive decolorizing agent, selenium.

Both manganese and selenium oxides act as neutralizing agents, masking the light green and blue colors caused by the inherent impurities in the raw ingredients with a complementary color. Both of these decolorizers produce yellow, red, and purple while the iron impurities produce blue and green. The mixing of these opposite colors results in a neutral color which has the visual effect of no color at all.

The use of selenium continued until around 1930, when arsenic became the popular decolorizer.

Unknown to, or at least disregarded by, glass manufacturers using manganese and selenium, was the fact that when decolorized glass is exposed to the ultraviolet rays of the sun it assumes an amethyst color if it contains manganese or a light amber color if it contains selenium. This reaction is explained by the facts that when the decolorizers were added, the ions within the substance were in a *reduced* state and when exposed to ultraviolet rays they are put into an *oxidized* state. Of interest may be the fact that when glass with a decolorizing agent in the oxidized state is reheated, the decolorizing agent returns to its original reduced state and the glass once more becomes clear.

Glass colored by ultraviolet sun rays is commonly called *sun-colored glass, purple glass,* or *desert glass.*

The amount of color decolorized glass will assume depends on two variables: (1) how much of a decolorizing agent was originally used; (2) how long the glass has been exposed to ultraviolet rays.

Certain misconceptions about sun-colored glass have been built up over the years. The bottle collector interested in sun-colored bottles should be aware of these. First, there is no one place in the country that the sun colors glass faster or better than another unless it gets more sunlight through a clearer atmosphere (free of dust, etc.). Keeping glass free of dirt and dust enhances coloring. Secondly, the desert does not provide a better background for sun coloring. Thirdly, glass cannot be effectively sunned through a glass window because the window absorbs much of the sun's ultraviolet rays.

In recent years artificial methods of sun-color-

ing glass have been discovered and used by hobby-ists. These methods are neither a secret nor a threat to the enthusiast of sun-colored bottles. These shortcut methods are treatment by mercury-arc radiation, X rays, gamma rays, and ultraviolet rays. The first three are generally not available to the hobbyist, but the fourth is.

The most popular artificial method of coloring bottles is with a 30-watt General Electric Germi-cidal Lamp, G30T8. (Similar lamps are, no doubt, produced by other companies.) These lamps are manufactured primarily for use by the medical profession but are easily obtained by anyone. The bulbs, which will fit most standard fluorescent light fixtures, come in both 18-inch and 36-inch sizes and cost between four and six dollars.

Since these lamps are dangerous to the eyes (overexposure can quickly cause conjunctivitis) they should be housed in a locked box. To gain maximum results the insides of the box should be covered with aluminum foil. The rays produced by this lamp are identical to those produced by the sun under ideal conditions; the advantage to the hobbyist lies in the fact that at the cost of burning a 30-watt fluorescent lamp, bottles can be "sunned" twenty-four hours a day.

Historically it has been popular to collect sun-colored glass. It is a fact that even before the relatively recent interest in bottles of all types, collectors were gathering sun-colored bottles.

Because of extended interest one would think that sun-colored bottles would be expensive and difficult to find but that is not true. During the period that manganese and selenium were used tremendous amounts of glass containers were manufactured and many are still easily obtainable at reasonable prices today. The real challenge to the collector of sun-colored bottles is probably being able to resist adding to his collection the multitude of other glass objects that have been sun-colored.

Bibliography

BOOKS

Kendrick, Grace. *The Mouth-Blown Bottle*. Ann Arbor, Michigan: Edwards Brothers, Inc., 1963.

————. *The Antique Bottle Collector*. Ann Arbor, Michigan: Edwards Brothers, Inc., 1968.

Zimmerman, Mary J. *Sun-Colored Glass*. Klamath Falls, Oregon: Smith-Bates Printing Co., 1964.

PART IV

Old

Bottles

14

Wine Bottles

Wine, usually the fermented juice of grapes, has been with mankind for many years. There are unmistakable evidences that organized viniculture was carried on in Mesopotamia about 2000 B.C. The Phoenicians are credited with spreading wine to the Mediterranean.

Early wine was different from modern wine; both Greeks and Romans lined their amphorae storage bottles with resin, which added a strong taste. (Bottle collectors highly skilled in the art of scuba diving are recovering some of these ceramic wine bottles today in the Mediterranean area.) They also flavored their wine heavily with spices, herbs, flowers, and perfume, and always diluted it with water; only barbarians drank undiluted wine. During the occupation of Gaul the Romans spread viniculture north as far as France; some of the finest vineyards in France have been under cultivation since the days of the Caesars.

During the Dark Ages western European viniculture was sustained largely by the energy of the medieval church. Quality more than quantity was the aim of the wine-making monastic orders; monks were responsible for developing the predecessors of the modern grape varieties. It was in the abbey wine cellars that they experimented with the forerunners of brandies and wine-based liqueurs.

Plagues, politics, war, and fads in drinking have modified the trading and drinking of wine. For example, a popular craze for gin seized wine-drinking England in the early eighteenth century (see Chapter 18).

America's influence on European wine making has been both harmful and beneficial. In 1869 an American insect, the aphid *Phylloxera vitifoliae,* entered Europe in a shipment of vines from America. Within a decade this pest devastated vineyards in Europe. The only way total disaster was averted was by tearing out the European vines and replacing them with the aphid-resistant American vines. European grape varieties were then grafted to the American roots.

Wine bottles were among the first containers of liquids to come to America. Squat wine bottles made in the 1600s are one of the types most desired by collectors; these bottles come in a variety of sizes and because they were free-blown no two are alike in shape. These squat wine bottles have several other names including "king's bottles," "onion bottles," "squats," "Dunmores," and "Wistarburgs." Squat wine bottles were made in England from about 1600 to 1730; it is not likely that any were made in America but if they were it would be difficult if not impossible to differentiate between the two types.

Squat wine bottles were also made by the Dutch during the seventeenth century. The Dutch version is usually found with a comparatively longer neck than the English model. Another difference between the two types of free-blown squat wine bottles can be found by examining their bases. English bottles of this type have an almost nonexistent basal kick-up (bottom of the container pushed up into the interior during construction) and a rather small pontil scar while Dutch versions have a rather severe basal kick-up and a large pontil scar. Still another difference can be found on the bottle necks: The Dutch examples feature flat wrap-around wafer-shaped rims, whereas the English specimens have an applied collar (laid-on ring).

Very large wine containers known as demijohns and carboys are worthy of a separate discussion at this point. These bottles command attention in any collection mainly because of their size. They sometimes are large enough to contain ten or more gallons and weigh up to thirty or forty pounds empty although both types are normally manufactured to hold from one to ten gallons. Demijohns were usually manufactured in a bulbous or bladder shape and have rather long necks; carboys, on the other hand, were generally cylindrical in shape and had short necks. From all indications demijohns were more popular in the early days when free blowing was the most practical method of producing bottles, and carboys be-

came popular when the use of molds became the most efficient method. Both were bulk containers that were reused until broken. Originally almost all of these large bottles were covered with wicker baskets or wooden boxes to reduce the chance of breakage. Bottle collectors almost always remove the basket or box so as to expose the crude beauty of these bottles. The earliest of these bottles were made in dark green to black glass but an amber specimen is sometimes located. Nineteenth-century examples are found in aqua and clear glass in addition to the common dark green and black, and of the blown-in-mold type.

The practice of attaching glass seals to the shoulders or sometimes the bodies of wine bottles began in England in the 1600s. Some of the earliest found bear dates from the 1650s. Some bottle collectors gather only bottles with seals.

Seals were not a new idea when adopted by the English; they go back to Roman times. On glass bottles, seals were applied after the bottles were completed. A gob of glass was taken from the furnace and lightly fused to the hot bottle, then while the gob was still hot it was impressed with a stamp rather like a stamp used for impressing sealing wax. The stamp would, of course, have lettering and/or design debossed backwards on it. (Such a process should not be confused with the later practice of debossed lettering either carved into the mold, or on plates that were inserted into the mold (see Chapter 8).

On wine bottles, seals were first used as identifying marks for taverns and persons of the upper class. Later the custom spread to shipping agents, merchants, and distillers. On the earliest wine bottles seals were the exception rather than the rule.

Not all bottles bearing seals were wine containers. Some seal-bearing bottles contained mineral water, rum, olive oil, anisette, and so forth; the same holds true for unmarked bottles and the large demijohns or carboys. Of the liquids other than wine that were put in bottles generally thought of as wine containers, rum was, no doubt, the most popular.

Numerous case bottles used for gin (see Chapter 18) also have seals.

Seals on wine bottles may also carry the date the bottle was manufactured or first used, and are especially helpful in dating the containers. Dating wine has by tradition been an important means of identifying the vintage, so it is to be expected that many wine containers, including those with seals, would be dated. Such dates, however, are not necessarily indicative of the period the bottle was used because glass bottles were expensive in the seventeenth, eighteenth, and nineteenth centuries and were often reused.

With the advent of plate molds in the late 1800s the use of seals began to decline. The hand seal process is still used to a certain extent, and some modern vessels have seals that were part of the mold, but this is of little concern to the bottle collector because modern bottles bearing seals are seldom collected. It might be thought that because of the plate mold wine bottles would be embossed, but this is not so; instead of adopting the tradition of heavily embossed bottles wine merchants did just the opposite, i.e., they eliminated seals and stressed a plain unembossed container. For identification they relied on paper labeling.

In addition to paper labels, which were used mostly to identify specific brands, distinctive bottle shapes were adopted as a means of identifying wine in general, and types of wine in particular. From about 1880 to 1910, turn mold bottles were extensively employed in the wine industry. These plain and highly polished bottles were replaced with bottles made by automatic blowing techniques early in the 1900s but retained their distinctive shapes.

Most wines of the world can be identified by three basic bottle shapes which have been used since the mid-1800s. *The Bordeaux shape* is a thinnish bottle with square shoulders and long straight sides. The wines that come in it include all the clarets, white Bordeaux, the better Chiantis, and the Spanish riojas. *The Burgundy shape* is a broader bottle with sloping shoulders. It always contains the red and white wines of Burgundy. *The German* or *Rhine wine flute bottle* is a tall thin container and is traditional for all the wines of Germany. Germany always puts its Rhine wines in amber glass bottles and its Moselles in green.

Of course, there are many other bottles, such as the heavy champagne and bottles made from special molds for one-of-a-kind proprietary products. In this latter group can be found bottles with embossments of monkeys, dogs, and so forth.

Cork closures on wine bottles are almost always found on free-blown squat bottles, mold-blown cylindrical bottles, turn mold bottles, and on modern machine-blown bottles. It is not known

when cork was first used as a closure on bottles and other containers; it is known that the ancient Greeks and Romans used the substance along with others on their earthenware jars and glass containers. By the sixteenth century, cork was used extensively as a closure and the cork industry was firmly established. Structurally, cork is an elastic mass of lifeless cells from tree bark containing a substance that makes it almost impenetrable to water and gases. It is very light and flexible because it is made up almost entirely of thin-walled cells filled with air. During the days of hand blowing bottle mouths varied from bottle to bottle and cork's flexibility enabled it to accommodate to the slight variations.

Wine containers and related types are generally no smaller than a pint and no larger than a gallon, with demijohns and carboys being the exception. Colors did not vary a great deal until the late 1800s. Early wine bottles were produced in various shades of dark green or black, since the exposure to light resulting from bottling in light glass was considered unfavorable for wine and spirits. From the late 1800s other dark colors were used. Some of these are amber, blue, amethyst, and red amber.

Wine bottles without seals that were made in the seventeenth and eighteenth centuries are rare and usually sell for $100 to $300. Early nineteenth-century specimens sell for about $25 less than their older cousins. Demijohns and carboys can be purchased for from $50 to $200 on the average. All of these prices depend on age, crudity, color, and condition. Wine bottles from the late 1800s on usually sell for $2 to $10 but can go higher if they are of an unusual color or have unusual embossments.

Except for the earliest wine bottles, this category has been much overlooked in the past by collectors but is slowly gaining in popularity. Museums have gathered and displayed these bottles for years; they are truly of historical and cultural significance.

Bibliography

BOOKS

Freeman, Larry. *Grand Old American Bottles.* Watkins Glen, New York: Century House, 1964.

McKearin, George and Helen. *American Glass.* New York: Crown Publishers, Inc., 1968.

Maust, Don, ed. *Bottle and Glass Handbook.* Uniontown, Pennsylvania: E. G. Warman Publishing, Inc., 1968.

Monroe, Loretta. *Old Bottles Found Along the Florida Keys.* Coral Gables, Florida: Wake-Brook House, 1967.

Munsey, Cecil. *Would You Believe.* San Diego, California: I.P.S., a division of Neyenesch Printers, Inc., 1968.

Reed, Adele. *Bottle Talk.* Bishop, California: Chalfant Press, 1966.

PERIODICALS

Barker, E. M. "Staughton Bottle," *Hobbies,* XLVII (October, 1942), 62.

"Bottle Seal Cannot Be Counterfeited," *Scientific American,* CLI (October, 1934), 201.

Carlton, E. "At the Sign of the Carboy," *Century,* LXII (April, 1902), 827–834.

Hudson, J. P. "17th-Century Glass Wine Bottles and Seals Excavated at Jamestown," *Journal of Glass Studies,* 1961, p. 27.

Hume, I. N. "17th-Century Virginians Seal; Dective Story in Glass; Sealed Wine Bottles," *Antiques,* LXXII (September, 1957), 244–245.

Munsey, Cecil. "The Vanishing Cork," *The Bottleneck,* II (February, 1967), 4.

Shafer, James F., II. "Sealed in Glass," *Western Collector,* VII (March, 1969), 139–143.

————. "New Insights on 'Free-Blown' Bottles," *Western Collector,* VII (June, 1969), 282–286.

Watkins, C. M. "Three Initial Cipher: Exceptions to the Rule: Colonial Beverage Bottle Seals," *Antiques,* LXXII (September, 1957), 320–321.

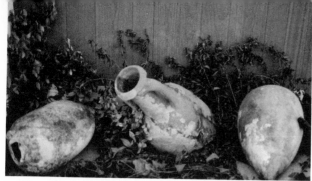

Greek or Roman amphorae (pottery) found in the Red Sea in 1969 by Dr. Jack Nelson, of Dallas, Texas.

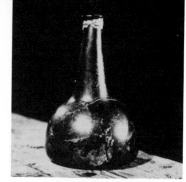

Squat wine bottle, dark olive-green, H. approx. 9 in., c. 1690–1700. (James F. Shafer II, Miami, Fla.)

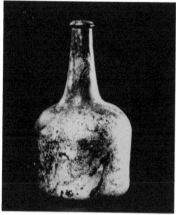

Wine bottle, dark green, H. approx. 8 in., c. 1750. This particular shape has often been called a Wistarburg after the famous American glassmaker Casper Wistar; the name is a misnomer because Wistar did not manufacture glass during the period that this shape was made. (James F. Shafer II, Miami, Fla.)

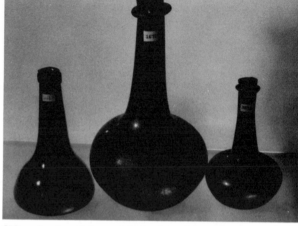

Wine bottles (left to right): (1) olive-green, Dutch, H. 6¼ in., eighteenth century; (2) olive-green, globular body, English, H. 9¼ in., eighteenth century; (3) olive-green, English, H. 5⅞ in., eighteenth century. (Charles B. Gardner, New London, Conn.)

Wine bottle, black globular body with long neck, seal reads "THE WHIT BEARE AT THE BRIDGE FOOT" above "TCD" over the figure of a bear, H. 8¾ in., c. 1650. (Charles B. Gardner, New London, Conn.)

Wine bottles (left to right): (1) dark olive-green, squat shape, seal reads "I. W. 1695," H. 6¼ in.; (2) dark olive-green, chestnut shape, seal reveals man holding arrows and "I. S. 1716" (this was the seal of Jonathan Swift, author of *Gulliver's Travels*), H. 8⅜ in. (Charles B. Gardner, New London, Conn.)

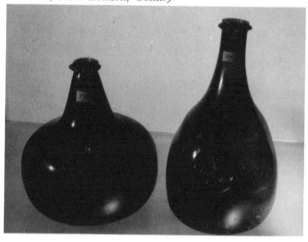

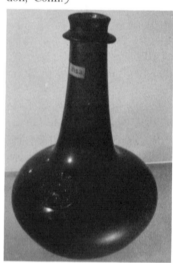

Cylindrical wine bottle, green, H. approx. 12 in., c. 1800. (James F. Shafer II, Miami, Fla.)

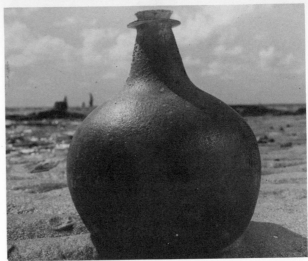

Squat wine bottle, light olive-green, H. approx. 11 in., c. 1675. (James F. Shafer II, Miami, Fla.)

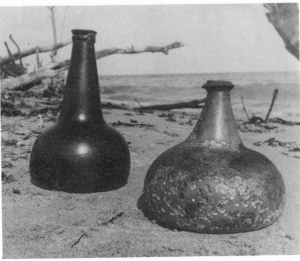

Squat wine bottles (left to right): (1) Dutch, black glass, H. approx. 9 in., c. 1700; (2) English, black glass, H. approx. 7 in., c. 1700. (James F. Shafer II, Miami, Fla.)

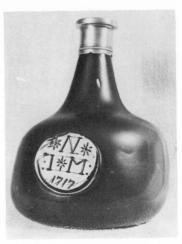

Squat wine table bottle, deep olive-amber, wrought silver top, H. approx. 10 in., 1717. (Hearn Collection) Photo by James F. Shafer II, Miami, Fla.

Squat wine bottles (left to right): (1) Dutch, black glass, H. approx. 8 in., c. 1700–1725; (2) English, black glass, H. approx. 7½ in., c. 1700–1725. (James F. Shafer II, Miami, Fla.)

Wine bottle, green, seal reads "WM. SAVERY, 1762." (Philadelphia Museum of Art, Philadelphia, Pa.)

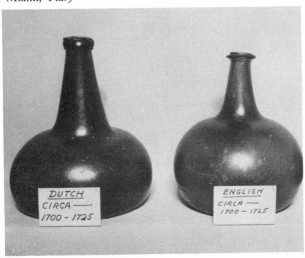

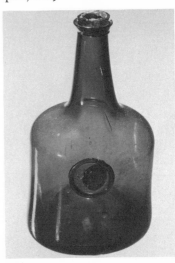

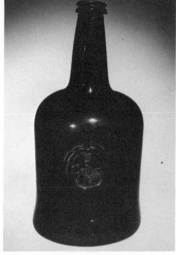

Wine bottle, with seal, English, transparent olive-green, H. approx. 9¼ in., 1767. (The Corning Museum of Glass, Corning, N.Y.)

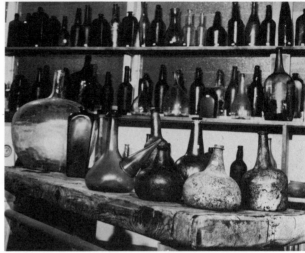

Wine and case bottles dating from about 1670 to about 1800. (James F. Shafer II, Miami, Fla.)

Selection of early wine bottles. (James F. Shafer II, Miami, Fla.)

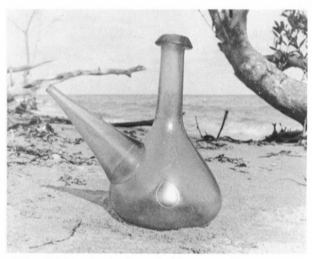

Wine drinking bottle, Spanish, blue-green, H. approx. 12 in., c. 1790. (James F. Shafer II, Miami, Fla.)

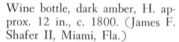

Wine bottle, dark amber, H. approx. 12 in., c. 1800. (James F. Shafer II, Miami, Fla.)

Wine bottles (left to right): (1) light green, c. 1840; (2) demijohn, aqua, sheared-type mouth, blown in a three-part mold, nineteenth century; (3) case bottle, black glass, c. 1790–1810. (James F. Shafer II, Miami, Fla.)

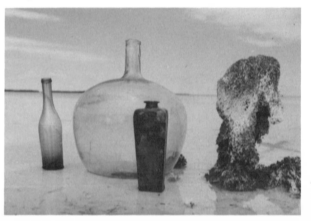

64

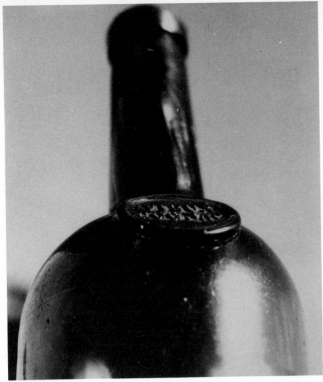

Closeup photograph of a seal on a French wine bottle; seal inscription reads "VIEUX COGNAC"; c. 1820–1840. (James F. Shafer II, Miami, Fla.)

A collection of wine-bottle corks from many parts of the world.

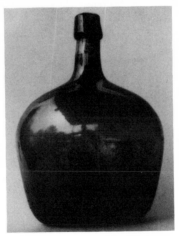

Wine bottle, green, embossment of monkey with his arms wrapped around the bottle, H. 13 in., c. 1950.

Demijohn, green, H. 15 in., c. 1860.

Wine decanter, green, embossed seal, H. 9 in., c. 1950. (John C. Fountain, Amador City, Cal.)

Paul Masson wine bottle, amber, heart-shaped, heart and chain of pearls embossment on side, H. 8½ in., c. 1960.

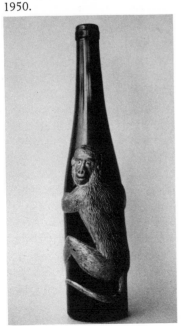

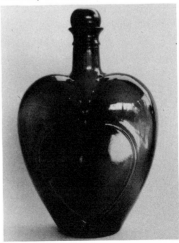

15

Patent and Proprietary

Medicine Bottles

Like so many things considered American, patent medicines originated in England. It is not known who was granted the first patent by the English king for a patent medicine but it is a matter of record that Richard Stoughton's Elixir was the second compound to receive a patent, in 1712. No doubt the first patent medicines in America came over with the colonists and were English. The eighteenth century was one of great awareness of physical ills and Englishmen and Americans alike dosed themselves quite readily with the various ready-made medicines offered for sale. By the 1750s patent medicines were being regularly shipped to Americans. An incomplete list published in England in 1748 listed 202 "proprietary" medicines.

Not all medicines were patented—in fact very few were. Medicines made in America were hardly ever patented by the king or, after the Revolution, by the United States government. The U. S. Patent Office opened in 1790 and the first patent for medicine was not issued until 1796, to Samuel Lee, Jr. of Windham, Connecticut, on a product he called "Bilious Pills." Because the maker would have to disclose the ingredients, a good portion of which was usually alcohol, registering the brand name was a better protection than patenting. Thus in the strict use of the word, all ready-made medicines cannot be called patent medicines; those whose brand names were registered are more properly called proprietary medicines. The term *patent medicine* has, however, become the generic one for all medicines sold without prescriptions.

Self-prescribed medicines were very popular by the mid-1700s; one of the reasons for this was the inferior quality of doctors. Even as late as 1870 the head of the Harvard Medical School explained that written examinations could not be given to medical students because a majority could not write well enough. With the lack of

quality went lack of respect for the title "doctor." Many who were called doctor had merely assumed the title. In addition there were midwives, apothecaries, and others who offered medical advice and treatment.

One of the oldest types of bottles that can be located is the two- to three-inch-high pear-shaped bottle that held Turlington's Balsam of Life. These heavily embossed mold-blown bottles were made in England as early as 1744 and were sold in America until almost 1900.

The Revolutionary War stopped shipments of English medicines and forced American manufacturers to supply the demand. After the war shipments from England resumed but by then much of the market had been captured by American vendors. The nationalistic spirit of the time helped American medicines to maintain their edge over English competitors. American medicines were generally cheaper as well.

By 1800 the use of *bitters* became popular. Because bitters bottles are so unusual and have been segregated by collectors for many years, they have been treated separately by this book (see Chapter 22). In reality, however, they properly belong in the medicine category and should, for the most part, be considered proprietary medicines; during the Civil War they were taxed as such (see Chapter 58).

The earliest of the truly American proprietary medicines came in plain unembossed bottles made in this country. Some, however, were probably produced in this country but were sold in plain and embossed bottles manufactured in England. The first evidence of an embossed bottle being made in America is an advertisement in the February 16, 1810, issue of the *Pittsburgh Gazette* which tells that Dr. Robertson's Family Medicines came in glass bottles of American manufacture. The advertisement further indicates that embossed on the glass was "DR. ROBERTSON'S

FAMILY MEDICINES, PREPARED BY T. W. DYOTT."
This advertisement also serves as the first proof
of mold-blown bottles being manufactured in
America. By 1810 there were around one hundred
American proprietary medicines.

Dyott, who later became famous as a glass-
maker (see Chapter 5), was the first king of the
nostrum vendors. By the 1820s Dyott was said
to be worth $250,000 (a tremendous amount in
those days). Part of Dyott's success as a vendor
of proprietary medicines was due to his price-
cutting tactics; he advertised that his medicines
would be sold to the laboring class at one-half
of the usual price. After building the glassmaking
community of Dyottville, he established very
strict rules for the residents which included no
swearing, fighting, gambling, or *drinking*. The
last is most interesting when it is learned that a
good portion of his proprietary medicines con-
sisted of alcohol.

One of the reasons for the rapid spread of
nostrums during the early 1800s was advertising
(see Chapter 56). From 1800 to about 1860 the
number of newspapers grew from 200 to 4000.
Nostrum vendors such as Dyott soon discovered
that newspaper advertising was one of the best
methods of increasing sales and just as effective
as price cutting. In the 1840s the federal govern-
ment enacted laws lowering postal rates for news-
papers. This not only increased the circulation of
newspapers but spread nostrum advertisements in
them to all parts of the land. The new laws also
helped the patent and proprietary medicine ven-
dors directly. They could mail brochures and
other advertising themselves at the cheap rates
given to newspapers. These vendors took complete
advantage of these laws and became among the
first, if not the first, American manufacturers to
seek a national market.

In the 1820s another very successful proprietary
medicine man emerged out of the fast-growing
crowd of quack doctors and vendors to offer his
product to "suffering mankind"; his name was
William Swaim and his product was called Swaim's
Panacea. This product was manufactured until
the 1900s and specimens of Swaim's bottles are
prized by bottle collectors. Of the first type of
bottle used by Swaim nothing is known, but in
1825 he used a rectangular bottle about seven
inches high made of aqua glass and embossed
"GENUINE SWAIM'S PANACEA, PHILADA." In 1829
he switched to a green cylindrical bottle blown
in a three-part mold that featured the embossed

lettering "SWAIM'S PANACEA, PHILADA" on three
separate vertically indented panels. In 1879 the
bottles of the firm once again became aqua in
color. The basic shape was retained but the words
"TRADE" and "MARK" were added to the panel
that was embossed "SWAIM'S."

All of the ready-made medicines could be
placed into two general categories: single-purpose
and all-purpose, or, in medicine-men language,
"specifics" and "cures." It might seem that the
specifics would have a hard time competing with
cures but such was not the case because cures,
for example, could claim to cure catarrh and
catarrh was a name applied to almost every dis-
ease by both doctors and nostrum vendors.

The approaches used to sell patent and propri-
etary medicines during the 1800s were many and
varied. Electricity was associated with healing in
the form of Magnetic Fluids, Galvanic Belts,
Electric Wrist Bands, plus a variety of shoes,
head caps, pads, necklaces, pillows, and so on.
Oxygen was another area explored by the nos-
trum peddlers. They offered such cures as Oxy-
Hydrogenated Air and Ozone Tonic. Radium was
still another scientific discovery twisted to fit into
patent and proprietary medicine appeals; Radol
was one such brand.

Electricity, botany, and chemistry were all used
by the nostrum vendors but they expanded to in-
clude the exotic—the authority of faraway places
and ancient times. By the mid-1800s medicine
appeals stressed the knowledge of the Orient with
such products as Dr. Drake's Canton Chinese
Hair Cream, Carey's Chinese Catarrh Cure, and
Dr. Lin's Celestial Balm of China. Other foreign
countries were also used. Mexican Mustang Lini-
ment, Incomparable Algerine [Turkish name]
medicine, Japanese Life Pills, Ayers Cherry [Jap-
anese] Pectoral, German Tonic, Peruvian Syrup,
Arctic Liniment, Brazilian Bitters, and so on.
Many of the stereotyped ideas Americans have
about people of foreign lands are probably the
indirect result of nineteenth-century patent and
proprietary medicine advertisements.

The American Indian was one of the most ex-
ploited of peoples. After the Indian had been
pushed far into the West, nostrum vendors, taking
over from Rousseau and the romantic novels of
James Fenimore Cooper, began to build the image
of the Indian as the noble savage (unspoiled,
strong, virile, healthy). The Indian was promoted
as a "natural" physician who had through the
years perfected botanic medicine. The numerous

medicines claiming Indian origin included Wright's Indian Vegetable Pills, Modoc Oil, Seminole Cough Balsam, Nez Perce Catarrh Snuff, Brown's Celebrated Indian Herb Bitters, Kickapoo Medicines, Ka-Ton-Ka Cures, and Dr. Morse's Indian Root Pills. In addition, scores of medicines pictured the Indian on their product. Sometimes long and wondrous stories were told about how the secrets were given to the proprietor of a particular nostrum by a grateful Indian.

The strength of an ox, the power of an elephant, the potency of a unicorn, the recuperative powers of a phoenix, were all mustered to promote ready-made medicines; the American Eagle, the Stars and Stripes, and Uncle Sam also were included in literature promoting specifics and cures. Even religion was not exempt from patent and proprietary medicine literature; the Bible was often quoted and testimonials from religious leaders were often used. Large numbers of recoveries were claimed and important people were mentioned in literature distributed by the nostrum vendors.

There is almost no end to the variety of promotional approaches used by the nineteenth-century medicine man. Among the most fascinating were the medicine shows. There were actually two types of medicine men and there was a strict caste distinction among the members of the patent and proprietary medicine business between the two types. A "high-pitch" medicine man was of the aristocracy, so to speak; the term sprang from the fact that he was always elevated above his audience in a vehicle or on a stage. A "low-pitch" medicine man put his product on a tripod and stood either on the pavement or on a low box. The low-pitch man always stopped selling if a high-pitch man elected to pitch on the same street. Another difference was that the high-pitch man made his pitch once and quit while the low-pitch man often pitched all day.

In most cases the high-pitch man did not try to sell immediately but softened his audience up first with some form of entertainment; some actually had a troupe that traveled with them. (The selling of medicine between acts at these shows evolved into what today is known as the commercial on radio and television.) The most elaborate shows resembled circuses. The heyday for medicine shows was from 1880 to 1900. Probably the largest operation in the field of ready-made medicines was the Kickapoo Medicine Company. "Doc" John E. Healy, "Texas Charley"

Bigelow, and "Nevada Ned" Oliver pooled their resources and imaginations to form this company. Their headquarters were in a four-story building in New Haven, Connecticut. These three men gathered together a large group of Indians and claimed they were of the Kickapoos, a subtribe of the Lake States Indians. Many of them lived in the headquarters building, which was called the Principal Wigwam. The Kickapoo Medicine Company put together a large number of shows and had as many as seventy-five touring the country at the same time. Because of the quality of the entertainment and what amounted to ethical standards, they established circuits and toured the same cities year after year. These shows even toured Europe and Australia. In some instances they played an entire season in one city; in such areas they earned up to $4000 a night. Local druggists, who might normally complain of a loss of business during a medicine show visit, were always glad when the Kickapoo shows came to town because they were always offered the opportunity to carry the full line of Kickapoo medicines.

The personal stories of the men who manufactured and sold patent and proprietary medicines are fascinating. In addition to William Swaim and Thomas W. Dyott, previously discussed, William Radam and his famous Microbe Killer (see Chapter 27) and David Hostetter (see Chapter 22) are examples of successful proprietary medicine vendors. Another great of the nostrum business was Perry Davis, vendor of Perry Davis' Pain-Killer. The real story of how Davis got started in the medicine field is lost to recorded history but if Mr. Davis's literature can be believed it goes something like this: "My stomach became very sore. My digestive organs became weak. My appetite failed. Night sweats followed. Then my kidneys were affected. Piles in their worst form were preying upon me. The canker in my mouth turned very troublesome. Under all the circumstances I thought I was a fit subject for the grave." Mr. Davis, at this point, decided to invent some concoction that would relieve his misery while he awaited death. He supposedly selected the choicest gums and plants in the world and "directed by the hand of Providence" put together his famous pain-killer. Needless to say, his efforts effected a complete cure and he decided to share it with his fellow human beings.

Mr. Davis started selling his pain-killer in Taunton, Massachusetts, in 1840 and by 1843 he had moved to Providence, Rhode Island, and had

assumed the title of "doctor." It was the cholera epidemic of 1849 that made his product famous. Before that year was out Davis was selling 6000 bottles a month. At about the same time, sea captains began to take his pain-killer with them on their voyages all over the world. Soon Perry Davis and Son opened a branch office in London. By the time the London office was opened sales had increased more than a thousandfold over those during the cholera epidemic. During his lifetime, Davis was a generous financial contributor to the Baptist Church and the temperance movement (Pain-Killer was 51 percent alcohol or 102 proof). At the age of seventy-one, in 1862, Perry Davis died and his son ran the business until his death in 1880. The business was sold and remained in Providence until 1895 when it was moved to New York City. (It is interesting to note that Mark Twain spoke of Perry Davis's pain-killer in his book, *The Adventures of Tom Sawyer,* Chapter XII, "The Cat and the Pain-Killer.")

Of all the vendors of proprietary medicines, one stands out above all others. Surprisingly, this peddler was a woman. Lydia Estes Pinkham of Lynn, Massachusetts, not only became one of the most successful of all nostrum vendors but was probably the most famous woman of nineteenth-century America. Lydia Pinkham (1819–1883) was a school teacher in her early years. She married Isaac Pinkham in 1843. They had three sons and a daughter. Lydia was a devout worker for temperance (even though her vegetable compound was mostly alcohol), abolition, and women's rights. In 1873, ten years before her death, a financial crisis stripped Isaac of his modest fortune and the family decided to sell Lydia's home remedy, which until then had been given away to neighbors. The medicine, Lydia E. Pinkham's Vegetable Compound, did not become an overnight success. Only through persistent merchandising by her sons and daughter did the medicine achieve a success that few, if any, proprietary medicines ever had. During her last years Lydia wrote a four-page folder called *Guide for Women* which told of female problems in plainer language than that used by doctors of the time. Over the years this booklet was printed by the millions and in 1901 was enlarged by the company to sixty-two pages and printed in five languages. Although the booklet contributed to the success of the compound that "cured female weakness," it was newspaper and periodical advertising that firmly established the medicine. These advertisements usually

featured a photograph of Lydia herself. Over the years some forty million dollars has been spent publishing pictures of Lydia. This not only contributed to the success of the medicine but made Lydia's the most familiar female face of the nineteenth century. When Queen Victoria died, several newspapers ran a picture of Lydia with the obituary because they did not have a picture of the Queen.

At its peak it took 450 employees to turn out the needed supply of the vegetable compound. Thousands of letters were received weekly from ailing females. At first Lydia answered the letters herself but soon a secretarial staff had to be employed to do the job. Through continued promotion, Lydia E. Pinkham's Vegetable Compound became a product used in homes all over the world. In China the name was translated "Smooth Sea's Pregnancy Womb Birth-Giving Magical 100 Per Cent Effective Water." Down through the years Lydia Pinkham's medicine has declined in popularity as medical science has advanced, but it is still to be found in stores today.

Not all nostrum manufacturers were as famous as Mrs. Pinkham but some were just as imaginative and interesting. In the early 1880s, after unsuccessful attempts at preaching, farming, and politics, Fletcher Sutherland of Warren's Corners, New York, his seven long-haired daughters and his son began to tour New York giving vocal and instrumental entertainment. They expanded their circuit and performed in the southern states; in 1881 the "Sutherland Concert of Seven Sisters and One Brother" had their own pavilion at the Atlanta Exposition in Georgia; in 1882 history finds the group with W. W. Coles Colossal Shows and by 1884 with "Barnum and Bailey's Greatest Show on Earth." It was during this period that Fletcher Sutherland realized that the public was more interested in his daughters' long hair (Isabella, six feet of hair; Grace, five feet; Sarah, three feet; Victoria, seven feet; Naomi, five and a half feet of hair; Dora, four and a half feet; and Mary, six feet) than their musical talents. With this in mind Sutherland concocted a mixture of vegetable oils, alcohol, and water and called it "Seven Sutherland Sisters Hair Grower." The product sold well, but in 1885, when Henry Bailey married Naomi, the fifth daughter and bass of the singing group, and took over as business manager of the Seven Sutherland Sisters Corporation, business really grew. They sold $90,000 worth of their nostrum from their New York office during

the first year and celebrated by opening another office in Toronto, Canada. Soon after that their success was such that they increased their products to include a scalp cleaner, a "Seven Sutherland Sisters Comb," and eight different shades of "Hair Colorators." They soon had offices in Chicago, Philadelphia, and Havana, Cuba. Later, retail stores were opened in St. Louis, Minneapolis, Kansas City, and Jacksonville. By 1892 they had 28,000 dealers in the United States, Canada, and Cuba, and their income was phenomenal. The group spent their money as fast as, and sometimes even faster than, it was earned. The seven sisters from Warren's Corners, New York, who had worked in the fields like men, wore dresses of burlap, and wore shoes only on Sundays, were not used to money and in the thirty-eight years their products were sold they let over $2.75 million slip through their hands.

When Fletcher Sutherland, the father, died in 1888 business was not affected but when Naomi unexpectedly died in 1893 the group had to find a replacement since business depended a great deal on personal appearances of the seven long-haired girls. Anne Louise Roberts of Carbondale, Pennsylvania, was selected to take Naomi's place. Ironically, Anne's hair was nine feet long, two feet longer than that of Victoria, who had the longest hair of all the Sutherland sisters.

In 1893 the septet built and occupied a fourteen-room mansion near Lockport, New York. Their home was the latest thing, featuring marble bathrooms, hot and cold running water (a tank in the attic, pumped full every day by a hired man, supplied the water), and a large twin furnace. In the living room was a life-size oil painting of the sisters, and halfway up the stairs on the wall was a large oil painting of Isabella with her six feet of auburn hair. The Sutherland sisters were not only unusual in appearance but in actions as well; their eccentricities were well known throughout the Lockport area: One of the girls had a dog who rang a bell when he wanted service, one had seventeen cats and a horse with gold-plated shoes, and they all rode bicycles around a gazebo in their yard clad only in scanty (for those days) bathing suits, While on tour each girl had a maid to comb her hair, and each carried a three-foot-tall doll with hair combed from their own heads.

Their best years were from 1886 to 1907; then business declined gradually to about 1917 when bobbed hair practically ruined the business. Sales in Canada continued for six or seven years longer. The story of the Sutherland sisters ended on January 13, 1946, when Grace, the fourth of the sisters, died at the age of ninety-two.

By 1906 the traffic in patent and proprietary medicines in the United States had reached a volume of eighty million dollars a year. But on October 7, 1905, Samuel Hopkins Adams, writing for *Collier's* magazine, began a series of articles called "The Great American Fraud." For the first time Americans were exposed to the truth about patent and proprietary medicines. Most Americans were shocked to learn that their cure-alls were made mostly of alcohol, opiates, or nearly worthless drugs and herbs. Adams made such statements as "more alcohol is consumed in this country in patent medicines than is dispensed in a legal way by licensed vendors." All of his accusations were backed by recent research and could not be refuted. Of the medicines on the market at that time it is an established fact that some 240 were required by law to be dispensed over the counter only with a liquor license. Adams produced various documents to substantiate his accusations, including one issued by the federal government prohibiting the sale of patent and proprietary medicines to the Indians because of alcoholic content.

As the series continued into 1906 the overall effect on the public was staggering. By the end of the series Adams had exposed 264 concerns and individuals by name. Only two lawsuits resulted; one was dropped before coming to trial and the other was still in the courts in 1907 when the famous Pure Food and Drug Act was signed in January. This legislation resulted in a number of medicines being taken off the market and changes (both in advertising and product content) in those which stayed in business. The public faith in ready-made medicines was shaken and the industry never recovered from the blow.

For the collector of patent and proprietary medicine bottles there is an almost unlimited field. In 1906 there were over fifty thousand medicines being manufactured and sold in America. By far the majority of these came in glass bottles. Sizes and shapes of these bottles were fairly consistent; standard sizes up to a quart were common, and cylindrical or rectangular were the common shapes. They were also quite consistently aqua or light green. Almost without exception, patent and proprietary medicine bottles utilized a cork closure.

A small percentage of patent and proprietary bottles were made in unusual sizes, shapes, and colors—and with fifty thousand types available that amounts to several hundred to a thousand at least. These unusual types are the ones most gathered by the sophisticated medicine bottle collectors.

Embossments were many and varied. Unlike most bottle categories, embossed designs are considered desirable, but it is the embossed lettering that commands a great deal of attention by the specialist in this field. Unusual names and claims appear embossed on many medicine bottles.

Price and rarity of patent and proprietary medicine bottles must be considered separately under the heading of common and uncommon types. Common medicine bottles, as described earlier, are plentiful and not difficult to obtain; they usually range between $1 and $20. The less common specimens of unusual shapes and colors are difficult to locate and are usually priced from $20 to $200. Age is a factor that greatly affects price; specimens bearing pontil scars are almost always sold for $10 and up.

Co-related material (see Chapter 60) is abundant in this area of bottle collecting, perhaps more so than in any other area. Patent and proprietary medicine vendors spent a great deal of money advertising their products. Newspaper and periodical advertisements were numerous, as were trade cards (see Chapter 57). Revenue stamps (see Chapter 58), badges, almanacs, and a host of miscellaneous items can be added to the patent and proprietary medicine bottle collection.

Bibliography

BOOKS

Adams, Samuel Hopkins. *The Great American Fraud*. Chicago: The Journal of the American Medical Association, 1905.

Agee, Bill. *Collecting the Cures*. Waco, Texas: privately published, 1969.

Burton, Jean. *Lydia Pinkham Is Her Name*. New York: Farrar, Straus & Co., 1949.

Carson, Gerald. *One for a Man, Two for a Horse*. Garden City, New York: Doubleday & Co., Inc., 1961.

Clifford, Richard A. *Re Mederi*. Winfield, Kansas: Variety Printing, 1967.

Cramp, Arthur J., ed. *Nostrums and Quackery*. Chicago: American Medical Association Press, Vol. I, 1912; Vol. II, 1921; Vol. III, 1936.

Freeman, Larry. *Medicine Showman and His Bottles*. Watkins Glen, New York: Century House, 1957.

Holbrook, Stewart H. *The Golden Age of Quackery*. New York: The Macmillan Co., 1959.

Israel, Fred L., ed. *1897 Sears Roebuck Catalogue*. New York: Chelsea House Publishers, 1968 (reprint).

Locke, Laurence D. *Pharmacy on the Niagara Frontier*. East Aurora, New York: Henry Stewart, Inc., 1968.

Lydia E. Pinkham's Private Text-Book Upon Ailments Peculiar to Women. Lynn, Massachusetts: The Lydia E. Pinkham Medicine Co., no date.

McKearin, George S. and Helen. *American Glass*. New York: Crown Publishers, Inc., 1968.

McNeal, Violet. *Four White Horses and a Brass Band*. Garden City, New York: Doubleday & Co., Inc., 1947.

Munsey, Cecil. *Would You Believe*. San Diego, California: I.P.S., a division of Neyenesch Printers, Inc., 1968.

Patent Medicines and Proprietary Articles. Princeton Junction, New Jersey: Stonybrook Associates, 1970 (catalog reprint).

Schroeder, Joseph J., Jr. (ed.). *1908 Sears Roebuck Catalogue*. Chicago: Gun Digest Co., 1968 (reprint).

Shimko, Phyllis. *Sarsaparilla Bottle Encyclopedia*. Aurora, Oregon: privately published, 1969.

Umberger, Art and Jewel. *It's a Sarsaparilla!* Tyler, Texas: Corker Book Company, 1968.

Young, James Harvey. *The Toadstool Millionaires*. Princeton, New Jersey: Princeton University Press, 1961.

————. *The Medical Messiahs*. Princeton, New Jersey: Princeton University Press, 1967.

PERIODICALS

Burns, Irving, and Frace, Donald. "Swaim's Panacea," *Western Collector,* VII (January, 1969), 43–46.

Munsey, Cecil. "Tom Sawyer's Bout with Patent Medicine," *The Bottleneck,* II (September, 1967), 5–6.

————. "Perry Davis' Pain Killer," *The Bottleneck,* II (October, 1967), 2–3.

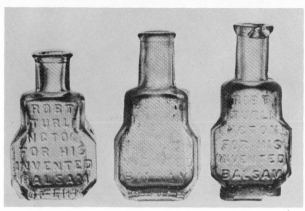

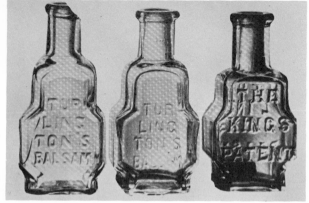

Medicine bottles, "ROBERT TURLINGTON'S BALSAM OF LIFE" (left to right): (1) and (2) light green, c. 1860–1875; (3) amethyst, c. 1880; (4), (5), and (6) clear, c. 1890–1900. (*Western Collector*, San Francisco, Cal.) Photos by Fred Rawlinson.

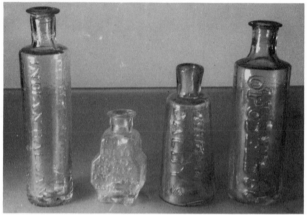

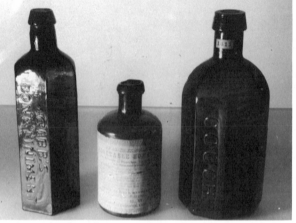

Medicine bottles (left to right): (1) aqua, embossed "MRS. N. M. GARDNER'S INDIAN BALSAM OF LIVERWORT," H. 6 in., mid–nineteenth century; (2) aqua, embossed "ROBT./TURLI/NGTON/FOR HIS/INVENTED/BALSAM/OF/LIFE," H. 3 in., early nineteenth century; (3) aqua, embossed "DALBY'S CARMINATIVE," H. 4½ in., mid-nineteenth century; (4) aqua, embossed "LIQUID OPELDELDOC," H. 5¼ in., early to mid-nineteenth century. (Charles B. Gardner, New London, Conn.)

Medicine bottles (left to right): (1) olive-green, embossed "GIBB'S BONE LINIMENT," mid-nineteenth century; (2) olive-green, embossed "JACKSON'S VEGETABLE HOME SYRUP," mid-nineteenth century; (3) olive-green, eight panels, embossed "LEWIS COUGH SYRUP" on three panels, mid-nineteenth century. (Charles B. Gardner, New London, Conn.)

Swaim's Panacea bottle, clear, embossed: "GENUINE SWAIM'S PANACEA PHILADA," pontil scarred, H. approx. 7 in., c. 1825. Embossment painted for photographing.

Portrait of William Swaim (the Second) taken about 1875.

Trademark of Swaim's Panacea, described by William Swaim as Hercules holding an upraised club over the many-headed Hydra.

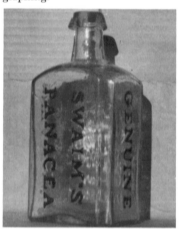

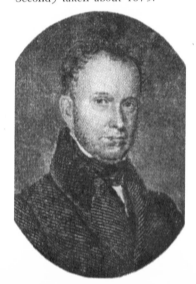

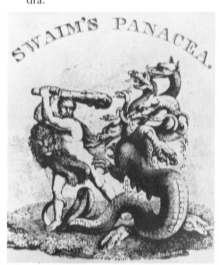

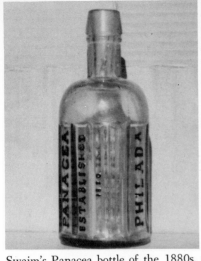

Swaim's Panacea bottle of the 1880s, aqua, H. approx. 6 in. Embossment painted for photographing.

Early 1880s magazine woodcut of a low-pitch patent medicine vendor.

1882 steel engraving depicting a high-pitch medicine man peddling Oriental Panacea.

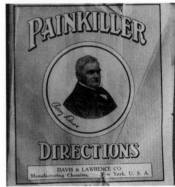

Perry Davis, originator of Perry Davis' Pain Killer, as shown on an 1895 booklet of directions that accompanied every bottle of painkiller. The picture of Mr. Davis is probably one taken around 1850, ten years after he first placed his product on the market and twelve years before his death in 1862.

Medicine bottle, aqua, embossed "DAVIS" on front side, with "VEGETABLE" on another side and "PAIN KILLER" on another side, pontil scar, H. 4 in., c. 1850.

"BININGER'S OLD DOMINION WHEAT TONIC," light green, square, quart, c. 1860–1875. (Western Collector, San Francisco, Cal.) Photo by Dr. Burton Spiller.

Proprietary medicine bottle, amber, embossed "EXPECTORAL WILD CHERRY TONIC" on one side, rectangular base, roped corners, cathedral-type arches on all sides, hand-applied lip, bare iron pontil, H. 10⅜ in.; c. 1865–1875. (Donald Frace, Escondido, Cal.)

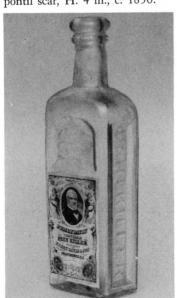
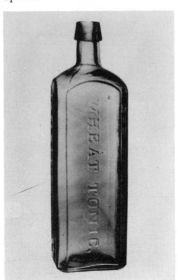

Left: Lydia E. Pinkham, age 25. *Right:* Lydia Estes Pinkham as she appeared in 1880, three years before her death. (John C. Fountain, Amador City, Cal.)

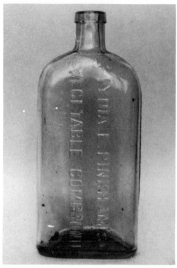

Proprietary medicine bottle, aqua, embossed "LYDIA E. PINKHAM'S VEGETABLE COMPOUND," H. 8 in., c. 1900.

Proprietary medicine bottle, emerald-green, embossed "C. W. MERCHANT LOCKPORT. N.Y.," H. 5 in., c. 1880. Contained Merchant's Gargling Oil.

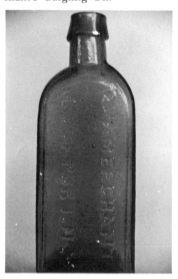

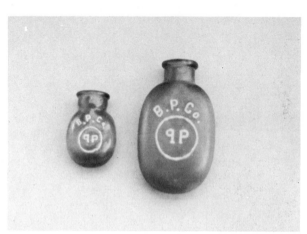

Pill bottles, cobalt, embossed "B. P. CO.," with "P" in a circle on the sides. H. 1¾ in. and 3 in., c. 1900. Embossing painted for photographing.

Miscellaneous selection of Chinese medicine bottles; third and fourth from left are opium bottles; fifth, sixth, and seventh are cobalt-blue, some have embossed Chinese markings on the side; range in size from 2 to 4 in.; c. 1870–1900.

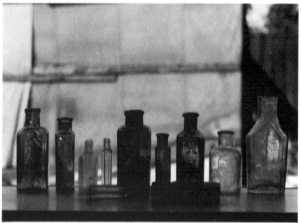

Above: Early photograph of the seven Sutherland sisters, whose hair totaled thirty-seven feet in length. It was from this photograph that the trademark photograph (right) for the Seven Sutherland Sisters' Hair Grower was taken. Note that in addition to eliminating their farmhouse living room background, the trademark photograph was retouched to make the sisters appear to have more hair than they actually had.

Oil painting of Isabella Sutherland with her six feet of auburn hair. This life-size oil painting hung on the wall of the stairwell of the Sutherland sisters' fourteen-room mansion near Lockport, New York. (John C. Fountain, Amador City, Cal.)

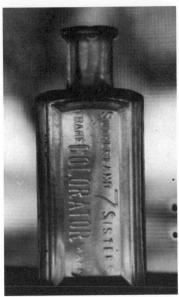

Medicine bottle, light aqua, embossed "SUTHERLAND 7 SISTERS/ TRADE COLORATOR MARK," H. 4½ in., c. 1900.

Medicine bottles of white milk glass (left to right): (1) embossed "PROF. I. HUBERT'S MALVINA LOTION, TOLEDO OHIO" on side, H. 5 in.; (2) embossed "E. S. REED'S SONS APOTHECARY, ATLANTIC CITY, N.J." on side, H. 6¾ in.; (3) embossed "SANITOL FOR THE TEETH" on side, H. 6 in., c. 1880–1910.

Medicine bottles, amber, embossed "FREDERICK STEARNS & CO. DETROIT, MICH," H. 4½ in. and 10 in., c. 1890–1910. Embossing painted for photographing.

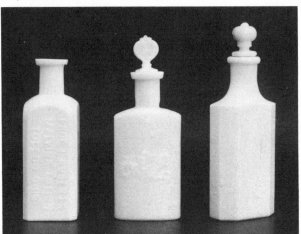

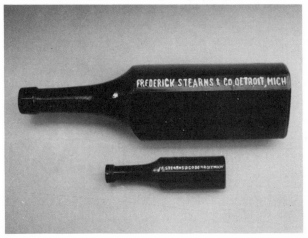

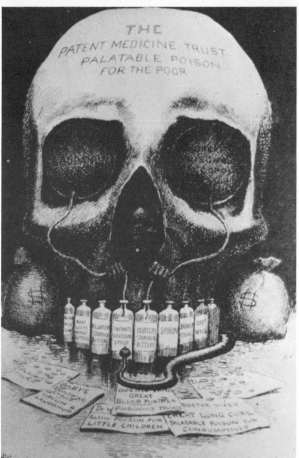

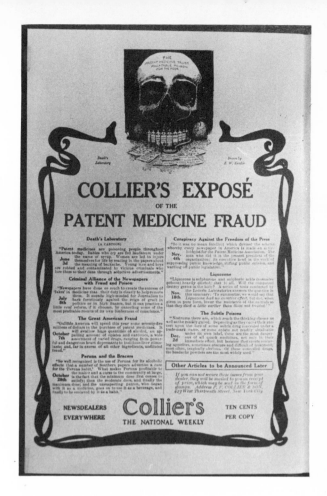

Left: "Death's Laboratory" drawn by E. W. Kemble. It was this cartoon that launched the famous 1905–1906 *Collier's* series "The Great American Fraud" by Samuel Hopkins Adams which resulted in the Pure Food and Drug Act of 1906. *Right:* Poster used by *Collier's* magazine late in 1905 to advertise their exposé of the patent-medicine industry.

Medicine bottle, "TIPPECANOE," amber, log shape with canoe embossed on one side, H. 9 in., c. 1907–1910. (Dr. Burton Spiller, Rochester, N.Y.) Photo by the Museum of Arts and Sciences, Rochester, N. Y.

Proprietary medicine bottle, amber, embossed with a safe and the words "WARNER'S SAFE KIDNEY & LIVER CURE, ROCHESTER, N.Y." on one side, H. 9½ in., c. 1900.

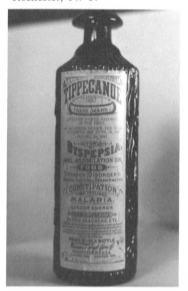

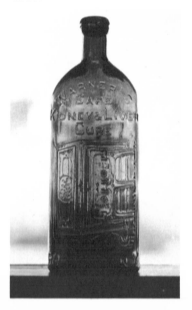

16

Snuff and

Snuff Jars

Snuff is a powder made from tobacco and is either inhaled through the nose or chewed. There are two basic types of snuff, moist and dry. Moist snuff is called *rappee* and dry snuff is known as *sweet*. Rappee is subjected to two processes of fermentation (heat and moisture) whereby aroma and strength are acquired and much of the nicotine and organic acids are removed. Sweet snuff is commonly adulterated with quicklime which gives it a biting and dry effect. Snuffs are usually scented with musk, essences of bergamot, lavender, attar of roses, tonka beans, cloves, orange flowers, jasmine, and other scents.

Tobacco was first discovered in the New World by Romano Pane, a Franciscan friar, who accompanied Columbus on his second voyage to America in 1493. Pane observed the Indians smoking and snuffing; he took some tobacco back to his native Portugal. Once tobacco had been introduced to Europe its use spread rapidly; nation after nation took up either smoking or snuffing. Most European countries took up snuff first and smoking later.

Jean Nicot, of Nîmes, France, took it from Portugal to his country and his name was given to the most widely used species: *Nicotinia tabacum*. The term *nicotine* comes from his name. It was in France that doctors first began to exploit tobacco as a medicine and claimed its use would cure many ailments. Soon physicians all over Europe were using tobacco as a medicine.

By 1575 tobacco was not only known in almost all countries in the world but was extremely popular in most. Popes and kings issued decrees for and against the use of tobacco; its popularity continued. In England, by the seventeenth century, women as well as men had taken to smoking and before long children were being taught how to smoke by their elders. Smoking houses, where pipes and tobacco were provided for patrons, were as common in London as were taverns.

Snuff-taking in England and America began in earnest in the eighteenth century. Snuffing became an art; a pinch of snuff was delicately taken from the container between the thumb and forefinger, and inhaled through a tube especially made for the purpose from a quill.

The containers for snuff were many and varied. Pockets, bags, pouches, mulls, bottles, and boxes were all used. Snuff bottles, at first, were not uncommon in Europe. In Norway, for example, bottles were made of wood, bone, horn, amber,

ivory, silver, and other metals. The word "mull" comes from Scotland and is pronounced "mill." A mull is an implement used not only for containing snuff but also for pulverizing it. It was the snuff box that finally dominated and became the popular snuff container of Europe.

Of interest to the collector of bottles are the glass and pottery jars used to get the snuff from the manufacturer to the consumer. In both Europe and America glass and pottery jars were most popular in the shipment of snuff in bulk. While the glass jars were used for relatively small amounts of snuff the pottery jars were primarily used for larger amounts (see Chapter 26). Glass jars were almost always free-blown and square, the result of paddling while the glass was hot. These glass jars or bottles are by tradition usually made in dark green or amber glass and most are about four inches high. Snuff bottles used a cork closure sealed over with wax to insure freshness of the snuff. Almost all glasshouses in America and Europe made these small square bottles. Because they were free-blown, no two are ever alike.

In the late 1800s when the use of molds became popular snuff bottles became more uniform in construction. Although some firms had bottles embossed with their names, the majority utilized plain bottles with elaborate paper labels.

From around the turn of the century to the present most snuff has been sold in square amber bottles about four inches high. These bottles come with a series of raised dots on their bottom. The number of dots, it has been said, is indicative of the strength of the bottle's contents. It has not been possible to verify this information.

Free-blown snuff jars are not easy to obtain because they have been gathered for years as excellent examples of early American and European glass. Their scarcity can also be partially attributed to the fact that they were usually thrown away after use.

While the later mold-blown snuff containers usually sell for between $1 and $5 the earlier free-blown specimens range in price from $20 to $60.

The collector who specializes in snuff jars can find a number of related items to include in his collection. Because snuff is tobacco, related items could range from the beautiful wooden cigar store Indians to tin boxes (see Chapter 60). Early advertisements are popular with snuff jar collectors as well (see Chapter 56).

Bibliography

BOOKS

Curtis, Mattoon M. *The Story of Snuff and Snuff Boxes.* New York: Liveright Publishing Co., 1935.

McCausland, Hugh. *Snuff and Snuff Boxes.* London: The Batchworth Press, 1951.

Robert, Joseph C. *The Story of Tobacco in America.* New York: Alfred A. Knopf, Inc., 1949.

PERIODICALS

Hausam, J. A. "Notes on Snuff Boxes and Snuff Bottles," *Hobbies,* LV (October, 1950), 99.

"Snuff Bottle Garden," *Hobbies,* LIX (March, 1954), 99.

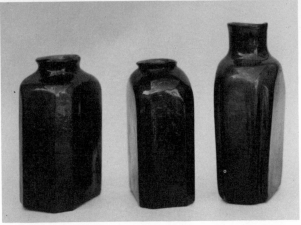

Snuff bottles (left to right): (1) olive-amber, H. 4⅛ in.; (2) amber, H. 4 in.; (3) amber, H. 5¼ in.; c. 1840–1860. *Right:* bases of the above snuff bottles.

Snuff bottles (left to right): (1) olive-brown, H. 4⅛ in.; (2) green, H. 4⅛ in.; (3) light amber, H. 4 in.; c. 1867.

Snuff bottles (left to right): (1) olive-green, H. 4½ in.; c. 1850–1860; (2) olive-green, H. 4 in.; c. 1840–1860; (3) olive-green, H. 4⅝ in.; c. 1850–1860. (Charles B. Gardner, New London, Conn.)

Snuff bottle, pottery, white, debossed "COPENHAGEN SNUFF, PITTSBURGH, PA.," H. 6 in., c. 1870–1900.

Snuff bottles (left to right): (1) olive-amber, H. 4¾ in.; (2) green, H. 4⅛ in.; (3) amber, rough pontil scar, flask shape, H. 5¼ in.; (4) yellow, rough pontil scar, H. 4 in.; c. 1840–1870.

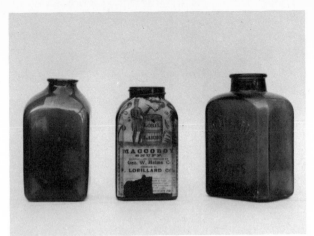

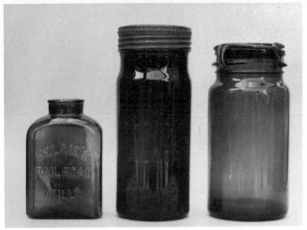

Snuff bottles (left to right): (1) olive-amber, rough pontil scar, H. 4¾ in.; (2) amber, paper label reads in part "Maccoboy Snuff manufactured and for sale for Geo. H. Helme Co., successor to P. Lorillard Co.," metal screw top (not pictured), H. 4½ in.; (3) amber, embossed "LORIL-LARD'S SNUFF" on side, H. 4¾ in., c. 1850–1900.

Snuff bottles (left to right): (1) amber, embossed "HELME'S RAILROAD MILLS" on side, H. 4¾ in.; (2) dark amber, embossed "HELME'S RAILROAD MILLS" on side, P. Lorillard Co., metal screw lid, H. 7½ in.; (3) amber, embossed "GEO. W. HELME CO., N.Y." and "PAT. 7–16–1872" on glass top, H. 6¾ in.; c. 1880–1900.

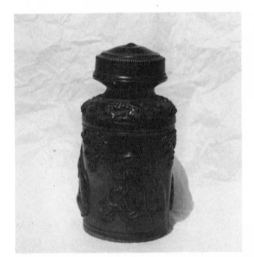

Ceramic snuff bottle, brown, Oriental figures using snuff embossed on all sides, metal screw lid over inner sealing lid, H. 8 in., c. 1890.

Snuff bottles (left to right): (1) amber, paper label reads in part "Lorillard, Maccoboy Snuff, Tobacco by Helme Products, Inc.," H. 5¾ in.; (2) aqua, paper label reads in part "Dr. Marshall's Catarrh Snuff," H. 3½ in.; (3) amber, paper label reads in part "Railroad Mills, Rose Scented, Maccoboy Snuff, Manufactured by Geo. W. Helme Co.," H. 2¾ in.; c. 1890–1910.

Snuff bottles (left to right): (1) amber, H. 3¾ in.; (2) yellow-amber, H. 4 in.; c. 1870–1880.

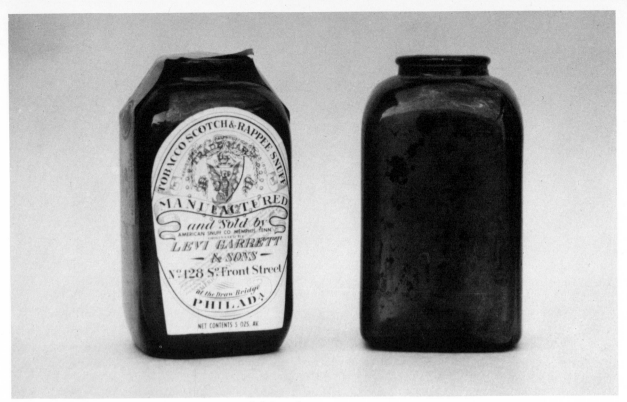

Snuff bottles (left to right): (1) amber, paper label reads in part "Manufactured and Sold by Levi Garrett & Sons, No. 128 So. Front Street . . . Philada.," H. 4 in., c. 1960; (2) amber, H. 4 in.; c. 1900.

Base of snuff bottle showing five embossed dots which probably indicate the strength of the snuff contained in the bottle.

17

Chinese Snuff Bottles

The fashion of taking snuff started in China at about the same time it started in Europe, i.e., circa 1550. Tobacco itself was brought to China from Europe by the Portuguese in 1537. During the period of adaptation, makeshift containers were used by the Chinese. They utilized medicine bottles, perfume bottles, and miniature vases to contain the fine powder.

By coincidence, the great period of the Chinese snuff bottle corresponds with that of the Manchu, or Ch'ing, Dynasty (1644 to 1912). The oldest known Chinese snuff bottle is dated 1646.

That snuff taking seems to have been a dainty act is evidenced by the fact that most Chinese snuff bottles came equipped with a tight stopper and an attached tiny spoon of ivory, silver, or tortoiseshell. The spoon was sometimes shaped like a tiny hand and was used to transfer a bit of snuff to the thumbnail, to be snuffed up the nose. Most Chinese snuff bottles carried on the person are only two to three inches in height while larger table-type bottles were used in the home.

Since it has always been an Oriental trait to make of an object of use a thing of beauty, it is not surprising to find that almost all Chinese snuff bottles are truly works of art. These bottles have been made of many materials which can be classified into five basic groups, according to Lilla S. Perry in her book, *Chinese Snuff Bottles:*

Glass

1. Monochrome, plain or carved
2. Painted, outside or inside
3. Cameo or overlay
4. Mottled
5. Imitations of many other materials

Ceramic

1. Porcelain: monochrome
2. Porcelain: underglaze decoration
3. Porcelain: overglaze decoration
4. Porcelain: molded or carved design
5. Pottery: stoneware, and so forth

Stone

1. Jade: nephrite, jadeite
2. Quartz—crystalline: rock crystal, rose quartz, amethyst, smoky crystal, hair crystal
3. Quartz—cryptocrystalline or chalcedony: agate, carnelian, jasper, moss agate, sard, sardonyx, onyx
4. Semiprecious stones: aquamarine, beryl, fluorite, lapis lazuli, malachite, steatite, serpentine, tourmaline, turquoise, ruby, and so forth

Organic materials

1. Amber
2. Coral
3. Horn
4. Ivory
5. Jet
6. Mother-of-pearl
7. Tortoiseshell
8. Bamboo
9. Wood
10. Lacquer in various types

Miscellaneous

1. Enamel
2. Metal in various types

Of all Chinese snuff bottles, perhaps glass ones are the easiest and most inexpensive to obtain. Glass was one of the most popular materials used in the manufacturing of Chinese snuff bottles. Glass overlay types are probably the most easy of the glass type to acquire. It is not uncommon to

find Chinese snuff bottles carved from as many as seven layers of glass, each one a different color. Another type of glass very popular in Chinese snuff bottles is mottled, of a variety of colors. Some bottles have paintings between the layers of glass.

In ceramic, porcelain is the predominant type found. The study of Chinese porcelain in itself is a lifetime project, for there are many types and techniques. Examining a grouping of porcelain snuff bottles from China usually reveals specimens that have been painted, enameled, overglazed and underglazed, carved, molded, incised, and reticulated. Among the many monochrome glazes there would be examples of crackles, soufflés, flambés, blanc de chines, mirror blacks, clair de lunes, and peach blooms. Because of advances made in ceramics, especially the area of porcelain, reproductions are common. It would be wise to have porcelain bottles examined by an expert before making a purchase; almost every city has at least one antique dealer who is an expert on Oriental antiques.

Stone snuff bottles from China are quite fascinating. Quartz is certainly a common mineral but when transformed from its natural state into a snuff bottle through numerous hours of effort by a Chinese artist, it becomes a thing of beauty. Carving is the predominant method of creating a snuff bottle out of stone. Jade is among the most popular stones from which the Chinese made snuff bottles. It is found in almost every color of the rainbow, and it is usually the colors that attract the specialist in jade snuff bottles.

Organic materials are many and varied; as with the stone bottles, most bottles made from organic materials are carved. Perhaps the most fascinating are those made of hornbill ivory. The helmeted hornbill, from whose bill such bottles are made, is said to be one of the ugliest of birds. There are sixty varieties of hornbills but only the bill of the helmeted variety is known to have been used for Chinese snuff bottles. Bottles made of this substance are extremely rare.

In the miscellaneous category are found mostly bottles made of a variety of metals, including gold and silver. Another important type is the enameled bottles; particularly beautiful are those called cloisonné. These are made with narrow bands or ribbons of metal, soldered edgewise to the base in such a way as to cover the surface with shallow cells called cloisons. The cloisons are filled with powdered enamel and fired.

For the collector of Chinese snuff bottles there is not much literature available. However the previously mentioned *Chinese Snuff Bottles* by Lilla S. Perry provides much specific information. There is, for example, a complete breakdown of the emperors of the Manchu Dynasty, the great period of the snuff bottle in China, and a discussion of the ideograms and seal marks of each emperor which are, of course, quite valuable in identifying these ancient Chinese containers. There is also a very lengthy and complete discussion of how to tell the various types apart.

The collecting of Chinese snuff bottles has been, throughout the years, a relatively unorganized part of bottle collecting that has been carried on mostly at the individual level. Surprisingly these bottles are comparatively inexpensive and range in price from $25 to $300 for the most part. There are specimens that command as much as $1000, but these are so seldom placed on the market that the average collector need not concern himself with them.

It is interesting that Chinese snuff bottles, which are truly some of the most beautiful ever created, have captured the eye of so few bottle collectors. Perhaps the explanation lies in the fact that it takes many hours of patient research to learn enough about Oriental history, culture, and art techniques to become a confident collector of these historic bottles.

China was the only country to use snuff bottles extensively. In other countries where snuff was popular, boxes were the popular containers.

Bibliography

BOOKS
Hitt, Henry C. *Old Chinese Snuff Bottles*. Bremerton, Washington: privately published, 1945.
Perry, Lilla S. *Chinese Snuff Bottles*. Rutland, Vermont, and Tokyo, Japan: Charles E. Tuttle Co., 1960.

PERIODICALS
Huggins, Mabel Irene. "Monkey in Chinese Art," *The Antiques Journal,* XXIV (February, 1969), 10–12.
Winnie, Thelma. "Snuff Bottles," *Western Collector,* III (November, 1965), 6–7.

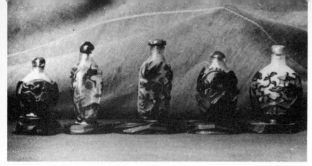

Snuff bottles (left to right): (1) three layers of glass, bottle is clear, second layer dark blue, third layer of hydras in iridescent colors; (2) two layers of glass, bottle is clear, second layer blue showing a crane and a deer; (3) two layers of glass, bottle is blue, second layer red showing a bird and peonies; (4) two layers of glass, bottle is white, second layer red showing a flying carp; (5) two layers of glass, bottle is white, second layer is red showing a scene, ground stopper. (*Western Collector,* San Francisco, Cal.) Photo by Thelma Winnie.

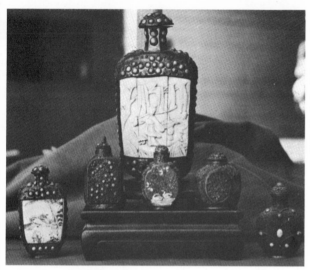

Snuff bottles, all made of tutenag, a metal alloy of zinc, copper, nickel, and iron peculiar to China. The designs are of twisted wire and are not soldered (front row, left to right): (1) tutenag decorated with turquoise set in metal cups, an outdoor scene; (2) tutenag, twisted wire design with turquoise insets; (3) tutenag, painted lacquer figures outlined by twisted wire; (4) tutenag, center insert of carved cinnabar; (5) tutenag, Persian influence in shape, stones of carnelian and turquoise. *Rear:* insets of turquoise and carnelian, center panels are carved ivory. (Charles Schwab Collection; *Western Collector,* San Francisco, Cal.) Photo by Thelma Winnie.

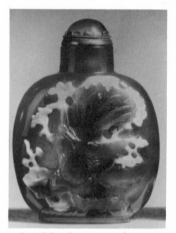

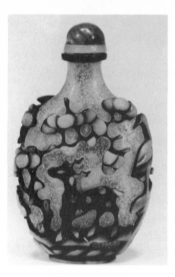

Snuff bottle, glass, opaque white with green cameo, gourd with vine, H. 2½ in., Ch'ing Dynasty, eighteenth or nineteenth century. (Seattle Art Museum, Eugene Fuller Memorial Collection)

Snuff bottle, glass, opaque white with black and white cameo, deer under prunus tree, H. 2¾ in., Ch'ing Dynasty, eighteenth or nineteenth century. (Seattle Art Museum, Eugene Fuller Memorial Collection)

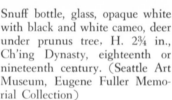

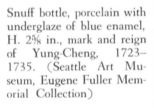

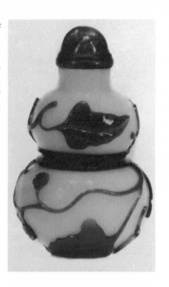

Snuff bottle, agate, phoenix under prunus tree, H. 2½ in., late eighteenth century. (Seattle Art Museum, Eugene Fuller Memorial Collection)

Snuff bottle, agate (jasper), grasshopper and cabbage top, H. 2½ in., late eighteenth century. (Seattle Art Museum, Eugene Fuller Memorial Collection)

Snuff bottle, porcelain with underglaze of blue enamel, H. 2⅝ in., mark and reign of Yung-Cheng, 1723–1735. (Seattle Art Museum, Eugene Fuller Memorial Collection)

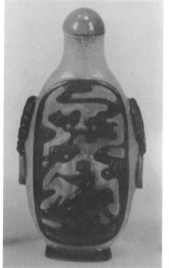

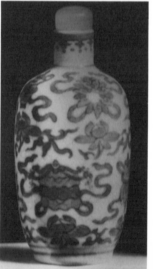

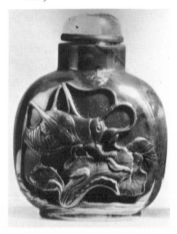

Snuff bottle, glass, white camphor with red cameo, man and ox under pine tree, H. 3½ in., Ch'ing Dynasty, eighteenth or nineteenth century. (Seattle Art Museum, Eugene Fuller Memorial Collection)

18

Case Bottles

Gin and its glass containers are not as aged as many collectors think. This is not to say that gin bottles are not old but rather that they are not as ancient as they might appear.

A study of the history of gin will serve as a basis for dating the earliest of gin bottles. Gin was discovered by accident in the mid-1600s by Francisco de la Boe (1614–1672), a professor of medicine at the University of Leyden in Holland. Gin is a liquor distilled from malt, barley, or rye and flavored with juniper berries or coriander seeds or angelica root. It was with the above ingredients that Professor de la Boe was experimenting, trying to perfect a diuretic to promote kidney function, when he unknowingly created what is known today as gin.

At first gin was dispensed as a medicine in apothecary shops but soon became so popular that many apothecaries switched to distilling it full time. They were, of course, soon joined by other distillers as gin gained in popularity. Gin is very inexpensive to make, and therefore it can be sold cheaply; this fact made gin a favorite drink of the lower classes, including the common soldier. It was the soldier returning from wars on the Continent who introduced gin to England. The English people readily accepted the new beverage and within a short time it had become almost the national drink. William of Orange (William III of England) introduced gin to the English nobility and it was immediately accepted at court.

By the mid-1700s Englishmen, especially the lower classes, were consuming so much gin that King George II became worried about his people; in order to reduce its use he imposed a heavy tax on the liquor. Instead of reducing consumption King George merely forced the people to find a way of avoiding the tax. Gin went back to the apothecary shops where it was originally dispensed. Gin with bitter flavoring added took on the guise of a medicine called bitters (see Chapter 22).

By the end of the eighteenth century gin had become a popular drink in most of Europe; the Dutch alone were producing an estimated fourteen million gallons annually.

The first names given to gin were *geneva* or *genever* which were Dutch alterations of *genièvre,* a French word for juniper. It was the English who shortened the word to "gin."

Containers for gin have been many and varied over the centuries. A variety of stoneware bottles were used as were many cylindrical glass bottles, but the most predominant of all gin containers has been square-bodied case bottles. The term "case bottle" originally referred to an octagonal bottle, not the tapered Dutch gin bottle as we know it today.

During the seventeenth and eighteenth centuries case bottles were used extensively by chemists and apothecaries; since gin was originally dispensed as a medicine it is safe to assume that from its inception it was distributed in case bottles. Case bottles of the seventeenth century differ little from those of the eighteenth and nineteenth centuries but the earlier examples were almost straight-sided, whereas the later type were more tapered.

It is difficult to differentiate between Dutch, English, and American specimens because English and American glasshouses made use of Dutch craftsmen, and vice versa. There are similar problems when dating is attempted. Unlike wine bottles the glass seals occasionally found on case bottles are seldom dated, since gin does not need aging. Very general dating can be accomplished, however, by noting crudeness, color, and deterioration of the glass. At best these methods are approximate, for flaws were quite common; colors

were generally light olive-amber, green, or black; and impurities in the basic glass mixtures varied, causing deterioration at different rates, so that precise dating is impossible by these means.

Perhaps a better dating method is to study construction. From around the beginning of the seventeenth century the flared mouth was predominant on case bottles. The flare was created by severing the neck from the blowpipe and widening it at the top with the aid of an appropriate tool; the lip was then fire polished.

Later types featured an applied collar; after severing from the blowpipe a separate piece of glass was added around the neck of the bottle and developed into a finished lip. There is little difference in the two collars except that one was developed from the neck while the other was developed from additional glass added to the neck. The neck lengths seem to be associated with manufacturing dates; the earliest case bottles have short necks while the later types have extended necks.

A third type of gin bottle which closely resembles the two flared mouth containers of the seventeenth, eighteenth, and nineteenth centuries is the sloping collared case bottles which are mostly from the nineteenth century.

Except for the slight variation of mouth formations most case bottles have the same basic shape already discussed. Case bottles blown before the mid-1800s approximately have scars on their base left by the breaking off of the pontil rod.

The earliest specimens of case bottles were obviously free-blown and squared by pressing with a wooden paddle, while later types (eighteenth and nineteenth century) were blown in dip molds. As two- and three-part molds became popular case bottles became less individualistic and more uniform in construction. Also during the latter part of the nineteenth century plate molds were used in the manufacturing of case bottles. With this improvement came a variety of embossments.

Another unusual case bottle is the expanded mouth or *wide mouth rum*. It is doubtful if this container was really used for rum; it seems more likely that it would have been utilized for things requiring a wide mouth container such as pickles, snuff, or powdered jalap (used as a purgative). The mouths of these containers range from two to three inches in diameter.

Some distillers adhering to tradition still sell gin today in case type bottles but these are of little interest to the collector at the present time. Some of these newer bottles have screw cap closures but some still romantically cling to the cork closure. Careful examination of such bottles will reveal their age; they are usually made by the automatic blowing machine and can be identified by the resulting mold markings.

The most outstanding feature of early case bottles is their traditional shape and crudeness. While there is little variation in shape, these bottles were made in a wide range of sizes from less than a half-pint to several gallons; the half-gallon size was usually about ten inches in height.

Although case bottles were made in dark colors (olive-amber) for the most part, they are occasionally located in light amber, light olive-amber, clear glass, and at least one example has been found in milk glass. Unusual colors, age, and crudeness all affect the prices of these containers. Prices for the seventeenth- and eighteenth-century specimens usually range between $75 and $200, while nineteenth-century examples generally sell for $25 to $100.

Embossments were numerous on the late nineteenth-century bottles. In addition to a range of lettering usually identifying the company whose product the bottle contained there were many figures and designs such as people, animals, birds, stars, and crests. These embossments affect the pricing, and highly embossed case bottles are, of course, considered more valuable.

Bibliography

BOOKS

Beare, Nikki. *Bottle Bonanza*. Florida: Hurricane House Publishers, Inc., 1965, pp. 62–64.

PERIODICALS

Shafer, James F., II. "Sealed in Glass," *Western Collector*, VII (March, 1969), 139–143.

————. ". . . in Half, Full, Two and Three Gallon Sizes," *Western Collector*, VII (March, 1970), 38–43.

Case bottle, transparent olive-green, expanded mouth, H. approx. 9½ in., early nineteenth century. (Ansted Collection) Photo by James F. Shafer II, Miami, Fla.

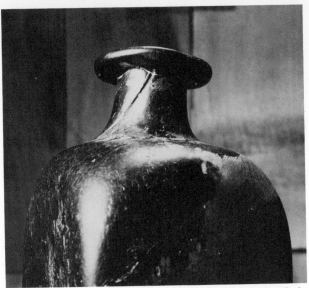

Top half of case bottle illustrating flared mouth, dark olive-amber, extended neck, seventeenth or eighteenth century. (James F. Shafer II, Miami, Fla.)

Bottoms of case bottles featuring crude and rough blowpipe pontil scars. (James F. Shafer II, Miami, Fla.)

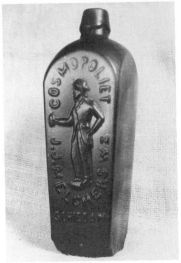

Case bottle, black, heavily embossed, H. approx. 10 in., late nineteenth century. (Hearin Collection) Photo by James F. Shafer II, Miami, Fla.)

Case bottle, dark olive-amber, applied sloping collar, late nineteenth century. (James F. Shafer II, Miami, Fla.)

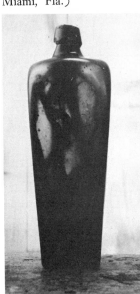

Case bottles, olive-green, applied lips (left to right): (1) embossed "A. C. A. NOLET SCHIEDAM" on side, H. 9¼ in.; (2) embossed "BOLL & DUNLOP ROTTERDAM HOLLAND" on side, H. 9½ in.; late nineteenth century. Embossing painted for photographing. (John C. Fountain, Amador City, Cal.)

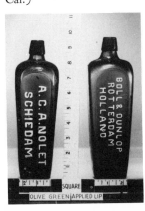

Case bottles, olive-green, unembossed, blown in a mold, sloping collars, H. 10½ in. and 9½ in., c. 1880. (John C. Fountain, Amador City, Cal.)

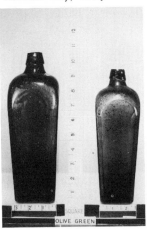

Case bottle, embossed "A VAN HOBOKEN & CO. ROTTERDAM" on side, olive-amber, applied seal, H. 11¹⁄₁₆ in., c. 1870.

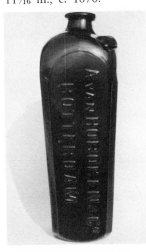

19

Historical and Pictorial Flasks

The category of historical and pictorial flasks is one of the richest in variety of decorations, design, and color, of the mold-blown American bottles. The historical flasks have more of a background of national tradition and historical significance than any other type of bottle. During the first half of the nineteenth century these bottles, in which whiskey was sold, were one of the sales promotional items that enjoyed great popularity. They were sold by various glasshouses to distillers who used them to distribute their product.

These interesting vessels have been, by common usage, separated into two groups according to their principal subjects or decorative motifs. Those with embossments of portraits of national heroes, presidents, or other personages; those with emblems and symbols of our sovereignty, of political parties, or societies; those with inscriptions related to the various subjects, famous sayings, or popular slogans of the period are classified as *historical* flasks while those bearing purely decorative motifs are classified as *pictorial* flasks.

Historical and pictorial flasks first appeared around the turn of the nineteenth century. One of the earliest flasks known is marked "JARED SPENCER" on one side and "MANCHESTER. CON." on the other; it holds a pint and is in light amber glass. This flask is attributed to the Pitkin Glass Works, which operated from about 1783 to 1830. At any rate, it was not many years before the historical and pictorial flasks replaced the earlier free-blown flasks, pattern-molded chestnuts (free-blown and flattened), and the Pitkins, none of which were ever uniform in capacity (see Chapter 5).

That these flasks were all well received by Americans of the period is evidenced by the vast numbers that have survived in comparison to other types of containers of that time still around today. It is quite possible that the development of the nineteenth-century glass industry was aided by the demand for these whiskey flasks; they were definitely an important and profitable product of large and small glass factories throughout New England, New York, New Jersey, Maryland, Virginia, what is now West Virginia, Pennsylvania, Ohio, and Kentucky. The great number of designs and the variations within specific designs would indicate not only how great in number were the bottles but also the keen competition between glass manufacturers and between whiskey distributors. By the mid-1820s these flasks were being produced by the thousands. For example, in 1825 the Philadelphia and Kensington Glass Works alone reported production of "36,000 Washington and Eagle pint flasks; 36,000 LaFayette and Eagle pint flasks; 36,000 Dyott and Franklin pint flasks; 25,000 Ship/Franklin and Agricultural pint flasks; 60,000 assorted Eagles, 'etc.'; 12,000 Common Ribbed flasks; and 48,000 Eagles [and] Cornucopia half pint flasks"; or a total of 253,000 historical flasks in one year. This number is further significant because in 1825 the popularity of historical and pictorial flasks was only just beginning to catch on. From the mid-1820s on, the production in numbers and variety of designs of these flasks grew by leaps and bounds, and their popularity continued through the 1870s. By 1840, approximately, almost every glasshouse in the country was blowing some type of historical and pictorial flask.

Prior to 1850 over four hundred different flasks

were made by the various glasshouses. From 1850 to the late 1870s another several hundred were added to the list. Like the free-blown and pattern-molded flasks these historical and pictorial flasks were predominantly of half-pint and pint sizes. Today's collections indicate that quart flasks were not made until about 1830 and that only about one variety in ten came in this size; the quart calabash (gourd-shaped) bottle appeared about 1850.

Some of the larger factories employed full-time mold makers and created their own designs. The small glass factories, on the other hand, purchased their molds, either in current patterns or made to order, from firms of mold makers. It is interesting to note that the older flasks (to about 1850) were superior in form and beauty of design to those produced from about 1850 to the 1870s.

The study of historical and pictorial flasks can reveal the political trend of the times. These flasks were designed for the common man of small resources and limited political privileges. They express the ardent nationalism that swept the country after the War of 1812.

Of the *pictorial* group (which is by far the smaller of the two) the most popular design was the scroll flask. These flasks were made over a period of many years by more glasshouses and have survived in more sizes (miniature to one gallon) than any other design. The cornucopia and sunburst were very popular on the earliest flasks; the sunburst pattern was used on over thirty different ones. The cornucopia or horn of plenty was also used on over thirty flasks.

In the *historical* group Masonic emblems and symbols appear on more than forty flasks. The reverse of the Masonic group usually has the embossment of the American eagle; these flasks were mostly made in New England and New York, which were strongholds of Masonry. With the story of an abduction of a prominent Mason named Morgan in western New York after he threatened to divulge the secrets of the order, flasks bearing Masonic emblems and symbols declined in popularity.

The emblems and symbols of the United States were used on flasks in varying degrees. The American flag is found on several flasks, as is Columbia, but the American eagle appears on more flasks than any other motif. It is found on well over one hundred.

At least two women and almost two dozen men were embossed on historical flasks. One of the women honored was Fanny Elssler, a famous ballet dancer of the 1840s. The other was Jenny Lind. Miss Lind was a very famous Swedish singer who was brought to the United States by showman P. T. Barnum (see Chapter 56) for a two-year tour (1850–1852). Jenny Lind's portrait appeared on over a dozen flasks, mostly of the calabash type.

Of the five presidents who were embossed on historical flasks (Washington, John Quincy Adams, Jackson, Harrison, and Taylor) George Washington was the most popular subject. Washington has been found on over sixty flasks which makes him second only to the American eagle in popularity. The flasks bearing the portraits of John Quincy Adams and Andrew Jackson are a result of a bitter campaign between the two in the 1820s. No doubt whiskey had been employed before and was later, but this was the first time in American politics the bottle containing whiskey was used as political propaganda. William Henry Harrison is found on only one flask, while Zachary Taylor is pictured on over two dozen.

Other celebrities who were "honored" by having their portraits appear on historical flasks include Benjamin Franklin, General Lafayette, Henry Clay, DeWitt Clinton, Major Samuel Ringgold, and Louis Kossuth. There were others pictured on flasks, some of whom cannot be identified. Thomas W. Dyott, patent medicine vendor and glassmaker (see chapters 5 and 15), honored himself on several flasks.

Other flasks of note made during the first half of the nineteenth century include "Success to the Railroad." The majority of these flasks have embossments of a horse and cart on rails; some were produced, however, with locomotives on them. Among the flasks embossed with ships are those bearing the steam frigate *Mississippi* and the frigate *Franklin*.

From 1850 to the 1870s there was a gradual but definite change in the shapes and decorative technique of historical and pictorial flasks. As already indicated, these later flasks were not as beautiful in design as their predecessors. The American eagle continued to be the most popular embossment but it seemed to lack the earlier vigor and expression. Portraits disappeared almost completely, as did many of the other elaborate designs of historical, political, and popular interest. Replacing these earlier types were some flasks simply inscribed with the name and location of the glassworks that made them and such decorations as the Union and clasped hands, the double eagle,

and Pikes Peak. Others of this period include one showing a girl riding a bicycle and singing "Not for Joe," a popular song; one with an anchor; one with the Star of David; and one with a soldier wearing a spiked helmet and carrying a gun.

Toward the close of the 1870s historical and pictorial flasks were rapidly losing their popularity and only an occasional new design appeared. One flask of interest that was produced before the turn of the century is the Bryan and Sewall flask. This flask was issued during the political campaign of 1896 and qualifies as a historical flask reminiscent of the period from 1820 to 1840. This flask bears the portrait of William J. Bryan and is inscribed "IN SILVER WE TRUST" and "BRYAN 1896 SEWALL"; it was made in amber glass.

Shortly after the turn of the century a few collectors began to seek out and save the historical and pictorial flasks of the past; their interest encouraged dealers in antiques to stock them. Partially because of these early bottle collectors and partially because other people retained these bottles there are many still in existence. Another reason for the large number of specimens still intact is that they were produced in tremendous quantities.

Some popular bottles have been reproduced early in this century and more recently. The early reproductions are in themselves collectors' items. One notable reproduction is the counterfeit Jenny Lind that was made in Haida, Czechoslovakia, in the early 1900s. Other Jenny Lind bottles have been made but are easily recognized by the smoke coming from the house on the reverse—the smoke is outlined with embossing while on the original the entire cloud of smoke appeared as a solid embossment. The recent reproductions of the Jenny Lind and numerous others are certainly collectible (see Part VI), but not as originals. One of the best methods of avoiding reproductions is to study the flasks in the McKearins' *American Glass* and their *Two Hundred Years of American Blown Glass*. Reproductions are often made in brilliant amethyst, blue, green, and amber; many of the original flasks were made in aqua and light green while some were olive-green and olive-amber. A few were made in blue and some in true green. Another method of identifying reproductions is by studying the glass itself to see if it is of the quality found in old bottles; also look for signs of wear on the base and other places that might be worn because of years of use.

The sizes of historical and pictorial flasks are generally half-pint and pint, with occasional quarts being found. Shapes vary somewhat but all flasks, by definition, are flat or almost so on the obverse and reverse (see *American Glass* for forty-one specific shape definitions). All flasks utilized a cork closure.

While some of the flasks can be classified as extremely rare most are listed as scarce. Popularity of these truly historic bottles in recent years has provided a market which is getting harder to satisfy. While there are, all things considered, a great number of these containers in existence they are mostly in collections and not on the market.

Prices of historical and pictorial flasks range from $30 to $300. Active interest throughout the years has helped to stabilize the price of these bottles. Prices are usually consistent with a slow but steady increase from year to year; this is a claim true only of a very few types of bottles.

Bibliography

BOOKS

McKearin, George S. and Helen. *American Glass.* New York: Crown Publishers, Inc., 1968.

McKearin, Helen and George S. *Two Hundred Years of American Blown Glass.* New York: Crown Publishers, Inc., 1950.

McMurray, Charles. *Collectors Guide of Flasks and Bottles.* Dayton, Ohio: 1927.

PERIODICALS

"American History in Bottles," *Collier's,* CXXVI (July 15, 1950), 50.

Decatur, S. "Masonic Emblems on Glass," *American Collector,* April, 1940, pp. 8–9.

Lewis, Doris M. "Historical Flasks," *Western Collector,* V (February, 1967), 38–40.

McGinley, A. "Pictorial Flasks for Campaign Publicity," *Hobbies,* LIV (June, 1949), 112.

Marsh, T. H. "Some Notes on Commemorative Bottles," *Hobbies,* LXVII (February, 1963), 86–87.

Perrot, P. N. "American Pictorial Flasks at the Corning Museum of Glass," *Antiques,* LXXVIII (September, 1960), 244–248.

White, H. H. "Seven Famous Bottles; Flasks of Historical Import," *Mentor,* XVI (January, 1929), 54–56.

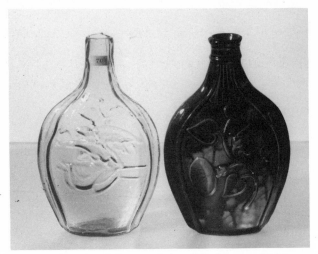

Historical flasks (left to right): (1) obverse, American eagle; reverse, morning glory and vine; aqua, pint, midwestern, early nineteenth century; (2) same as (1) except made in pottery. (Charles B. Gardner, New London, Conn.)

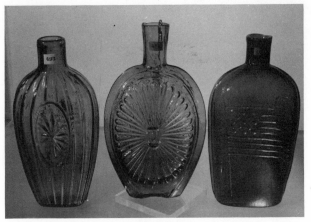

Pictorial flasks (left to right): (1) heavy vertical ribbing on all sides with sunken oval panel on front side which contains sunburst with twelve rays, green, half-pint, early nineteenth century; (2) large oval sunburst with thirty-six rays with five oval ornaments in center, yellow, pint, c. early nineteenth century; (3) obverse, American flag; reverse, embossed "NEW GRANITE GLASS WORKS, STODDARD, N.H."; amber, pint, c. early nineteenth century. (Charles B. Gardner, New London, Conn.)

Historical flasks (left to right): (1) obverse, Masonic archway with keystone in center; reverse, American eagle over an oval frame, embossed "H.S." (Henry Schoolcraft); olive-green, pint, Keene, early nineteenth century; (2) obverse, Masonic arch, pillars and pavement, no emblems above and at sides of arch and pillars, beehive beneath pavement at right; reverse, American eagle over plain oval frame; olive-green, pint, probably Keene, very rare, early nineteenth century. (Charles B. Gardner, New London, Conn.)

Historical flask, circular shape, concentric rings around oval medallion in center where an American eagle is placed, same design on both sides, green, quart, possibly Keene, early nineteenth century. (Charles B. Gardner, New London, Conn.)

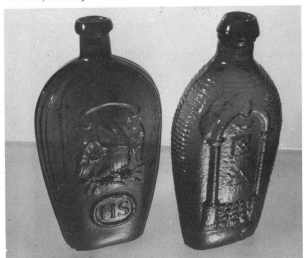

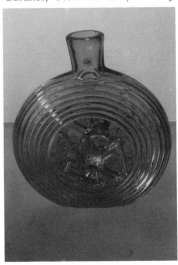

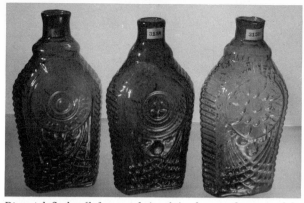

Pictorial flasks (left to right): (1) obverse, large medallion with inscription "JARED SPENCER:"; reverse, same as obverse with inscription "MANCHESTER, CON."; olive-green, pint, probably Pitkin, early nineteenth century; (2) same as (1) but with no inscription in medallion; (3) same as (1) and (2), no inscription; medallion, instead, contains eight pointed petals alternating with eight large pearls. (Charles B. Gardner, New London, Conn.)

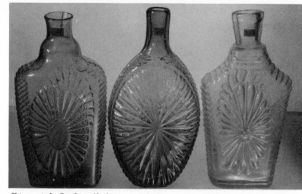

Pictorial flasks (left to right): (1) obverse and reverse, large elliptical sunburst, twenty-eight rays, plain oval center; pale green, pint, early nineteenth century; (2) obverse and reverse, large elliptical sunburst, sixteen rays converging at point in center; green, pint, early nineteenth century; (3) obverse and reverse, large elliptical sunburst, twenty-four round rays converging at petal-shaped ornament in center; clear, pint, early nineteenth century. (Charles B. Gardner, New London, Conn.)

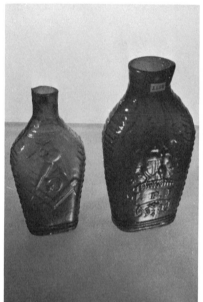

Historical flasks (left to right): (1) obverse, crossed keys beneath a five-pointed star; reverse, square and compasses enclosing a letter "G" that is reversed; olive-green, half-pint, early nineteenth century; (2) obverse, American eagle over an oval frame containing letters "J.P.F."; reverse, cornucopia coiled to left and filled with produce over the inscription "CONN."; olive-green, pint, probably Pitkin, early nineteenth century. (Charles B. Gardner, New London, Conn.)

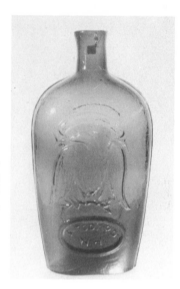

Historical flask: obverse, American eagle facing dexter and words "GRANITE GLASS CO." in oval frame; reverse, similar eagle as on obverse with words "STODARD, NH" in oval frame; olive-amber, quart, early nineteenth century. (Charles B. Gardner, New London, Conn.)

Historical flasks (left to right): (1) obverse, American eagle; reverse, scroll medallion; pale violet, pint, early to mid-nineteenth century; (2) obverse, American eagle; reverse, serpent grasped in eagle's beak; pale violet, pint, early to mid-nineteenth century. (Charles B. Gardner, New London, Conn.)

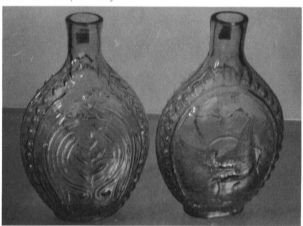

Pictorial flasks, scroll or violin shape, light aqua, quart and pint, rough pontil scars, c. 1840–1860.

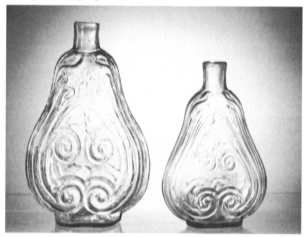

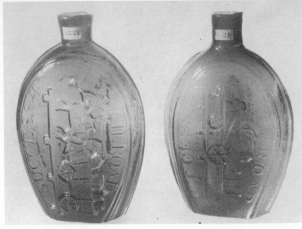

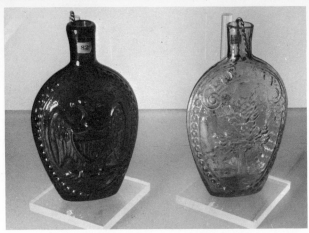

Historical flasks (left to right): (1) obverse, horse pulling cart; reverse, same; olive-green, pint, embossed "SUCCESS TO THE RAILROAD," early nineteenth century; (2) obverse, early crude locomotive on rails; reverse, same; olive-green, pint, embossed "SUCCESS TO THE RAILROAD," early to mid-nineteenth century. (Charles B. Gardner, New London, Conn.)

Historical flasks (left to right): (1) amber; obverse, American eagle; (2) green; reverse (of #1), tall tree with foliage (generally referred to as "Charter Oak") and word "LIBERTY" in frame over the tree; half-pint, mid-nineteenth century. (Charles B. Gardner, New London, Conn.)

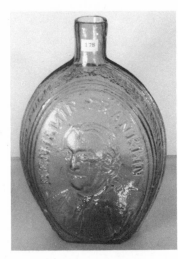

Historical flask; obverse, Benjamin Franklin in three-quarter profile facing left, and words "BENJAMIN FRANKLIN"; reverse, Thomas W. Dyott in three-quarter profile facing right and words "T. W. DYOTT, M.D." and "ERIPUIT COELO FULMEN. SCEPTRUM QUE TYRANNIS—KENSINGTON GLASS WORKS, PHILADELPHIA"; green, quart, mid-nineteenth century. (Charles B. Gardner, New London, Conn.)

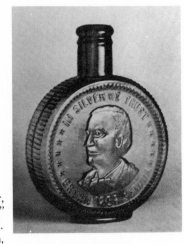

Historical flask, golden amber, embossed "IN SILVER WE TRUST" moves to reveal cork stopper, H. 7½ in., 1896. (John C. Fountain, Amador City, Cal.)

Historical flasks (left to right): (1) obverse, three-quarter profile of Benjamin Franklin, embossed "BENJAMIN FRANKLIN" in arch over profile; reverse, three-quarter profile of T. W. Dyott with words "WHEELING GLASS WORKS" embossed in arch over profile; green, pint, mid-nineteenth century; (2) obverse, three-quarter profile of Zachary Taylor, embossed "ROUGH & READY" in arch over bust; reverse, ten five-pointed stars over an American eagle; aqua, pint, mid-nineteenth century. (Charles B. Gardner, New London, Conn.)

Historical flasks (left to right): (1) obverse embossed "GENL. TAYLOR NEVER SURRENDERS" in arch over a cannon; reverse embossed "A LITTLE MORE GRAPE CAPT. BRAGG" surrounded with grapes on vine; green, half-pint, probably Baltimore Glass Works, mid-nineteenth century; (2) obverse, log cabin; reverse, American flag, words "HARD CIDER," and a barrel; blue, pint, mid-nineteenth century; (3) obverse embossed "GENL. TAYLOR NEVER SURRENDERS" in arch over a cannon; reverse, Baltimore Monument; green, half-pint, mid-nineteenth century. (Charles B. Gardner, New London, Conn.)

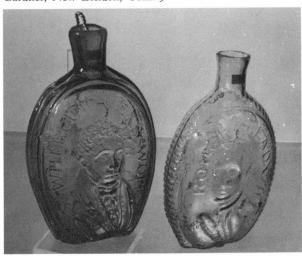

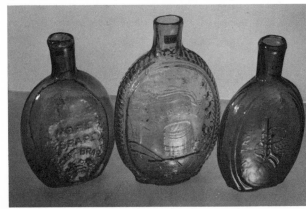

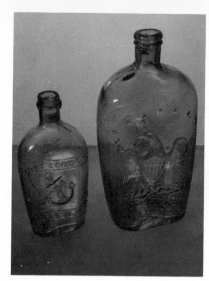

Historical flasks (left to right): (1) obverse, American eagle standing on a laurel wreath; reverse, anchor in diagonal position, with end of rope facing toward right and embossed "NEW LONDON" and "GLASS WORKS"; deep aqua, half-pint, mid-nineteenth century; (2) same as (1) except end of rope on anchor faces toward left, color is light green and size is quart, mid-nineteenth century. (Charles B. Gardner, New London, Conn.)

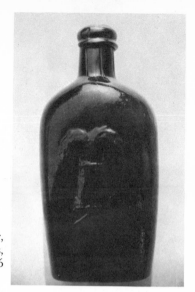

Pictorial flask, dark olive-amber, sheaf of wheat embossed on sides, crude pontil scar, H. approx. 6 in., mid-nineteenth century.

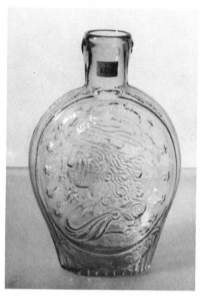

Historical flask; obverse, Columbia with Liberty Cap facing left; reverse, large American eagle and words "UNION CO.," "KENSINGTON"; pale yellow, half-pint, mid-nineteenth century. (Charles B. Gardner, New London, Conn.)

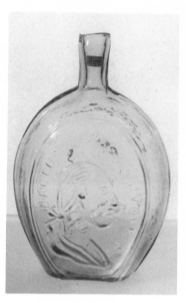

Historical flask; obverse, profile of George Washington facing right and words "BALTIMORE X GLASS WORKS"; reverse, profile of Henry Clay facing right; aqua, quart, early to mid-nineteenth century. (Charles B. Gardner, New London, Conn.)

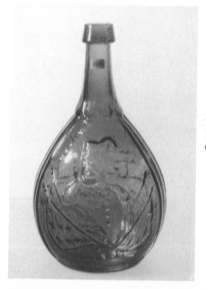

Historical flask; obverse, full-faced bust of Kossuth in uniform with high hat and plume and words "LOUIS KOSSUTH" in semi-circle over bust; reverse, large frigate sailing left and words "U.S. STEAM FRIGATE MISSISSIPPI, S. HUFFSEY"; yellow-green, quart, mid-nineteenth century. (Charles B. Gardner, New London, Conn.)

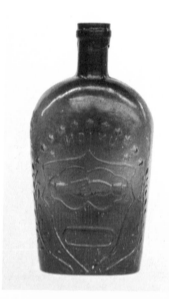

Historical flask, light amber, embossed "UNION" with clasped hands, H. approx. 6 in., mid-nineteenth century.

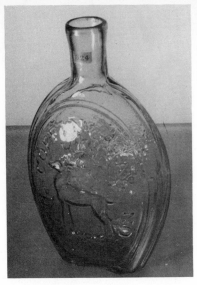

Historical flask; obverse, American eagle; reverse, stag and words "COFFIN & HAY" and "HAMMONTON"; aqua, pint, mid-nineteenth century. (Charles B. Gardner, New London, Conn.)

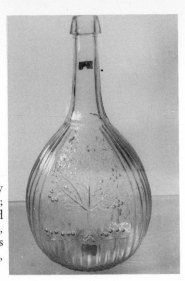

Historical flask; obverse, Jenny Lind and words "JENNY LIND"; reverse, tree with foliage and clusters of fruit; aqua, quart, mid-nineteenth century. (Charles B. Gardner, New London, Conn.)

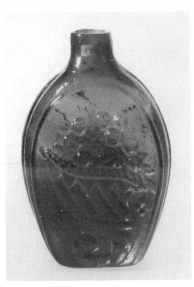

Historical flask; obverse, large American eagle; reverse, large cornucopia coiled to left and filled with produce; olive-green, pint, early to mid-nineteenth century. (Charles B. Gardner, New London, Conn.)

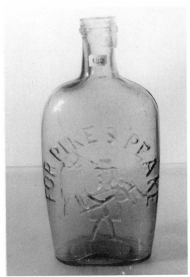

Historical flask; obverse, prospector, cane in hand, pack over shoulder, walking to left and words "FOR PIKE'S PEAK"; reverse, prospector facing left shooting deer; aqua, half-pint, mid-nineteenth century. (Charles B. Gardner, New London, Conn.)

Historical flasks (left to right): (1) obverse, three-quarter profile of Andrew Jackson with inscription "GENERAL JACKSON" in arch over head; reverse, American eagle over oval frame containing inscription "B & M"; amethyst, pint; (2) very similar to (1) except inscription in oval on reverse reads "J.R.," amethyst, pint, mid-nineteenth century. (Charles B. Gardner, New London, Conn.)

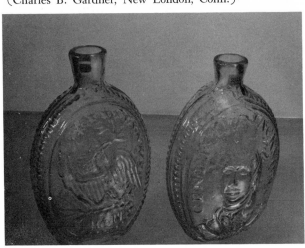

Historical flask; obverse, American eagle; reverse embossed "FARLEY & TAYLOR/RICHMOND, KY"; aqua, half-gallon, mid-nineteenth century. (Charles B. Gardner, New London, Conn.)

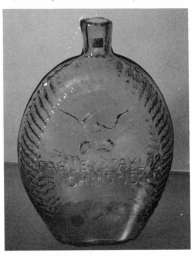

20

Figural Bottles

There is a popular parlor game based on the idea that all things in the world can be divided into three general categories: animal, vegetable, and mineral. A similar statement can be made in defining figural bottles, i.e., they are made in the shape of things: animal (including humans), vegetable, and mineral. At first reading, this statement may seem a bit broad but be assured that it is not; there is hardly any *thing* that has not, throughout container history, been characterized in a bottle shape.

Figural bottles are as old as ceramic and glass containers themselves. Ancient potters and glassmakers quite frequently made bottles in the shapes of things (see chapters 2 and 4) and many interesting specimens have been and are still being discovered by collectors.

Whereas many bottle collectors restrict themselves to the gathering of bottles of specific size, shape, color, or type (according to brand or product), the collector of figural bottles will insist that his collection be of bottles shaped like things animal, vegetable, or mineral. Consequently, the figural bottle collector will have specimens that would fit into collections of almost all of the specialties just mentioned. Because a figural bottle collection overlaps so many other specialties, figural bottles can be found in almost all chapters of this book, and the bottles included in this chapter could legitimately be included in chapters devoted to other specialties.

Because of the extensiveness of the field of figural bottles, it is not uncommon to find collectors who have devoted themselves to sub-specialties within the field—for example, someone may decide to collect only bottles shaped like people.

Otha D. Wearin, in his pioneering book dealing with figural bottles entitled *Statues That Pour,* speculates that the first figural bottle may have been a conch shell. He suggests that by sealing the mouth of such a shell and drilling a hole in the other end a fine container for liquids could be made. This is rather speculative but it at least allows the reasonable possibility that figural containers are as old as civilized man himself.

The production of these interesting bottles was limited in most areas of the world until the eighteenth century. During the 1700s figural bottles became relatively popular in Europe and America; their popularity has been steadily increasing ever since. From the mid-1950s until the present there has been a sudden surge in figural bottle production, especially in the area of ceramics.

Spirits and cosmetic manufacturers have been leaders in recognizing and catering to this trend; they have discovered that their products are more successfully merchandised in such containers (see Part VI).

Figural bottles of both ceramic and glass range from fractions of an ounce to a full gallon. Some of the smallest are the fragrance bottles and some of the largest are spirits containers.

Colors, both in ceramic and glass, are numerous. In ceramic figural bottles, glazes of all colors have always been employed. In glass specimens, all colors are represented, too. A ceramic container usually displays a variety of colors while glass containers generally are limited to one color.

Embossments seem to be of little importance to the figural bottle collector because of their preoccupation with shapes. It is important to point out that a heavily embossed bottle such as the classic wine bottle embossed with a monkey (see Chapter 14) is not considered to be a figural bottle. While the monkey is the predominant feature of the bottle and is embossed to appear as if he is clinging to the bottle, the container is basically of common wine bottle shape. For a bottle to qualify as a figural bottle, by definition, the *shape* of the bottle must be mostly figural in makeup.

Closures, like embossments, seem to be of little importance to the collector of figural bottles. The majority of figural bottles of the earlier types utilized the common cork closure and the more recent specimens come quite often with screw cap closures.

Partially because figural bottles are among the first containers ever made, the ancient and early specimens (see Chapter 4) are difficult to obtain and must be considered rare. There are also some contemporary figural bottles that can be considered rare because of limited production. Prices are very much related to rarity. Ancient and early bottles in the figural category do sell for as high as several thousand dollars, while the rarest of Jim Beam bottles (see Chapter 46) commands a price approaching $2000. Generally, however, figural bottles sell for prices of $1 to around $300, according to age and rarity.

While it does not seem practical to predict a tremendous growth in popularity for early figural bottles, it does for contemporary ones. Whether the almost certain growth in contemporary types will be a lasting thing depends on the collectors and manufacturers of such items. Marketing trends indicate that more and more manufacturers of liquid products are packing their wares in figural bottles.

Bibliography

BOOKS

Belknap, E. M. *Milk Glass*. New York: Crown Publishers, Inc., 1959.

Freeman, Larry. *Grand Old American Bottles*. Watkins Glen, New York: Century House, 1964.

Umberger, Jewel and Arthur. *Collectible Character Bottles*. Tyler, Texas: Corker Book Company, 1969.

Wearin, Otha D. *Statues That Pour*. Denver: Sage Books, 1965.

PERIODICALS

Bennett, Mrs. F. F. "Figure Bottles," *Hobbies*, LIV (October and November, 1949), 116 and 103.

Hansbrough, V. "There's History in Figure Bottles," *Hobbies*, LXII (January, 1958), 72–73.

Hubbard, Clarence T. "Bottle-ized Profiles," *Hobbies*, LXV (April, 1960), 70–72.

————. "Character Bottles in Demand," *Hobbies*, LII (June, 1947), 88.

————. "How Sweet It Is," *Western Collector*, IV (April, 1966), 27–29.

————. "Looking For Glamor? Glass Has It," *The Antiques Journal*, XXIV (January, 1969), 34–35.

————. "These Are Real Characters," *American Home*, LV (May, 1956), 32–33.

Lindsey, B. M. "Octopus Bottle, Mail Box Bottle," *Hobbies*, LIII (August, 1948), 92–93.

————. "Uncle Sam Bottle," *Hobbies*, LIII (September, 1948), 82.

Loomis, L. "Sandwich Glass Pomade Bears," *Old Glass*, September, 1938.

Mosoriak, P. "Whiskybury: Vest Pocket Flask in the Form of a Watch," *Hobbies*, LII (October, 1947), 40–41.

Nagel, J. D. "Figure Bottles," *Hobbies*, LVII (March, 1952), 78–81.

Peterson, A. G. "Columbus, World, and United States Bottles," *Hobbies*, LXVI (October, 1961), 72.

————. "Patented Cabin Bottles," *Hobbies*, LXVII (June, 1962), 68–69.

Figural bottle, fisherman, ceramic, yellow shirt, blue pants, black hat, brown boots, grey net, hat removes to reveal cork stopper, H. 12 in., debossed "GESETZL FESCH, 275, B & L" on base, mid-nineteenth century.

Figural bottles, French, ceramic, girl is yellow, blue, and rose, and boy is blue and lavender, "A.P." embossed on bottom of girl, cork closures behind hats, H. 10 in., c. 1800.

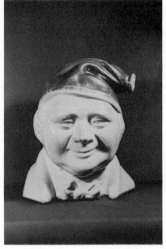

Figural bottle, ceramic, shape of a head, opening in end of cap, H. 8 in., an English cider jug, c. 1870–1900. (John C. Fountain, Amador City, Cal.)

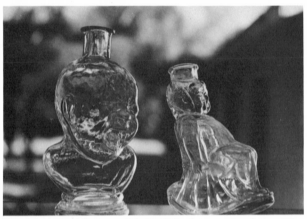

Figural bottles (left to right): (1) clear, crying baby, H. 6 in., embossed "PATENTED JUNE 2, 1874" on reverse; (2) clear, little girl in rocking chair, hair hangs down the back, chair rocks, H. 4½ in., c. 1875–1890. (John C. Fountain, Amador City, Cal.)

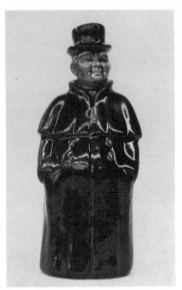

Figural bottle, coachman, ceramic, dark brown coat, black hat, tan face, H. 9¾ in., late 1800s.

Figural decanter, man in the moon, amber, cork stopper, metal spigot, L. approx. 10 in., c. 1880–1900. (Also made in milk glass.)

Figural bottle, amber, cigar shape, L. 5¼ in., c. 1890–1920.

Figural bottle, Statue of Liberty base, white milk glass, H. 10 in., ground top with metal cover (not pictured), a memorial bottle, c. 1884.

Figural bottle, opaque black glass, bear shape, H. 5 in., contained Bear Pomade, embossed "R. & G.A. WRIGHT, PHILADELPHIA" on bottom, c. 1870–1890. Presented to the Toledo Museum of Art by glassmaker Edward Drummond Libbey in 1917. (The Toledo Museum of Art, Toledo, O.)

Figural bottle, bust of Alleroe Galliano, late nineteenth-century Italian hero, embossed "ALLEROE GALLIANO—1897" on side, H. 6 in.

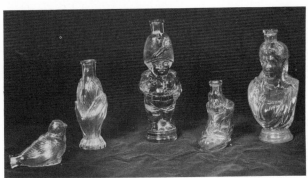

Figural cologne or scent bottles, clear (left to right): (1) robin, L. 2¾ in.; (2) hand holding a tulip bulb, H. 3½ in.; (3) Hessian soldier, H. 5 in.; (4) Puss-in-Boots, H. 2½ in.; (5) girl with long hair, H. 4¼ in.; c. 1880–1900. (Western Collector, San Francisco, Cal.)

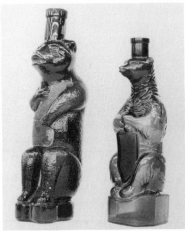

Figural bottles, bears sitting on hind legs (left to right): (1) dark amethyst, H. 10¾ in., held Russian kümmel, also made in amber and milk glass; (2) dark olive-amber, H. approx. 9 in., late nineteenth century.

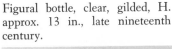

Figural bottle, clear, gilded, H. approx. 13 in., late nineteenth century.

Figural bottles (left to right): (1) frosted white, baby breaking out of a shell, head removes at neck to provide opening, H. 13 in., c. 1890; (2) Negro waiter, frosted, black head, white body, probably a wine bottle from France, H. 14 in., c. 1890. (John C. Fountain, Amador City, Cal.)

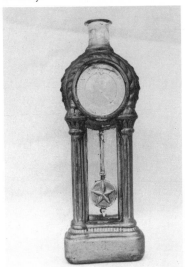

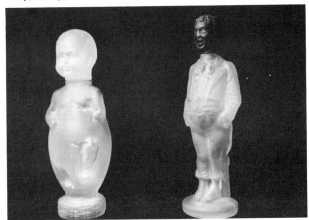

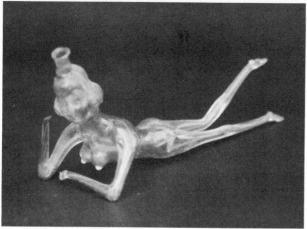

Figural bottle, nude female, cork closure, L. 5 in., H. 2¼ in.

Figural bottle, porcelain, hand painted, cork closure in top of head, H. approx. 3 in., probably made in Japan.

Figural perfume bottle, Bunker Hill monument, emerald green, H. 15 in., c. 1900.

Figural bottle, cloth-covered to resemble a monkey, head removes to reveal metal "shot-glass" closure, H. 7¾ in., c. 1910–1920. (John C. Fountain, Amador City, Cal.)

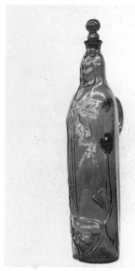

Figural bottle, Madonna, cobalt-blue, H. approx. 13 in., made in Mexico, c. 1930–1935. These bottles are still being produced today.

Figural bottle, violin, cobalt-blue, H. 8¼ in., c. 1920–1960.

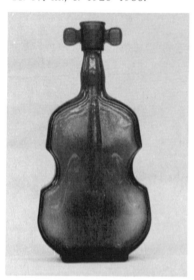

Figural bottle, poodle, cobalt-blue, metal screw lid, paper label (not shown) reads "Selig's Kennel Delight—A Dog's Delight—net contents 6 oz. Made by the Selig Co., Atlanta, Ga." H. 8 in., 1933.

Figural bottle, elephant, amber, embossed "OLD SOL" on top of head, cork closure, H. 10⅛ in., c. 1935.

Figural bottle, green, metal screw top, H. 5½ in., 1968.

Figural bottle, book, ceramic, black leather covering, embossed "MY BEST CELLAR" and "I.B. THIRSTY," ceramic-covered cork stopper, H. 7⅛ in., 1959.

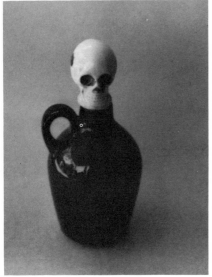

Figural bottle, ceramic, dark brown jug, white skull stopper, H. 6½ in., 1960.

Ceramic figural bottle made for the author by ceramicist K. D. Clothier of St. Petersburg, Florida, H. 13 in., hat with cork serves as closure, 1969. Typical of contemporary bottles that are being issued in limited quantities.

Mineral and Soda Water Bottles

This chapter tries to make an artificial separation between mineral water bottles and soda water bottles. The separation is hard to maintain because at one period mineral water and soda water were one and the same in many cases.

It would help to understand that *natural* mineral waters were often carbonated by nature and that when *artificial* carbonation was invented, terms became confused, i.e., there were natural mineral waters without carbonation, there were natural mineral waters with carbonation, there were artificially carbonated mineral waters, and there were artificially carbonated waters.

The division became clear when flavors were added to the artificially carbonated water. Water so treated can absolutely be identified as soda water.

MINERAL WATER BOTTLES

Natural mineral waters are those which have dissolved appreciable amounts of salts and, in some cases, gases from the rocks and soil of their underground course. History reveals that natural mineral waters were considered to have medicinal properties even in the earliest days of Greece and Rome. Greek physician Hippocrates, in 400 B.C., wrote a book on the subject entitled *Airs, Waters, and Places*. In 77 A.D., the great historian Pliny wrote about some of the mineral springs of Europe. As the Roman Empire expanded, many of the famous springs in Italy, Germany, Belgium, and England were discovered.

In Europe beginning in the late eighteenth century it became very fashionable to visit these "watering places." The wealthy gathered and either drank of the "healthful" waters or bathed in them.

In America, the spas were less elaborate but were nevertheless considered the most fashionable resorts in the land and a definite accessory to the social life of the times. In addition to a spring or springs these resorts featured parks, hotels, gambling, and horse racing. Only the very rich could afford to frequent these resorts, but there was a great demand by the average citizen for these "wonderful waters." As a result of this consumer demand, as early as 1767 the waters of Jackson's Spa in Boston were bottled and sold. About 1800 the waters of the mineral springs in Ballston near Albany, New York, were bottled commercially. In 1819 Thomas W. Dyott, "M.D.," of Philadelphia (who was destined to make bottle manufacturing history through his subsequent purchase of the famed Kensington Glass Works—see Chapter 5) advertised Congress Spring Water, "bottled and wired at the spa."

Some books credit Elie Maglorie Durand, a Philadelphia druggist, as being the first to bottle mineral water at his drugstore on the corner of 6th and Chestnut Streets in 1825. A search of the Philadelphia directories has revealed that there was no such person on record before 1828, when the directory lists an "Elias Durand, Apothecary & Druggist, S. W. Corner of Chestnut and 6th Streets." The claim of his being the first bottler can probably be discounted but Durand undoubtedly was one of the bottling pioneers.

It is probably practical to assume that plain bottles were used for the early bottlings of mineral water and that even if found today there would be no way of telling them from the other plain bottles of the period.

For the mineral water bottle collector the development of the Saratoga Springs in Saratoga County, New York, is of prime interest. As early as 1767 these springs were considered for development but it was not until 1783 that General Philip Schuyler opened a road to the springs. In that same year George Washington tried to purchase one of these springs but to no avail. It was a man named Gideon Putnam who finally got the springs opened to the public a few years after Schuyler had built the road. The first bottled water from Saratoga Springs was sold around 1820 by the Reverend D. O. Griswold, who sold the water under the name of Dr. Clarke.

The very beautiful dark olive-green or olive-amber embossed Saratoga bottles were first produced in 1844. In that year, because of a fuel shortage, the Mt. Vernon Glass Works of Oneida County, New York, closed and moved to Mt. Pleasant in Saratoga County to supply the Saratoga Springs with mineral water bottles.

By 1865 the glassworks at Mt. Pleasant was sold to the Congress and Empire Spring Company and was moved to Saratoga Springs. Because it was located in a section of town called Congressville it was called the Congressville Glass House. The embossed mineral water bottles produced at this location are mostly a deep rich or emerald green. Some are light amber. Most Saratoga-type bottles are rather crude in construction and contain an abundance of glass, making them unusually heavy for their size.

In 1850 about 7,200,000 bottles were made to supply the needs of the Saratoga Springs; in 1878 just the Congress and Empire Company alone used approximately one million bottles.

Mineral water specialists would have a large collection even if they ignored the wide range of bottles from the numerous other springs in other parts of the country; in Saratoga types alone there are over three dozen brands and, of course, the usual variations and size differences.

A fairly extensive but definitely not complete listing of mineral water bottles is offered by Dr. Larry Freeman in his book, *Grand Old American Bottles*. There were other companies, however; notably some of the famous western springs such as Jackson's Napa Soda Springs and Bartlett Springs in California.

Of all mineral water bottles, one brand stands out as being most unusual. This is the Moses bottle, which contained the mineral waters of Poland Springs, about twenty-five miles from Portland, Maine. This famous spring was owned by Hiram Ricker in 1860 when the water was first offered for sale to the public. It was in 1876, however, that the famous Moses bottle was first made. The inspiration to make the bottle in the shape of Moses came from the Bible where it is reported that Moses drew water from a rock in Horeb. The first Moses bottles were not structurally successful; many were broken during shipment. Use of these first bottles was discontinued for a time.

The Poland Spring water was exhibited at the 1893 World's Columbian Exposition and was awarded a medal and diploma "for great purity as a natural medicinal water." At the St. Louis Universal Exposition it received the Grand Prize, which is the highest award ever accorded an American water.

At undetermined dates prior to World War I this famous bottle was reissued three times. These three reissues can be identified by their rounded tooled lip as opposed to the crude sloping collar on the originals.

By the mid-1920s another Moses bottle was issued. The colors of this bottle are varied shades of green. The embossment on the reverse clearly states, "FAC-SIMILE OF THE FIRST POLAND WATER BOTTLE."

In the 1930s the company began to sell gin in Moses bottles and these bottles bear the embossment "FEDERAL LAW FORBIDS THE SALE OR REUSE OF THIS BOTTLE."

The January, 1969, issue of *Western Collector* magazine carries a complete list and description of the thirty known variants and their colors.

Because mineral springs were popular in Europe many immigrants to the United States continued to use mineral water from Europe. Much of the importing was done in pottery jugs (see Chapter 27). These ceramic containers are quite unusual and certainly deserve a place in the mineral water bottle collection.

Following the Civil War the fashion of using mineral water began to wane. The people who frequented the early spas were following the new trend of vacationing at seashore and mountain resorts. By the twentieth century most of the famous watering places had barely enough business to stay open. Naturally the consumption of bottled mineral water faltered as well.

For the mineral water bottle enthusiast this means that the bottles he seeks were made mostly during the period 1850–1900. Bottles made during that period are necessarily hard to find and usually range in price from $5 to $50, with Moses bottles selling for something over $100.

As mineral waters declined in popularity, plain spring water replaced them to some extent. Of interest to the bottle collector are the table water bottles that were given to the spring water customers who did and still do buy their water in five-gallon containers.

The common sizes of mineral water bottles are pints and quarts but they are also discovered occasionally in other sizes.

Since the period of greatest production for mineral water bottles was during the era of cork closures most of the ones located are crude and have hand developed necks and lips. Some, however, were made after the invention of the Lightning stopper (see Chapter 23) and the Hutchinson stopper (see the discussion on soda water bottles) and are thus located with these closures. Some of these bottles even have crown cork closures (see later discussion).

Shapes in mineral water containers are varied and range from the Saratoga types to the very

unusual Moses figural bottle. One difficulty a mineral water bottle collector will have relates to soda water bottles: Both beverages used the blob-top soda water–type bottle.

Embossing of these bottles follows the familiar pattern and a great variety of bottles can be found with unusual objects embossed on them. The use of individualized plates in the standard molds adds variety to this speciality.

Although many mineral water vessels were produced in the common aqua and light green colors some were manufactured in amber and green. The Saratoga types are unusual because they have beautiful deep shades of green and amber. Blue mineral water bottles are known but are unusual.

Co-related items in this area of bottle collecting are for the most part limited to advertisements from newspapers and magazines. Advertising brochures are also available—much of the advertising budgets of the larger spas was spent on extensive and well-written brochures with abundant photographs. Some tin trays and glass and ceramic mugs can also be located (see chapters 56 and 60).

SODA WATER BOTTLES

As early as 1500 scientists studied bubbling springs of natural carbonated water trying to discover methods of duplicating nature's process. Although it is claimed that Torbern Bergman, a Swedish chemist, produced artificial carbonated water in 1770, Dr. Joseph Priestly (the discoverer of oxygen) is given credit for discovering the first practical method in 1772. It can be stated that the soda water industry had its beginning with the English scientist's discovery.

Professor Benjamin Silliman of Yale University manufactured and bottled small quantities of artificially carbonated water in New Haven, Connecticut as early as 1806. In that same city in 1808 a newspaper advertisement indicates that A. Thaddeus Sherman set up a soda fountain at which water was "drawn off brisk and sparkling." This same water, it is reported, was also bottled by a local doctor.

Going back a year to 1807, an Englishman named Joseph Hawkins, who was living in Philadelphia, introduced artificially carbonated mineral water. Hawkins applied for and was granted a patent for machinery improving upon the Schweppes's process used in London since 1792. The manufacturing firm's name was at first Cohen & Hawkins, soon followed by Shaw and Hawkins. A search of Philadelphia directories of that period fails to verify either of these names, but in the 1809 directory A. H. Cohen is listed as a manufacturer of artificial mineral waters. Also in Philadelphia in 1807 Townsend Speakman, who carbonated water for a Dr. Philip Syng Physick, added fruit juices to the water but the idea did not find acceptance and was dropped. Dr. Physick's soda water was sold to his patients for $1.50 a month for one glass a day.

In New York in 1810 an early fountain was dispensing various homemade Vichy, Kissingen, and Apollinaris "seltzers" that were a supposed cure for obesity. In that same year Charles D. Simons and Gene J. Riondel of Charleston, South Carolina, were issued a patent for a process of "saturating water with carbonic acid gas."

By 1818 a Boston newspaper advertised that an "Old Established Mineral and Soda Fountain put up [water] in bottles to suit Town, Country, and World markets." The "Old" would indicate that the firm had been in business some time before 1818.

It was John Matthews, a transplanted Englishman, who in the early 1830s began manufacturing artificial carbonated water on a large scale and revolutionized the industry. While operating his business at 55 Gold Street in New York, Matthews introduced the use of marble chips in making carbonated water. In fact, Matthews even acquired all the scrap marble from the building of St. Patrick's Cathedral; these chips alone gave him enough marble to make over twenty-five million gallons of soda water.

While most of Matthews's competitors had periodic explosions in their plants he had none. Matthews had a special, if rather unusual, method of preventing explosions. He employed an ex-slave named Ben Austen, who placed his thumb over the pressure cock of the carbonation machinery; when the pressure blew his thumb away, Matthews knew his water was at optimum pressure.

There were others who helped to develop the rapidly growing carbonated water industry; John ("Charles") Lippincott of Philadelphia, A. D. Puffer of Boston, and James W. Tufts of Somerville and Boston, Massachusetts. (Tufts became so successful financially that in later years he founded the city of Pinehurst, North Carolina.)

The soda water and mineral water industries finally became two separate businesses in about 1838 or 1839 when Eugene Roussel, a Philadelphia perfume dealer, introduced flavors to the soda water he sold at his shop. The idea of flavored soda water, although not original, caught

on quickly this time and gave the industry the boost that assured it a permanent place in the American way of life.

The bottles used during these early days of the industry are called *blob-top sodas* by today's collector. Actually the name is not technically correct, but is very descriptive. The earliest of these bottles had tops that were applied separately during their manufacture. To hold the cork under pressure, a wire was placed over the top of the bottle and secured around the neck. These early blob-top soda bottles can be found with pontil scars and iron pontil marks but are mostly found with plain bottoms because they became most popular after the development of the snap.

The interest in other than cork closures came with the invention of the *Lightning stopper* in 1875 by Charles de Quillfeldt (see Chapter 23). Lightning stoppers were not used extensively because of the relatively low cost of soda water and the relatively high cost of Lightning stoppers.

Charles G. Hutchinson, the son of a prominent Chicago bottler, on April 8, 1879, invented the most popular of the internal stoppers that in time replaced the cork closure on blob-top soda bottles. He named his invention the *Hutchinson stopper*. This invention heralded the beginning of a new bottle—the Hutchinson-stoppered bottle. The stopper consisted of a rubber gasket (which came in five sizes to accommodate neck diameters) held between two metal plates and attached to a spring wire stem (which came in three sizes to accommodate neck lengths). A portion of the looped wire stem protruded above the mouth of the bottle while the lower end with the gasket and plates extended far enough into the bottle to allow the gasket to fall below the neck.

To seal the bottle after it had been filled the rubber disk was pulled up by the wire stem. The bottle was then inverted and righted; this motion formed the seal—the pressure of the carbonation forced the rubber gasket to remain against the shoulder of the bottle.

A very romantic container, to say the least, the Hutchinson-stoppered bottle (and its several imitators) enjoyed great popularity during the closing years of the nineteenth century. By 1890, W. H. Hutchinson & Son claimed a customer list of over three thousand and reported that their price of $2 to $2.50 per gross was more than competitive.

During the last twenty years of the nineteenth century numerous internal stoppers were invented and several rivaled in popularity the one developed by Hutchinson. One of these was the *gravitating stopper* invented by John Matthews of New York in 1864. This was an internal glass stopper that worked on the same principle as the Hutchinson type. Since soda bottles utilizing the Hutchinson and gravitating stoppers were of the same type it is hard to be sure which sealing device was used in a particular bottle if the stopper is missing.

The most unusual and fascinating of the internal stoppers is, perhaps, the *Codd stopper*. This unique device was first patented and used in England in September of 1872. It was also patented in the United States, in 1873. This bottle, because of its appearance while in a prone position, is sometimes called a *pig bottle*. Another popular but incorrect name for this bottle is *marble bottle;* it is so called because of the closure, which features a glass ball that was imprisoned in the neck during the manufacturing process. The bottle also had a rubber ring which was fitted into a groove on the inside of the bottle neck.

This bottle had to be filled upside down; the seal was formed when the filling of the bottle was completed—the instant the filling stopped the marble would drop down against the rubber ring. After the bottle was righted the marble was held in place by gas pressure.

Besides the expensive bottling equipment needed to use the Codd bottle it had the even bigger disadvantage of being a "one trip" bottle, that is, quite often the bottles were never returned to the bottler because children broke them to obtain the glass balls, which are in reality just marbles. To early bottlers an expensive bottle had to be used and returned many times before the initial cost of the bottle could be justified.

At this point it seems appropriate to correct two misconceptions about the bottles discussed thus far. First, because of their short, squatty-necked appearance, Hutchinson-type bottles are frequently called blob-tops. As already stated, blob-top bottles are those used before the invention of the Hutchinson type. Second, many collectors of soda bottles continue to spread the story that flavored soda water got the popular nickname "soda pop" as a result of the "pop" that accompanied the opening of internally sealed soda bottles. It may be true that internal stoppers helped perpetuate the nickname, but Robert Southey, an English poet, is quoted as having said in 1812 while describing ginger ale, "a nectar, between soda water and ginger beer, and called pop, be-

cause *'pop goes the cork'* [italics added] when it is drawn."

William Painter, foreman of a Baltimore machine shop, became quite fascinated with bottle closures and in 1885 patented one similar to the Lightning stopper. Shortly thereafter he patented a closure he called the *Baltimore loop seal* (see Chapter 23). Neither of these closures enjoyed much favor even though the loop seal was adopted by the famous Moxie Company. It was Painter's third closure, which was patented in its final form in 1891, that eventually made all other beverage closures obsolete. He called this device the *crown cork*. This closure was essentially the same as those used on beverage bottles today.

The crown cork was not an immediate success because it required a new type of bottle, uniformly made. The initial investment in bottles and bottling apparatus required of bottlers made the transition a slow one. The development of the Owens automatic glass blowing machine in the early 1900s hastened the change to crown cork bottles by making a great number of uniform bottles possible at relatively small cost.

By 1912 the adoption of the crown cork was so widespread that the largest manufacturer and originator of Hutchinson-type stoppers, W. H. Hutchinson & Son of Chicago, ceased production. As late as the 1920s, Hutchinson-stoppered bottles were being used by some small American companies, but shortly thereafter all states adopted laws restricting the use of internal stoppered bottles on the basis that they were unsanitary. These laws resulted in complete acceptance of Painter's crown cork.

Generally speaking, a soda bottle collector can expect his collection to consist of the three basic types stressed thus far, i.e., blob-top, Hutchinson-type, and crown-cork bottles. However, there are several variations, involving pointed, round, and semi-round bottom bottles. The pointed, or torpedo-shaped as it is frequently called, and the round bottom bottles were mostly imports from Europe, notably England. The vessels contained ginger ale primarily. Without the usual flat bottom these bottles could never be stood up, which is precisely why they were so designed. A cork is much like a sponge in that it expands when moist and contracts when dry. Soda water, such as ginger ale, was corked under pressure and if the cork was allowed to dry the danger of the cork being forced out of the bottle was enhanced. Round bottom bottles, by always having to be kept on their side, ensured a moist cork, thus a more secure closure.

The history of specific soda water firms and their bottles is, in itself, worth several volumes. Most of the early bottlers produced their own syrups, manufactured limited quantities of soda water, and sold their product within a limited area—usually their own city. After the turn of the century, however, a few of these small firms began to expand and develop into large corporations. Notable among them were such familiar brands as Hires Root Beer, Moxie, Coca-Cola, Pepsi-Cola, and a little later (in the 1930s) 7-Up. Because of space limitations, a brief summary of the most famous of them all, Coca-Cola, will have to suffice.

Coca-Cola was invented by Dr. John S. Pemberton, an obscure druggist in Atlanta, Georgia, in the year 1885 while he was working on the modification of a proprietary medicine called French Wine Coca. The drink (mixed with plain water) was offered for sale at a local soda fountain as a headache cure. The accidental mixing with carbonated water one day in 1886 turned the "medicine" into a popular soda water beverage. From the first year's gross of $50 the sum of $46 was spent on advertising. The rapid growth of this firm can be seen in its advertising budgets: In 1892 $11,401.48 was spent; by 1901 $100,000 was spent annually; in 1909 advertising costs had reached $760,000; today the company spends in excess of $75,000,000 a year on advertising. Much of the advertising money went for a variety of items that are of interest to today's collector (see chapters 56 and 60).

The Coca-Cola bottle is probably the world's most famous container. Originally, however, it was just one of the thousands of Hutchinson-type bottles being used in almost every community in the United States. Ironically the first Coke bottle was embossed JOSEPH A. BIEDENHARN, the name of the first man to actually bottle the product in 1894 in Vicksburg, Mississippi. The bottling of Coke by Biedenharn was mostly just an experiment; Asa G. Candler, president of the Coca-Cola Company at the time, really had no interest in bottling his product. This is quite evident from the fact that in 1899 two lawyers bought almost exclusive bottling rights to the beverage for one dollar, which, by the way, they never bothered to pay. Historians mark the event as the signing of one of the most valuable contracts in the annals of American business.

The first plant to bottle Coca-Cola exclusively was opened in Chattanooga in 1899. Other plants soon followed. The bottles involved were usually the Hutchinson type, with the name of the bottler. A few bottlers had COCA-COLA embossed on their containers, but very few; less than a dozen such bottles are known to exist. The first Hutchinson-stoppered bottle discovered was from Talladega, Alabama, and was manufactured in 1904. At the time bottlers of Coca-Cola were being established the crown cork was becoming extremely popular so most of the earlier Coke plants bought and used this type.

The soda bottle enthusiast can make a sizable collection of just early Coke bottles; they came in varying shapes and colors and with varied embossments.

In 1915 after an extensive campaign by the parent company a unique bottle was uniformly adopted. This bottle, except for minor changes, has remained the same throughout the years. Because of its unusual bulge toward the shoulders this bottle was nicknamed the "hobble skirt" or "Mae West" bottle.

The collecting of soda water bottles is a relatively new specialization in bottle collecting. For the most part these containers are not excessive in price. Of course, in obtaining the more unusual and older specimens the collector must expect to pay more. Generally the range in price is between $2 and $80.

As is true with other food containers many were made in the common colors of aqua and light green. Soda bottles made in dark greens, browns, and cobalt-blue are considered quite valuable.

Although there is a relatively small variety of shapes and sizes, variations exist, and such bottles must be considered rarer than the more common shapes and sizes.

Closures were pretty well standardized but some of the more obscure inventions did get into production. These unusual specimens are of great interest.

One of the factors which determine rarity in soda water bottles is the embossments. As in some other areas of bottle collecting, soda water bottles were made with a wide range of objects embossed in the glass. The more unusual and attractive the embossment, the more desirable the bottle. The use of plates was quite popular for these containers and because their usage was so widespread a great variety of companies was represented.

Co-related items are numerous and much sought after by the collector (see Chapter 60).

Bibliography

BOOKS

Bailey, Shirley R. *Bottle Town*. Millville, New Jersey: privately published, 1968.

Beare, Nikki. *Bottle Bonanza*. Miami, Florida: Hurricane House Publishers, Inc., 1965.

Ferraro, Pat and Bob. *A Bottle Collector's Book*. Sparks, Nevada: Western Printing & Publishing Co., 1966.

———. *The Past in Glass*. Sparks, Nevada: Western Printing & Publishing Co., 1964.

Fountain, John C., and Colcleaser, Donald. *Dictionary of Soda and Mineral Water Bottles*. Amador City, California: Ole Empty Bottle House Publishing Co., 1968.

Freeman, Larry. *Grand Old American Bottles*. Watkins Glen, New York: Century House, 1964, pp. 317–325.

Lief, Alfred. *A Close-Up of Closures*. New York: Glass Container Manufacturers Institute, no date.

Munsey, Cecil. *Would You Believe*. San Diego, California: I.P.S., a division of Neyenesch Printers, Inc., 1968.

Tufts, James W. *The Manufacture and Bottling of Carbonated Beverages*. Ft. Davis, Texas: Frontier Book Company, 1969.

Vincent, Pal. *The Moses Bottle*. Poland Spring, Maine: The Palabra Shop, 1969.

PERIODICALS

Collins, Donald R. "The Hutchinson Stopper," *Old Bottle Magazine*, II (July, 1969), 8–9.

Ferraro, Pat and Bob. "Saratoga Mineral Water Bottles," *Western Collector*, V (April, 1967), 37–40.

Humphrey, Walt. "Moses Bottles," *Western Collector*, VII (January, 1969), 48–52.

Morrison, Joseph L. "The Soda Fountain," *American Heritage* (August, 1962), 10–19.

Munsey, Cecil. "Coca-Cola, Part I: A Refreshing Taste of Americana," *Western Collector*, V (August, 1969), 12–17.

———. "Coca-Cola, Part II: The World's Most Famous Bottle," *Western Collector*, V (September, 1967), 41–46.

———. "Would You Believe a Mistake in 'Would You Believe'?," *The Bottleneck*, III (May, 1968), 4–5.

Rickabaugh, Helen. "A Century at Bartlett Springs," *Western Collector*, VI (January, 1968), 41–45.

Mineral water bottle, amber, embossed "ALLEN MINERAL WATER," H. 11½ in., c. 1885.

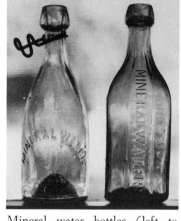

Mineral water bottles (left to right): (1) aqua, embossed "MINERAL WATER" on side, iron pontil mark, H. 7½ in., c. 1865–1875; (2) dark aqua, eight individual panels, three panels are embossed "MINERAL WATERS" and "THIS BOTTLE IS NEVER SOLD" and "JOHN S. BAKER," iron pontil mark, H. 7½ in., c. 1865–1875.

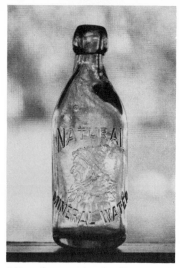

Mineral water bottle, lime-green, embossed with the words "NATURAL MINERAL WATER" and the figure of a man wearing a stocking cap and a scarf, H. 7 in., c. 1875–1895.

Mineral water bottle, aqua, embossed "GEYSER SPRING, SARATOGA SPRINGS, STATE OF NEW YORK" on one side, and "THE SARATOGA SPOUTING SPRING" on another side, H. 9⅜ in., c. 1870–1880.

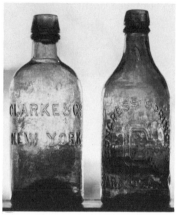

Mineral water bottles (left to right): (1) dark blue-green, embossed "CLARKE & CO., NEW YORK" on side, iron pontil mark, H. 7¾ in.; (2) emerald-green, embossed "CONGRESS SPRING CO., SARATOGA, N.Y.," around a large "G" on side, H. 8 in., c. 1870–1880.

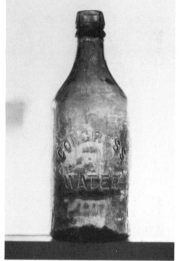

Mineral water bottle, emerald-green, embossed "CONGRESS WATER" on side, H. 8 in., c. 1870–1880.

Table water bottles, light green (left to right): (1) conical shape, unembossed; (2) round, embossed "SPARKLETS" on side, matching glass stopper; (3) square bottom tapering to round narrow neck, embossed "PURITY" on side; c. 1900–1920.

Mineral water bottle, light green, embossed "MADDEN MINERAL WATER CO., CLARENDON SPRINGS, DERRY" (Ireland), note round bottom, L. 7 in. (unusually small size), c. 1880.

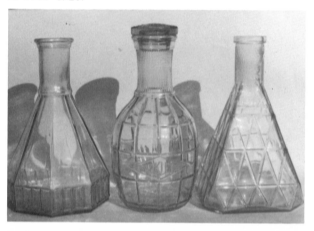

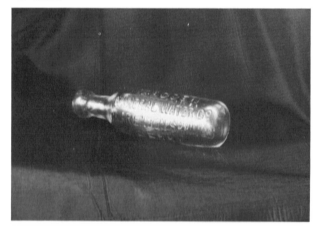

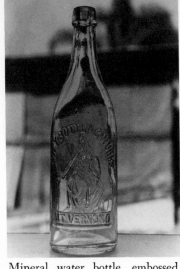

Mineral water bottle, embossed "CITY BOTTLING WORKS, MT. VERNON, O." with a seated maiden in flowing garments on side, clear, H. 11 in., hand-finished top, c. 1890.

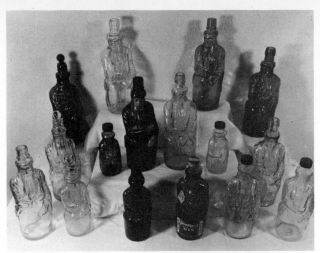

Miscellaneous assortment of Moses Poland Water and gin bottles, c. 1876–1965. (Walter J. Humphrey, Reseda, Cal.)

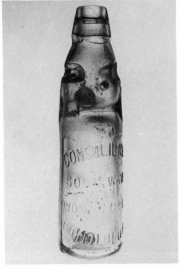

Codd marble-stoppered soda water bottle, c. 1875. (Rex R. Elliott, Ewa, Hawaii)

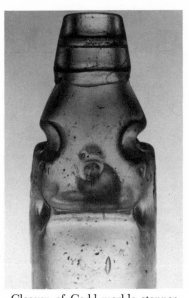

Closeup of Codd marble stopper. (Rex R. Elliott, Ewa, Hawaii)

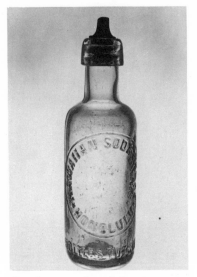

Inside screw threaded soda water bottle, c. 1902. (Rex R. Elliott, Ewa, Hawaii)

Executives of Crown Cork & Seal Company; photograph taken in the main office in Baltimore in 1900. Standing: King Camp Gillette (encircled), who later became famous for his 1895 invention of the safety razor. Seated: William Painter (encircled), inventor of the Baltimore loop seal and the crown cork. (*Soft Drinks* magazine, New York—formerly the *National Bottlers' Gazette*)

William Painter, of Baltimore, Maryland, inventor of several beverage bottle closures including the Baltimore loop seal in 1887 and the crown cork in 1891. (*Soft Drinks* magazine, New York—formerly the *National Bottlers' Gazette*)

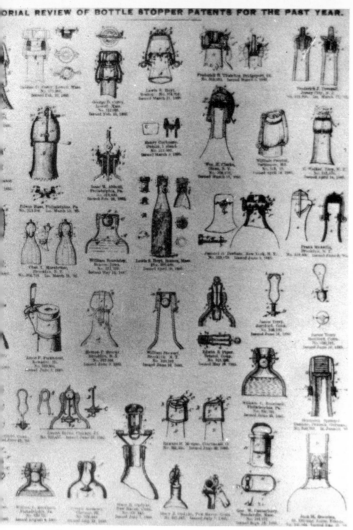

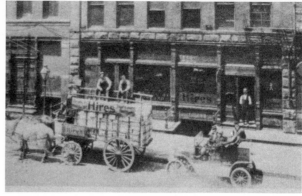

The Charles E. Hires Company, the world's largest manufacturer of root beer, first started making root beer in the early 1870s in Philadelphia. The photograph shows the plant (in the background) and the horse and wagon used to deliver the root beer in the early 1900s. (*Soft Drinks* magazine, New York—formerly the *National Bottlers' Gazette*)

A page from the *National Bottlers' Gazette* (1880s) showing the number of closures patented in a one-year period. In the last twenty years of the nineteenth century, hundreds of bottle closures were tried. (*Soft Drinks* magazine, New York—formerly the *National Bottlers' Gazette*)

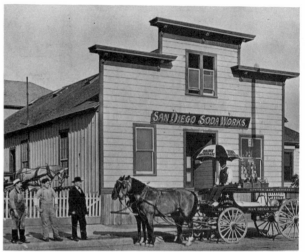

As the era of Hutchinson-stoppered bottles ended and the crown cork became popular, the delivery of soda water was accomplished by horse and wagon. (Bruce C. Aschenbrenner, San Diego, Cal.)

Soda water bottles (left to right): (1) blob-top bottle, embossed "HOLLISTER & CO., HONOLULU," c. 1870; (2) Codd marble-stoppered bottle embossed "TAHITI LEMONADE WORKS COMPANY, HONOLULU," c. 1875; (3) round bottom Hutchinson-stoppered bottle embossed "CRYSTAL SODA WORKS," c. 1880–1900; (4) eight-sided Hutchinson-stoppered bottle embossed "ARTIC SODA WORKS, HONOLULU," c. 1880–1900; (5) blob-top bottle, embossed "FOUNTAIN MINERAL AND SODA WATER," c. 1880; (6) inside screw threaded bottle embossed "HAWAIIAN SODA WORKS HONOLULU," c. 1902; (7) crown cork bottle, embossed "LIHUE ICE CO.," c. 1910. All bottles are light green or light aqua and range in height from 7 in. to 9 in. (Rex R. Elliott, Ewa, Hawaii)

Jacobs' Pharmacy, Atlanta, Georgia, in 1886. It was from the soda fountain at this store that Coca-Cola was first sold in 1886. (*Soft Drinks* magazine, New York—formerly the *National Bottlers' Gazette*)

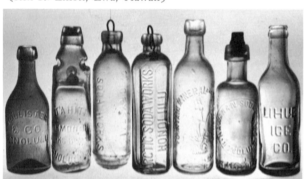

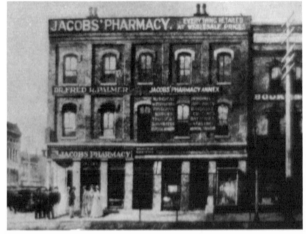

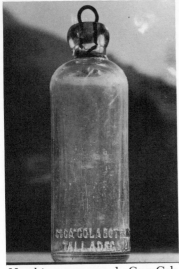

Hutchinson-stopperd Coca-Cola bottle (earliest type used by this company), c. 1890.

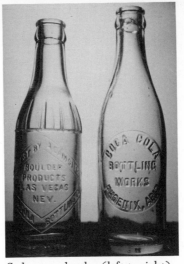

Soda water bottles (left to right): (1) light green, embossed "BEST BY A DAM SITE COCA COLA BOTTLING CO. BOULDER PRODUCTS LAS VEGAS NEV.," H. 7¾ in., 1936; (2) light green, embossed "COCA COLA BOTTLING WORKS PHOENIX, ARIZ.," H. 8 in., c. 1905. (Lou Alvarado, San Diego, Cal.)

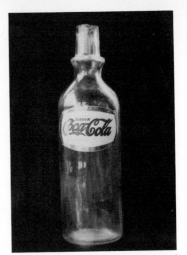

Fountain syrup bottle, clear, cork closure with metal measuring cup (not pictured), H. 11¾ in., c. 1920.

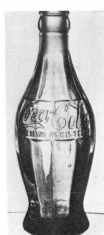

Soda water bottle: original Coca-Cola "hobble skirt" design by Alex Samuelson of Root Glass Co., 1915. This model never reached production stage. (Coca-Cola Company, Atlanta, Ga.)

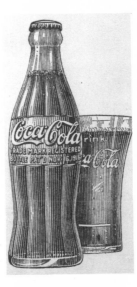

Soda water bottle: sketch of production model of "hobble skirt" Coca-Cola bottle, 1916. (Coca-Cola Company, Atlanta, Ga.; photo by Harold J. Terhune)

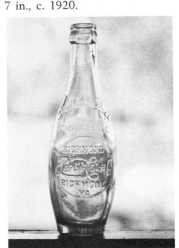

Coca-Cola bottle, flashed gold on outside, applied color label, H. 7⅝ in.; one of the commemorative bottles given to a bottler who has been in business for fifty years; usually filled with Coke and capped, c. 1950–1960.

Soda water bottle: amethyst, embossed "INDIAN ROCK GINGER ALE" and, in a circle, "RICHMOND PEPSI-COLA CO., RICHMOND, VA." H. 7 in., c. 1920.

Soda bottle, clear, H. 7 in., Hutchinson stopper. This bottle given away at the 32nd Annual Convention of the Western States Chain of the Grocers Association on May 17–21, 1953, Sun Valley, Idaho, by the California and Nevada manufacturers of carbonated beverages. Embossed "SINCE THE DAYS OF OLD, THIS IS ONE OF THE FIRST RETURNABLE SOFT DRINK BOTTLES. IT BROUGHT CUSTOMERS BACK TO GROCERS 75 YEARS AGO. DEPOSIT BOTTLES BRING TODAY'S CUSTOMER BACK TO YOU BY THE MILLIONS" on side, 1953.

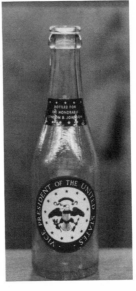

Soda water bottle made especially for Vice President Lyndon B. Johnson by the Canada Dry Beverage Co., c. 1960–1963.

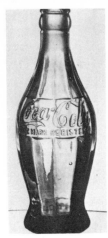

22

Bitters Bottles

Bitters seems to have originated in seventeenth-century Germany; from there it spread to Italy and England. In England during the reign of George II (1727–1760) it was decided, by his majesty, that the English people were drinking too much gin. In an effort to control this excessive drinking and raise revenue at the same time, a tax was levied on gin and the number of pubs was restricted.

Not to be denied the lucrative business of peddling gin, the gin sellers added various herbs to their product and sold it as a medicinal liquor (a ploy that has been used ever since in many countries whenever there have been attempts to control the distribution of spirits). They called their product Bitters, Coltick Water, and Gripe [sic] Water but it was the term bitters that stuck. In a feeble attempt to prosecute those selling gin disguised as medicine, vendors of bitters were taken to court. One such defendant, in trying to explain the sudden popularity of his product, indicated that the new tax had given so many people the "cholick" they needed to take medicine.

In colonial America, since there was a tax on gin and West Indian rum, the favorite alcoholic beverages of the time, bitters did enjoy some popularity with those colonists who wished to avoid the alcohol taxes. In 1785, when Dr. Benjamin Rush, of Philadelphia, published his "Inquiry into the Effects of Ardent Spirits on the Human Mind and Body," American drinking habits began to change. This article, condemning drinking, emphasized the fact that many workmen habitually squandered family funds on alcohol, and many anti-drinking groups resulted. Within the his-

torically short period of a hundred years anti-drinking groups were firmly established. The Woman's Christian Temperance Union (W.C.T.U.), organized in 1874, was one of the most effective. It remained, however, for the Anti-Saloon League of America, organized in 1895, to bring the final legislative pressures which led to national prohibition in 1920.

Shortly after Dr. Rush's article, it is probably safe to assume, Americans *began* to abandon gin and rum in favor of the more socially acceptable bitters. Still, gin and rum captured a good share of the market. In the post-Revolutionary period taxes on gin, rum, and bitters were abandoned; the infant United States Government derived most of its revenue from customs duties and property taxes. It was not until the beginning of the Civil War that the government initiated taxes. The Revenue Act of 1862 taxed many things including proprietary medicines (bitters came under this classification) and liquor. Since the tax on liquor was substantially more than the one on medicine, taxation became, once again, a major consideration of the consumer of alcohol. The popularity of bitters climbed rapidly during this period and probably explains why the vast majority of collectible bitters bottles were produced between 1860 and 1900.

An examination of the percentage of alcohol in some of the more popular brands of bitters of the late 1800s illustrates how bitters could be acceptably substituted for liquor. Dr. H. W. Vaughin, State Assayer of Rhode Island, wrote in the June 1882 *Druggists Circular* that his analysis revealed Richardson's Bitters contained 59.14 percent al-

cohol, Hostetter's 43.20 percent, Baker's 40.57 percent, Atwood's Quinine 40.10 percent, Drake's Plantation 38.24 percent, Wild Cherry 35.89 percent, Warren's Bilious 29.60 percent, Atwood's Jaundice 25.60 percent, Puritan 25.50 percent, Standard Wine 25.49 percent, Peruvian 22.40 percent, Sherry Wine 22.40 percent, Hoffland's German 20.85 percent, Oxygenated 19.23 percent, California Wine 18.20 percent, Luther's Temperance 16.68 percent, Walker's Vinegar 7.50 percent, and Pierce's 6.36 percent. When these percentages are transferred into the more familiar measure of alcohol proof the point becomes clearer; Richardson's Bitters, the highest in alcohol of those tested, was 118.28 proof, and Pierce's, the lowest tested, was 12.72 proof.

Although it is realistic to assume that many Americans consciously consumed bitters as a liquor substitute for economic and social reasons, it is only fair to point out that many people firmly believed that they were drinking medicine. With typical American ingenuity bitters producers emphasized the supposed value of their products and expanded their medical claims until there was practically no human affliction their "medicine" purportedly would not cure. Much of the information we have today about claims made by specific brands comes from such primary sources as newspaper advertisements, trade cards, and almanacs (see Chapter 56). In addition to excessive and absurd medical claims, bitters manufacturers assumed the title of "doctor" to lend status to their products and obtained testimonials from distinguished citizens of all walks of life.

Of all the bitters ever marketed, perhaps the most famous and most popular of them all was Dr. J. Hostetter's Celebrated Stomach Bitters. The history of this particular brand is not only quite romantic but in many ways typical of other brands.

Hostetter's Bitters had its beginning in 1853 when Dr. Jacob Hostetter, a physician in Lancaster County, Pennsylvania, retired from his practice. Upon retiring he gave his son, David, consent to manufacture and sell commercially a formula he had developed and used in his practice. David had run a grocery store in San Francisco in 1850 but lost it in one of the many fires that swept the hastily built city. Broke, he returned to Pennsylvania and decided to go into the proprietary medicine business. He went into partnership with George W. Smith, who put up $4000; they manufactured Dr. J. Hostetter's Stomach Bitters in part of a rented building. Hostetter went

on the road to obtain orders while Smith managed the business. The first bottles were blown in Pittsburgh in the early 1850s. They spent enormous sums on advertising their product and it soon became a best seller.

With the start of the Civil War, Hostetter suggested that the government supply troops with his bitters as an invigorant before a dangerous battle, rather than the whiskey and quinine that was being used. The government bought their bitters by the boxcar load; the product was 47 percent alcohol or 94 proof at the time. After the war, a Pittsburgh historian wrote, "Hostetter's vaunted remedial properties were sadly lacking, but many a frightened Yankee at Gettysburg knew he faced Pickett's Charge as bravely as he did because of a swig of Hostetter's under his belt." Retail sales mounted after the war, surpassing a million dollars a year. Hostetter expanded his business enterprises into oil, natural gas, coke, and his own railroad (the Pittsburgh and Lake Erie). His partner, Smith, died in 1884 and Hostetter succumbed to a kidney ailment four years later in 1888. He left the business to his son, Herbert, who continued well into the twentieth century.

Bitters bottles have been collected for many years and certainly provide the specialist with a challenge. Most authorities agree that there are over a thousand types known, with new finds showing up regularly. In addition to having a very romantic history bitters bottles are generally quite attractive because of their colors and shapes.

The most common colors are varying shades of amber; next is aqua in a variety of shades, then clear, and green in a wide range. Extremely rare are such colors as blue, puce, amethyst, and milk glass.

Probably the most popular are the figural bitters bottles. These have been found in shapes such as globes, cannons, pigs, Indians, drums, fish, balls, horseshoes, ears of corn, lighthouses, and soldiers. Over a dozen kinds of barrel-shaped bottles are known and a number of brands were made in the shape of cabins or were roofed at the shoulders like a building. There are many kinds of round bitters bottles, well over a dozen elliptical, some triangular, and a great many that are rectangular. Other shapes in which bitters bottles are found are hexagonal, octagonal, twelve-sided, flask-shaped, long bulged neck, and handled jugs.

One other factor that has attracted collectors to bitters bottles over the years is that the majority

were identified, at least partially, by embossed lettering or designs. Of course, some bitters are to be found in bottles identified with only paper labels.

There are several good books available on bitters bottles; perhaps the most extensive is the two-volume set, *Bitters Bottles* and *Supplement to Bitters Bottles,* by Richard Watson. Another good book with good photographs is *Grand Old American Bottles* by Dr. Larry Freeman. For the collector interested in only bitters of the West there is *Western Bitters* by Bill and Betty Wilson.

At first it might seem that bitters bottles are expensive, ranging from as little as $1 to several hundred dollars, but actually this is not so. These bottles have been collected for many years; the market is firmly established and current prices seem to represent true value. In other specializations within the hobby it can be noted that prices are higher and less stable because interest is relatively recent.

Bibliography

BOOKS

Adams, Samuel Hopkins. *The Great American Fraud.* Chicago: P. F. Collier & Son, 1907, pp. 12–22.

———. *Grandfather Stories.* New York: Random House, 1955, pp. 209–228.

Bartholomew, Ed. *1001 Bitters Bottles.* Fort Davis, Texas: Bartholomew House, 1970.

Carson, Gerald. *One for a Man, Two for a Horse.* Garden City, New York: Doubleday & Company, Inc., 1961, pp. 42–43.

Freeman, Larry. *Grand Old American Bottles.* New York: Century House, 1964, pp. 176–252.

Thompson, James H. *Bitters Bottles.* Watkins Glen, New York: Century House, 1947.

Watson, Richard. *Bitters Bottles.* New York: Thomas Nelson & Sons, 1965.

———. *Supplement to Bitters Bottles.* Camden, New Jersey: Thomas Nelson & Sons, 1968.

Wilson, Bill and Betty. *Western Bitters.* Santa Rosa, California: Northwestern Printing Company, 1969.

PERIODICALS

Bennett, Mrs. F. F. "Bitters Bottles," *Hobbies,* LIV (January, 1950), 84–85.

Thompson, J. H. "Definition and Classification of Bitters Bottles, with a Checklist of Exclusive Ones," *Hobbies,* XLVII (September and November, 1942), 62–67 and 64.

———. "Give Bitters Bottles Their Due," *Antiques,* VI (October/November, 1944), 230.

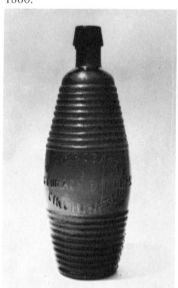

Figural bitters bottle, embossed "DR. C. W. ROBACK'S STOMACH BITTERS, CINCINNATI, O." on side, amber, barrel shape, H. 10 in., c. 1860.

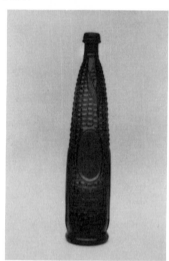

Figural bitters bottle, embossed "NATIONAL BITTERS" on side, amber, represents an ear of corn partially shucked, H. 10½ in., 1867.

Bitters bottle, dark puce, embossed "CAREY'S GRECIAN BEND BITTERS" on side, rectangular, roped corners, H. 10½ in., c. 1865–1880. (Charles B. Gardner, New London, Conn.)

114

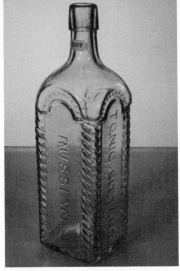

Bitters bottle, aqua, embossed on three separate sides "TONIC BITTERS/IMPERIAL/RUSSIAN," H. 9½ in., c. 1870–1890. (Charles B. Gardner, New London, Conn.)

Bitters bottle, amber, embossed "MCKEEVER'S ARMY BITTERS" on horizontal line in top band of drum, lower portion of bottle shaped like a drum, upper portion represents a pile of cannon balls, H. 10½ in., c. 1860–1870. (Charles B. Gardner, New London, Conn.)

Bitters bottle, light golden amber, embossed "SEAWORTH/BITTERS/CO./CAPE MAY/NEW JERSEY/USA" on side, lighthouse shape, H. 11½ in., c. 1870–1890. (Charles B. Gardner, New London, Conn.)

David Hostetter, son of Dr. J. Hostetter, founder of D. J. Hostetter's Celebrated Stomach Bitters. (John C. Fountain, Amador City, Cal.)

Whiskey and bitters bottles, white milk glass, case-type bottles (left to right): (1) embossed "R.B." on side, H. 9 in.; (2) embossed "S.B. ROTHENBERG, SOLE AGENT, U.S." on side, H. 9 in.; (3) embossed "HARTWIG KANTOROWICZ, POSEN, HAMBURG, GERMANY" on side, H. 9½ in.; (4) embossed "LOHENGRIN BITTERS, ADOLF MARCUS, VON BÜTON, GERMANY" on side, H. 9 in.; (5) embossed HARTWIG KANTOROWICZ, NACHFLG., JOSEF LOEWENTHAL" on side, H. 9½ in., late nineteenth century.

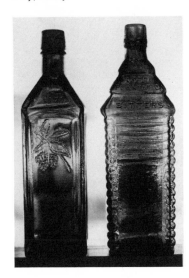

Bitters bottles (left to right): (1) amber, embossed on four panels of roof, "1872" in one panel, "DOYLES," "HOP," and "BITTERS" in remaining three panels, a bunch of hops is embossed on one side panel, H. 9½ in., c. 1880; (2) amber, roof embossed on three levels, "S.T. DRAKE" on first level, "1860 PLANTATION" on second level, and "X BITTERS" on third level, reverse embossed "PATENTED" on second level, and "1862" on third level, front and reverse have six logs, sides are covered with logs, H. 10 in., c. 1865–1875.

Bitters bottle, embossed "DR. J. HOSTETTER'S STOMACH BITTERS" on side, black, square, H. 9¾ in., c. 1860. Embossing painted for photographing. (John C. Fountain, Amador City, Cal.)

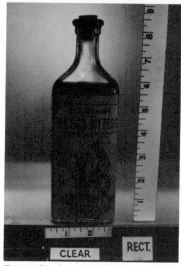

Bitters bottle, "C.K. Wilson's Wa-Hoo-Bitters," clear, rectangular, paper label, H. 8¾ in., c. 1900. (John C. Fountain, Amador City, Cal.)

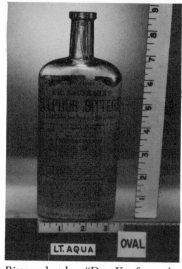

Bitters bottle, "Dr. Kaufmann's Sulphur Bitters," light aqua, oval, paper label, H. 9 in., c. 1890. (John C. Fountain, Amador City, Cal.)

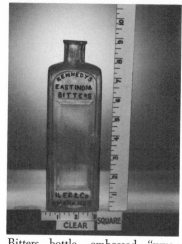

Bitters bottle, embossed "KENNEDYS EAST INDIA BITTERS, ILER & CO., OMAHA, NEB." on side, clear, square, H. 9 in., c. 1870. Embossing painted for photographing. (John C. Fountain, Amador City, Cal.)

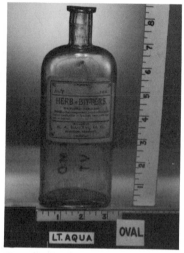

Bitters bottle, "Herb Bitters," light aqua, oval, paper label, H. 8¾ in., c. 1880. (John C. Fountain, Amador City, Cal.)

Bitters bottles: white milk glass, case-type, embossed "HARTWIG KANTOROWICZ, POSEN, HAMBURG, GERMANY" on side, H. 9½ in. and miniature 3¾ in., c. 1895–1910.

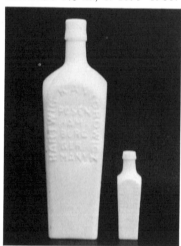

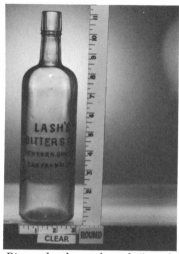

Bitters bottle, embossed "LASH'S BITTERS CO., NEW YORK, CHICAGO, SAN FRANCISCO" on side, clear, round, H. 11 in., late nineteenth century. Embossing painted for photographing. (John C. Fountain, Amador City, Cal.)

Bitters bottles, embossed "DR. HARTERS WILD CHERRY BITTERS ST. LOUIS" on side, amber, rectangular, H. 4 in. (trial size) and H. 7¾ in., c. 1880. Embossing painted for photographing. (John C. Fountain, Amador City, Cal.)

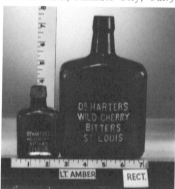

Bitters bottle, "Saxerac Aromatic Bitters," white milk glass, H. 12 in., "PHD & CO." in monogram form embossed on shoulder, c. 1880.

Bitters bottle, embossed "GOFF'S BITTERS" on side, clear, rectangular shape, H. 5½ in., c. 1906. Embossing painted for photographing. (John C. Fountain, Amador City, Cal.)

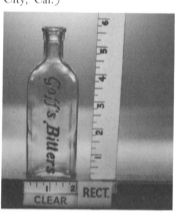

23

Beer Bottles

The first beer in America was brewed at the Roanoke Colony, Virginia, in 1587. Beer came over with the Pilgrims on the Mayflower. Such famous Americans as William Penn, Samuel Adams, Thomas Jefferson, Patrick Henry, Benjamin Rush, James Madison, and George Washington were all home brewers. It was William Penn who started one of the first breweries, in 1683, at Pennsbury, Pennsylvania. The oldest brewery still operating in the United States is the Francis Perat's Sons Malting Company of Philadelphia. This firm, which was started in 1687, has descended from father to son for eight generations.

Bottles that were used to contain beer in Colonial days were few in number because most of the beverage was dispensed from barrels at local taverns or inns. Those bottles that were used were the plain and unmarked black glass bottles used for many liquids (see Chapter 7), so common until approximately the Civil War period. Early beer bottles are not only hard to acquire but difficult to identify.

By 1860 most cities had at least one brewery but bottling was not carried on to any great extent. Most beer, as in Colonial days, was consumed at the saloon and the little that did leave the premises was carried in open buckets. Only beer carried great distances to isolated areas was bottled. The bottles involved were often the heavy blob-top soda water type (see Chapter 21). The bottles were produced in common aqua and light green, sometimes in cobalt-blue, and in amber.

Stoneware beer bottles (see Chapter 26) imported from England during the 1860–1890 period were often reused by American bottlers. These durable containers seldom were broken and survived many trips from the bottler to the consumer and back.

In glass, a standard beer bottle shape was adopted by the 1870s. The first bottles of this type were free of embossment, in quart size, and were approximately ten inches high. They featured a cylindrical body about six inches around, with slightly sloping shoulders and a tapered neck and lip about four inches in circumference. These bottles utilized a cork closure that was held in by a wire over the cork and twisted around beneath a ring of glass on the neck.

Beginning in about 1870, the eastern and midwestern areas of the country used beer bottles with embossments. Many of these bottles were embossed by the plate mold process. By 1890 the western half of the country, too, had an abundance of embossed beer bottles. Everywhere beer bottles were being manufactured mostly in pint and quart sizes.

One of the most interesting of all the bottles made for beer is from St. Louis, Missouri. Not only is this the only known bottle of beer bottle shape that is made in cobalt-blue glass, but it held a product with the interesting name "Liquid Bread—A Pure Extract of Malt." This truly beautiful bottle is free of embossment except on the bottom, where "A.B.C.M. CO., BELLEVILLE, ILL." and "1" can be found. Liquid Bread was made by David Nicholson of St. Louis who claims on the paper label to be the "sole proprietor" of this product. In the southern part of Germany beer is called "Fluessiges Brot" or, literally translated, "liquid bread."

With the invention of the Lightning stopper by Charles de Quillfeldt of New York City in 1875, the beer industry had a new practical closure. The device can be described as a toggle- or linkage-type lever-operating seal for jars or bottles. The device was secured to the bottle by a tie wire and had two complete loops on opposite sides that served as fulcrums for the lever wire; the lever wire was hooked to fit the loops. The lever wire also had two loops that received the bail wire, which centered over the stopper. When the lever was lowered with the stopper in place, the stopper was pulled down into the mouth of the bottle and was locked in place against the side of the neck by being moved past the center of the most tension. Lightning stoppers were used on other containers, notably fruit jars. They were utilized extensively on beer bottles until around 1915 and are still popular closures in foreign countries today.

Along with the Lightning stopper, the Baltimore loop seal was a favored closure for a number of years after being invented by William Painter, of Baltimore, about 1887. This was probably the first multiple-use closure, excluding corks, of course. It was inexpensive and easy to use and consisted of an internal rubber gasket that when pushed into a ring-shaped groove just inside the mouth of the bottle formed the seal aided by internal pressure.

116

The period of particular interest to the beer bottle specialist is between 1870 and 1920 approximately; it was during these years that the most interesting specimens of bottles and closures were produced. After Prohibition beer bottles with crown corks and paper labels, and eventually cans, were the common containers for beer.

Of special import to a beer bottle enthusiast will be *Anderson's Turn-of-the-Century Brewery Directory*. This volume lists all of the breweries in the United States that were operating in 1890, 1898, 1904, and 1910.

It is interesting to note that the last bottle of beer produced by the Joseph Schlitz Brewing Company before Prohibition was considered of such historical significance that it was insured for $25,000.

For some reason the collecting of beer bottles has been rather sporadic; they have not attracted the eye of the specialist on a large scale. As a result many of the really fine examples are obtainable from the many collectors who save them but do not persist in amassing an entire collection of them.

As with most bottles, the specimens made before the turn of the century are especially interesting for a variety of reasons. The closures already discussed are of prime interest. The Lightning type came in more than a few variations of the basic principle.

With beer bottles, shape is not of special importance. Most were of standard beer bottle shape, perhaps with slight modifications. Size too is not of great significance although there are some untypical specimens.

These bottles generally came in varying shades of aqua, green, and amber. Because of the theory that dark glass has a superior preserving effect many bottles were produced in amber glass, so a collection of beer bottles would be predominantly this color.

Already considered in this chapter has been the cobalt-blue bottle made to contain Liquid Bread. Another group of beer bottles unusual because of their color are the ruby examples produced mainly for the Joseph Schlitz Brewing Company by the Anchor Hocking Glass Company periodically during the 1950s and 1960s. These brilliant red bottles were made in large quantities (fifty million in 1950 and four million in 1963) but only a small percentage have survived to be included in bottle collections. Still another beer container of a most unusual color is one produced in milk glass for the Carling Brewing Company. This twelve-ounce stubby bottle was made in 1964 by the Owens-Illinois Glass Company of Toledo, Ohio.

Prices of these containers have been relatively static but they are not underpriced by any means. With exceptions the extremely rare specimens of these bottles may be purchased for prices generally ranging from $5 to $60.

Embossments could, perhaps, be considered the most interesting aspect of collecting beer bottles. In addition to the great number of firm names in embossed lettering many of the companies added embossments of animals, symbols, and the like; these bottles are very much in demand.

As ambivalent as it may seem, many of the related items that would go with a beer bottle collection have been of interest to collectors longer than the bottles themselves. Because of their unusual beauty such items as serving trays, mugs, and colorful advertising posters have found their way into collections of other than bottle collectors. Still, with persistence, the beer bottle collector can obtain some of these co-related items (see chapters 56, 57, and 60).

Bibliography

BOOKS

Anderson, Sonja and Will. *Anderson's Turn-of-the-Century Brewery Directory*. Privately published, 1968.

————. *Beers, Breweries and Breweriana*. Privately published, 1969.

Lief, Alfred. *A Close-Up of Closures*. New York: Glass Container Manufacturers Institute, no date.

Lynch, Patrick, and Vaizey, John. *Guinness's Brewery in the Irish Economy, 1759–1876*. Cambridge and New York: Cambridge University Press, 1960.

Munsey, Cecil. *Would You Believe*. San Diego, California: I.P.S., a division of Neyenesch Printers, Inc., 1968.

Wilson, Bill and Betty. *Spirits Bottles of the Old West*. Wolfe City, Texas: Henington Publishing Company, 1968.

PERIODICALS

Howard, F. D. and Lee. "Bottles of Milk Glass," *Western Collector*, IV (October, 1966), 28–29.

Toulouse, Julian H. "Those Royal Ruby Beer Bottles," *Spinning Wheel*, XXV (September, 1969), 14–15.

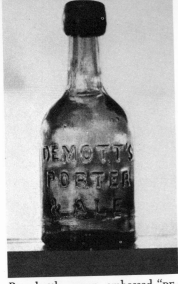

Beer bottle, green, embossed "DE-MOTT'S PORTER & ALE," H. 6½ in., c. 1870–1880.

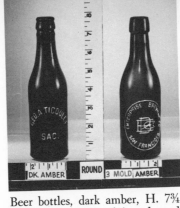

Beer bottles, dark amber, H. 7¾ in. (left to right): (1) embossed "GEO. A. TICOULET, SAC." on side, crown cap, c. 1910; (2) embossed "ENTERPRISE BREWING, SAN FRANCISCO" in a circle around a monogram of overlapping letters "E," "B," and "CO.," applied top, cork closure, c. 1890. Embossing painted for photographing. (John C. Fountain, Amador City, Cal.)

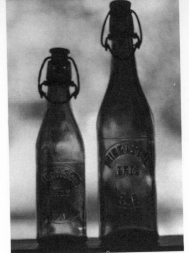

Beer bottles, amber, embossed "MIRASOUL BROS. S.F.," H. 8 in. and 10 in., c. 1880–1900, Lightning stoppers, blown in plate mold.

Beer bottle, amber, embossed "ALABAMA BREWING CO. SAN FRANCISCO," H. 7½ in., c. 1880–1900, Baltimore loop seal closure, blown in plate mold.

Beer bottle, green, embossed "FREDERICKSBURG BOTTLING CO., S.F.," and "THIS BOTTLE NOT TO BE SOLD," H. 15 in., c. 1890–1900, Lightning stopper, blown in plate mold.

Wire device used to hold a cork closure in beer and soda water bottles under pressure.

Cork closure held in place by a wire over the cork and twisted around beneath neck of the bottle. (*A Close-Up of Closures* by Glass Container Manufacturers Institute, New York)

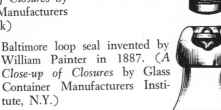

Baltimore loop seal invented by William Painter in 1887. (*A Close-up of Closures* by Glass Container Manufacturers Institute, N.Y.)

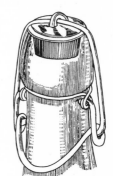

Lightning Stopper invented by Charles de Quillfeldt in 1875. (*A Close-Up of Closures* by Glass Container Manufacturers Institute, New York)

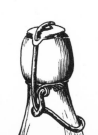

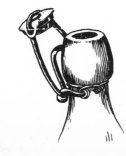

Lightning-type closures of the late nineteenth century. *Left:* Electric Stopper. *Right:* Pittsburgh Stopper. (November 1, 1888, *National Bottlers' Gazette*)

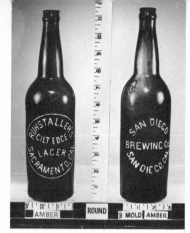

Beer bottles, amber, crown cap, H. 11½ in. (left to right): (1) embossed "RUHSTALLER'S GILT EDGE LAGER SACRAMENTO, CAL." on side; (2) embossed "SAN DIEGO BREWING CO., SAN DIEGO, CAL." on side; c. 1910. Embossing painted for photographing. (John C. Fountain, Amador City, Cal.)

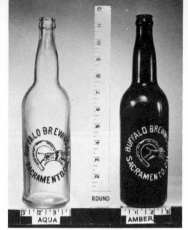

Beer bottles, crown caps, embossed "BUFFALO BREWING CO., SACRAMENTO, CAL." around a bull jumping through a horseshoe, H. 11½ in. (left to right): (1) aqua; (2) amber; c. 1910. Embossing painted for photographing. (John C. Fountain, Amador City, Cal.)

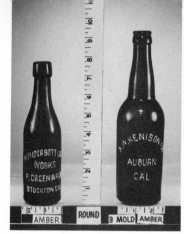

Beer bottles, amber (left to right): (1) embossed "WUNDER BOTTLING WORKS, P. GREENWALD, STOCKTON, CAL." on side, applied top, cork closure, H. 7¾ in., c. 1890; (2) embossed "A. W. KENISON CO., AUBURN, CAL." on side, crown cap, H. 9½ in., c. 1910. Embossing painted for photographing. (John C. Fountain, Amador City, Cal.)

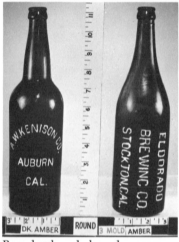

Beer bottles, dark amber, crown cap, H. 11½ (left to right): (1) embossed "A. W. KENISON CO., AUBURN, CAL." on side; (2) embossed "EL DORADO BREWING CO., STOCKTON, CAL." on side; c. 1910. Embossing painted for photographing. (John C. Fountain, Amador City, Cal.)

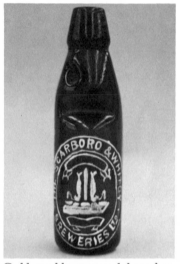

Codd marble-stoppered beer bottle, green, embossed "THE SCARBORO & WHITBY BREWERIES LTD.", H. 9 in., c. 1900. This type of bottle was used most extensively in the bottling of soda water. Embossing painted for photographing.

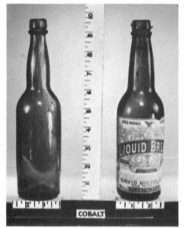

Beer bottles, cobalt-blue, H. 9¾ in. (left to right): (1) "Liquid Bread—A Pure Extract of Malt," unembossed, paper label removed; (2) same bottle displaying paper label; c. 1885. (John C. Fountain, Amador City, Cal.)

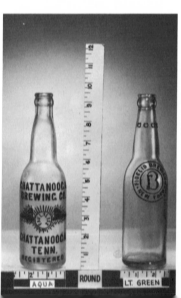

Beer bottles, crown caps (left to right): (1) aqua, embossed "CHATTANOOGA BREWING CO., FAULTLESS [in a circle with wings], CHATTANOOGA, TENN. REGISTERED" on side, H. 9¾ in.; (2) light green, embossed "FIDELIO BREWERY, NEW YORK" in a circle around a "B" in another circle, H. 9¾ in., four heart shapes embossed near top of neck; c. 1910. Embossing painted for photographing. (John C. Fountain, Amador City, Cal.)

Beer carafe, amber, enameled floral design on side and words "One fresh drink makes the old young" hand painted in German, ornate pewter handle, H. 18 in., late nineteenth century.

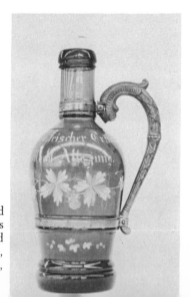

24

Ink Bottles

Until the nineteenth century, containers for ink were mostly made in ceramic (see Chapter 26). The major suppliers of ink to the Colonies shipped their product from England almost exclusively in pottery bottles.

The first ink manufactured in America was made by Maynard and Noyes Company, of Boston, in 1816; another early manufacturer was the Thaddeus Davis Ink Company, of New York City, which began manufacturing ink in 1825. Others soon began to make and sell ink in America. Most firms ordered pottery bottles from England and sold their ink in a wide variety of ceramic containers.

There are two basic types of ink containers. First there is the *master ink* or bulk container. These bottles are comparatively large (pints and quarts mostly) and contained bulk ink either ready to use or in concentrated form which had to be diluted with water before using. The master inks were obviously used for storage.

The vessel that actually was on the desk and from which the writer obtained ink by dipping the pen was one of two types: (1) *the inkwell;* (2) *the ink bottle.*

Today's bottle collectors, because of their preoccupation with common containers, have focused their attention on the collecting of ink bottles. The inkwell was a permanent and decorative container that was a relatively expensive item. There is no reason why a bottle collector could not include inkwells in an ink bottle collection, and some have. Of course, for many years inkwells have held the interest of the antique collector. As a consequence most of the very interesting specimens have been gathered and included in antique collections.

To a certain extent the writing device determined the design of the container used for ink. Until the 1850s the quill, a feather with the end of its shaft sharpened, was the main writing device for Europeans and Americans. A split-pointed piece of metal used in a holder—called a pen and invented by Peregrine Williamson, of Baltimore, Maryland, in 1809—became popular after 1858, when Richard Esterbrook established a factory in Camden, New Jersey, and produced steel pens on a commercial basis. Because these pens must be dipped into the ink container frequently during writing, ink bottles were designed to minimize tipping. The fountain pen, invented in Reading, Pennsylvania, by D. Hyde in 1830, was not manufactured commercially until 1884, when two hundred were produced by hand by the L. E. Waterman Company of New York City. The advent of the fountain pen affected ink bottle manufacturing by reducing the need for a container to be always at hand. The result was a standard round or square container that was usually kept in a drawer. By 1900 most ink bottles were of these standard shapes.

There are well over a thousand types of ink bottles and their variants, representing literally hundreds of firms. A good book which lists many of these firms and has sketches of many of the bottles involved is *Old Inks* by Lavina Nelson and Martha Hurley. Literature on this specialty is rather limited because collectors have only in recent years become interested in the common ink container.

The major characteristic of ink bottles is their shape. A good variety of shapes is to be found in these bottles mainly because of the need to design a bottle that would not tip, and the demand that early ink bottles be attractive because they, of necessity, remained out on the writing table in plain sight. One of the unusual shapes is the umbrella type which is conical and eight-sided. Three companies known to have produced great numbers of these bottles are the Whitney Glass Works, the Isabella Glass Works, and Whitall, Tatum. In general the umbrella ink bottle was popular from the 1820s to the 1880s; many have been located that were hand blown and bear pontil scars.

A container similar to the umbrella is the conical ink bottle, which is not faceted. The one firm that specialized in this shape is the Carter Ink Company. Even though this firm has been producing ink bottles only since 1858 some of their early bottles are found with pontil scars.

It is interesting to note that umbrella ink bot-

tles were referred to in early catalogues as fluted cone stands and conical ink bottles were called cone stands, but these names have not persisted.

Another major shape is the teakettle or side-spouted ink bottle. These bottles are quite numerous in slight variations of the basic shape and some collectors restrict themselves exclusively to this type. The Sandwich, Massachusetts, glassworks was responsible for many of the teakettle ink bottles. Extreme variations of the teakettle shape which feature the off-center mouth are often referred to as igloo-, banana-, or cucumber-shaped bottles.

As far back as the 1840s a few ink bottles were blown in figural shapes, including shoes, turtles, barrels, buildings, people, and boats.

The size of an ink container depends greatly on its type. Master ink containers were most common in pints and quarts but occasionally can be found in gallon size. Individual desk bottles are also fairly standardized at one to several ounces.

Ink-bottle closures are of interest to the collector of these containers but are not of great importance. Except for a relatively few unusual metal closures, the vast majority of both master and individual ink bottles utilized cork closures. Many of the early glass bottles used for ink are not only crude in their construction but also in their finish; many of them are found with crudely ground-off necks. Even after the Owens machine made screw tops practical, ink bottles were still made to use cork closures. In the 1920s screw caps did finally prevail.

Color is a very important aspect of the specialization in ink containers. In the ceramic vessels brown and white were the most ordinary colors. In glass ink bottles the common aqua and light greens were prevalent. Uncommon and harder to find are bottles in varying shades of amber, cobalt-blue, amethyst, and dark green. The unusual colors, as well as other unusual characteristics, increase value.

Prices of ink bottles range greatly from $1 or $2 for the common containers to well over $100 for the rarer ones.

Embossments on ink bottles are neither common or uncommon. For the most part they are limited to lettering identifying the company who made the ink. Many ink producing firms relied on paper labeling to identify their product; these labels tend to be fancy and quite colorful. As might be expected, paper labels are not plentiful and most have been destroyed over the years.

Co-related material for the interested ink-bottle collector could include a variety of pens, advertising materials and the like.

One problem the collector may encounter with the common types of glass bottles involves identification. Glass manufacturers often sold bottles with the same basic shape to companies merchandising glue and shoe polish. At present there is virtually no collector interest in the latter two types. Unless specifically embossed or labeled "glue" or "shoe polish," ink bottles of all shapes are usually included in their collections by ink-bottle collectors.

Bibliography

BOOKS

Kane, Joseph Nathan. *Famous First Facts.* New York: The H. W. Wilson Company, 1964.

Munsey, Cecil. *Would You Believe.* San Diego, California: I.P.S., a division of Neyenesch Printers, Inc., 1968.

Nelson, Lavina, and Hurley, Martha. *Old Inks.* Nashua, New Hampshire: Cole Printing Co., Inc., 1967.

PERIODICALS

"Hall's Ink Bottle for Use on School or Other Desks," *Scientific American,* LXVI (April 23, 1892), 260.

Hawthorne, Roger. "American Glass Inkwells and Ink Bottles," *Spinning Wheel,* XXV (December, 1969), 20–21 and 40.

Peterson, A. G. "Ink Bottle Patents," *Hobbies,* LXXII (July, 1968), 98h–98i.

Whited, Gene. "Inks That Left Their Mark," *Western Collector,* V (October, 1967), 41–45.

Inkwell, dark olive-amber, Coventry, Conn., 2½ in. x 1¾ in., early nineteenth century.

Ink bottle, clear, cone shape, rough pontil scar on bottom, H. 3 in., c. 1850–1860. (John C. Fountain, Amador City, Cal.)

Master ink bottle, cobalt-blue, three-piece mold, unembossed, H. 10 in., c. 1880–1900.

Ink bottle, clear, L. 4 in., embossed "W. E. LEWIS MFR., PAT. JUNE 30–91," rubber-covered mouth, c. 1891–1900.

Ink bottle, embossed "WHEELER'S BLACK INK" on side, aqua, H. 2½ in., only ink ever manufactured in San Diego, California, c. 1900. Embossing painted for photographing.

Ink bottle, white milk glass, H. 3 in., unembossed, c. 1890.

Master ink bottles, cobalt-blue, H. 10 in. (left to right): (1) embossed "UNDERWOODS INKS" on side, pouring spout; (2) unembossed, reversible pouring stopper, c. 1890–1910.

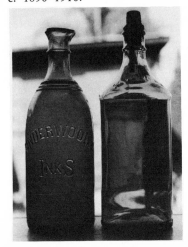

Ink bottle, embossed "CARTER" twice near base, cobalt-blue, six cathedral-type panels on sides, H. 9½ in., c. 1920.

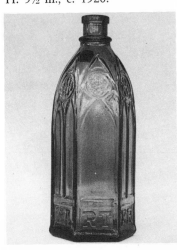

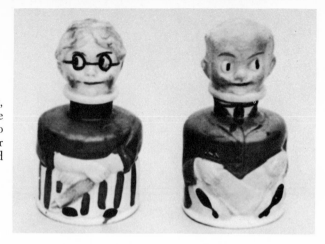

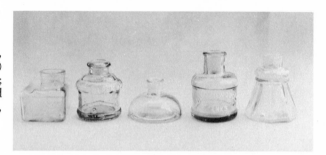

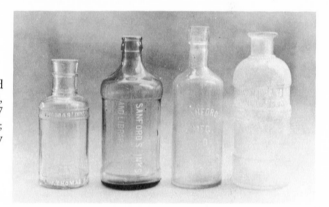

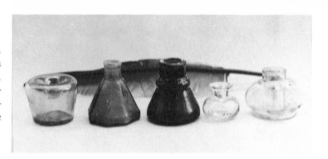

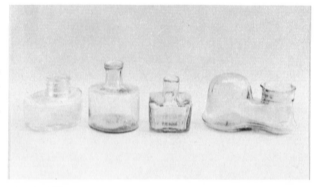

Ink bottles, distributed by the Carter's Ink Company, ceramic, Mrs. Carter is red and white, Mr. Carter is blue and white, H. 3⅝ in. Bottles, first issued from 1914 to 1916 for advertising purposes, made in Germany. Later editions made by an American company after World War I.

Ink bottles (left to right): (1) amber, rectangular shape, embossed "DIAMOND INK CO." on base, H. 2¼ in.; (2) aqua, embossed "SSS FOUNTAIN PEN INK," H. 2¾ in.; (3) aqua, dome shape, H. 2 in.; (4) aqua, embossed "UNDERWOOD'S INKS," H. 3¼ in.; (5) aqua, conical shape, unembossed, H. 3 in.; c. 1880–1900.

Master ink bottles (left to right): (1) aqua, embossed "THOMAS' INKS, L. H. THOMAS CO.," H. 6 in.; (2) amber, embossed "SANFORD'S INKS AND LIBRARY PASTE," H. 7 in.; (3) aqua, embossed "SANFORD MFG. CO.," H. 7¾ in.; (4) aqua, embossed "CHAS. M. HIGGINS & CO., NEW YORK," H. 7½ in.; c. 1880–1910.

Ink bottles (left to right): (1) sapphire-blue inkwell, unembossed, H. 2 in.; (2) green, umbrella type, rough pontil scar on base, H. 2¾ in.; (3) amber, umbrella type, unembossed, H. 2¾ in.; (4) amethyst, embossed "SANFORDS INKS," H. 1½ in.; (5) amethyst, embossed "DIAMOND INK, MILWAUKEE" on base, H. 2 in.; mid- to late nineteenth century.

Ink bottles (left to right): (1) aqua, boat shape, unembossed, L. 2¼ in.; (2) aqua, circular shape, rough pontil scar on base, H. 2¾ in.; (3) aqua, square shape, sheared top, H. 2¼ in.; (4) amethyst, igloo type, H. 4 in., c. 1860–1890.

25

Whiskey Bottles

Though whiskey and whiskey bottles came early in America's history the collector of whiskey bottles usually restricts his collection to those bottles produced from about the mid-1800s to Prohibition (1920). Whiskey bottles before and after this period will be mentioned in this chapter but are also discussed elsewhere.

Some of the earliest whiskey bottles were made by the great American glassmaker William Henry Stiegel (see Chapter 5). Stiegel as well as other glassmakers of the 1700s and early 1800s made fine whiskey bottles and flasks; these bottles have long been collected, more as pieces of early American glass than as whiskey bottles.

Shortly after the turn of the nineteenth century the popular whiskey bottle became the historical and pictoral flasks (see Chapter 19). These whiskey containers are also very interesting and have been enthusiastically gathered for many years. Like Stiegel, Pitkin, South Jersey, Keene, midwestern, and other bottles and flasks, the interest in historical and pictorial flasks has been shown by collectors of early American glass.

Perhaps the first bottles designed specifically for whiskey that the whiskey bottle collectors like to include in their collections are the Bininger bottles. Bininger bottles were produced mainly from about 1840 to about 1870 for the several New York grocery stores owned by the Bininger family. By 1860 this merchant family had one of the finest stocks of wines and liquors in the United States. Most of their spirits were sold in a large variety of interesting bottles including square bottles, clock-shaped bottles, cannon-shaped bottles, barrel-shaped bottles, handled glass jugs, and flattened pear-shaped flasks. Specimens of Bininger bottles have been located that date as early as the 1820s and as late as the 1880s. For their time the Bininger stores were quite progressive in their glass packaging. Bininger bottles are favored by collectors not only for their unusual shapes but also for their extensive embossments and their beautiful colors which include most shades of amber and green plus several shades in puce, one of the most sought-after colors in any type of bottle.

Another whiskey bottle of the mid-1880s, and one that has become a classic in bottle-collecting circles, is the amber E. G. Booz Old Cabin Whiskey bottle. This highly desirable bottle was produced around 1860 for a Philadelphia whiskey vendor named Edmund Booz.

Because of its popularity throughout the years many stories are told about the Booz bottles. Unfortunately most of these are untrue. One story places the bottle at 1840, mainly because "1840" is embossed on the roof of this cabin-shaped bottle. Also because of the embossed date, many claim the bottle figured politically in the "log cabin and barrel of cider" struggle between William Henry Harrison and Henry Clay over who would oppose Martin Van Buren for the Presidency. In the first place the bottle is in the shape of a cabin, but not a log cabin; secondly a recent search of the Philadelphia city directories revealed that Edmund Booz was not listed at the address embossed on the bottle ("120 WALNUT STREET") until 1860; before that time Booz was listed as an importer at 54 South Front Street.

Another story regarding Booz and his bottle claims that the slang term for whiskey, "booze," was a result of the cabin-shaped Booz bottle. Again, research fails to substantiate this. It can be readily proved that the term "booze" was a corruption of "bouse," a word for liquor used in the seventeenth century. Similar words can also be found in earlier German, French, and Dutch. The *Oxford Dictionary of the English Language* maintains that the word "boozy—affected by drinking" was in use in 1529. Although it would seem possible that the Booz bottle could be responsible for the word's renewed popularity, it is not possible to claim that "booze" originated with the Booz bottle.

Over the years, the cabin-shaped Booz bottle has enjoyed immense popularity and has been reproduced from time to time. Even today, Booz bottles containing a whiskey called E. G. Booz are being sold; these, unlike many of the other reproductions, are easily identified by the added embossment, required until recently by Federal Law, "FEDERAL LAW FORBIDS SALE OR RE-USE OF THIS BOTTLE." Other recent reproductions can be identified by their unusual colors: bright blue, green, purple, and yellow. The earlier reproductions are difficult to tell from the originals. Some

collectors claim that the original bottles were tapered at both ends of the bottle where the roof peaked. While it is true that some of the originals had this feature it is also true that some did not. A careful examination of the original mold, used by the Whitney Glass Works, which is on display at the Philadelphia Museum of Art, reveals that the mold has been altered by the addition of iron pieces at the roof's peak. These additions would produce the tapered peaks. It is probable that some of the first cabin-shaped bottles were made with completely peaked roofs but that because these peaks were easily broken the mold was modified.

Perhaps the best way to determine an original E. G. Booz bottle, but by no means a foolproof one, is to examine the side of the bottle embossed "E. G. BOOZ OLD CABIN WHISKEY." The original mold has a period after the word "whiskey," and some of the reproductions do not—some do, however, so this is not a foolproof method. It is interesting that an authenticated original Booz bottle sells for around $300 and the early reproductions that are identical or almost so sell for almost $200, with the exception of those produced in milk glass; these sell for about $30. Recent reproductions with the added embossment "FEDERAL LAW FORBIDS SALE OR RE-USE OF THIS BOTTLE" usually sell for about $6.

At about the time Edmund Booz was distributing his whiskey in the now famous cabin-shaped bottle, other distillers were beginning to use the cylindrical glass bottles whose capacity is a fifth of a gallon. This trend came at about the time when the historical and pictorial flasks were decreasing in popularity. The cylindrical fifth was generally rather crude in construction because of prevalent glassblowing techniques, and featured heavy embossments. These embossments consisted mainly of the brand name and/or a design. Even though many of these bottles were made during the period from 1860 to 1880, a relatively small number of specimens have survived. By about 1880 the heavily embossed cylindrical fifth for whiskey was firmly established; oval (often called pumpkinseed) and rectangular flasks were also becoming more popular. These bottles were produced mostly in half-pint and pint sizes. They also featured heavy embossments of words and/or designs. The period from about 1880 to 1910 was one of tremendous whiskey bottle production because of improved glassblowing methods and extensive use of the plate mold. Since vast numbers

of these bottles were produced many are still available.

As yet there is no book that is devoted to whiskey bottles of the entire nation. *Spirits Bottles of the Old West* by Bill and Betty Wilson is probably the best of the many available books on western whiskey bottles. This work specializes mostly in bottles of the West from about 1860 to 1910. Because many of the bottles pictured and discussed were national brands, interested collectors from all parts of the country will be likely to find the book valuable.

Of the many interesting and unusual people that have been involved in the distilling and selling of whiskey during the "whiskey bottle period" (c. 1860–1920), perhaps the most interesting and unusual was the Tennessee distiller Jack Daniel. Jack Daniel was an unorthodox person from early childhood; he ran away from home at the age of five and never returned except for visits. In 1863, at the age of fifteen, Jack Daniel had learned the distilling business and was a full partner in a distillery. By 1866 Daniel owned his own distillery and the three hundred acres upon which it stood. Part of his unusualness was the fact that he was only five feet, two inches tall. Shortly after becoming the sole owner of his own distillery, Jack Daniel began to wear a formal long black frock coat and large black planter's hat. This outfit became a uniform of sorts and he dressed that way for the remainder of his life. Jack Daniel died a bachelor at the age of sixty-three in 1911. Even though much of Jack Daniel's whiskey was sold in ceramic jugs (see photographs in Chapter 27) he did bottle some in glass containers. Like Jack, his glass bottles were somewhat unusual; they resembled mineral water bottles (see Chapter 21). Jack Daniel, around the turn of the century, joined his competitors in giving away bar bottles (see Chapter 32) enameled with his product's name; at least one of these bottles has survived. Jack Daniel's whiskey has gone on to become one of the best whiskeys in the United States according to many of its consumers.

Many distillers besides Jack Daniel used ceramic jugs as well as bottles and gave away promotional bar bottles; both jugs and bar bottles are generally left to specialists in those areas by the whiskey bottle collector.

In 1920, when Prohibition was initiated on a national scale, the liquor industry, for all intents and purposes, was shut down. The only whiskey produced legally was supposed to be for medicinal

purposes. Recently, bottle collectors have taken an interest in the few bottles used for whiskey during this period. Because of their supposed medicinal use some of these whiskey bottles made during Prohibition (mostly flasks) came with metal measuring caps which screwed over the cork closure.

With the repeal of Prohibition in 1933 the distilling of whiskey for general consumption was resumed under strict government regulation. The most notable regulation of interest to collectors of bottles is the one that required all liquor bottles to be embossed "FEDERAL LAW FORBIDS SALE OR RE-USE OF THIS BOTTLE." This regulation was in effect until 1964. Generally, bottles bearing this embossment are of little interest to bottle collectors. But there will probably come a time when this embossment will be considered in a positive way as being one of the most exact methods of dating spirits bottles from 1933 to 1964. This positive use of the embossment will, no doubt, parallel a belated interest by bottle collectors in the currently much-overlooked glass containers of the 1920–1960 period.

In the past several years there has been widespread interest in ceramic and some glass bottles used by distillers and the like to market their alcoholic products. The bottles are not gathered because they contained whiskey but rather because they are decanters (see Chapter 32) in some cases and figural in shape (see Chapter 20) in most cases. These bottles are pictured and discussed extensively in the chapters devoted to contemporary bottles (see Part VI).

The following general discussion of whiskey bottles will apply only to those glass whiskey containers made between 1850 and 1920.

Both sizes and shapes of these whiskey bottles are fairly standardized. The few exceptions in shape are of particular interest to collectors. Colors are limited for the most part to varying shades of amber, and clear glass. Green glass, however, is not rare. Cobalt-blue can be considered rare and is very much sought after.

The predominant characteristic of whiskey bottles is embossing. While whiskey bottle embossments are not exceptional when compared to many other types of bottles, they are the most unusual aspect of whiskey bottle collecting and, therefore, of major importance to the collector.

Closures on whiskey bottles are almost exclusively of the common cork variety. Screw caps are found on some of the more expensive bottles. Inside screw closures were used for a few years around 1860 but because of the manufacturing expense and difficulties involved this closure, featuring a threaded stopper which screwed into internal female threads in the neck of the bottle, was set aside until around 1900. From about 1890 to 1910 a comparatively large number of whiskey bottles were made with inside screw closures. After this period the industry went back to the less expensive cork closure.

Bottles made before 1880 are quite scarce and many can be considered rare. Bottles made before 1880 are very expensive and sell for prices of $100 to $1800. Bottles made after 1880 can usually be obtained for $10 to $100.

Whiskey bottle collectors have a large variety of co-related items that they can include in their collections. Some of the most interesting include trays, glasses, mugs, posters, corkscrews, periodical and newspaper advertisements, and trade cards (see chapters 56, 57, and 60).

Bibliography

BOOKS

Carson, Gerald. *The Social History of Bourbon*. New York: Dodd, Mead & Co., 1963.

Fountain, John C., and Colcleaser, Donald E. *Dictionary of Spirits and Whiskey Bottles*. Amador City, California: Ole Empty Bottle House Publishing Co., 1969.

Freeman, Larry. *Grand Old American Bottles*. Watkins Glen, New York: Century House, 1964.

McGuire, Eric. *The Old San Francisco Directory of Liquors Wholesale and Retail*. Privately published, no date.

Munsey, Cecil. *Would You Believe*. San Diego, California: I.P.S., a division of Neyenesch Printers, Inc., 1968.

Snyder, Robert E. *Bottles in Miniature*. 2 vols. Amarillo, Texas: privately published, 1969 and 1970.

Thomas, John L. *Whiskey Bottles*. Privately published, no date.

Wilson, Bill and Betty. *Spirits Bottles of the Old West*. Wolfe City, Texas: Henington Publishing Co., 1968.

PERIODICALS

Hubbard, Clarence T. "The Log Cabin Lullaby," *Western Collector*, IV (August, 1966), 27–28.

Spiller, Burton. "Bininger Bottles," *Western Collector*, VI (May, 1969), 235–239.

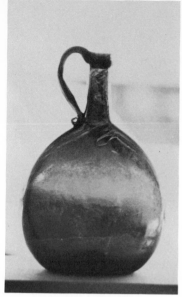

Whiskey flask, dark amber, chestnut shape, heavy pontil scar, H. 9 in., c. 1850.

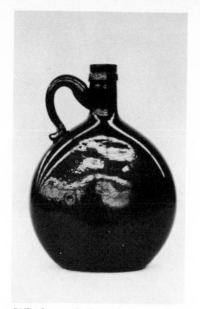

Whiskey flask, dark amber, chestnut shape, applied handle, pontil scar, H. 7 in., c. 1850.

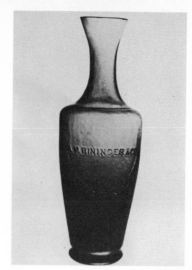

"A. M. BININGER & CO., NO. 19 BROAD ST., NEW YORK," amber, urn shape, quart, c. 1860–1863. (*Western Collector*, San Francisco, Cal.) Photo by Dr. Burton Spiller.

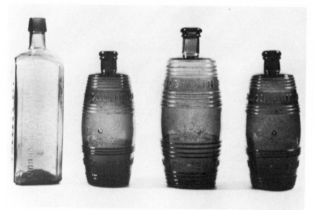

"BININGER'S OLD KENTUCKEY BOURBON" (left to right): (1) amber, square, quart, note misspelling of Kentucky (Kentuckey); (2) amber, barrel shape, ¾ quart; (3) amber, barrel shape, quart; (4) amber, barrel shape, ¾ quart; c. 1860–1875. (*Western Collector*, San Francisco, Cal.) Photo by Dr. Burton Spiller.

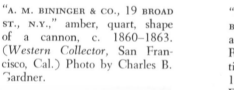

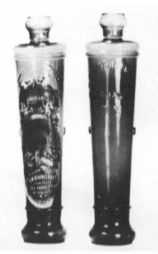

"A. M. BININGER & CO., 19 BROAD ST., N.Y.," amber, quart, shape of a cannon, c. 1860–1863. (*Western Collector*, San Francisco, Cal.) Photo by Charles B. Gardner.

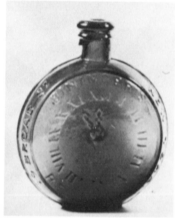

"BININGER'S REGULATOR, 19 BROAD ST., NEW YORK," dark amber, shape of a clock with Roman numerals indicating the time as eleven o'clock, c. 1860–1863. (*Western Collector*, San Francisco, Cal.) Photo by Dr. Burton Spiller.

"A. M. BININGER & CO., NO. 19 BROAD ST., NEW YORK," amber, round, applied handle, pint, c. 1860–1863. (*Western Collector*, San Francisco, Cal.) Photo by Dr. Burton Spiller.

"BININGER'S TRAVELER'S GUIDE," amber, pear shape, half-pint flask, c. 1850–1875. (*Western Collector*, San Francisco, Cal.) Photo by Dr. Burton Spiller.

127

128

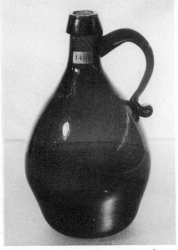

Whiskey bottle, olive-green, free-blown handled jug, probably Keene, H. 9 in., early nineteenth century. (Charles B. Gardner, New London, Conn.)

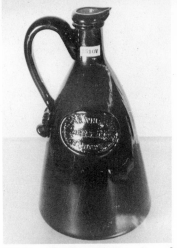

Whiskey bottle, amber, embossed "STAR WHISKEY, NEW YORK, W. B. CROWELL, JR." in oval frame, inverted cone shape, applied handle, blown in ribbed mold and expanded, quart, early to mid-nineteenth century. (Charles B. Gardner, New London, Conn.)

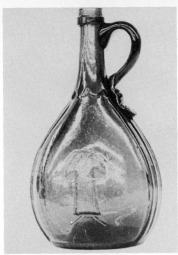

Whiskey flask, amber, applied handle, sheaf of wheat embossment on side, H. approx. 10 in., c. 1840–1860.

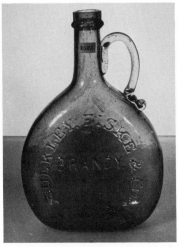

Spirits bottle, light amber with green applied handle, embossed "BULKLEY FISKE & CO. BRANDY" on side, H. approx. 9 in., mid-nineteenth century. (Charles B. Gardner, New London, Conn.)

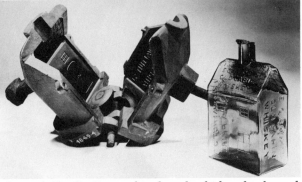

Original E. G. Booz cabin-shaped whiskey bottle and mold; amber, embossed "E. G. BOOZ'S OLD CABIN WHISKEY" and "120 WALNUT ST. PHILADELPHIA," H. 7½ in., c. 1860, made at the Whitney Glass Works in Glassboro, New Jersey. (Philadelphia Museum of Art)

Tennessee whiskey distiller Jack Daniel (1849–1911) dressed in the formal long black frock coat he wore almost daily for approximately the last forty years of his life. (Jack Daniel Distillery, Lynchburg, Tenn.)

I. W. Harper whiskey bottles and jug (left to right): (1) glass flask, c. 1875; (2) wicker-covered amber bottle, c. 1880; (3) clear glass bottle with gilt lettering and design, c. 1890; (4) jug; (5) pinch bottle decanter with enameled lettering, c. 1900; (6) decanter with ground out and filled gold lettering, c. 1910. (Carl Byoir and Associates, Inc., New York)

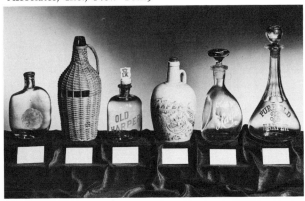

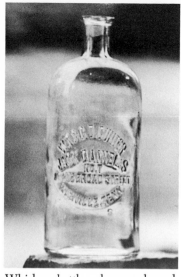

Whiskey bottle, clear, embossed "W. T. & C. D. GUNTER JACK DANIEL'S NO. 7, 208 BROAD STREET, NASHVILLE, TENN.," c. 1875–1885. (Jack Daniel Distillery, Lynchburg, Tenn.)

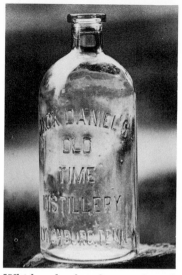

Whiskey bottle, clear, embossed "JACK DANIEL'S OLD TIME DISTILLERY LYNCHBURG, TENN.," c. 1890–1910. (Jack Daniel Distillery, Lynchburg, Tenn.)

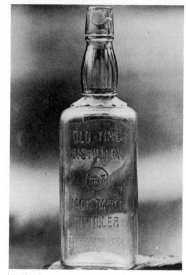

Whiskey bottle, clear, embossed "OLD TIME DISTILLERY JACK DANIEL DISTILLER LYNCHBURG TENN" and "NO 7" in a circle, H. approximately 11 in., c. 1890–1900. (Jack Daniel Distillery, Lynchburg, Tenn.)

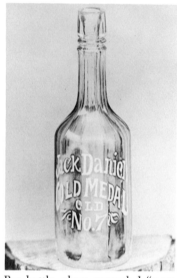

Bar bottle, clear, enameled "JACK DANIEL'S GOLD MEDAL OLD NO. 7," H. approximately 11 in., c. 1905–1910. (Jack Daniel Distillery, Lynchburg, Tenn.)

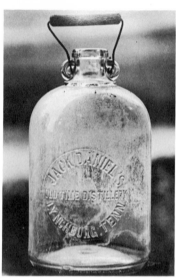

Whiskey bottle, clear, wire and wood handle, embossed "JACK DANIEL'S OLD TIME DISTILLERY LYNCHBURG, TENN.," c. 1900–1920. (Jack Daniel Distillery, Lynchburg, Tenn.)

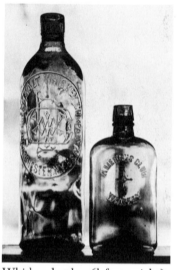

Whiskey bottles (left to right): (1) amber, embossed "THE DUFFY MALT WHISKEY COMPANY, ROCHESTER, N.Y., USA," in a circle around an overlapping monogram of "D. Co.," H. 10 in., c. 1885–1915; (2) amber, pocket flask shape, embossed "AMERICUS CLUB WHISKEY" on side, H. 6 in., c. 1895–1905.

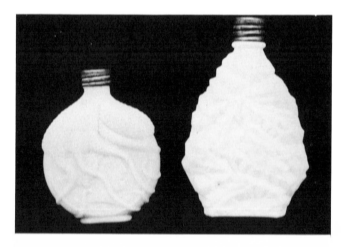

Whiskey flasks (left to right): (1) milk glass, depicts a large American silver dollar being strangled by an eight-armed octopus originally painted red, obverse shows the head of Liberty with her mouth open as though screaming with pain, reverse shows an American eagle under which the date 1901 has been embossed, H. 4½ in., commemorates Frank Norris's book *The Octopus*, which relates the struggle between the wheat growers and the Southern Pacific Railroad in the San Joaquin Valley at the turn of the century; (2) milk glass, shape of a gold nugget, inscribed "KLONDYKE" on top of metal screw cap (in 1860 Klondyke was a mining town in the Northern California Mother Lode country), originally painted gold with reddish-brown flecks, H. 6 in., c. 1860–1865.

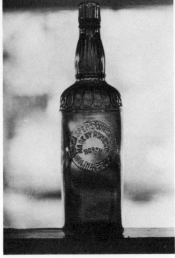

Whiskey bottle, cobalt-blue, embossed "CASPER'S WHISKEY, MADE BY HONEST NORTH CAROLINA PEOPLE" in circular frame on one side, H. 12 in., c. 1895–1902.

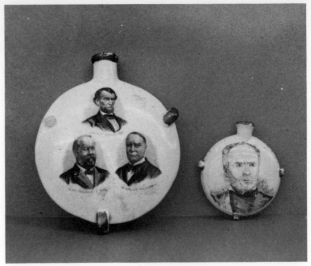

Porcelain whiskey flasks (left to right): (1) Lincoln, Garfield, and McKinley, H. 5½ in., 1901; (2) "Stubenville Grand Army Day," H. 3 in., 1891.

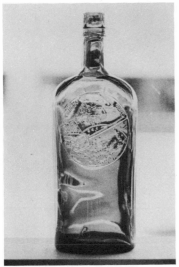

Whiskey bottle, green, H. 11 in., c. 1900.

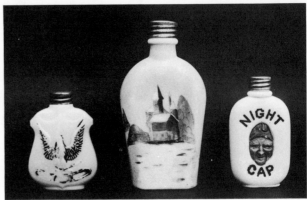

Whiskey flasks, white milk glass, threaded ground tops (left to right): (1) eagle with spread wings standing on two crossed arrows, H. 3½ in., embossing hand painted; (2) "The Old Homestead Fine Bourbon Whiskey (Samuel Westheimer Distiller, St. Louis, Mo.)," H. 6½ in., unembossed, peasant house surrounded by rocks and trees hand painted on side, very rare, c. 1895–1905; (3) "NIGHT CAP," H. 4 in., words and face of man with night cap debossed and hand painted, late nineteenth century.

Whiskey bottles, white milk glass (left to right): (1) embossed "E. G. BOOZ'S OLD CABIN WHISKEY" on side, H. 8 in., hand finished, c. 1920; (2) embossed "QUIRYE—DR. KOCH, BERLIN" with a dog profile on the side, H. 8¼ in., late nineteenth century.

Liqueur bottle, white milk glass, Crème de Italia, H. 8 in., unembossed, rough pontil scar, c. 1890.

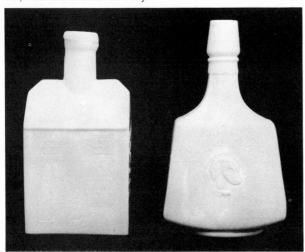

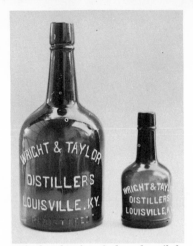

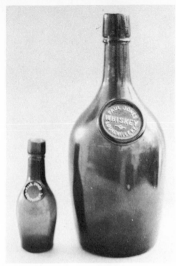

Whiskey bottle, embossed "J. W. FRIEDENWALD & CO., FAMILY WINE & LIQUOR EMPORIUM, 107 TO 111 N. EUTAW ST., BALTIMORE, MD." on side, olive-green, H. 10½ in., c. 1890–1910.

Whiskey bottles, dark amber (left to right): (1) embossed "WRIGHT & TAYLOR DISTILLERS, LOUISVILLE. KY., REGISTERED," H. 9¾ in.; (2) embossed "WRIGHT & TAYLOR DISTILLERS, LOUISVILLE, KY.," H. 5½ in., c. 1900. Embossing painted for photographing.

Whiskey bottles, amber, embossed "PAUL JONES, WHISKEY, LOUISVILLE, KY." on side in a round frame, H. 4½ in. and 9½ in. (⅖ gallon), c. 1900–1910. Embossing painted for photographing.

Miniature whiskey bottles (left to right): (1) amber, embossed "CROWN DISTILLERIES COMPANY" on side, inside screw cap, H. 5½ in.; (2) clear, embossed "TAYLOR & WILLIAMS, INCORPORATED, WHISKEY, LOUISVILLE, KY.," on side, H. 4½ in.; (3) sun-colored amethyst, embossed "BROWN-FORMAN CO., LOUISVILLE, KY.," on side, H. 4½ in.; (4) amber, embossed "THE DUFFY MALT WHISKEY CO., ROCHESTER, N.Y., U.S.A." on side, H. 4 in.; (5) clear, embossed "QUAKER MAID WHISKEY" on side, H. 4½ in.; (6) amber, embossed "TRADE MARK" in a wreath and "JESSE MOORE OLD BOURBON & RYE: JESSE MOORE & CO., LOUISVILLE, KY,: JESSE MOORE-HUNT CO., SAN FRANCISCO," H. 6¼ in.; c. 1890–1910. Embossing painted for photographing.

Miniature spirits bottles (left to right): (1) clear, paper label reads in part "Tequila 7 Leguas Supremo," H. 4½ in., mid-twentieth century; (2) clear, paper label reads in part "Rieger's Monogram Whiskey," H. 4½ in., c. 1875; (3) clear, paper label reads in part "Booth's Distiller London Dry Gin," H. 4 in., mid-twentieth century; (4) clear, paper label reads in part "Gordon's Ginebra Destilada," H. 4 in., mid-twentieth century.

Gin bottles, embossed "LONDON, GORDON'S DRY GIN, ENGLAND" on the sides: (1) green, H. 8½ in. (⅖ gallon); (2) aqua, H. 4 in.; c. 1900. Embossing painted for photographing.

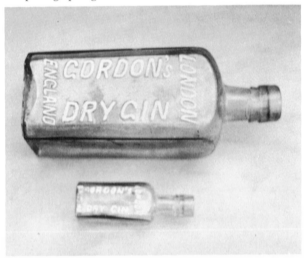

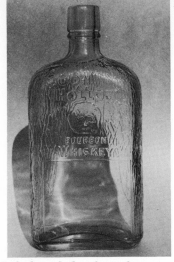

Whiskey flask, clear glass, embossed "COON HOLLOW BOURBON WHISKEY," H. 8 in., c. 1900–1915.

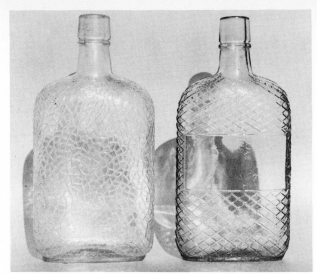

Whiskey flasks, clear glass, H. 8 in., c. 1900–1915.

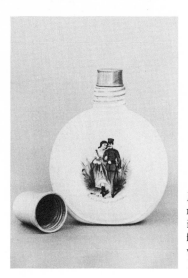

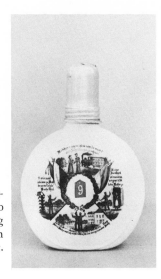

Left: obverse of porcelain whiskey flask made in Germany, inscribed with picture of soldier and girl and "So ist der Dienst am Schousten." *Right*: reverse featuring four pictures and associated sayings around a wreath with the number "9" in the center, H. approx. 6 in., c. 1890–1920.

Left to right: whiskey bottles, white milk glass, embossed "OLD BELLE OF ANDERSON" on side, H. 7 in. and 8¼ in., c. 1910.

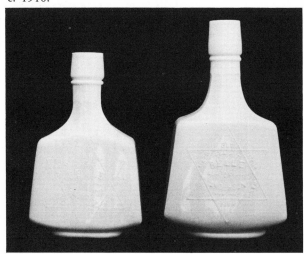

Whiskey bottle, blue, ceramic, matte finish, debossed "OLD-ORKNEY SCOTCH OO WHISKY STROMNESS-DISTILLERY SCOTLAND" in white on side, H. 9¾ in., c. 1910–1920.

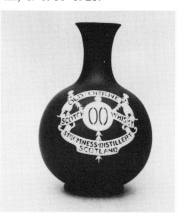

Prohibition whiskey bottle, amber, spider-web embossments on all sides, shot-glass cap over cork closure, H. 8 in., c. 1925.

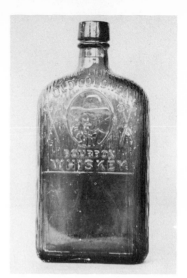

Prohibition whiskey bottle, amber, embossed "OLD COLONEL BOURBON WHISKEY," profile of Southern Colonel in oval frame with two crossed swords on each side of frame, H. 8 in., c. 1930.

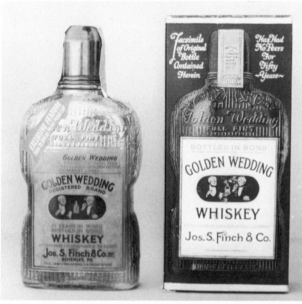

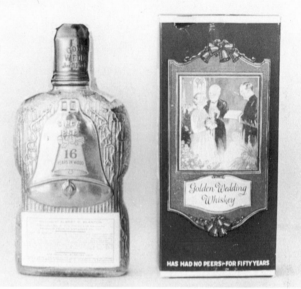

Whiskey bottle, embossed "GOLDEN WEDDING, FULL PINT" on one side and a bell with words "SINCE 1856" on another side. Bottled by the Jos. S. Finch & Co., Inc., Schenley, Pa., during Prohibition. Paper label on reverse reads: "For Medicinal Purposes Only—Sale or Use for Other Purposes Will Cause Heavy Penalties To Be Inflicted." Carnival-type glass, H. approx. 8 in., c. 1930.

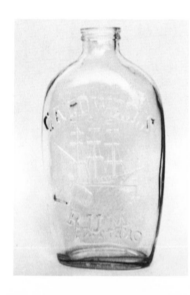

Obverse of post-Prohibition whiskey flask featuring an embossment of a sailing ship moored at a dock unloading rum, embossed "CALDWELL'S RUM."

Reverse of post-Prohibition whiskey flask featuring the embossed lettering "FEDERAL LAW FORBIDS SALE OR REUSE OF THIS BOTTLE."

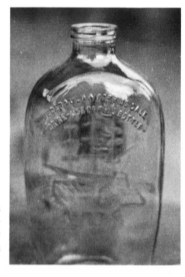

26

Pottery Bottles

Clay is a mineral in the form of a fine earthy powder which is plastic when wet, coheres when dry, and hardens like stone when subjected to heat. Clay is used in terra-cotta, brick, china, pottery, stoneware, and porcelain, among other things.

The use of clay has been known from earliest times. Its use by man occurred in almost every civilization throughout history. One of the most common uses was, and in some places still is, for container construction. Some of the earliest bottles were made of clay.

Although clay was not an especially popular material from which to manufacture bottles in America, today's collector will have no difficulty in gathering a fine collection of what are most often called by bottle collectors "pottery" bottles. The abundance of pottery bottles in this country was mostly the result of importation from foreign countries. Until approximately 1900 pottery bottles used for a variety of products were imported in great numbers.

In addition to being good containers, pottery bottles are quite heavy when compared to their glass counterparts. Because of this characteristic they were popular with the masters of the early sailing vessels as ballast. Ships returning to this country after delivering a cargo of cotton or wheat to Europe often had to sail with partially filled holds; sailing ships without cargo are top-heavy and prone to capsizing. As a result there was always an interest in shipments of heavy pottery bottles.

Many of the important American clay bottles originated in England at the Denby Pottery, started by Joseph Bourne in 1809. The earliest containers from the Denby Pottery are impressed "Vitreous Stone Bottles, Warranted Not to Absorb, J. Bourne, Patentee, Denby & Codnar Park Potteries Near Derby." In the mid-1830s the impressing was changed to include "J. Bourne & *Son* [italics added]."

In the 1870s the Henry C. Stephens, Ltd., company of England became a large manufacturer of pottery containers; these bottles are impressed "Stephens-Aldersgate, London."

In America, John Pride of Salem, Massachusetts, started a pottery as early as 1641 and in 1680 Dr. Daniel Coxe of Burlington, New Jersey, was making clay containers. Even though America had a number of potteries throughout the years, pottery bottles were never made in great numbers. The bottle collector's American pottery usually consists of jugs (see Chapter 27).

During the days of hand glassblowing pottery bottles were cheaper to produce than those made of glass. Around the turn of the century pottery bottles began to decline in popularity because automatic glassblowing made glass bottles cheaper. Another handicap for pottery bottles, which hastened their demise, was that it was difficult to fill them by sight, and difficult to be sure if they were clean if reused. The filling and cleaning of glass bottles was much easier because workers could see into the container. Still another problem came with the development of the crown cork (see Chapter 21), which made it too troublesome to work with cork stoppers, Lightning stoppers, or inside screw stoppers.

There were two advantages to pottery bottles that glass bottles could not challenge: stoneware bottles kept beverages at a cooler, more even temperature and they shielded the bottle's contents from harmful rays of the sun. Still, the disadvantages outweighed the advantages and the use of clay bottles declined greatly and quickly.

Even though pottery bottles could logically be included in specialized collections of beer, whiskey, ink, medicine, and soda water bottles, often they are not.

While the glass bottle collector generally stays within a specialty based mostly on bottles that contained a particular product, the pottery bottle collector includes almost any container of clay, regardless of the product it contained.

For convenience only, the pottery bottles to be discussed in this chapter will be treated by types mostly according to the product they contained, and pottery jugs are discussed separately in the next chapter.

Mineral water bottles (see Chapter 21) of clay

are quite interesting. Like most pottery bottles, they are generally very crudely made. Many were made by hand. They range in color from tan to dark brown. Clay mineral water bottles almost always have a handle near the neck, are about twelve inches tall, and contain around a quart of water. Many of these containers are impressed with a seal which identifies their origin. Many came from Germany and Holland; one of the most common is stamped "Nassau," which is a region in the province of Hesse in Germany. Mineral water was imported to meet a demand by immigrants to this country who were fond of mineral waters from the "old country."

Pottery ink bottles (see Chapter 24) are quite numerous and almost always take up a good portion of any collection of clay bottles. The main characteristic of this type is the complex assortment of sizes and shapes.

Pottery ink containers came mostly from France and England. There are two reasons for this: Both of these countries have long been famous for the production of high-quality ink, and they are also famous for their excellent deposits of clay and resulting clay bottles.

One of the main features of pottery ink bottles from England and France is their nonabsorbence caused by high firing which makes the bottles like stone. Depending on the techniques used, these stoneware bottles have glazes ranging from dull to very shiny. The surface texture, too, varies from smooth to granular, the latter being the result of salt glazing.

English ink containers made by J. Bourne & Son for the Arnold Ink Company came in shades of brown, while those produced by Bourne for the Prang and Carter ink companies are cream-colored or white.

As with other bottles made of clay, ink containers were impressed with lettering that identifies their origin; such stamping is more prevalent in the large master inks than on the smaller individual bottles.

Although crude in construction, ink bottles are less so than other clay containers. Some of the ink vessels have pouring spouts in their lips; others do not. The group that originally contained concentrated ink usually have wide mouths.

Pottery beer and ale bottles came almost exclusively from England and are probably the most abundant of all pottery containers. The earliest of these bottles, dating from the early nineteenth

century, were especially crude in construction and came in a variety of colors, of which grey is the most predominant. After the mid-1800s beer and ale bottles of clay were produced mostly in either white, or brown and white. Pints and quarts were the most popular sizes.

Early beer and ale bottles often have a salt glaze finish while later ones are found mostly with a shiny glass-like finish. These bottles, like almost all others of the nineteenth century, used a cork as a closure but because of the pressure created by the beverage the corks were wired down as was done on glass beer bottles.

The marking of pottery beer bottles was sometimes done by stamping, but more often printing was applied before glazing and baked right into the glaze. Printing allowed manufacturers of pottery bottles to provide their customers with elaborate lettering and design and gives today's collector the opportunity to include some very interesting specimens in his pottery-bottle collection.

Ginger beer pottery bottles are not included with beer or ale bottles, since ginger beer is more of a soda water; it consists of fermented ginger, cream of tartar, sugar, yeast, and water.

Through recent shipments by antique dealers in England, bottle collectors have had the opportunity to acquire large quantities and varieties of stoneware ginger beer bottles which were still popular in that country as late as the 1930s.

Ginger beer bottles resemble the older beer and ale bottles in many ways but are generally smaller, having held ten ounces of liquid on the average. Some of these bottles used a cork closure but many are found with Lightning stoppers (see Chapter 23) and inside screw stoppers (see Chapter 25), called "tap-hole jars" in England.

In color, these bottles come in brown and white, white, and varying shades of brown. Most ginger beer bottles of pottery produced around the turn of the century have a glasslike finish.

Pottery medicine bottles (see Chapter 15) are few and far between. One bottle marked "Spruce Beer" contained a liquid brewed from the extract of young sprouts of black spruce. This medicine was supposed to prevent or cure scurvy. Another medicine found in pottery containers was "Dr. Cron's Sarsaparilla Beer." This octagonal bottle contained a liquid that was supposed to be good for syphilis, chronic rheumatism, and kidney and liver problems.

Chinese pottery bottles are the last group that

remains to be discussed. In some parts of the United States during the 1800s great numbers of Chinese workers were imported to work on the railroads and at various other projects. Many came to work the gold fields of the 1849 gold rush. These people brought with them and had imported a varied assortment of pottery containers.

Perhaps the best known of these vessels is the "Tiger Whiskey" bottle. It actually contained what would more appropriately be called a wine than a whiskey. These bell-shaped bottles came in a range of brown colors and a variety of glazes. Tiger Whiskey bottles are all the same shape and were imported, when the law allowed, from the mid-1800s until the present, so it is difficult to determine the exact age of a specific specimen. One feature distinguishing bottles from the 1930s to the 1960s is the embossed lettering "FEDERAL LAW FORBIDS THE RE-USE OR RESALE OF THIS BOTTLE" which is found embossed on the shoulder of this pottery bottle.

In addition to the Tiger Whiskey bottle there are a variety of small pots and jugs that are included in the pottery bottle collector's gathering. Many of these vessels are readily identified as being Chinese in origin because they are impressed or embossed with Oriental writing. The glaze is rather unusual on these containers; while generally being highly glazed they most often feature a rough sandy-looking finish.

Clay is used in a variety of ways, from terra-cotta to fine china, and there are more types of ceramic bottles than are discussed in this chapter. Two general categories that are purposely being omitted here are figural bottles (see chapters 4 and 20) and contemporary bottles made in ceramic (see Part VI).

There is one fine china bottle that will be mentioned here because of its age and the fact that an occasional bottle of similar construction and type is found by pottery bottle collectors and included in their collection. This bottle was commissioned in 1911 by Andrew Usher, II, of Edinburgh, Scotland. Usher and his family are world-famous for their Scotch whiskey. The commission was to commemorate the coronation of King George V and Queen Mary of England and was given to W. T. Copeland and Sons, proprietors of the Spode Works, which is famous for its fine china and has been in business since 1770.

The bottle was executed in two varieties: olive-green and tan, and blue and grey. The bottles are identical except for color. The two bottles were made in limited quantities. Hand-applied decorations, reminiscent of Wedgwood china, feature the royal crest of England, and portraits of King George and Queen Mary.

Bottles such as these are not plentiful but do exist and occasionally find their way into pottery bottle collections, whiskey bottle collections, or wine bottle collections; whiskey and wine firms throughout the years have occasionally had similar bottles made.

In general, pottery bottles cover a wide range of sizes, shapes, and values. Colors are usually restricted to various shades and combinations of tan, brown, white, and cream.

Embossments are not particularly common on pottery bottles, the favored techniques of identification being impressment into the clay before it is baked or a colored marking baked into the glaze. Although most are not still in existence, paper labels were used extensively on unmarked containers. Closures were mostly corks, Lightning stoppers, or inside screw stoppers.

Because of a lack of interest pottery bottles are not unreasonable in price. Except for exceptionally unusual bottles these vessels range from $1 to $50. At bottle shows, flea markets, auctions, and antique shops the specialist in pottery bottles is likely to find a good selection from which to choose. This will probably not be true in future years.

Bibliography

BOOKS

Ferraro, Pat and Bob. *The Past in Glass.* Sparks, Nevada: Western Printing & Publishing Co., 1964, pp. 38–39.

Kendrick, Grace. *The Antique Bottle Collector.* Ann Arbor, Michigan: Edwards Brothers, Inc., 1963, pp. 73–74.

Munsey, Cecil. *Would You Believe.* San Diego, California: I.P.S., a division of Neyenesch Printers, Inc., 1968, pp. 12 and 22.

PERIODICALS

Bowman, Orval. "Earthenware Beverage Bottles," *Western Collector,* V (June, 1967), 35–40.

Munsey, Cecil. "Usher's Coronation Bottle," *Spinning Wheel Magazine,* XXV (April, 1969), 58–59.

Whited, Gene. "Inks That Left Their Mark," *Western Collector,* V (October, 1967), 41–45.

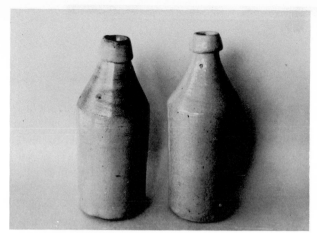

Beer or ale bottles (left to right): (1) tan and brown, H. 8¾ in.; (2) grey, H. 9 in., c. 1840–1860.

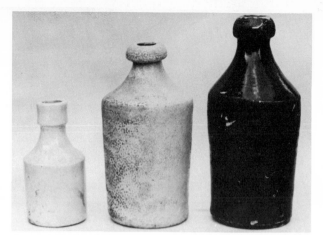

Pottery bottles (left to right): (1) light grey, H. 4¾ in.; (2) grey, salt glaze, H. 6¾ in.; (3) dark brown, H. 8 in., c. 1859–1900.

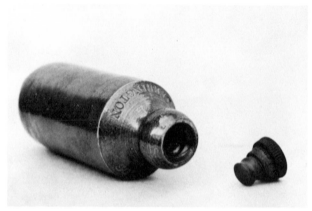

Pottery bottle, reddish-brown, debossed "HARRINGTON-SOUTH END-BOURNE 12-DENBY," inside screw stopper, H. 7 in., c. 1900.

Jar, brown, H. 9½ in., c. 1870. (John C. Fountain, Amador City, Cal.)

Ale bottle, tan and brown, imprinted "Brilliant to the Finish. Tennants' Celebrated Ales, Exchange Brewery, Sheffield, Wrightson's Patent."; H. 13 in., capacity one gallon, c. 1900–1920. (John C. Fountain, Amador City, Cal.)

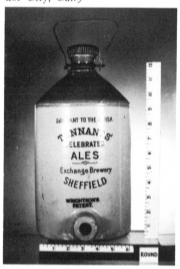

Left to right: beer or ale bottles, tan and brown, white, impressed "J. Macintyre, Liverpool," H. 10½ in., 8½ in., 10½ in., 8½ in., c. 1880–1900.

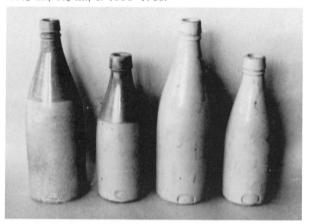

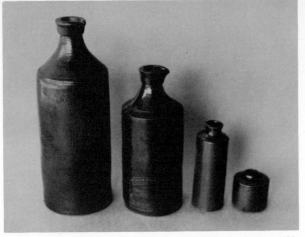

Left to right: ink bottles, brown, H. 9½ in., 7 in., 4½ in., and 1¾ in., c. 1870–1890.

Left to right: master ink bottles, brown, tan, H. 8 in., 7¼ in., 7½ in., and 7¼ in., c. 1880–1900. (John C. Fountain, Amador City, Cal.)

Pottery bottles (left to right): (1) reddish-brown, debossed "F. C. KONIG, STEINHÄGER BRENNERE" on side, sample bottle for German beer, H. 2¼ in.; (2) tan, debossed "F. C. KONIG, STEINHÄGER BRENNERE" on side, H. 5¼ in.; (3) dark brown, debossed "P. & J. ARNOLD" on side, H. 2¾ in., ink bottle; (4) light brown, debossed "P. & J. ARNOLD" on side, round bottle with square top, pouring spout, H. 5¾ in.; (5) light brown, ink bottle, cone shape, H. 3 in.; c. 1870–1900.

Soy-sauce jug, brown, H. 5 in., c. 1890.

Chinese (left to right): (1) Tiger Whiskey bottle, brown, H. 6½ in.; (2) bean pot, dark brown, H. 4½ in.; (3) Tiger Whiskey bottle, brown, H. 6½ in., c. 1880–1890.

Left to right: Japanese sake bottles, porcelain, white, H. 8¾ in., 8¾ in., 9 in., 11½ in., and 11 in., c. 1890–1910. (John C. Fountain, Amador City, Cal.)

Ginger beer bottle, tan and brown, imprinted "Ohio Ginger Beer Co., Toledo, Ohio. O. Ginger Beer Brewed by English Process, Trade Mark," H. 7 in., Lightning stopper, c. 1900.

Left to right: (1) fruit jar, cream color, H. 6 in., c. 1890; (2) food bottle (Heinz Apple Butter), cream color, H. 9 in., black glass lid with Lightning-type fastener, c. 1900.

139

Mineral water bottle, tan, impressed "Nassau," H. 11 in., c. 1880–1900.

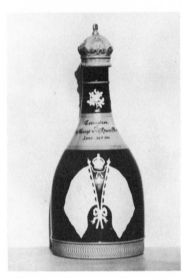

Whiskey bottle, ceramic, olive-green and tan with white flowers, crown, and flags, which display portraits of King George and Queen Mary, ceramic-covered cork closure made in the shape of a crown, H. 10 in.; a commemorative bottle for the coronation of King George V and Queen Mary of England, June 22, 1911.

Reverse of King George and Queen Mary commemorative bottle displaying in white the royal crest of England and indicating that the product contained in the bottle was made by Andrew Usher Distillers, of Edinburgh, Scotland.

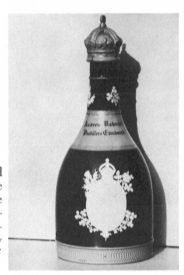

Bottom of King George and Queen Mary commemorative bottle indicating the bottle was manufactured by W. T. Copeland & Sons, Spode Works, Stoke-on-Trent, England.

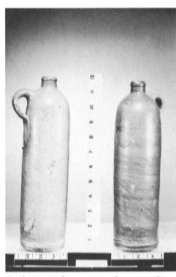

Left to right: mineral water bottles, tan and brown, impressed "Nassau," H. 12 in. and 11½ in., c. 1880–1900. (John C. Fountain, Amador City, Cal.)

27

Pottery Jugs

Pottery jugs seem to hold a special place in the minds of bottle collectors. Whereas a collector of glass bottles will often pass up the opportunity to own other ceramic containers, he will generally include a few unusual pottery jugs in his collection. The collector of pottery bottles finds jugs to be an important part of his collecting efforts.

While a relatively small number of clay bottles were domestic in origin, just the opposite is true of stoneware jugs; most of those used in this country were produced here.

Early settlers in the Ohio and Pennsylvania areas were from the pottery-making centers of England; many of them were potters. When it was discovered that stoneware clay was plentiful in these areas many of them began making utilitarian containers such as crocks, pickle jars, butter crocks and churns, pudding molds, mugs, and so forth. They also made a few pottery bottles and jugs for molasses, vinegar, batter, and, of course, whiskey.

Beginning early in the 1800s, utilitarian items of stoneware (except bottles) were made almost exclusively in the United States. American stoneware jugs, like those manufactured elsewhere, were fired at high temperatures. The resulting jugs were so hard that they defy scratching even with a steel knife.

The salt glazes so common on the earliest of American jugs were achieved by throwing common salt into the kiln at the time of firing when the temperature was at its highest. The intense heat turned the salt to vapor, releasing the chlorine and leaving the soda to combine with the acid in the clay. The resulting glaze is in reality soda glass which is extremely hard and acid-resistant. Salt glazing gave the jugs and other items a pitted surface likened to that of an orange peel.

The color of early jugs was usually grey but some were light to dark brown. Later pottery jugs (after 1890) were made in a larger variety of colors; they are the usual browns, white, mustard color, red, and cream color.

Jugs made after 1900, approximately, are glazed on the inside. Early jugs were not glazed on the bottom outside, but later ones were. These two facts will be of help in dating these containers. Shape can also be of value in differentiating between the very old and not-so-old jugs. Jugs made in America from approximately 1800 to 1900 are pleasantly curved, starting with a narrow neck, going to gently sloping shoulders and ending at a bottom which is usually smaller in circumference than the shoulder. Jugs made after about 1900 are rather bulbous in shape or cylindrical in the body, with a severely tapered shoulder going all the way to the neck.

Early jugs were generally decorated in cobalt-blue lettering and/or designs, including feathers, flowers, leaves, insects, birds, and even humans. One of the most favored designs was that of the American eagle.

Another interesting feature of American stoneware jugs is that many were marked with a number which indicated their capacity: gallon, pint or quart. In order to make effective use of the unusual system of numbers the user had to have a general idea of the capacity of the container in the first place.

Among the most unusual pottery jugs are those used for medicine. Of these, perhaps the most interesting are the jugs used by William Radam for his famed Microbe Killer.

In 1885 the medical world burst forth with the news of its latest discovery, the microbe. Quickly, all diseases of man and beast were laid to one microbe or another.

In Texas a Prussian immigrant named William Radam was struggling to make a living by raising vegetables on his thirty-acre farm and operating a run-down feed store while handicapped by a case of malaria (which he, of course, attributed to one of the newly discovered microbes). One day while examining his cabbage patch, which was sick with "blight," he had what he thought was a splendid idea. In his own words, "If I can discover anything that will kill blight without killing the cabbage, I should also possess something that will cure me." Not having a scientific background he offered $1000 to anyone who could kill the blight without killing the cabbage. Several would-be scientists tried but failed. In desperation,

Radam had to try himself. For six months he mixed chemicals and substances used in plant care. Finally he was satisfied he had a product that would kill microbes. He applied his discovery liberally to himself and his cabbages—both were cured, the story goes. He decided to perform other "scientific" experiments to make sure he really had the answer to the microbe problem. He selected a man with consumption and a woman with a growth. After giving them his invented liquid they both were "cured."

In 1886, Radam took out a patent for a "New and Improved Fumigating Composition for Purifying Purposes." This name was soon manipulated until the product became "William Radam's Microbe Killer." For a trademark he selected a well-dressed man in a business suit wielding a club in a menacing fashion at a tall skeleton which represented the microbe. This trademark was embossed on his square quart bottles made in amber glass. On his gallon pottery jugs he modestly had embossed or painted in the glaze, "Wm. Radam's Microbe Killer."

By 1890, Radam's microbe-killing business had expanded to an empire of seventeen factories. Each of these widely scattered factories produced the liquid to fill thousands of gallon jugs and quart bottles. After the passing of the 1906 Pure Food and Drug legislation (see Chapter 15) the government gradually forced Mr. Radam out of business. At one point the government seized and destroyed 539 wooden boxes and 322 pasteboard cartons of Microbe Killer. It was estimated that the entire shipment would have sold for $5,166. Since it was proved that Microbe Killer was 99.381% water and the remainder red wine, it was estimated that the destroyed shipment cost $25.82 to manufacture—Radam was making a 20,000% profit.

At any rate, of the many types of pottery jugs available to today's bottle collectors those that contained medicines are among the most interesting.

Pottery jugs made before the turn of the century are quite scarce and expensive. They usually range in price from $10 to $100. Those made after 1900 are relatively easy to obtain and very seldom cost more than $20.

Bibliography

BOOKS

Munsey, Cecil. *Would You Believe*. San Diego, California: I.P.S., a division of Neyenesch Printers, Inc., 1968, p. 31.

PERIODICALS

Chamberlain, Jacqueline. "American Stoneware," *Western Collector*, IV (May, 1966), 8–10.
Munsey, Cecil. "Wm. Radam's Microbe Killer," *The Bottleneck*, II (June, 1967), 3.
Springer-Papa, Joan. "The Legacy of Stoneware," *The Antiques Journal*, XXIV (March, 1969), 16–17.

Pottery jug, brown, salt glazed, H. 10 in., c. 1700.

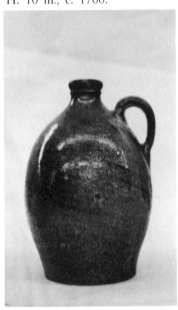

Pottery jug, debossed "J. W. & C. W. UNDERWOOD, FT. EDWARD, N.Y." on side, hand-painted blue floral design on side, H. 14 in., c. 1840.

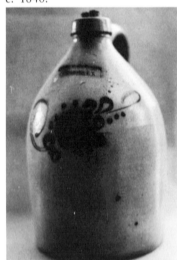

Pottery jug, off-white with blue hand-painted bird on foliage on the side, debossed "HAXSTUN OTTHAN & CO., FORT EDWARD, N.Y." in large letters on side, H. 16 in., c. 1850.

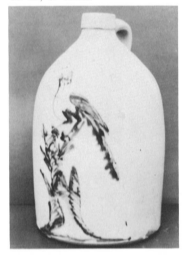

142

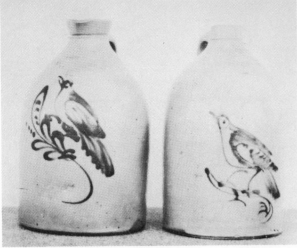

Pottery jugs, off-white with hand-painted bird design in deep blue on sides, H. 16½ in., c. 1880. (*Western Collector*, San Francisco, Cal.) Photo by Thelma Winnie.

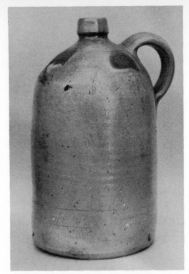

Pottery jug, grey, unembossed, H. 16 in., c. 1870.

William Radam, late-nineteenth-century proprietary medicine manufacturer.

William Radam's Microbe Killer trademark as stamped on cover of book entitled *Microbes and the Microbe Killer* by William Radam. Same trademark was used in advertising and on labels.

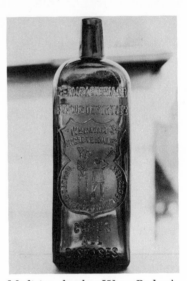

Medicine bottle, Wm. Radam's Microbe Killer, amber, square, embossed with "GERM BACTERIA OR FUNGUS DESTROYER, WM. RADAM'S MICROBE KILLER, REGISTERED TRADE MARK, DEC. 13, 1887, CURES ALL DISEASES" and a man hitting a skeleton with a club on the side, H. 10½ in., c. 1887–1900.

Pottery jugs (left to right): (1) cream-colored, painted "Wm. Radam's Microbe Killer No. 2"; (2) tan, embossed "WM. RADAMS MICROBE KILLER"; both 11 in. high, c. 1890–1900.

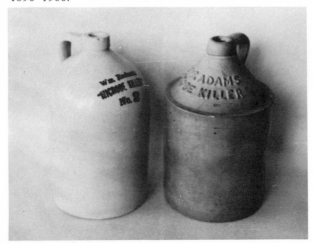

Pottery jug, cream-colored, paper label reads "Wm. Radam's Microbe Killer," H. approx. 11½ in., c. 1880–1900.

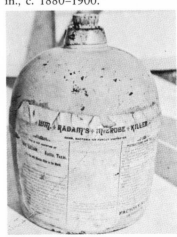

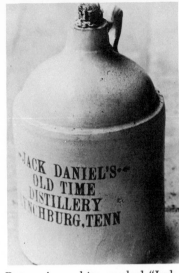

Pottery jug, white, marked "Jack Daniel's Old Time Distillery, Lynchburg, Tenn.," H. approx. 10 in., c. 1890–1910. (Jack Daniel Distillery, Lynchburg, Tenn.)

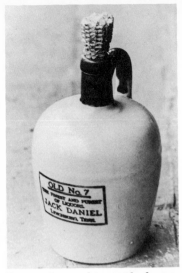

Pottery jug, white with brown neck and handle, marked "Old No. 7, The Finest and Purest of Liquors, Jack Daniel, Lynchburg, Tenn.," H. approx. 9 in., c. 1890–1910. (Jack Daniel Distillery, Lynchburg, Tenn.)

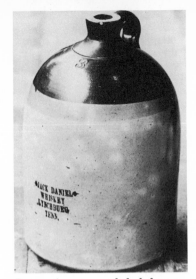

Pottery jug, tan and dark brown, impressed "3" and marked "Jack Daniel Whiskey, Lynchburg, Tenn.," H. approx. 10 in., c. 1870–1880. (Jack Daniel Distillery, Lynchburg, Tenn.)

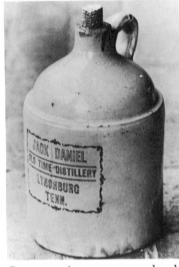

Pottery jug, cream-colored, marked "Jack Daniel Old Time Distillery, Lynchburg Tenn.," H. approx. 10 in., c. 1880–1900. (Jack Daniel Distillery, Lynchburg, Tenn.)

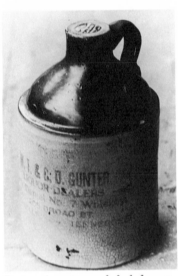

Pottery jug, tan and dark brown, marked "W. T. & C. D. Gunter, Liquor Dealers, Jack Daniel No. 7 Whiskey, 208 Broad St., Nashville, Tennessee," H. approx. 10 in., c. 1875–1885. (Jack Daniel Distillery, Lynchburg, Tenn.)

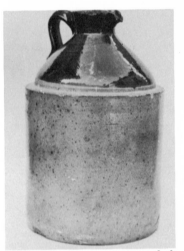

Pottery jug, top portion dark brown, highly glazed, lower portion tan, pouring spout, H. 10½ in., c. 1880.

Pottery ink jug, stenciled "1 GALLON, SANFORD'S, INKS, THE QUALITY LINE, PASTES, ILLEGAL TO REFILL THIS JUG FOR RESALE" on side in black letters, H. 10½ in., c. 1900.

Pottery jugs (left to right): (1) mustard color, H. 10 in.; (2) cream and tan, H. 10½ in., c. 1870–1900.

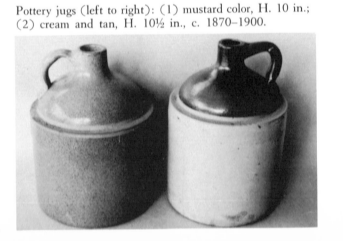

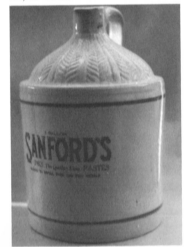

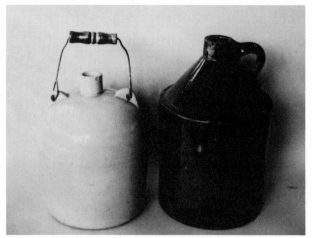

Pottery jugs (left to right): (1) white, unusual wire handle, H. 9¼ in.; (2) reddish brown, H. 11½ in., c. 1900.

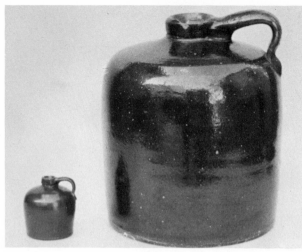

Left to right: pottery jugs, dark brown, H. 2 in. and 7½ in., c. 1900.

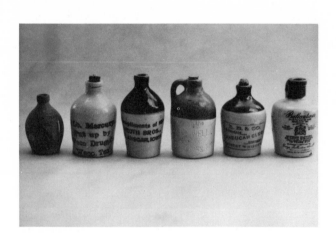

Miscellaneous assortment of miniature pottery jugs (left to right): (1) grey, painted on side "EUTSCHES ORF, 1893 WORLD'S FAIR" H. 2½ in.; (2) tan, stenciled on side, "1 LB. MERCURY PUT UP BY WACO DRUG CO., WACO, TEXAS," H. 3¼ in.; (3) dark brown top, tan bottom, stenciled "COMPLIMENTS OF AROTH BROS., ST. ANSGAR, IOWA," H. 3½ in.; (4) light brown top, tan bottom debossed "THE LITTLE BROWN JUG FROM THE BIG WELL, GREENSBURG, KANSAS," H. 3 in.; (5) dark brown top, light brown bottom, stenciled "L. B. & CO., HANDMADE, PADUCAH CLUB, KENTUCKY, FINEST WHISKEY," H. 3 in.; (6) dark brown neck, tan body, main embossment on side reads "BALLAN-TINE'S 100 YEAR OLD SCOTCH," "MADE IN SCOTLAND" is debossed on bottom, H. 3 in., c. 1870–1910.

Pottery jugs (left to right): (1) cobalt-blue, H. 8½ in., c. 1930–1950; (2) white, painted, H. 7½ in., c. 1950–1960. (John C. Fountain, Amador City, Cal.)

Pottery jugs (left to right): (1) dark brown; (2) white; both 9 in. high, c. 1860–1880.

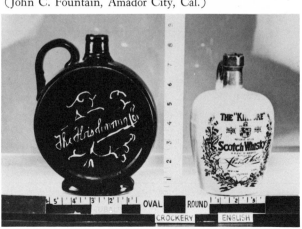

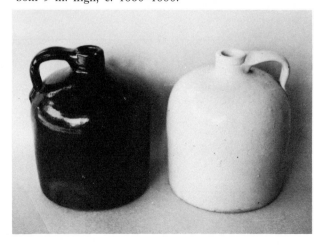

28

Fruit Jars

Napoleon Bonaparte played a part in the development of the fruit jars that are so eagerly sought after by today's bottle collectors. In 1795, with France heavily involved in military conflicts led by Napoleon, the French government offered 12,000 francs (about $4000) for the development of a method of preserving foods. A military force with an adequate food supply would certainly, in those days, enjoy a great advantage over one whose food supply was less certain.

Fourteen years after the plea by the French government, Nicolas Appert stepped forward to claim the prize. In 1810, one year after Emperor Napoleon personally presented Appert the 12,000-franc prize, Appert published his discovery in a book entitled, *L'Art de Conserver les Substances Animales et Vegetables* (in England this was translated as *The Art of Preserving*). Basically Appert's idea was to enclose the substances to be preserved in a glass container, seal it, and then boil the container to kill bacteria.

In 1812, Appert's book was published in English in New York. This book was received in America with much enthusiasm. The demand for glass jars was great. Commercial canning was started in 1815. By 1829 Thomas W. Dyott, who was to become one of America's most famous bottle makers (see Chapter 5), was advertising the sale of "fruit jars" made at his glasshouse in Philadelphia. From Dyott's advertisements the term "fruit jar" became the common one for glass jars used in preserving. "Canning jar" is also a term applied to these containers but the term "fruit jar" is most often used today.

Development of the fruit jar was relatively slow because of the lack of an adequate closure; for approximately the first fifty years that the fruit jar was used the closure was merely a cork sealed with wax. As in all phases of glass container manufacturing the development of a standardized closing device was hampered by the fact that each vessel made was unique, and therefore a cork was practically the only device flexible enough to fit all containers.

For the American fruit jar the first important improvement was an inverted saucer-shaped tin lid which could be inserted into a groove in the mouth of the jar; the groove was then covered with melted wax. This device was invented in 1855 by Robert Arthur and made possible some standardization within the industry. More important, though, the relatively low cost of tin lids as opposed to cork made it financially feasible to produce the more practical wide mouth jar. In 1856 the Hero Glass Works of Philadelphia developed a glass lid operating on the same principle which fit their fruit jar, the Gem; this was the first all-glass fruit jar. (Throughout the years over two dozen jars have been manufactured with Gem in the name.)

John Landis Mason was responsible for the next important development in fruit jar history. Mason, probably the most famous of fruit jar pioneers, was neither the inventor of the fruit jar nor even a jar manufacturer. Mason's contribution came through his skill as a tinsmith; he made the first successful zinc screw lid (there had been at least two prior attempts). The main advantage of Mason's invention was cheapness in manufacture; the jar involved needed only a small amount of grinding after it had been annealed to be ready to accept the Mason lid. Because Mason was only interested in making and selling lids the jars utilizing his lids were made by others. Thus a precedent was set and the selling of jars and lids separately went on until 1890. Even though Mason's lid was an ingenious device it didn't enjoy a great deal of popularity because it was not desirable to have food exposed to zinc.

Mason's zinc lid required that threads be blown into the container; because of this many bottle collectors think that he invented this type of closure. This is not true at all. It is not known exactly who first thought of carving threads in a mold and making a screw cap to fit the threads, but it is recorded that such a process was used in Germany during the 1600s (see photograph in Chapter 3) and in England during the eighteenth century. Both the Stiegel (established 1763) and Sandwich glassworks (established 1825) produced a few bottles with threads that utilized pewter and glass screw caps (see Chapter 5). In 1861 the Whitney Glass Works in New Jersey patented a "screw-in glass stopper" but it was not used to any great extent. Not only was it difficult and time-consuming (thus expensive) but the pewter lids would not stand the pressure necessary to make the opening of the early bottles airtight. Screw

caps were not widely used on bottles until about 1900. But bottle collectors should not overlook the fact that screw caps on both bottles and jars were used before 1900. Eventually Mason's contribution was so widely used that "Mason jar" became the generic term for glass containers used in preserving foods.

After several relatively unsuccessful attempts by Charles Inlay, in 1865, to develop an all-glass lid that could be closed mechanically as could Mason's zinc screw cap, Salmon B. Rowley of the Hero Company developed the first commercially successful glass lid in 1868 and 1869. Rowley's lid was actually a flat piece of glass that covered the top of the jar and was held in place by a screw cap of zinc similar to Mason's.

Lewis R. Boyd, of New York City, saved the Mason lid in 1869 by inventing an opal glass liner (opal because it would hide any seepage and look clean). Boyd's invention was used by several other companies, so collectors can find them on several brands of jars of that period.

Using an idea patented in 1875 by Charles de Quillfeldt (an American) and purchased from him, Henry W. Putnam modified a beverage bottle stopper named Lightning to fit fruit jars. Putnam worked for seven years before achieving an entirely successful model. (As in the case of John Mason, many credit Putnam with inventing something he did not—the Lightning stopper.)

There were, of course, other contributions to the development of the fruit jar—hundreds in fact —but these are some of the major ones made by the early pioneers in the industry. For the most complete history of fruit jars, their use, canning methods, and a listing of most of the known specimens, the interested collector should read *Fruit Jars* by Julian Harrison Toulouse.

From a collecting standpoint fruit jars are in their infancy—a real interest has been expressed only in the past six years or so. Lack of a real variety of shapes and colors has probably been the main reason these interesting glass containers have been overlooked for so many years.

Of the well over one thousand known types of fruit jars most do have one basic shape because of the wide mouth, and most were produced in light aqua or green colors. Unlike many other specializations within the hobby, small variations in color do exist and are a real challenge, as a result, to collect. Amber jars are by far the easiest of the unusual colors to obtain; they were produced by only a dozen or so companies. The truly rare colors are black, emerald-green, cobalt-blue, white (milk glass), and unusual shades of the basic colors. In addition to glass fruit jars some preserving containers were produced in pottery. These ceramic containers are certainly worthy of inclusion in any collection of fruit jars.

Fruit jar prices have yet to stabilize. While the common jars start at less than $1, certain jars command as much as $1000. For the most part, age is the main determining factor of price within this category; the mid-nineteenth-century wax sealers bring the top prices.

Of prime interest to jar collectors are closures and embossments. Some of the most interesting, unusual, and obscure closing devices in bottle collecting are associated with fruit jars. What was embossed on the container, always an important consideration, is especially important to gatherers of fruit jars. The true connoisseur of jars will gather not only the different brands and types but the variations within each. In addition to lettering there can be found stars, animals, crowns, shields, anchors, bells, people, crosses, globes, birds, and many other designs.

Co-related items of prime interest to the collector include advertisements, recipe books, and a variety of tools (see Chapter 60).

Bibliography

BOOKS

Ball, Edmund F. *From Fruit Jars to Satellites.* New York: The Newcomen Society of North America, 1960.

Creswick, Alice, and Rodrigues, Arleta. *The Cresrod Blue Book of Fruit Jars.* Grand Rapids, Michigan: Cresrod Publishing Co., 1969.

Harvest Fruit Jar Finders Price Guide. Milwaukee, Wisconsin: Harvest Publishing Co., 1969.

Toulouse, Julian Harrison. *Fruit Jars.* Camden, New Jersey: Thomas Nelson & Sons, and Hanover, Pennsylvania: Everybody's Press, 1969.

Webb, Verlon. *Fruit Jars and Their Relatives.* Centerville, Indiana: privately published, 1969.

PERIODICALS

Ellsberg, Helen. "New Interest in Old Jars," *Western Collector,* IV (November, 1966), 38–43.

Toulouse, Julian Harrison. "The Men Behind the Fruit Jar," *Spinning Wheel,* XXIV (September, 1968), 18–20.

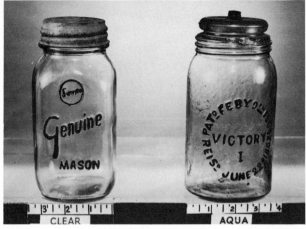

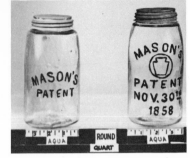

Fruit jars (left to right): (1) embossed "SAMCO GENUINE MASON" on side, clear, quart, c. 1920–1940; (2) embossed "PAT'D FEBY 9TH 1864, REIS'D JUNE 22D 1867" in a circle around "VICTORY I" on side, aqua, quart, glass lid held by toggle, c. 1909. Embossing painted for photographing. (John C. Fountain, Amador City, Cal.)

Fruit jars (left to right): (1) embossed "MASON'S PATENT" on side, aqua, quart, c. 1900–1915; (2) embossed "MASON'S PATENT NOV. 30TH 1858" with a keystone in a circle on side, aqua, quart, ground lip, c. 1870–1890. Embossing painted for photographing. (John C. Fountain, Amador City, Cal.)

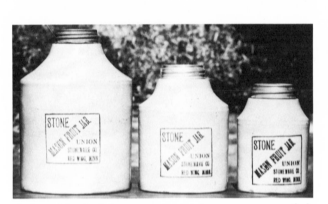

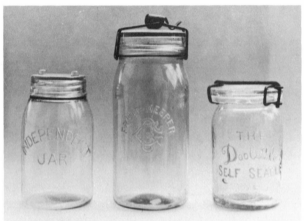

Left to right: fruit jars, pottery, metal screw caps, stenciled lettering on sides, H. 10 in., 8 in., and 7 in., late nineteenth century.

Fruit jars (left to right): (1) embossed "INDEPENDENT JAR" on side, glass screw cap, clear, c. 1882; (2) embossed "FRUIT-KEEPER" on a monogram of "C. G. CO.," glass lid with cam lever, c. 1880–1890; (3) embossed "THE DOOLITTLE SELF SEALER," glass lid held by two spring clips permanently mounted on lid, aqua, c. 1900–1905.

Fruit jars (left to right): (1) embossed "BALL" in script over "STANDARD" on side, groove ring wax sealer, bluegreen, c. 1888–1912; (2) embossed "STAR GLASS CO., NEW ALBANY, INC." on side, groove ring wax sealer, green, c. 1860–1875.

Fruit jars (left to right): (1) embossed "IMPROVED EVERLASTING JAR" on side, cam lever holds on glass lid, clear, c. 1905; (2) embossed "MILLVILLE ATMOSPHERIC FRUIT JAR" on side, glass lid held on by yoke and thumbscrew, light green, c. 1862; (3) embossed "WOODBURY" above a monogram of "W, G, W," on side, glass lid with central threaded stud and iron yoke, green, c. 1865.

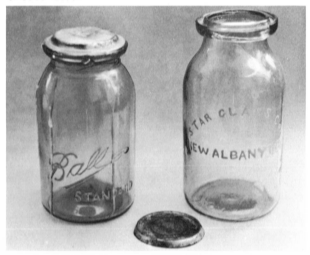

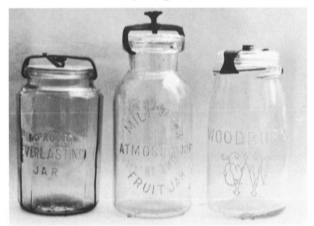

148

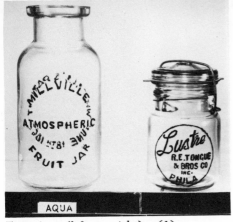

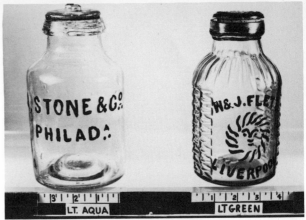

Fruit jars (left to right): (1) embossed "MILLVILLE ATMOS-PHERIC FRUIT JAR" on side, aqua, quart, glass lid held by a yoke and thumbscrew, c. 1862; (2) embossed "LUSTRE R. E. TONGUE & BROS CO INC. PHILA" on side, light green, pint, Lightning closure, c. 1890–1900. Embossing painted for photographing. (John C. Fountain, Amador City, Cal.)

Fruit jars (left to right): (1) embossed "A. STONE & CO., PHILADA." on side, light aqua, quart, groove ring wax sealer, c. 1860–1870; (2) embossed "W. & J. FLETT" and "LIVERPOOL" around embossment of sun on side, light green, quart, glass stopper holds cork or rubber side seal ring, c. 1880. Embossing painted for photographing. (John C. Fountain, Amador City, Cal.)

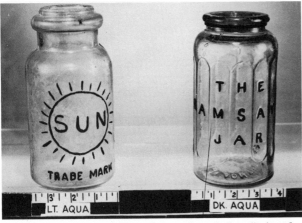

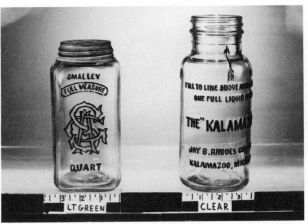

Fruit jars (left to right): (1) embossed "SUN" (inside the drawing of a sun) and "TRADE MARK" on side, light aqua, quart, glass lid and cast metal yoke over a bulbous finish, c. 1895; (2) embossed "THE RAMSAY JAR," dark aqua, quart, glass lid, c. 1867. Embossing painted for photographing. (John C. Fountain, Amador City, Cal.)

Fruit jars (left to right): (1) embossed "PRESTO WIDE MOUTH GLASS TOP" on side, clear, quart, glass lid with metal screw band, c. 1925–1946; (2) embossed "PRESTO SUPREME MASON" on side, clear, pint, metal lid, c. 1929–1946. Embossing painted for photographing. (John C. Fountain, Amador City, Cal.)

Fruit jars (left to right): (1) embossed "SMALLEY FULL MEASURE," a monogram of overlapping "A," "G," and "S," and "QUART" on side, light green, quart, ground lip, c. 1896–1907; (2) embossed "FILL TO LINE ABOVE AR-ROW, ONE FULL LIQUID QUART, THE 'KALAMAZOO' JAY B. RHODES COMPANY, KALAMAZOO, MICHIGAN" on side, clear, quart, c. 1920–1929. Embossing painted for photographing. (John C. Fountain, Amador City, Cal.)

Fruit jar, embossed "KNOWLTON VACUUM FRUIT JAR" with a star on side, blue, quart, glass lid with perforated full cap to give spring action, c. 1903–1910. Embossing painted for photographing. (John C. Fountain, Amador City, Cal.)

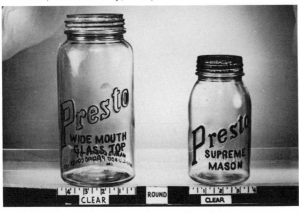

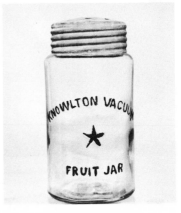

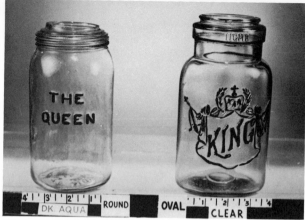

Fruit jars (left to right): (1) embossed "THE QUEEN" on side, dark aqua, quart, ground lip, glass lid with metal screw band, c. 1869; (2) embossed "KING" across a banner, a flag on each side with a wreath and crown above, clear, quart, Lightning closure, c. 1907–1919. Embossing painted for photographing. (John C. Fountain, Amador City, Cal.)

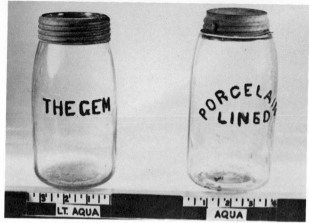

Fruit jars (left to right): (1) embossed "THE GEM" on side, light aqua, quart, c. 1869; (2) embossed "PORCELAIN LINED" on side, aqua, quart, ground top, c. 1873–1880. Embossing painted for photographing. (John C. Fountain, Amador City, Cal.)

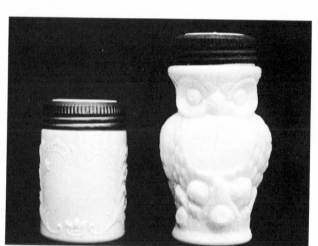

Left to right: (1) fruit jar, bluish-white opal glass, H. 4¼ in., ground top, matching bluish-white opal lid with metal screw band, c. 1890–1900; (2) mustard jar, white milk glass, H. 6½ in., owl shape, ground top, white milk glass lid with metal screw band, c. 1890–1900.

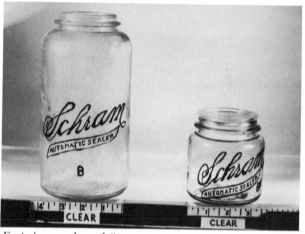

Fruit jars, embossed "SCHRAM AUTOMATIC SEALER B" on side, clear, quart (left) and half pint (right), c. 1920–1925. Embossing painted for photographing. (John C. Fountain, Amador City, Cal.)

Fruit jars (left to right): (1) embossed "DOUBLE SEAL" on side, clear, quart, Lightning stopper, c. 1920; (2) embossed "CROWN CORDIAL & EXTRACT CO., NEW YORK" on side, clear, quart, c. 1885. Embossing painted for photographing. (John C. Fountain, Amador City, Cal.)

Fruit jars (left to right): (1) embossed "MASON PATENT NOV 30TH 1858" with circled keystone on side, aqua, quart, c. 1870–1890; (2) embossed "MASON'S PATENT NOV. 30TH 1858" with Hero Cross (trademark of the Hero Fruit Jar Company) above the lettering on the side, aqua, metal screw lid, c. 1870–1890. Embossing painted for photographing. (John C. Fountain, Amador City, Cal.)

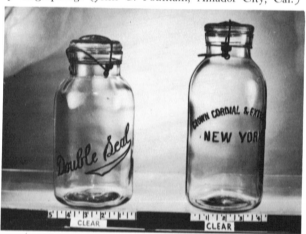

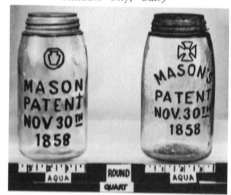

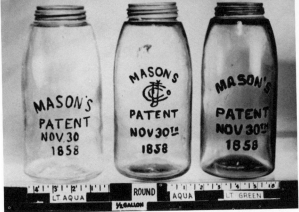

Fruit jars (left to right): (1) embossed "MASON'S PAT-ENT NOV. 30 1858" on side, light aqua, ½ gallon, c. 1900–1915; (2) embossed "MASONS" arched over "C," "F," and "J" "CO." monogram, followed by "PATENT NOV 30TH 1858" on side, aqua, handmade, ground lip, c. 1895–1912; (3) embossed "MASON'S PATENT NOV 30TH 1858" on side, light green, ground lip, c. 1880–1904. Emboss-ing painted for photographing. (John C. Fountain, Amador City, Cal.)

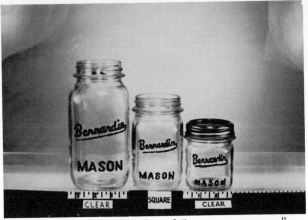

Left to right: fruit jars, embossed "BERNARDIN MASON" on side, clear, quart, pint, and half pint (pint embossed "EX-CELLENT FOR JELLIES" on back side), c. 1932–1938. Embossing painted for photographing. (John C. Fountain, Amador City, Cal.)

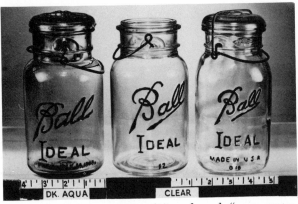

Fruit jars (left to right): (1) embossed "BALL IDEAL PAT'D. JULY 14, 1908" on side, dark aqua, quart, Light-ning closure, c. 1930–1962; (2) embossed "BALL IDEAL 12" on side, clear, quart, Lightning closure, patent date is on back side, c. 1930–1962; (3) embossed "BALL IDEAL MADE IN USA" on side, clear, quart, Lightning closure, c. 1930–1962. Embossing painted for photo-graphing. (John C. Fountain, Amador City, Cal.)

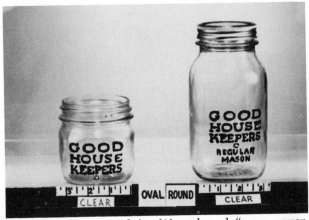

Fruit jars (left to right): (1) embossed "GOOD HOUSE KEEPERS" on side, clear, pint, metal screw lid, c. 1935–1946; (2) embossed "GOOD HOUSE KEEPERS REGULAR MASON" on side, clear, quart, metal screw lid, c. 1935–1946. Embossing painted for photographing. (John C. Fountain, Amador, Cal.)

Fruit jars (left to right): (1) embossed with a large an-chor superimposed with an "H" and the word "MASON" on side, clear, pint, metal screw lid, c. 1937 to present; (2) embossed "ANCHOR HOCKING" and "MASON" with an anchor superimposed with an "H" between the words on the side, clear, quart, metal screw lid, c. 1937 to present. Embossing painted for photographing. (John C. Fountain, Amador City, Cal.)

Fruit jar, clear, Lightning clo-sure, embossed "SILICON GLASS COMPANY PITTSBURGH PENNA.," on side, quart, c. 1925–1930. Embossing painted for photo-graphing. (John C. Fountain, Amador City, Cal.) Photo by Mrs. Elinor Cates, Glendora, Cal.

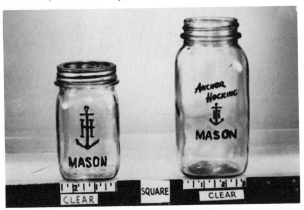

Fruit jars, clear, embossed "MANSFIELD MASON" (left) and "MANSFIELD MASON IMPROVED" (right), c. 1900. The jars are two of the five known types of fruit jars produced by the Mansfield Glass Works of Lockport, New York.

Photograph taken from a book published around the turn of the century by the Mansfield Glass Works of Lockport, New York. Close inspection will reveal that the wagon is loaded with Mason fruit jars produced at the plant.

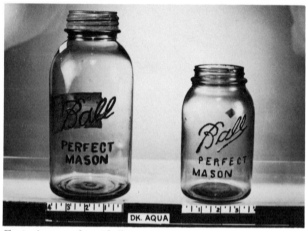

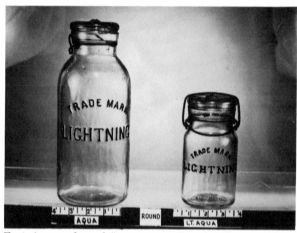

Fruit jars, embossed "BALL PERFECT MASON" on side, dark aqua, quart (left) and pint (right), c. 1915. Embossing painted for photographing. (John C. Fountain, Amador City, Cal.)

Fruit jars, embossed "TRADE MARK" and "LIGHTNING" on side, aqua, quart (left) and pint (right), Lightning closure, c. 1882–1900. Embossing painted for photographing. (John C. Fountain, Amador City, Cal.)

Fruit jars, embossed "BROCKWAY CLEAR-VU MASON" on side, clear, pint (left) and quart (right), c. 1925–1936. Embossing painted for photographing. (John C. Fountain, Amador City, Cal.)

Fruit jars (left to right): (1) embossed "IMPROVED GEM MADE IN CANADA" on side, clear, quart, c. 1920; (2) embossed "BOSCO DOUBLE SEAL" on side, clear, Lightning closure, c. 1915–1930. Embossing painted for photographing. (John C. Fountain, Amador City, Cal.)

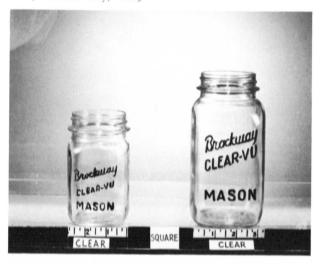

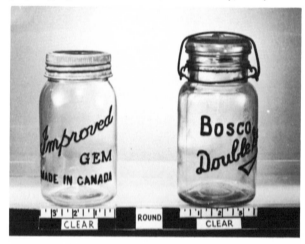

29

Food Bottles

Bottles made especially for foods are quite numerous and, in fact, constitute a large portion of bottles made. Because of their vast numbers, twentieth-century specimens have not attracted a great deal of collecting interest, and only those made prior to 1900 are definitely sought after.

Certain types of food containers have been collected with more enthusiasm than others. An example is fruit jars, which in this book are treated as a separate collecting speciality (see Chapter 28). Many food containers are included in other specialties within the hobby, e.g., food bottles of a particular shape may be collected by the figural bottle collector (see Chapter 20), and ceramic food bottles may be of interest to the collector of pottery bottles (see Chapter 26).

In this chapter food bottles not readily falling into other categories or specialties will be featured. These bottles contained a variety of products including pickles, sauce, mustard, catsup, oil, vinegar, and so forth. Often, a particular bottle shape has been associated with a particular product for so long that it is seldom used by manufacturers for anything else.

Excepting fruit jars, perhaps the most popular food bottles are pickle jars and peppersauce bottles. The most interesting of the pickle jars are the one-quart to one-gallon sizes that have four or more side panels of a gothic arch design. The cathedral-type bottles were produced for about forty years—twenty years on either side of the turn of the century. The more intricate the embossed gothic design the more valuable the container. The jars most often are aqua or light green in color but on occasion are found in dark green or amber; these darker colors enhance value an appreciable amount. Prices of these cathedral pickle jars start at around $25 and go as high as $150.

Peppersauce bottles are smaller than pickle jars on the average and are either plain or fancy in design. The fancy specimens most often have a series of spiral ridges, layered rings, or gothic panels similar to the larger pickle jars. As with pickle jars the common colors are aqua or light green. Also like pickle jars, peppersauce bottles are found in darker colors which enhance their value; in addition to dark green and amber, these bottles are sometimes located in dark blues. The degree to which those specimens with panels feature an embossed design affects desirability. Peppersauce bottles are sold for as little as $1 for the plain examples and as high as $100 for the ornate and darker-colored ones.

Oil bottles are usually tall and slender in shape and aqua or light green in color. Those of special interest are usually cobalt-blue. By far the majority of oil bottles do not have any embossments.

Other bottles that qualify as food bottles are too numerous to discuss in great detail and for the present, at least, are not in much demand by bottle collectors. Some that are discovered with unusual colors, closures, shapes, and so forth are more valued than others.

Food bottles are a wide-open area. It seems inevitable that with plastics gradually replacing glass and ceramic containers, and interest in collecting bottles growing, the area of food bottles is one in which there will eventually be much activity.

Bibliography

BOOKS

Ferraro, Pat and Bob. *A Bottle Collector's Book.* Sparks, Nevada: Western Printing & Publishing Co., 1966.

Rinker, Meryle. *A Dash of This . . . A Pinch of That.* Ashland, Oregon: privately published, 1968.

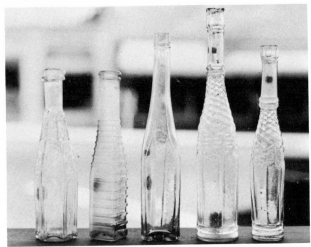

Food containers (left to right): (1) green, H. 8¼ in.; (2) purple, H. 8¼ in.; (3) green, H. 10 in.; (4) green, H. 11 in.; (5) green, H. 9½ in.; probably contained sauce, c. 1880–1900.

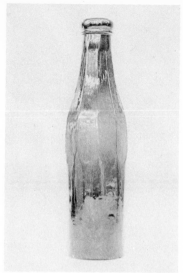

Food container, olive-amber, blue-berry or cranberry jar, H. 14 in., early 19th century.

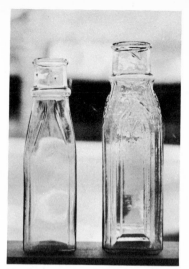

Food containers (left to right): (1) purple, H. 10½ in.; (2) green, H. 11½ in.; contained pickles, c. 1870–1890.

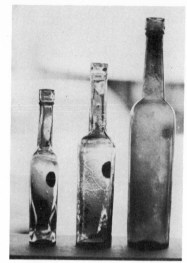

Left to right: food containers, cobalt-blue, probably contained oil, H. 7 in., 8 in., and 10¼ in., c. 1890.

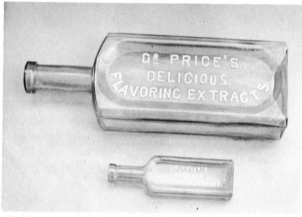

Food containers, clear, embossed "DR. PRICE'S DELICIOUS FLAVORING EXTRACTS" on sides, H. 10 in. (top) and 4¾ in. (bottom), c. 1890–1910.

Left to right: pickle jars, white milk glass, flower and leaf embossments, H. 7¼ in., 5¼ in., 7¼ in., and 5¼ in., c. 1910.

Food containers (left to right): (1) emerald-green, unembossed, H. 7 in., probably contained mint sauce, c. 1890–1900; (2) green, embossed "ROYAL MINT SAUCE, H. C. MFG. CO., DETROIT," H. 6 in., c. 1895–1910.

Food container, clear, cork closure, paper label reads in part "Tomato Cocktail" and "Prepared Solely for and Guaranteed by Henry A. Klein, Chicago, Ill.," unusual food container since, without paper label, it looks like whiskey bottle, H. 11 in., c. 1900.

Food containers, white milk glass, embossed "ARMOUR AND COMPANY, CHICAGO" on side, H. 5½ in. (left) and 8½ in. (right), matching white milk glass stoppers, probably contained beef extract, c. 1900–1920.

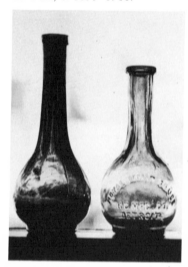

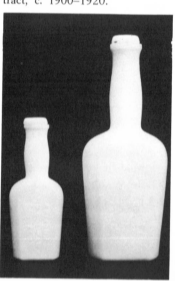

30

Perfume, Scent, and Cologne Bottles

Before the time of Christ, when glassmaking was in its infancy, perfume containers were already being made (see Chapter 2). Many ancient perfume bottles have been found in the ruins of the old civilizations (see Chapter 3), and examples are still being unearthed.

In America, perfume and scent bottles were among the products of such early glassmakers as Stiegel (see Chapter 5). In many countries, including America, pre-twentieth-century bathing habits were, to say the least, not what they are today. Bathing was not easy, because of the lack of indoor plumbing, and was not expected. Consequently, the use of perfume to mask body odor was very popular.

There was a definite difference between perfume and scent, both in smell and use. While perfume was and still is used mainly for personal embellishment, scent commonly meant perfume that contained ammonia and was used for reviving fainting females or just "social smelling," i.e., masking body odors of others. Perfume and scent bottles were, however, very similar.

Before the common use of hinged molds perfume and scent bottles were either free-blown or blown in a dip mold. Around the turn of the nineteenth century perfume and scent bottles of great beauty were beginning to be produced in hinged molds. These bottles were often highly decorated and as a result were comparatively expensive, as were their contents. By the mid-1800s, double scent bottles came into vogue. These interesting containers usually consisted of two separately blown bottles welded together at the base during the manufacturing process when the glass is hot. The purpose of these bottles was to allow the owner to carry both perfume and scent in what for all practical purposes was one container.

In the 1840s, in Cincinnati, Ohio, a former school teacher named Solon Palmer opened a small cosmetics store, including among his wares several perfumes that he manufactured himself.

In 1871 because the business had grown so much and because it was becoming increasingly difficult to obtain necessary perfume ingredients, Solon Palmer moved his business to New York

City. Here he added new perfumes to his line; these included Jockey Club and Frangipanni. By 1879 Palmer products were being sold in almost all drugstores. His line had been expanded to include thirty kinds of soap scented with Palmer perfume.

After Palmer took his son Eddy into the business in 1892 more perfumes were added; these included Baby Ruth (named after President Grover Cleveland's daughter) and Dewey Bouquet (named after the hero of Manila Bay).

When Solon Palmer died in 1903 his New York-based firm was one of the largest in the field. His son, Eddy, continued the business and today it still operates under the direction of Eddy's sons and grandsons. Solon Palmer is important to bottle collectors because of the unusual bottles he used to package his perfumes. These bottles are easily recognizable by their script embossment, "Palmers," and especially by their rich emerald-green color. Although the company produced a large variety of cosmetics it is remembered by bottle collectors mostly for its beautiful green perfume and cologne bottles.

One of the most interesting bottle stories is associated with the cosmetic bottles produced around 1880 featuring embossments of a child and the name "CHARLEY ROSS." These bottles, of which four different types are known, contained as unknown brand of perfume or hair oil and were made to remind the public of the first kidnapping for ransom in America. On July 1, 1874, Charles Brewster Ross, the youngest of seven children belonging to a retail grocer in Germantown, Pennsylvania, was abducted while playing with his brother in their yard. Both boys were lured into a horse and buggy by two shabbily dressed men who offered them candy and a ride. The men sent the older brother into a store for fireworks and drove off with four-year-old Charley. The father received a note asking for ransom, which he did not pay; he never saw his son again. The incident caused a national uproar. Men were killed for just talking to children; and mothers took their chlidren out of school. The case was never solved. The father actively did everything

he could to recover his son. In the *New York Weekly Witness* of September 21, 1876, can be found an advertisement requesting "Charley Ross Agents" for "every town in America." The advertisement offered interested persons literature giving a full account of the abduction, the pursuit, facsimiles of the ransom letters, and literature describing all the various incidents connected with the search for the child. Also included in the package was a portrait of Charley, "with other choice illustrations and information calculated to lead to the recovery of the lost boy, for whom the Father offers a reward of $5,000." This and other efforts failed but Mr. Ross never gave up hope and around 1880, through his grocery store connections, he was instrumental in having the Charley Ross bottles produced not only to remind the public of the tragedy but to keep the search alive.

It was around the turn of the century that cologne became popular. Cologne is a perfume containing a large proportion of alcohol. The odor of cologne is not as strong or as lasting as regular perfume, and consequently more cologne has to be used more often to achieve the same effect as perfume. This means that cologne bottles are generally larger than perfume bottles. Because of their close relationship, perfume, scent, and cologne bottles are usually considered to be one speciality in bottle collecting, and the term "perfume" has generally become the generic one for all three types.

With the improvements related to the use of synthetic aromatic chemicals in perfume manufacturing around 1875 there came a large increase in the number of firms specializing in perfume making in America. At first the glass industry had difficulty keeping pace with the demand for perfume bottles but by the early 1900s, with the development of the automatic glassblowing machine, glasshouses were more able to supply the bottle needs of manufacturers. Many bottle designs became standardized in shape, size, and colors as mass production progressed. The standardization was of great importance to the perfume industry. Because, by tradition, perfume bottles had to be attractive and usually had glass stoppers the improvements in glassmaking had a positive effect on the production of these containers and many perfume bottles of beauty were mass-produced.

Since the early 1900s many perfume companies have utilized bottles that are of great interest to the perfume bottle collector. One of the most interesting firms to contribute to the collect-

ing of perfume bottles is the Avon Products Company (see Chapter 45).

For the collector of perfume bottles the major interest lies in their beauty and size. Usually much time and effort are put into the designing of perfume containers. Perfume bottles are generally less than six inches in height and this factor has great appeal to many collectors who associate smallness with quality.

Shapes of many kinds can be found in the perfume bottle collection, including figural types (see Chapter 20). Many shapes are predominantly geometric.

In the more common bottle types embossments are of interest. Both lettering and design are to be found on many perfume bottles. For collectors who dwell on the collecting of bottles by brand name, embossments are very important.

While the majority of twentieth-century perfume bottles have been made from clear glass there are many specimens to be located in a wide range of colors. The pre-1900 specimens are especially noted for their colors. Most twentieth-century specimens were made with matching glass stoppers; on the more expensive bottles the stoppers were specially ground to fit. Before 1900 the common cork closure was popular. Sometimes a combination glass and cork stopper was utilized; such closures usually featured a cork ring within the neck of the bottle into which a glass stopper fit.

Prices of twentieth-century perfume bottles are comparatively low. Such bottles usually sell for from $5 to $25. The early and ancient specimens are, as would be expected, much more scarce and are priced accordingly, the range being roughly from $25 to $200.

Co-related items in this category include revenue stamps (see Chapter 58), trade cards (see Chapter 57), and early magazine, newspaper, and catalogue advertisements (see Chapter 56).

Bibliography

BOOKS

Freeman, Larry. *Grand Old American Bottles.* Watkins Glen, New York: Century House, 1964.

McKearin, George and Helen. *American Glass.* New York: Crown Publishers, Inc., 1968.

Maust, Don (ed.). *Bottle and Glass Handbook.* Uniontown, Pennsylvania: E. G. Warman Publishing, Inc., 1968.

156

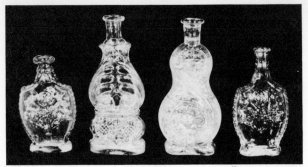

Perfume bottles (left to right): (1) clear, embossed with flowers (rose, daisy, and pansy) and "HL 132," flared lip, ground pontil scar, H. 4⅛ in.; (2) clear, flared lip, ground pontil scar, H. 5⅞ in.; (3) light blue, pontil scar, H. 5¾ in.; (4) similar to (1) except color is green, H. 4½ in., and lip is not flared; mid-nineteenth century. (Don Robinson, Memphis, Tenn.)

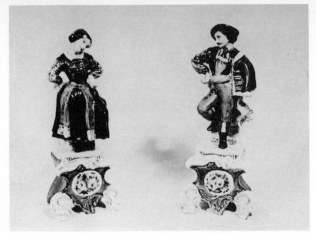

Perfume bottles, ceramic, Jacob Petite, opening in back, H. 6 in., c. 1840. (John C. Fountain, Amador City, Cal.)

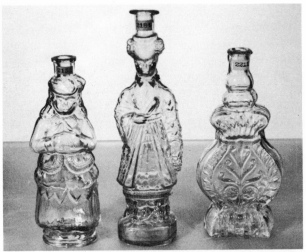

Cologne bottles (left to right): (1) Lady, clear, H. 6¼ in.; (2) Chinese mandarin, H. 7¾ in.; (3) conventional violin shape, H. 6⅜ in.; mid-nineteenth century. (Charles B. Gardner, New London, Conn.)

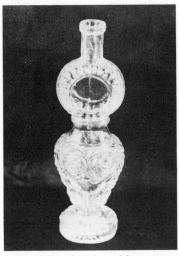

Perfume bottle, clear, blown in a mold, probably French, H. 10¾ in., late nineteenth century. (Don Robinson, Memphis, Tenn.)

Perfume bottle, painted red, round mirror over paper label on side, crude pontil scar, H. 3½ in., mid-nineteenth century. (Don Robinson, Memphis, Tenn.)

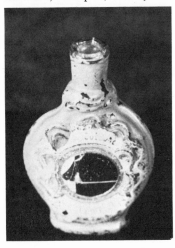

Perfume bottles (left to right): (1) clear, pontil scar, H. 4¾ in.; (2) pale green, rolled lip, pontil scar, embossed with basket-weave pattern around unembossed oval frame on bulbous portion, H. 2⅞ in.; (3) clear, embossed with stem and leaf design, flared lip, H. 4¼ in., mid-nineteenth century. (Don Robinson, Memphis, Tenn.)

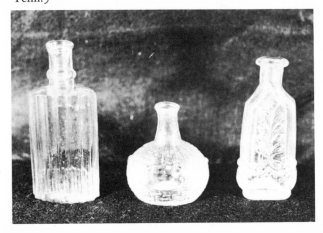

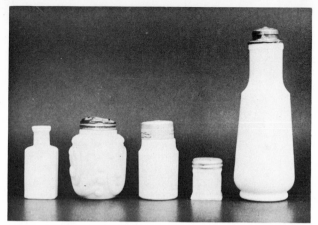

Medicine, cosmetic, and food containers, white milk glass (left to right): (1) unembossed, H. 2½ in.; (2) spice container, H. 3 in., shaker top; (3) embossed "CREME SIMON" on side, H. 2½ in.; (4) embossed "BEL BON" on side, H. 1⅜ in.; (5) talcum powder, embossed "VIOLET PARIS" on side, H. 6 in., shaker top, c. 1900–1920.

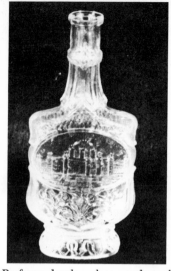

Perfume bottle, clear, embossed with picture of a building in an oval frame with words "MEMORIAL HALL 1876" in arch over building, H. 6⅛ in., c. 1876.

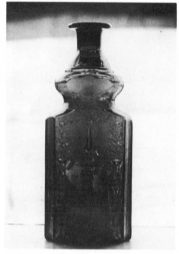

Perfume or cologne bottle, cobalt-blue, H. 8 in., two-piece mold, c. 1870.

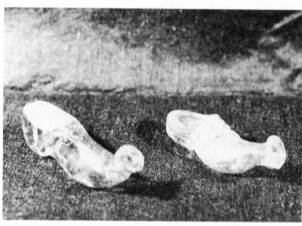

Cosmetic bottles, slippers, clear, paper label reads in part "Rose Hair Oil," ground pontil scar, H. 3⅜ in., c. 1860–1870. (Don Robinson, Memphis, Tenn.)

Cologne bottle, light blue, three panels of vertical diamond design alternating with three smooth panels, flared lip, three-part mold, H. 7¼ in., c. 1860–1870.

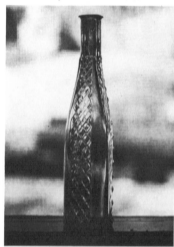

Cologne bottles, Florida Water, aqua (left to right): (1) embossed "FLORIDA WATER, LAZELL DALLEY & CO., NEW YORK" on side, H. 6 in.; (2) embossed "BAKER'S FLORIDA WATER" on side, H. 6½ in.; (3) embossed "FLORIDA WATER, MURRAY & LANMAN, DRUGGISTS, NEW YORK" on side, H. 7½ in.; (4) embossed "CALIDAD SUPERIOR" on side, H. 5½ in.; (5) embossed "FLORIDA WATER, MURRAY & LANMAN, DRUGGISTS, NEW YORK, SAMPLE" on side, H. 4¼ in., c. 1865–1880. (Western Collector, San Francisco, Cal.) Photo by Van Porter.

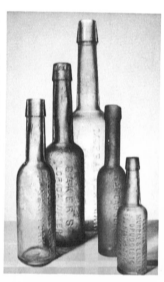

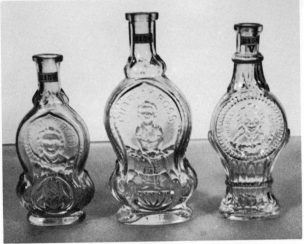

Left to right: hair-oil bottles, embossed with the words "CHARLEY ROSS" and a figure of a young boy, clear, H. 4⅞ in., 6 in., 5½ in., c. 1880. (Charles B. Gardner, New London, Conn.)

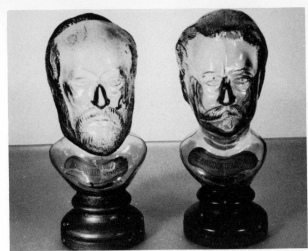

Cologne bottles (left to right): (1) Bust of James A. Garfield, clear, H. 7¾ in.; (2) Bust of John Hancock, clear, H. 7¾ in., c. 1880. (Charles B. Gardner, New London, Conn.)

Perfume bottles, white milk glass (left to right): (1) banjo shape, H. 3½ in.; (2) climbing rose and cable, H. 7½ in.; (3) violin shape, H. 3½ in.; c. 1880–1900.

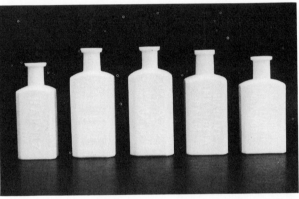

Medicine and cosmetic bottles, white milk glass (left to right): (1) embossed "BARNIZ" on side, H. 4¾ in.; (2) embossed "VELVETINA SKIN BEAUTIFIER, GOODRICH DRUG CO., OMAHA, USA" on side, H. 5¼ in.; (3) embossed "BOERNER-FRY CO., IOWA CITY, IOWA" on side, H. 5¼ in.; (4) embossed "HAGAN'S MAGNOLIA BALM" on side, H. 5⅛ in.; (5) embossed "C. W. LAIRD PERFUME, NEW YORK" on side, H. 4¾ in., c. 1880–1910.

Dresser bottle, bluish milk glass, H. 8 in. (11 in. with stopper), profile of Victorian woman embossed on side, matching white milk glass stopper, c. 1890–1900.

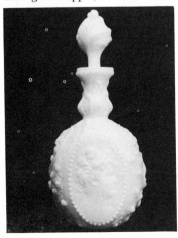

Dresser bottles, white milk glass with matching stoppers (left to right): (1) perfume, flower and vine design on body painted gold, H. 5½ in.; (2) perfume, alternating figure 8 and diagonal stripe pattern, H. 5½ in.; (3) perfume (in top) and powder (in base), hobnail pattern, H. 7½ in., c. 1890–1900.

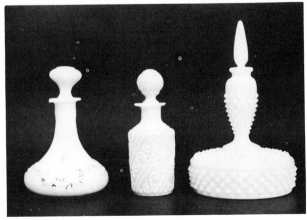

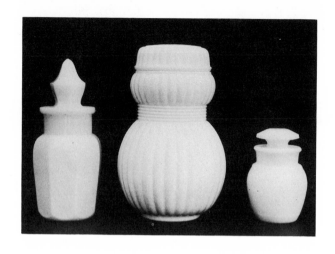

Cosmetic bottles, white milk glass (left to right): (1) bath salts, unembossed, matching glass stopper, H. 7 in.; (2) bath salts, horizontal and vertical ribbed design, screw lid, H. 7¼ in.; (3) cold cream jar, embossed "LUXOR, TRADEMARK, COLD CREAM" on side, embossed "ARMOUR & CO., CHICAGO" on bottom, H. 4 in.; c. 1890–1910.

Cologne bottles from an early-1900s Whitall Tatum Co. catalogue. Bottles range in size from 3 in. to 5 in.

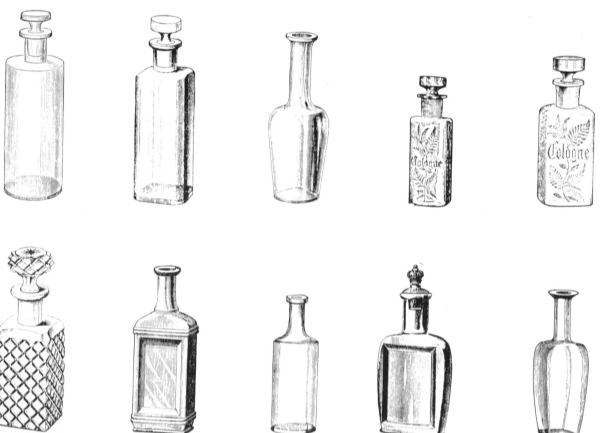

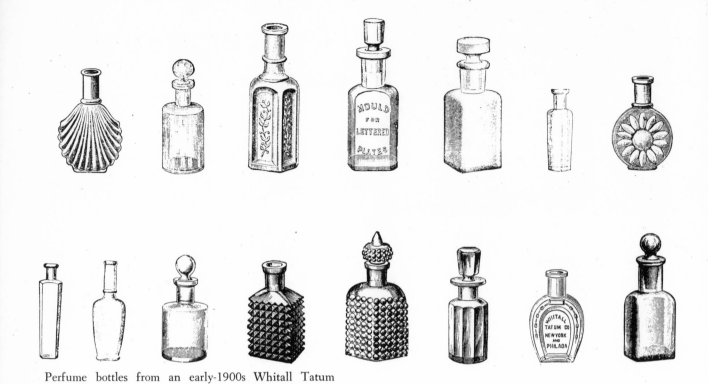

Perfume bottles from an early-1900s Whitall Tatum Co. catalogue. Bottles range in size from 2 in. to 3½ in.

Hair-oil bottle (obverse) embossed with portrait and words "CHARLEY ROSS," clear, H. 5½ in., c. 1880.

Hair-oil bottle (reverse) with a round mirror embedded in a sunken panel, clear, H. 5½ in., c. 1880.

31

Poison Bottles

As civilized man learned about the use of poisons there developed a need for restricting their use. One of the most obvious methods of control (not necessarily the most effective) was to pass laws; this was done in practically every country in Europe by the end of the Middle Ages.

Another means of control was a variety of protective methods adopted to prevent accidental dispensing of poisons. Such methods included the marking of poison containers. One of the first attempts to mark poison containers distinctly occurred in Denmark. Early nineteenth-century porcelain apothecary jars used to contain poisons were clearly marked with three large plus signs (+ + +), a practice still used today in Denmark and other European countries.

In America, the first law regarding the labeling of poisons was passed by the State of New York in 1829. This law required that all poisonous items could not be sold without first "endorsing on . . . [them] the word 'poison'."

Until early in the nineteenth century the skull and crossbones was a Christian symbol. It was often included in paintings of the crucifixion because of a legend that the cross upon which Christ died rested on the skull and bones of Adam. After eighteenth-century pirates began using it on their Jolly Roger flag, the symbol took on a negative connotation. Soon it came to mean death and became associated with poisons. In 1853 the American Pharmaceutical Association passed a resolution recommending that either the word "poison" or a "death's head symbol" be used to identify poisonous substances.

In the late 1850s and early 1860s the British Parliament considered a law requiring all poison containers to be physically identifiable, i.e., embossed with the word "poison" or constructed in such a way as to be readily identifiable upon handling. The law was never passed but pharmacists began to utilize unusual containers for poisons on their own. One of the first physically unusual containers had its opening at the bottom.

The first American to receive a patent for a poison bottle was Joseph Harrison, of Philadelphia, in 1871. Harrison's bottle was similar to the now-famous Whitall Tatum poison bottle, which was first produced in 1872 and continuously manufactured until 1920. At first the quilted cobalt-blue Whitall Tatum bottles were made in sizes ranging from one-half ounce to sixteen ounces. This is perhaps the most popular and easy-to-obtain poison bottle. Later both the Whitall Tatum Company and Hagerty Brothers & Company, of New York City, who copied the Whitall Tatum bottle, made these containers in sizes larger than sixteen ounces. The two types are easily identifiable; the Whitall Tatum bottles have no markings, whereas the Hagerty Brothers bottles are embossed "H.B.C." on the bottom.

In 1872 the American Medical Association recommended that druggists put all *external* medicines in colored glass bottles that were rough on one side and were labeled "Poison." The idea was to appeal to as many senses as practical so that even in the dark mistakes in handling poisons could be avoided. This philosophy of using unusual shape, color, and embossments was predominant until approximately the 1930s.

During the period from about 1870 to about 1930 many unusual poison containers were produced and marketed. Some of the most unusual ones that are a real challenge to add to a collection include a coffin-shaped bottle patented in 1876 by James W. Bowles of Louisville, Kentucky. In 1890, Samuel Snellenburg of Philadelphia invented another coffin-shaped bottle with a skull and crossbones embossed on it. Another unusually shaped bottle was made in 1893 by Edward M. Cone of Newark, New Jersey; this container was fashioned in the shape of a long bone, and was decorated with a skull and crossbones. Both of these last two were produced in cobalt-blue glass. Still another unique specimen of the poison bottle era is the one shaped like a human skull sitting on crossed bones (embossed in heavy relief on the base) with "POISON" embossed across the forehead; it is cobalt-blue in color. This bottle was patented in 1894 by Carlton H. Lee of Boston. One other quite unusual container was invented by Henry Lemmermann of Hasbrouck Heights, New Jersey; this bottle's most

unusual characteristic is its neck, bent at a 90-degree angle from the body.

As early as 1886, John H. B. Howell, of Newton, New Jersey, invented a bottle for poison that emphasized not color, shape, or embossment, but a safety closure. Safety closures did not become popular for many years, however. In the 1930s it was generally decided that colorful, unusually shaped, and heavily embossed bottles attracted children's attention, thereby defeating their purpose; this change in philosophy ended the era of the unusual poison bottle and gave birth to the era of relatively plain bottles stressing safety closures.

Between 1870 and 1930 poison bottles were made in many unusual shapes; in addition to the quilted cobalt-blue Whitall Tatum bottle already discussed, the only other really popular shape was triangular, usually in cobalt-blue glass. Though this basic shape was used by several companies, no organization employed it more than the Owl Drug Company of California. This firm began manufacturing triangular poison bottles with an owl embossed into the glass in 1903. They issued bottles ranging in size from one-half ounce to thirty-two ounces. Other poison bottles came in less startling shapes but still are unusual because they are ribbed, quilted, checkered, or in some way display an unusual embossment that will identify them readily by touch as poison containers.

Next to shape in importance to the poison-bottle enthusiast is glass color. These fascinating containers almost always were made in a variety of colors—in fact it is quite unusual to locate a poison bottle made of clear glass. The most popular color was cobalt-blue but many poison containers were produced in amber or green.

The collector of poison bottles does not have the problem of overwhelming numbers, as do some specialists; there are probably several hundred kinds of basic shapes and somewhat more if all sizes within basic shapes are considered.

While there is not great variety in poison bottle embossments (most bottles feature the word "poison" and/or a skull and crossbones) each one is unusual.

The most unusual specimens command prices ranging from $10 to over $100; the more common-shaped ones are usually less than $10. The very unusual poison containers have been saved for years, while the less ornate bottles that are more simple in basic design have only recently been in demand. This means that the unusual specimens will be most difficult to obtain, while most of the common examples will be found more easily and often.

There are limited related items to be included in a poison bottle collection, consisting mostly of periodical advertisements (see Chapter 56), and bottle stoppers. Some of the best examples of the latter are the Whitall Tatum stopper with its sharp points, the Bailey Safety Alarm Cork-Screw, and the stopper made in the shape of a skull and crossbones by John S. Stites of Brooklyn, New York. Other co-related items of possible interest are corkscrews, bottle labels featuring the word "poison," or any number of drugstore items.

Bibliography

BOOKS

Stier, Wallis W. *Poison Bottles, A Collectors' Guide*. Privately published, 1969.

PERIODICALS

Griffenhagen, George B. "One Man's Poison Is Another Man's Hobby," *Western Collector*, X (October, 1969), 476–481.

Poison bottles (left to right): (1) dark amber, embossed "FREDERICIA," half-pint, mid-nineteenth century; (2) light green, unidentified, half-pint, mid-nineteenth century. (Charles B. Gardner, New London, Conn.)

Safety closure for poison bottles patented by John H. B. Howell of Newton, New Jersey. (*Scientific American*, February 20, 1886)

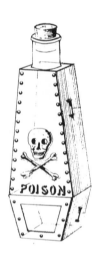
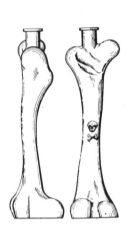
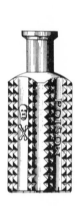
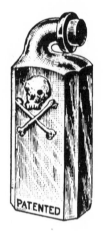

1 2 3 4 5

Unusual poison bottles as sketched for U.S. Patent Office (left to right): (1) Patent No. 183,117 granted to James W. Bowles, of Louisville, Kentucky, on October 10, 1876; (2) Patent No. 20,135 granted to Charles P. Booth, of Atlantic City, New Jersey, on September 9, 1890; (3) Patent No. 22,835 granted to Edward M. Cone, of Newark, New Jersey, on October 17, 1893; (4) Patent No. 541,133 granted to James H. Valentine, of Chatham, New Jersey, on June 18, 1895; (5) Patent No. 26,482 granted to Henry Lemmermann, of Hasbrouck Heights, New Jersey, on January 8, 1897. (George B. Griffenhagen, *Journal of the American Pharmaceutical Association*)

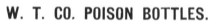

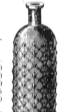

W. T. CO. POISON BOTTLES.

Blue Glass, covered, except space for label, with sharp diamond-shape points.

	Per gross.		Per gross.
Assorted, 1 gross in box	$6 50	4 ounce	$7 00
½ ounce	3 00	6 ounce	8 50
1 ounce	3 75	8 ounce	10 50
2 ounce	4 75	12 ounce	13 75
3 ounce	5 50	16 ounce	16 50

The contents of an Assorted Case of Poison Bottles is as follows: 2 dozen ½ ounce, 3 dozen 1 ounce, 3 dozen 2 ounce, 2 dozen 4 ounce, ½ dozen 6 ounce, 1 dozen 8 ounce, ½ dozen 16 ounce.

STOPPERS FOR BOTTLES CONTAINING POISON.

Blue Glass, covered with sharp points.

Per gross.
No. 1. With No. 2, 3, or 4 Corks for ½ to 4 ounce bottles $6 00
No. 2. With No. 5 or 6 Corks for 6 to 16 ounce bottles 7 00

These stoppers are made with screw thread on shank, and can easily be fitted with shell corks to suit any size bottle.

Whitall Tatum Co. quilted poison bottle and stopper (portion of a page from an early-1900s Whitall Tatum Co. catalogue).

164

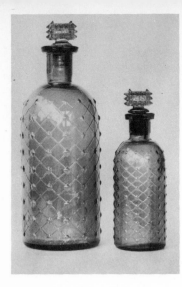

Left to right: poison bottles, cobalt-blue, embossed quilted pattern covering two-thirds of bottle with unembossed rectangular frame on side to accommodate paper label, sharp points on all sides of rectangular cork closure, H. 10 in. and 5¾ in. (including stoppers): (1) manufactured by Whitall Tatum Co., and (2) manufactured by Hagerty Brothers & Co., New York ("H. B. CO." embossed on base), c. 1872–1920.

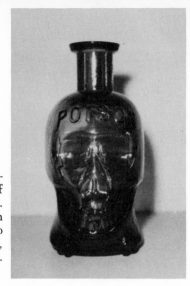

Poison bottle, cobalt-blue, embossed "POISON" near the top of skull-shaped bottle, H. 3 in., c. 1894, U.S. Patent Office design patent number 23,399 granted to Carlton H. Lee of Boston, Mass., on June 26, 1894. (Wallis W. Stier, Boise, Idaho)

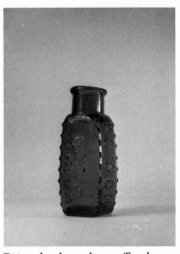

Poison bottle, amber, coffin shape, embossed "POISON" on sides with skull and crossbones embossed on front, H. 3 in., c. 1900.

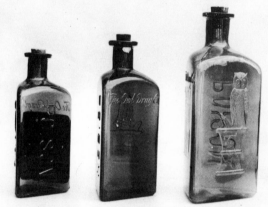

Left to right: poison bottles, cobalt-blue, H. 7 in., 8 in., and 9½ in., triangular, each identically embossed with "POISON" on one side, "THE OWL DRUG CO." on another side, and an owl perched on a mortar stirring with a pestle on another side (trademark of The Owl Drug Co.), c. 1892–1908.

Poison bottles, amber, embossed "POISON" on sides, H. 8 in. (top) and 2¾ in. (bottom), c. 1910–1920. Embossing painted for photographing.

Poison bottles, amber, embossed "POISON" on sides, H. 10 in. (top) and 2¾ in. (bottom), c. 1910–1920. Embossing painted for photographing.

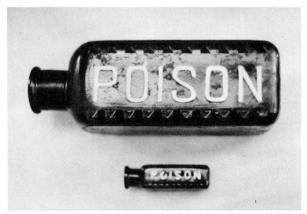

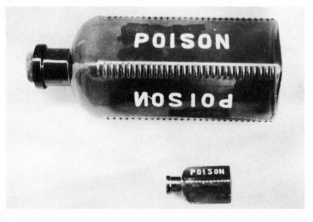

32

Decanters and Bar Bottles

Some of the first bottles ever manufactured were used to decant liquids—wine or other spirits—and are, therefore, called *decanters*. Since most liquids came in bulk containers such as barrels, demijohns, and other large vessels it was necessary to transfer small amounts to a handier container; this was usually a decanter. Decanters, generally, can be distinguished from regular bottles by the matching stopper. Even from the earliest times much time and effort were put into the making of a decanter and its matching stopper (see Chapter 3). More often than not decanters were highly decorated. Decorative techniques were also employed to identify the contents of some decanters and many are found with "gin," "rum," "brandy," "sherry," "port," "whiskey," etc., lettered on them. In addition, designs such as ships, eagles, and other traditional decorative motifs were etched, engraved, or otherwise marked on or into decanters.

For the collector of bottles—especially the collector of decanters—the glasshouses in Bristol, England, are of great importance. From about 1780 to 1840 the glasshouses of Bristol produced some of the finest decanters ever made. Although technically decanters, these bottles from Bristol are called Bristol flagons. Bristol flagons were made in blue, green, amber, clear, and amethyst glass, are oblong with flattened sides, and feature an applied loop handle. Since these bottles were made before the development of the snap all known specimens have pontil scars—the earliest featuring rough scars and the latest with the scars smoothly ground. The necks of these unusual decanters are encased in pewter, silver, or brass. Bristol flagons have associated stoppers; these are either ball-shaped, disc-shaped, or formed into a bunch of grapes with a loop. The disc-shaped stoppers have a round loop of metal with a mother-of-pearl insert upon which is painted the type of spirits to be kept in the decanter. Wealthy colonists often purchased Bristol flagons, and because of their glass quality, beauty, and excellent craftsmanship these decanters have been kept in

families for generations. Decanter collectors in America have a good chance of being able to acquire some examples.

In America, decanters were an important product of nearly all the early glasshouses. During the nineteenth century very ornate molds, some in three vertical pieces, were created to produce these highly decorated bottles. Another characteristic of decanters and related types of bottles that were made to be kept indefinitely is the ground-away pontil scar.

By the last quarter of the nineteenth century competition between whiskey distillers brought about the highly decorated bar bottle. The distillers offered public bar-owners decanters for dispensing the spirits they bought in bulk quantities. Because they were used primarily in bars, these decanters were called bar bottles. Most often they featured the brand name of the product and were given free to the bar-owners as an inducement to buy a particular brand of spirits. Bar bottles were usually made of clear glass and displayed enameled lettering; they very seldom had glass toppers, as did other decanters, but generally utilized a common cork closure. Sometimes these corks had a porcelain cap on them. Bar bottles were in common usage until around 1920, the beginning of Prohibition.

Some of the most unusual bar bottles featured a sunken panel on the body of the container. Pictures of girls and colorful scenes were placed in the sunken panels and sealed over with a curved piece of glass (see Chapter 34).

Around the turn of the century, as competition between distillers grew more intense, bar-owners were offered free bar bottles enameled with the bar name. It is not uncommon when studying a collection of bar bottles to find some with bar, restaurant, and hotel names enameled on them.

One of the most interesting bar bottles was produced around 1900 by the Hayner Distilling Company of Troy, Ohio. This bottle is of clear glass and features a *combination lock stopper*, which was patented on April 20, 1897. Just in-

side the neck is a groove into which dogs on the stopper fit when the bottle is locked. This bottle was sold by the Hayner Company to both individuals and bars. This is one of the few bottles that can be locked.

After Prohibition (1920–1933) the practice of distillers providing bars with personalized bottles was discontinued because of strict liquor laws, but whiskey manufacturers circumvented these laws somewhat by packaging their products in decanters featuring their company name. This was not a popular merchandising technique, however, until the 1950s, when this type of bottle was heavily advertised as a gift decanter. These decanters resemble the pre-Prohibition bar bottles but contemporary whiskey decanters have matching glass stoppers (see Part VI).

Decanters and bar bottles are very collectible. The pre-1920 types have been saved by collectors for years because of their beauty, but the more modern types have only recently captured the interest of bottle collectors.

There is little size variation in decanters and especially in bar bottles. The usual sizes are one-fifth of a gallon and one quart. In shape, decanters are found in great variety, although bar bottles are more often found in standard cylindrical bottle shapes and slight modifications thereof.

Color is a more important consideration for the collector of decanters than it is for the bar-bottle specialist. Decanters can be found in almost all colors, whereas bar bottles are most often found in clear glass.

Embossment is not of great importance in either decanter or bar bottle collecting; the predominant characteristics of both are the variety of other decorative techniques applied to them and the ornately sculptured molds used in their construction.

With the exception of the unusual combination lock stopper already described, closures on decanters and bar bottles are either stoppers or corks and seem to command little interest; although a decanter without its stopper is greatly reduced in value.

Prices range a great deal according to age and type. Early decanters (pre-1900) generally sell for $20 to $100, but contemporary decanters rarely sell for more than $20 unless they are of special interest to a collector for reasons other than the fact that they are decanters—good examples are some of the first Jim Beam decanters (see Chapter 46). Bar bottles, on the other hand, are very popular with collectors; those with enameled brand names sell for $15 to $100 generally. Bar bottles with labels and pictures sealed under glass are not common and sell for $50 to $200 on the average.

Bibliography

BOOKS

Crompton, Sidney. *English Glass.* New York: Hawthorn Books, Inc., 1968.

Freeman, Larry. *Grand Old American Bottles.* Watkins Glen, New York: Century House, 1964.

Maust, Don, ed. *Bottle and Glass Handbook.* Uniontown, Pennsylvania: E. G. Warman Publishing, Inc., 1968.

Wilson, Bill and Betty. *Spirits Bottles of the Old West.* Wolfe City, Texas: Henington Publishing Co., 1968.

PERIODICALS

"Decanters," *House and Garden,* CXIX (March, 1961), 134.

Roach, Lew D. "Bar Serving Bottles," *Western Collector,* IV (December, 1966), 38–40.

Thorpe, W. A. "Evolution of the Decanter," *Connoisseur,* 1929, pp. 196–207.

Turman, D. H. "Canta on the Decanter," *Hobbies,* LVI (January, 1952), 107.

Van Nostrand, L. C. "Blown Decanters," *Old Glass,* 1940, p. 5.

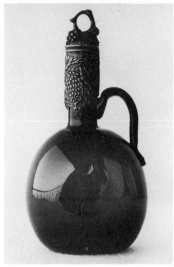

Bristol (England) flagon, blue, H. approx. 8 in., c. 1780–1840, neck and stopper pewter or "Brittania metal." (Gary Eichhorn, Missoula, Mont.) Photograph by Gordon Laridon.

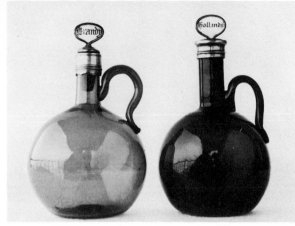

Left to right: Bristol flagons, amber and dark emerald-green, H. approx. 8 in., c. 1780–1840, necks encased in silver, stoppers labeled "Brandy" and "Holland's" (gin). (Gary Eichhorn, Missoula, Mont.) Photograph by Gordon Laridon.

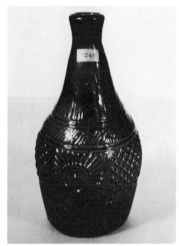

Decanter, deep olive-green, three-piece mold, pint, early nineteenth century. (Charles B. Gardner, New London, Conn.)

Decanter, brilliant green, quart, English (probably Bristol), c. early nineteenth century. (Charles B. Gardner, New London, Conn.)

Decanter, deep olive-green, three-piece mold, quart, early nineteenth century. (Charles B. Gardner, New London, Conn.)

Unusual decanter or bar bottle closure. When the bottle is tipped, the marble is moved automatically away from the opening, allowing the contents to be poured. (Charles B. Gardner, New London, Conn.)

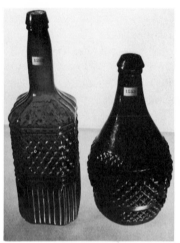

Decanters: both olive-green, three-piece mold, Keene, quart, early nineteenth century.

Decanters (left to right): (1) clear, New England pineapple decanter, pint, early nineteenth century; (2) clear, New England pineapple decanter, bar lip and unusual wire enclosed marble sealing device, pint, early nineteenth century. (Charles B. Gardner, New London, Conn.)

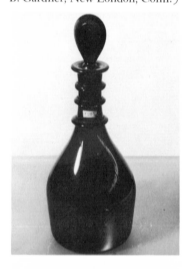

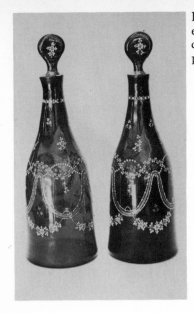

Decanters, free-blown, cobalt-blue, enameled design, H. 10¾ in., including matching ground stoppers, late eighteenth century.

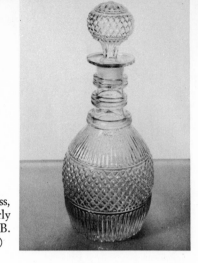

Decanter, clear, Sandwich glass, three-piece mold, quart, early nineteenth century. (Charles B. Gardner, New London, Conn.)

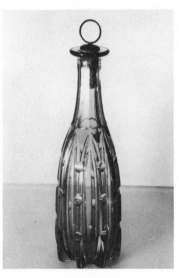

Decanter, unidentified, clear, olive-green, quart, mid-nineteenth century. (Charles B. Gardner, New London, Conn.)

Bar bottles (left to right): (1) clear, banjo shape, label under glass "OLD GILT EDGE BOURBON WICHMAN, LUTGEN & CO. SOLE AGENTS." on side, H. 9⅞ in.; (2) clear, enameled "R-M-C SPECIAL BOURBON" on side, H. 11 in., c. 1880–1910. (*Western Collector*, San Francisco, Cal.) Photo by Warren Whited.

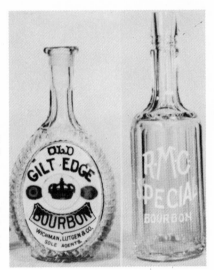

Bar bottles (left to right): (1) clear, gilded "O.K. LOG CABIN WHISKEY" on side, H. 10¾ in.; (2) clear, enameled "JESSE MOORE" on side, H. 10⅞ in.; (3) amber, enameled "C. & K. BOURBON, CASEY & KAVANAUGH, SACRAMENTO" on side, H. 11 in.; (4) clear, enameled "CLERMONT, AAA" on side, H. 11 in.; c. 1880–1910. (*Western Collector*, San Francisco, Cal.) Photo by Warren Whited.

Bar bottles (left to right): (1) clear, gilded "ARGONAUT BOURBON" on side, H. 11 in.; (2) clear, enameled "MONOGRAM WHISKEY, BERTIN & LEPORI, SAN FRANCISCO, CAL." on side, H. 11¼ in.; (3) clear, gilded "EBNER BROTHERS FINE WHISKEY" on side, H. 11 in.; (4) clear, enameled "IMPERIAL CABINS" on side, H. 11¼ in.; c. 1880–1910. (*Western Collector*, San Francisco, Cal.) Photo by Warren Whited.

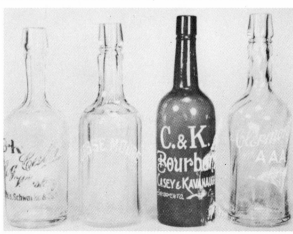

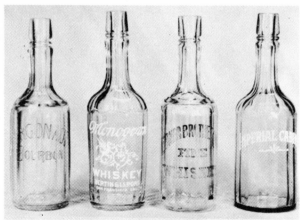

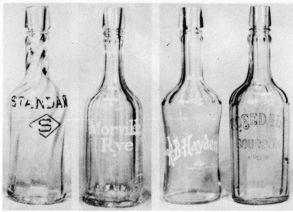

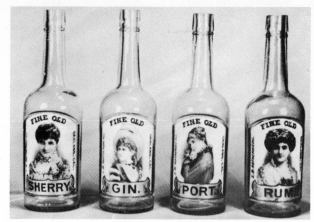

Bar bottles (left to right): (1) clear, gilded "STANDARD" with an "S" in a diamond design on the side, H. 11 in.; (2) clear, enameled "MORVILLE RYE" on side, H. 11 in.; (3) clear, enameled "OLD R. B. HAYDEN" on side, H. 11 in.; (4) clear, gilded "ROSEDALE BOURBON, A BLEND" on side, H. 11 in.; c. 1880–1910. (*Western Collector,* San Francisco, Cal.) Photo by Warren Whited.

Bar bottles, lithographed labels are covered with a glass panel, H. 11 in.; c. 1880–1900. (*Western Collector,* San Francisco, Cal.) Photo by Warren Whited.

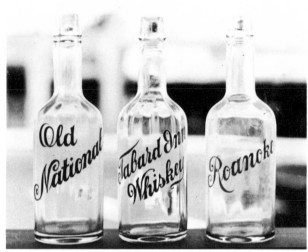

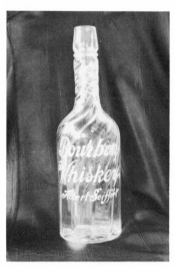

Bar bottles, clear (left to right): (1) enameled "OLD NATIONAL," H. 11 in.; (2) enameled "TABARD INN WHISKEY," H. 10¾ in.; (3) enameled "ROANOKE," H. 11 in.; c. 1880–1910.

Bar bottle, clear, enameled "BOURBON WHISKEY, ALBERT SEIFFERT" on side, H. 11 in., extremely handsome bottle, twisted effect gives off a colorful iridescence when held to light, c. 1890–1910.

Bar bottle, clear, unembossed, leafy pattern engraved on body, scroll pattern silvered around shoulder, upper portion of neck also silvered, H. 11 in., c. 1900.

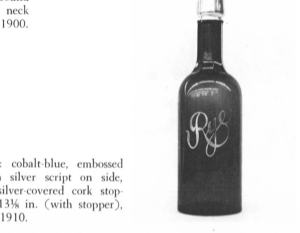

Decanter: cobalt-blue, embossed "RYE" in silver script on side, sterling silver-covered cork stopper, H. 13⅛ in. (with stopper), c. 1900–1910.

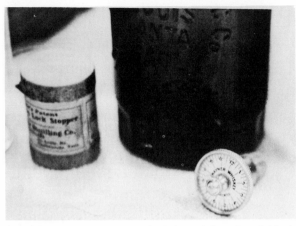

Combination lock stopper (right) and box in which it came (left). This stopper was produced for the Hayner Distilling Company of Troy, Ohio, c. 1900.

INSTRUCTIONS: How to Operate Combination Lock Stopper

SEE that the Lock-Stopper is unlocked—which can be determined by pressing in the two dogs which extend out just above the cork. If the dogs will not press in, then the Stopper is locked—and can be unlocked by following the instructions "To Unlock the Stopper" given below.

WHEN the Lock-Stopper is unlocked—press it into the neck of the Lock-Stopper Decanter until the dogs set into the groove inside the neck of the bottle. Then turn the combination a few times and the bottle is locked.

TO UNLOCK THE STOPPER—Set pointer at 12, then turn entirely around to the Left one or more times stopping at 9. Then turn to the Right back to 1¼. Catch the Stopper by the outside rim and lift it out of the bottle

Instructions for the combination lock stopper produced for the Hayner Distilling Company. (E. L. Parsons, Guide Rock, Neb.)

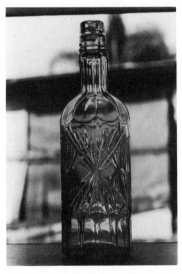

Bar bottle sold or given away by the Hayner Distilling Company, H. 11½ in., c. 1900. This bottle is designed to utilize a combination lock stopper.

Closeup of groove inside neck of Hayner Distilling Company bar bottle. Grooves are designed to accommodate dogs of associated combination lock stopper.

Bar bottle, clear, H. 11 in., c. 1900. Hand-painted floral design on sides; obverse features a young lady standing behind a bush upon which the words "Poetry and Prose" are painted; from the reverse (looking through the bottle) the same young lady can be seen standing in her undergarments. (Roy Fowler collection, Los Angeles, Cal.)

33

Barber Bottles

During the last fifty years of the nineteenth century, when many men went to barbershops for a shave as well as a haircut, it became the custom to provide special customers with personalized shaving mugs and hair tonic bottles. In addition, each barber had his own set of two bottles of tonic for other than special customers, and a matching bowl. Some barber bottles could be more properly called dresser bottles because they were used in the home. Since there is no way to distinguish between bottles used in barber shops and those used at home, and because the majority of these bottles were used in barber shops, no distinction will be made in this book.

The tonics kept in these bottles were bay rum, witch hazel, "Tiger Rub" (perfumed alcohol), and a variety of liquids with such appealing names as "Lilac," "Rose," and "Spice." Some of these tonics were commercial products and some were made by the barber himself. The 1906 Pure Food and Drug laws (see Chapter 15) prohibited such personalized mixtures and restricted the manufacture of some commercial products. This, coupled with the success of King Camp Gillette (who was also involved in the soda water industry—see photograph in Chapter 21) in marketing the safety razor in 1903 (which reduced daily trips to the barber), brought about the death of barber bottles in both the shop and home.

At first these containers were kept around barber shops and homes as decorations; some persistent individuals even refilled them with commercial products available at the time, but this became burdensome, and by the 1920s these beautiful bottles had attracted the eye of art-glass collectors. Because of this early interest by collectors very few of the bottles were lost but by the same token few are available today; those that are can usually only be obtained through antique shops with the aid of good amounts of money. Barber bottle prices start at about $25, and go as high as several hundred dollars.

The personalized bottles sometimes had a picture of a then-reigning stage great, a political figure, or some romantic scene. The pictures were lithographed in full color on a thin paper. The paper was pasted in the side of the bottle in a frame and covered with a glass panel curved to fit the contour of the bottle. The customer's name was usually printed in gold across the top of the bottle and the name of the tonic across the bottom.

Other barber bottles were highly decorated with enamel or were made by one of the fine art-glass techniques. There are bottles of frosted glass, vaseline glass, milk glass, hobnail, Mary Gregory, cut glass, thumbprint, and even Tiffany. The range in colors is practically unlimited: ruby, sapphire, cobalt, green, orange, yellow, pink, amethyst, and so on.

Many of the bottles came from such glass centers as Bohemia and England; some were made at Sandwich, Massachusetts; ruby-red containers were made in the Pittsburgh area; but by far the majority of domestic barber bottles were made in Glassboro, New Jersey.

Since most barber bottles were ornately decorated very few are found with embossments unless some of the raised designs are counted. Closures, for the most part, were pewter, silver, or porcelain. Many of these closures have been lost over the years and most barber bottles stand headless on the bottle collector's shelf.

Co-related items are many and varied. The enthusiastic collector will go so far as to include antique barber chairs and barber poles in his collection. The most sought-after co-related item is the bowl that went with the usual pair of matched bottles. These bowls are quite difficult to obtain because not many of them have survived the years. Razors and other barber instruments are often included in a collection of barber bottles.

An extensive barber bottle collection would be expensive and difficult to amass, but such a collection would be one of the most beautiful.

Bibliography

BOOKS

Freeman, Larry. *Grand Old American Bottles.* Watkins Glen, New York: Century House, 1964, pp. 370–371.

Maust, Don, ed. *Bottle and Glass Handbook.* Uniontown, Pennsylvania: E. G. Warman Publishing, Inc., 1968, p. 155.

PERIODICALS

McMillen, Dorothy. "Armor's Barbers Bought Better Bottles," *Old Bottle Magazine,* II (March, 1969), 6–9.

Wearin, Otha. "Barber Bottles," *Western Collector,* IV (January, 1966), 5–7.

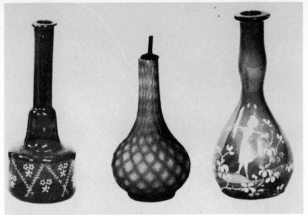

Barber bottles (left to right): (1) Tiffany type, enameled floral design on sides, purple slag, H. 9 in.; (2) pink satin glass overlay, H. 7 in.; (3) Mary Gregory glass, H. 9 in.; c. 1890–1900. (*Western Collector*, San Francisco, Cal.) Photo by Otha Wearin.

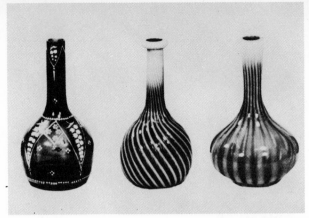

Barber bottles (left to right): (1) Tiffany type, enameled floral design on side, purple slag, H. 8½ in.; (2) amber and white candy stripe, H. 8 in.; (3) lavender and white opaque stripe, H. 7¾ in.; c. 1880–1900. (*Western Collector,* San Francisco, Cal.) Photo by Otha Wearin.

Personalized barber bottles, pale pink milk glass, H. 8½ in., hand-painted scenery, mid-nineteenth century.

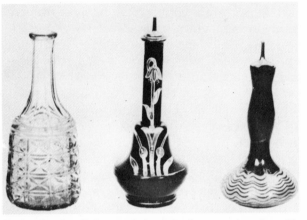

Barber bottles (left to right): (1) clear, pattern glass, H. 9 in.; (2) Tiffany type, enameled floral design on side, purple slag, H. 8¾ in.; (3) Tiffany type, enameled floral design on side, purple slag, H. 7 in.; c. 1880–1900 (*Western Collector*, San Francisco, Cal.) Photo by Otha Wearin.

Barber bottles (left to right): (1) cranberry hobnail, H. 8 in.; (2) cobalt-blue, enameled flowers on side, H. 8½ in., late nineteenth century.

Barber bottles, white milk glass (left to right): (1) hand-painted lettering and flowers, H. 8¾ in., late nineteenth century; (2) stenciled lettering and flowers, blown in a soda bottle mold, crown cork top, H. 8½ in., c. 1905.

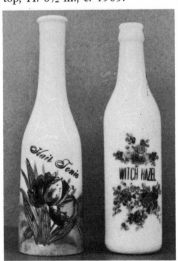

Barber bottles (left to right): (1) pale-blue frosted glass, hand-painted flowers, H. 9 in., late nineteenth century; (2) Stars and Stripes, red, white, and blue, H. 8½ in., late nineteenth century.

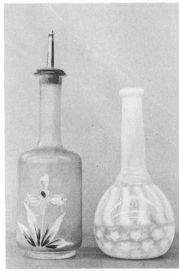

173

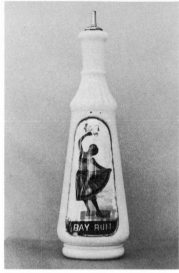

Barber bottle, white milk glass, Bay Rum label covered with glass. H. 8½ in., late nineteenth century.

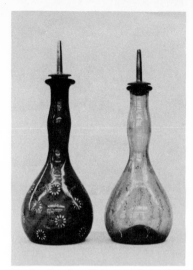

Barber bottles (left to right): (1) emerald-green, H. 8¼ in.; (2) lime-green, H. 8 in.; enameled floral decorations; late nineteenth century.

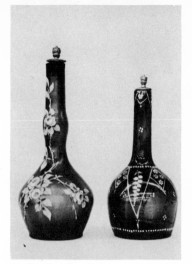

Barber bottles (left to right): (1) cobalt-blue, H. 9 in.; (2) amethyst, H. 8 in.; enameled floral decoration; late nineteenth century.

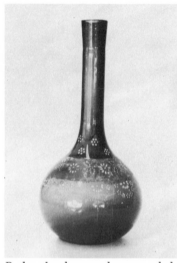

Barber bottle, purple, enameled, H. 8 in., late nineteenth century.

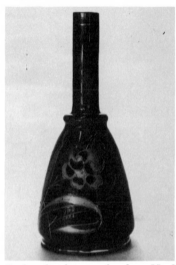

Barber bottle, purple slag, H. 8 in., late nineteenth century.

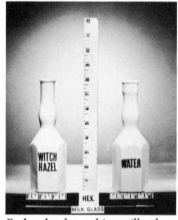

Barber bottles, white milk glass, H. 8 in., contents stenciled in black on side, late nineteenth century. (John C. Fountain, Amador City, Cal.)

Barber bottle, white milk glass, H. 10½ in., note recessed area where label was placed, then covered with glass, c. 1890.

Barber bottles (left to right): (1) amber hobnail, H. 8 in.; (2) clear, enameled picture of a child on side, H. 11¾ in.; c. 1890–1900. (*Western Collector,* San Francisco, Cal.) Photo by Otha Wearin.

Barber bottles, white milk glass (left to right): (1) unembossed, H. 7 in.; (2) painted (stenciled) lettering and floral pattern, H. 9 in.; (3) unembossed, H. 7¾ in.; late nineteenth century.

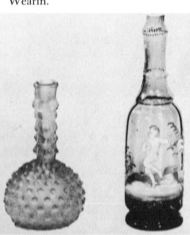

34

Drugstore Bottles

There are essentially two major groups of drugs: ethical and proprietary. Proprietary medicines and their bottles are discussed in Chapter 15. The bottles to be discussed here will be those used for ethical (prescribed) medicines and the various other types of bottles associated with pharmacies (drugstores), excepting poison bottles which are treated separately in Chapter 31.

Pharmaceutical bottles go back to the time of the Egyptians, but not many early examples have survived. These specimens of ancient glass are quite difficult to obtain compared with the more common types of ancient bottles. The first pharmaceutical bottles featuring enameled labeling are from sixteenth-century Venice; some of these occasionally show up at glass auctions.

In America both Wistar and Stiegel made and sold medicine phials, globes, and other bottles for apothecaries (physicians who both prescribed and manufactured drugs). Later glassmakers, such as Dyott, also had a line of pharmaceutical bottles. These bottles frequently are found at auctions, sales, and in antique shops.

Many of the more permanent glass containers used by apothecaries and pharmaceutists (the early name for pharmacists) were ornately labeled by painting, enameling, and so forth. An interesting and unusual method of labeling pharmaceutical, barber, and bar bottles during the last half of the nineteenth century was that of sealing labels on bottles under glass. In 1862 William N. Walton, of New York, patented the recessed label, a label applied to an indented portion of the bottle. On bottles featuring recessed panels the labels are often covered with a glass curved to fit the shape of the bottle.

The labels for bottles used in a drugstore are attractively made in gold foil and related materials and are very durable. Because of their durability, and because they were reused (and even passed from father to son), many have survived and are readily available to an interested collector. Almost without exception these reusable drug bottles were

made with matching glass stoppers that were ground to insure a near perfect closure. The inside of the bottle neck was often ground, as well, for the same reason.

Similar bottles made to be used indefinitely in drugstores featured embossed labeling. Frequently the raised lettering is ground, giving the letters a flat surface and a dull finish.

In almost all apothecary shops and the later pharmacies there was a pair of highly decorated bottles for show. These bottles were generally from one to several feet high and were most often filled with colored water. A popular name for these containers is *show-window bottles*. Some of the more elaborate examples were made in three separate parts which were placed one on top of the other. Technically, such a show-window bottle is really three bottles; each piece was filled with water of a different color. By tradition, pharmacies had a variety of large, attractive bottles and expensively labeled bottles throughout the store, as well as smaller versions, some of which were utilitarian and contained items for sale, while others were filled with colored water and used just for show.

Except for poison bottles the most popular of the drugstore bottles from a bottle collector's viewpoint are the prescription bottles. There are two types of these: plain and embossed. The plain bottles usually featured sunken panels into which paper labels were glued. These are not especially interesting because in most cases the labels are missing. The popular prescription bottles are the ones with embossments. Beginning in the late 1880s the large glass-manufacturing firms had bottle molds of standard shapes into which they inserted the customer's personalized plate and then blew a supply of bottles. This was an inexpensive means of obtaining the necessary prescription bottles, and almost all drugstores took advantage of it. Large drugstores and chains of drugstores usually had their own exclusive molds made and did not use plate-molded bottles. Many

specialists collect bottles of just one or several of the major chains of drugstores. Probably the most popular of the large drugstore chains is the Owl Drug Company. This firm featured an owl, perched on a mortar and holding a pestle in one claw, embossed on almost all of their bottles. Since they sold a complete line of pharmaceutical items, many in bottles, there are numerous shapes and sizes for the specialist's collection. The Owl Drug Company, founded in San Francisco in 1892, became affiliated with Rexall in 1919, and sold out completely to the United Drug Company (Rexall Division of the Rexall Drug and Chemical Company) in 1933. The Owl Drug bottles of most interest to the specialists were made from 1892 to 1933; the chain became the Owl-Rexall Drug Company after 1933 and mostly used paper labels on their otherwise plain bottles.

Of the other bottles that were sold in the early drugstores, table jars and tooth-powder bottles are among the most interesting. These rather small containers were produced in attractive shapes. Tablet jars featured glass stoppers while most tooth powder bottles had screw caps or cork-encircled stoppers. These tooth powder stoppers usually had a second screw cap at the tip of the stopper; this was to allow for the use of small amounts of tooth powder.

A number of bottle types are lumped together in the category of drugstore bottles. As a result, sizes within this category vary a great deal. Labeled and glass-stoppered bottles that were reused by pharmaceutists were usually several inches to ten inches in height. Show-window bottles were generally as tall as several feet; other show jars and bottles were shorter (one to two feet). Prescription bottles of all types seldom exceeded twelve inches in height. Table jars and tooth powder bottles were usually one to several inches high.

Shapes in all types of drugstore bottles varied greatly except in the reusable labeled bottles, which were mostly cylindrical or square, and prescription bottles, which were mostly oblong. Show-window and display bottles and jars were made in numerous original shapes.

Although closures on the more expensive bottles and jars were usually glass stoppers, on the expendable and less expensive prescription bottles the cork closure was common. Embossments, though common on prescription bottles, were for the most part limited to descriptive lettering and some designs.

Colors, though not rare, were limited to amber and occasionally green, as well as blue in prescription and reusable labeled bottles. In other types and most prescription and reusable labeled drugstore bottles, clear glass was predominant. In the show-window and display jars and bottles clear glass was desired because it allowed the contents to provide the colorful display.

Drugstore bottles used before the 1900s are quite scarce and command prices as high as $100. Bottles and jars made for drugstore use after 1900 are more easily obtainable and generally fairly inexpensive. Unusual shapes and colors increase the value a great deal. Reusable labeled bottles sell for $10 to $30 on the average; show-window bottles are priced around $50 but go as high as $150 if they are exceptionally attractive; the same is true of display jars and bottles. Prescription bottles seldom cost more than $5 unless they were made in amber, green, or blue; then prices go as high as $20. Popular containers from such large firms as the Owl Drug Company sell for from $50 to $200 because of the demand.

Co-related items include tin containers and almanacs. The large chain drugstores often sold their own brand of combs, toothbrushes, shaving brushes, and so forth; these are of prime interest to the specialist bottle collector.

Bibliography

BOOKS

Beseker, W. J. *Glass Labels for Bottles*. London: Stationers Patent Office, 1854.

Freeman, Larry. *Grand Old American Bottles*. Watkins Glen, New York: Century House, 1964.

Jensen, Al and Margaret. *Old Owl Drug Bottles and Others*. Mountain View, California: Peninsula Press, Inc., 1968.

Munsey, Cecil. *Would You Believe*. San Diego, California: I.P.S., a division of Neyenesch Printers, Inc., 1968.

PERIODICALS

Griffenhagen, George E. "World's Fanciest Pill Bottles," *Today's Health*, XLII (December, 1964), 42–45.

Marco, Ken. "The Tail of the Owl," *Western Collector*, IV (September, 1966), 27–29.

Mordue, H. W. "Druggists Show Bottles," *Hobbies*, LXV (May, 1960), 28.

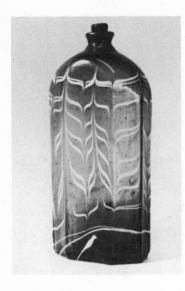

Drug bottle, free-blown, six-sided, paddled, pewter cap, amber, white enameling on all sides, H. 7⅜ in., c. 1770–1775.

Drugstore bottles (left to right): (1) amber, embossed "BROWNA-TONE KENTON PHARMACAL CO., COVINGTON, KY." on side, H. 3⅝ in., c. 1910; (2) blue, embossed "ACKER'S ENGLISH REMEDY" on one side, "W. H. HOOKER & CO., PROPRIETORS, NEW YORK, USA." on another side, and "FOR THE THROAT AND LUNGS" on another side, H. 4¾ in., c. 1890–1905.

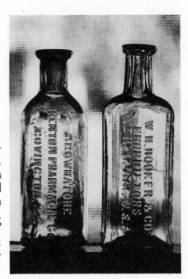

Sample plates (used in plate mold) for prescription bottles; from Whitall Tatum Co. catalogue.

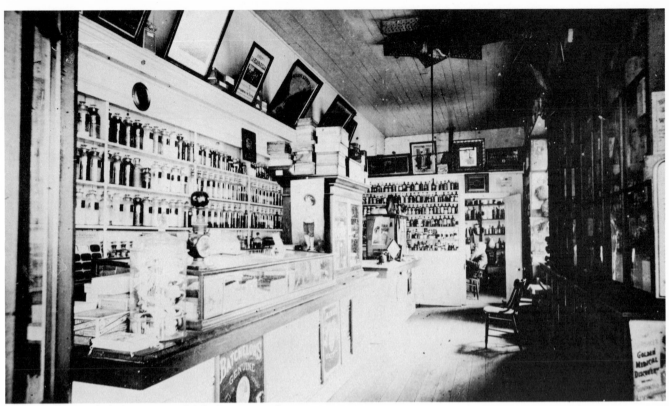

Typical drugstore of the 1880s. (Title Insurance Company, San Diego)

Plate-mold prescription bottles from an early-1900s Whitall Tatum Co. catalogue.

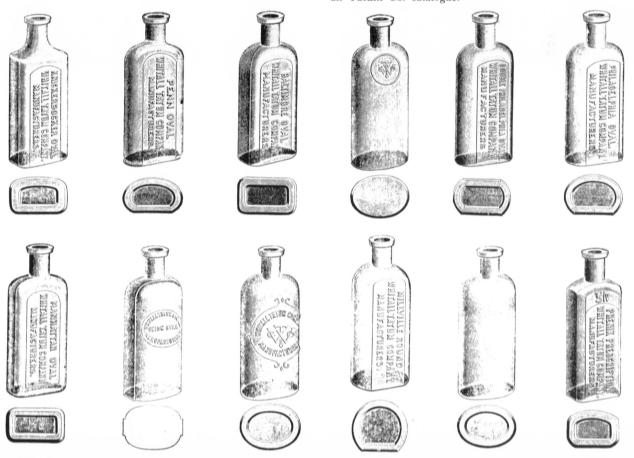

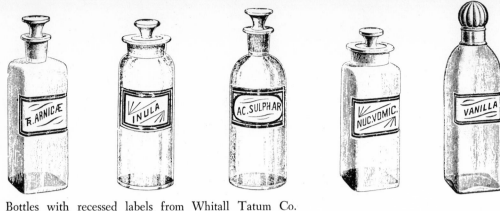

Bottles with recessed labels from Whitall Tatum Co. catalogue.

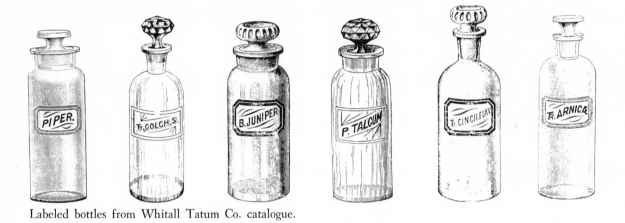

Labeled bottles from Whitall Tatum Co. catalogue.

Miscellaneous apothecary jars and globes from Whitall Tatum Co. catalogue.

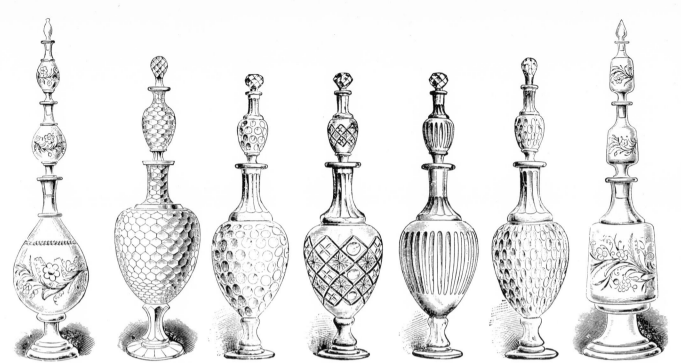

Show-window bottles from Whitall Tatum Co. catalogue.

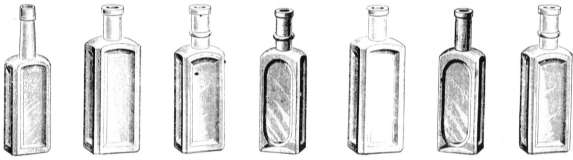

Paneled prescription bottles from Whitall Tatum Co. catalogue.

Bottles with ground lettering from Whitall Tatum Co. catalogue.

Tablet jars from Whitall Tatum Co. catalogue.

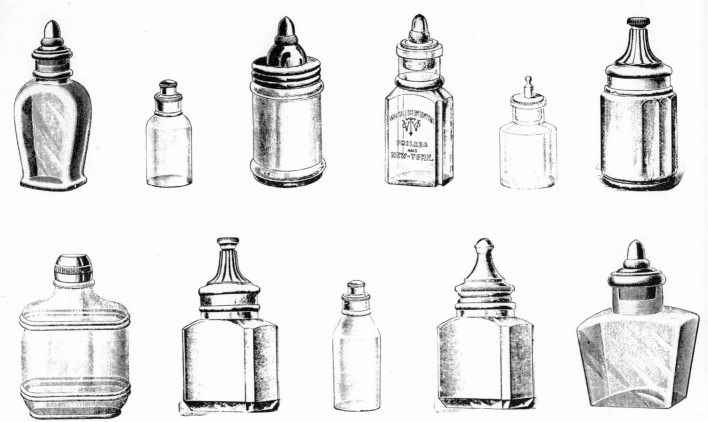

Tooth-powder bottles from Whitall Tatum Co. catalogue.

Left to right: drugstore bottles, amber, H. 4½ in., 4 in., and 3¼ in., owl perched on a mortar stirring with a pestle embossed on the side (trademark of The Owl Drug Co.), c. 1892–1908.

Left to right: drugstore bottles, white milk glass, H. 5½ in., 5 in., 4¾ in., and 4⅛ in., embossed owl trademark of The Owl Drug Co., c. 1892–1908.

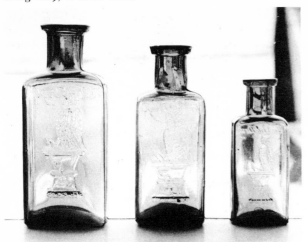

Drugstore bottles (left to right): (1) clear, H. 11¾ in.; (2) amber, H. 11¾ in.; (3) clear, H. 11 in.; (4) clear, H. 10¼ in.; (5) green, H. 8 in.; (6) clear, H. 6⅜ in.; square, embossed owl trademark of The Owl Drug Co., c. 1892–1908.

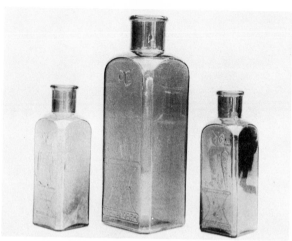

Drugstore bottles, cobalt-blue (left to right): (1) H. 6¼ in., c. 1910–1930; (2) H. 9⅜ in., c. 1892–1908; (3) H. 6¼ in., c. 1892–1908; contained citrate of magnesia, square, embossed "W. T. CO. C. USA" on bottom, owl trademark of The Owl Drug Co. on side.

Drugstore bottles (left to right): (1) clear, H. 10 in., owl trademark of The Owl Drug Co. embossed on the side, rectangular with rounded shoulders, c. 1892–1908; (2) smoky grey, H. 10¾ in., embossed "THE OWL DRUG CO., SAN FRANCISCO, CAL" on side, rectangular, c. 1892; (3) clear, H. 9 in., owl trademark of The Owl Drug Co. embossed on the side, rectangular with rounded shoulders, c. 1892–1908.

Drugstore bottles (left to right): (1) emerald-green, H. 9¾ in., embossed "THE OWL DRUG CO., SAN FRANCISCO" on side in a circle around an owl perched on a mortar stirring with a pestle (trademark of The Owl Drug Co.), c. 1892–1908; (2) amber, H. 8¼ in., owl trademark of The Owl Drug Co. embossed on the side, c. 1910–1930.

Drugstore bottles from The Owl Drug Company (left to right): (1) amethyst, H. 2¾ in.; (2) amber, H. 3⅛ in.; (3) clear, H. 6⅛ in.; c. 1900–1925. (Bruce C. Aschenbrenner, San Diego, Cal.)

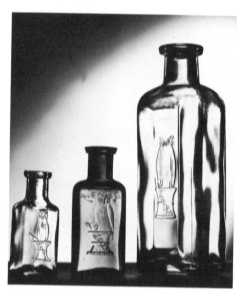

35

Nursing Bottles

Containers used in the nursing of infants are among the oldest of vessels; pottery nursers have been found that were used as early as 1500 B.C. Such feeding devices have also come from the excavation of Greek and Roman graves. Until the 1800s baby-feeding devices were made of a variety of materials including stone, metal, wood, and pottery (the Indians of Arizona are known to have used vessels made of red clay). In eighteenth-century England pewter was popular.

Not all baby-feeding devices were made to accommodate milk. Throughout the years a soft gruel-like substance called pap was fed to small babies. Pap was made of a number of things including ground cornmeal and water with crushed walnuts added. Containers from which pap was dispensed include hollow spoons and boat-shaped vessels with hollow handles through which the pap was blown into the baby's mouth. Other pap feeders were made in a modified teapot shape of metal or ceramic.

In America it was Charles M. Windship, of Roxbury, Massachusetts, who patented the first glass nursing bottle in 1841. Windship's bottle was unusual in that it was to be superimposed on the mother's breast so that the nursing infant would be deceived into thinking that the milk was coming directly from the mother.

In 1864 the idea of a glass tube stuck through a cork that fit into the neck of a glass bottle was brought to America from England. The glass tube was connected to a long rubber tube at the end of which was a nipple-shaped mouthpiece made of metal or organic materials. The tube-type nursing bottle enjoyed popularity for a few years until it was realized that the hard-to-clean tube was a potential germ carrier. Beverage bottles were frequently used in conjunction with the tube-type devices.

Although the first rubber nipple was patented by Elijah Pratt of New York in 1845, it was not until the early 1900s that a truly practical rubber nipple for nursing bottles was developed. The pre-1900 rubber nipples not only had a strong odor but were easily destroyed in hot water. As a result, a variety of mouthpieces were used before the improvements in rubber nipples. Rags, chamois, or sponges stuffed into the neck of glass bottles were used; whittled wooden nipples were not uncommon.

In the late 1800s a large variety of glass nursing bottles were produced in the United States. While some were of the types that could stand up straight on end, most of the turn-of-the-century types were designed to lie flat on their sides. A few in this latter group had openings on their side for the milk or pap and sometimes had permanently attached nipples.

By the end of World War II the U. S. Patent Office had issued over 230 patents for nursing bottles. Most of these are of interest to the collector who concentrates on baby-feeding bottles.

Unusual shapes and embossments are the predominant characteristics of glass nursing bottles. Some of the most interesting include specimens shaped like a baby's head, a papoose strapped to the back of its Indian mother, and a baby's shoe. But nonfigural shapes are just as interesting and unusual. Nursing bottles can be found in a variety of bladder shapes with curved necks; others are oval, cylindrical, bulbous, and rectangular. Embossments include lettered brand names and slogans such as "FEED THE BABY" and "BABY'S DELIGHT." Other embossments feature brand designs or pictures of crying babies, animals, fairy-tale characters, and toys.

Nursing bottles were rarely produced in sizes larger than sixteen ounces, and the majority held eight ounces of liquid. The larger bottles were used mostly around 1900 or before; the smaller ones became standard after the turn of the century.

Most of these containers were made in clear glass or the common aqua or light green glass. Some, however, may be located in varying shades of purple, caused by exposure to the ultraviolet rays of the sun (see Chapter 13).

Closures on nursing bottles commonly are the standard cork type or feature a ring of glass over which a rubber nipple is stretched. The closing devices themselves are very interesting. If only the cork and tube types are considered there is quite a variety. Nipples, too, were and still are produced in a variety of shapes.

Co-related items in a nursing bottle collection could include the bottle closing devices and nipples mentioned above. A selection of breast pumps would certainly fit into a nursing bottle collection; these pumps were used primarily before 1900 by mothers who found it difficult to provide enough milk during nursing. The pumps enabled them to obtain and store for later use the needed amounts of milk. Nipple shields, also, could be considered an integral part of the nursing bottle collection; these shields were also popular just before the turn of the century. Nipple shields were usually a glass cuplike device which fit on the mother's breast. From the cup a tube led to a rubber nipple. Though not in direct physical contact with the mother, the baby was able to obtain milk directly from the breast through the nipple shield; such shields were helpful in nursing teething babies. Of course, teething rings, toys, and other baby items could also be included in the nursing bottle collection.

Any of the bottles and devices made prior to 1900 are difficult to obtain and the more unusual ones could be considered rare. Accordingly, prices are high, ranging from $10 to about $70. Bottles made after 1900 usually may be obtained for less than $20.

Although bottle collectors have only recently become interested in nursing bottles, doctors and museums have availed themselves of these containers for years. The early pap spoons and feeders, and vessels of metal and organic materials, are to be found mostly in the few sophisticated private collections and museums. However, today's nursing bottle collector can rely on the fact that as interest grows, more of all types will be discovered and put on the market.

Bibliography

BOOKS AND PAMPHLETS

Freeman, Larry. *Grand Old American Bottles.* Watkins Glen, New York: Century House, 1964.

Putnam, H. E. *Bottle Identification.* Privately published, 1965.

1892 Annual Price List, Whitall Tatum Co. Millville, New Jersey: privately published by Shirley R. Bailey, 1969 (edited reprint).

PERIODICALS

"Feeding Baby through the Ages," *Today's Health,* XLII (April, 1964), 38–41.

Hommel, R. "Brief History of Old Nursing Bottles," *Hobbies,* LIV (April, 1949), 65.

Hubbard, Clarence T. "Bottles," *The Antiques Journal,* XXIV (May, 1969), 26–27.

———. "Nursing Bottles," *Western Collector,* V (January, 1967), 39–42.

Humm, M. "Sandwich Nursing Bottle," *Antiques,* 1944, p. 311.

"Pediatrician Collects Old Nursing Bottles," *Hobbies,* XLV (March, 1940), 56.

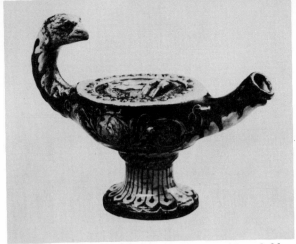

Feeding vessel, fired enamel, majolica, gold and blue, eighteenth century. (*Western Collector,* San Francisco, Cal.) Photo by Clarence T. Hubbard.

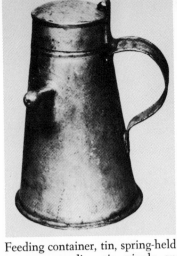

Feeding container, tin, spring-held cover, protruding tin nipple on side, H. 6 in., early nineteenth century. (*Western Collector,* San Francisco, Cal.) Photo by Clarence T. Hubbard.

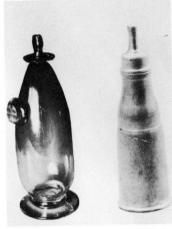

Nursing bottles (left to right): (1) glass, free-blown, cork closure on side, permanent glass nipple on top, H. 8 in., c. 1850 (from collection of Dr. Langewisch); (2) pewter, cork closure, pewter nipple-stopper on top, H. 8 in., c. 1860. (*Western Collector,* San Francisco, Cal.) Photo by Clarence T. Hubbard.

Feeding spoon (called pap boat), pewter, hinged lid on top, hollow handle through which food could be blown out of a slit on opposite end into baby's mouth, boat length 4 in., c. 1800. (*Western Collector,* San Francisco, Cal.) Photo by Mead Johnson, New York.

Assortment of nursing bottles. (*Western Collector,* San Francisco, Cal., from the collection of Dr. Langewisch) Photo by Clarence T. Hubbard.

Feeding bottle, clear, cork stopper with tube inserted into cork, H. 7 in., 1864. (*Western Collector,* San Francisco, Cal.) Photo by Mead Johnson, New York.

Nursing bottles (left to right): (1) embossed "LONDON FEEDING BOTTLE" on side, aqua, H. 5¼ in.; (2) clear, H. 6 in., eight-oz. markings embossed on side; (3) clear, H. 5½ in., eight-oz. markings embossed on side and three stars embossed on another side; (4) embossed "FRANKLIN" on side, clear, H. 6 in.; c. 1880–1920.

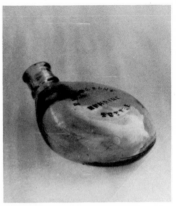

Nursing bottle, bent neck, sun-colored amethyst, embossed "N. WOOD & SONS NURSING BOTTLE," L. 6½ in., c. 1900–1910.

Nursing bottles from an early-1900s Whitall Tatum Co. catalogue.

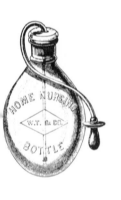
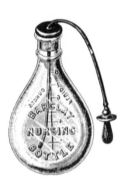
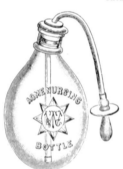
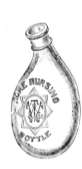

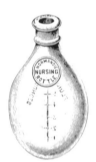

36

Candy Bottles

The origin of glass bottles made to contain candy is unclear. What is known for sure, however, is that a bottle in the shape of the Liberty Bell was sold at the Centennial Exhibition in Philadelphia in 1876. This may or may not have been the first time figural candy bottles were sold.

Candy bottles are generally regarded as toys, made for children. While this is certainly true of candy bottles produced from about 1920 on, it was not necessarily true of the earlier bottles. The Liberty Bell, for example, cannot, without hesitation, be considered a toy. It would seem more appropriate to consider this and others of that period as having been designed and manufactured more for the souvenir market. As evidence of the souvenir theory it can be shown that during the 1890s it was popular to sell souvenir railroad lanterns filled with candy. The glass lantern-shaped bottles were common items in railroad stations and on the trains themselves. Politicians during this period often gave away glass hats filled with candy as a vote-getting device. Also supporting the souvenir idea is the fact that many candy bottles in such shapes as horns, suitcases, and clocks are found with hotel and city names on them, indicating that they were originally purchased as souvenirs of trips, vacations, and so forth.

Other candy bottles were sold as commemorative items. Bottles shaped like locomotives, telephones, airplanes (the *Spirit of St. Louis*), and automobiles could be placed in this category, especially those that appeared shortly after an historic event relating to any of them. Many candy bottles were designed to serve a dual purpose—it was quite common for many types to feature a closure with a slit cut into it, so the bottle could serve as a money bank after the candy had been removed.

Sometime after 1920, when many variations of railroad lanterns, automobiles, locomotives, fire engines, guns, and other items had been marketed, they began to be thought of as toys. A search of an 1897 and a 1908 Sears, Roebuck & Co. catalogue fails to reveal any listing of candy containers. But the 1928–1929 Sears, Roebuck & Co.

catalogue and the 1930–1931 Montgomery Ward and Company catalogue both have advertisements for candy-filled glass toys (see Chapter 56). By far the majority were produced for a young masculine market—airplanes, guns, locomotives, cars, and so forth.

There are few specimens of these unusual bottles from the 1930s, presumably because of the Depression. By 1940 a variety of the standard train lanterns, trains, guns, etc., began to reappear along with new shapes related to World War II machinery. This latter grouping included newer airplanes, jeeps, anti-aircraft guns and tanks.

Dating glass candy bottles is not as difficult as it is in many other areas of bottle collecting. A fairly reliable method is to study the design of the bottle and determine when the particular item commemorated by the bottle was first used. For example, a bottle shaped like a 1940 car body could only have been produced during or a little after 1940. Another reliable method is to consider the fact that as a result of the 1906 Pure Food and Drug legislation manufacturers and packagers were required to list themselves on the bottle or label. "Oz. AVOR" was the standard marking for contents during the early 1900s, while from 1940 on "CONTENTS" and "INGREDIENTS" were the terms used. From the 1950s on, warnings about sterilizing before placing near the mouth were generally marked on the labels of the containers.

Beginning in 1940 these candy-filled figural bottles were produced either in very small or relatively large sizes. Another trend during this period was to employ new forms. The most popular was plastic. Many of the containers featured plastic appendages, e.g., telephones with plastic receivers.

The predominant characteristic of candy bottles is their figural shape. Shapes included airplanes, automobiles, animals, humans, birds, ships or boats, guns, cannons, clocks, buildings, lanterns, locomotives, Santa Claus, and telephones.

Sizes of these bottles range from one to several inches. There is a noticeable lack of color in these glass bottles; most are found in clear glass. Since they were designed to hold colorful candy there was little need or desire for colored glass. Some embossments are found on these bottles but because of their figural nature embossments are minimal and of little consequence.

Closures are of interest on these candy bottles; quite a variety were utilized. The dependable cork,

of course, was used, as well as screw caps, but many featured metal or cardboard strips that slid into grooves along the container's opening. Bent metal strips that clamped over the opening were also popular.

Because of a general lack of interest in these souvenir/toy figural bottles they cannot be considered rare, but they are becoming increasingly harder to locate as interest grows. Prices generally range from $1 to $10, with earlier specimens commanding slightly higher prices.

Bibliography

BOOKS

Eikelberner, George, and Agadjanian, Serge. *American Glass Candy Containers.* Belle Mead, New Jersey: Serge Agadjanian, 1968.

PERIODICALS

Hubbard, Clarence T. "Those Contriving Candy Containers," *Western Collector,* V (April, 1967), 18–21.

Candy containers, white milk glass (left to right): (1) shaped like the battleship *Maine,* L. 8 in., removable lid, c. 1895; (2) suitcase shape, brass handle, gold-painted straps, L. 3¾ in., metal slide closure on bottom, c. 1906.

Candy container, bust of Empress Alexandra of Russia, white milk glass, H. 13½ in., embossed LA TSARINE/BONBONS/JOHN TAVERNIER on side in three lines, closure in bottom, c. 1900–1920.

Candy bottles (left to right): (1) "Learned Fox," clear, ground top, metal screw cap, H. 4½ in., c. 1910; (2) rabbit, clear, embossed "CONTENTS 1¾ AVD OZ [sic]" on front side, metal screw closure on base, H. 5½ in., c. 1920; (3) rabbit sitting on dome, clear, metal screw closure on base, H. 4¼ in., c. 1920; (4) rabbit with basket on arm, clear, metal screw closure on base, H. 4¼ in., c. 1920.

Candy bottles (left to right): (1) owl, clear, metal screw cap, H. 4¼ in., c. 1960; (2) Scotty dog, clear, paper closure on base, H. 3¼ in., c. 1946; (3) hound, clear, ground top, H. 3 in., c. 1910–1920; (4) hound, clear, small hat, paper covering on top, H. 3¾ in., c. 1920.

Candy bottles (left to right): (1) lantern, clear, metal screw cap, H. 4½ in., c. 1920–1940; (2) lantern, clear, metal screw cap, embossed "BOND-PEA MATE" on top, H. 4½ in., c. 1920–1940; (3) lantern, clear, metal screw cap, embossed "USA, AVOR, 1 OZ" on side, H. 3½ in., c. 1920–1940.

Candy bottles (left to right): (1) telephone, clear, paper closure on base, H. 4¼ in., c. 1945–1950; (2) radio, clear, embossed "TUNE IN" on front, metal slide closure on base, H. 4⅝ in., c. 1925–1930; (3) horn, clear, metal screw cap on bell end, H. 5 in., c. 1930.

Candy bottles (left to right): (1) electric iron, clear, paper closure on on base, L. 4½ in., c. 1945; (2) "Charlie Chaplin," clear, barrel containing candy had tin twist-on cap, embossed "CHARLIE CHAPLIN" on front beneath figurine, embossed "GEO. BORGFELDT & CO., NEW YORK, SOLE LICENSEES" on rim base of barrel, and "PATENT APPLIED FOR" in center of barrel base, H. 3¾ in., c. 1915–1920; (3) top hat, tin brim, which serves as metal screw cap closure, clear, H. 2 in., c. 1940.

Candy bottles (left to right): (1) chicken on a basket, clear, embossed "AVOR ¾ OZ" and "USA" on sides, embossed "V. G. CO. J'NET., PA" on inside, L. 3½ in., c. 1920; (2) bulldog, clear, paper closure on base, H. 3¾ in., c. 1935; (3) chicken on a nest, clear, paper closure on base, H. 4¾ in., c. 1940.

Candy bottles (left to right): (1) bulldog, clear, metal screw closure on base, embossed "¾ OZ. AVOR. USA" on front between legs, H. 4¼ in., c. 1920; (2) Peter Rabbit figure, clear, embossed "MFG. BY J. H. MILLSTEIN CO., JEANETTE, PA., PAT. APP. FOR" on bottom edges, paper closure on base, H. 6¼ in.; (3) Santa Claus, painted clear glass bottle, plastic head serves as closure, H. 5½ in., c. 1940.

Candy bottles (left to right): (1) lantern, clear, beaded vertical and horizontal ribs, metal screw cap, H. 3½ in., c. 1910; (2) telephone, clear, metal screw cap, H. 3¾ in., c. 1950–1955; (3) Uncle Sam by barrel, clear, metal screw top (with slot for bank) on barrel, H. 3¾ in., c. 1940–1945.

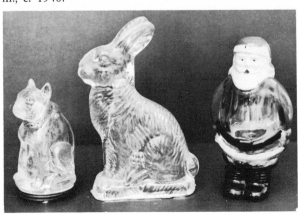

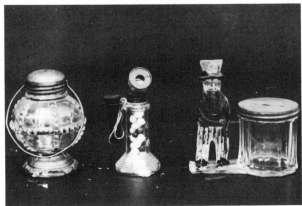

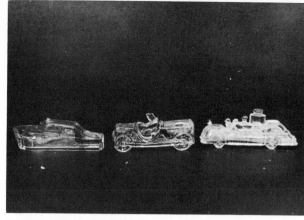

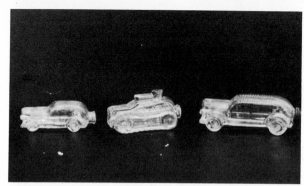

Candy bottles (left to right): (1) cabin cruiser, clear, paper closure on base, L. 4¾ in.; (2) jeep, clear, embossed "JEEP" on sides, paper closure on base, L. 4¼ in.; (3) fire engine, clear, metal closure on base, L. 5¼ in.; c. 1940–1945.

Candy bottles (left to right): (1) sedan, clear, cork closure in rear, embossed "3 DR. J. S. CO." on bottom, L. 3⅛ in.; (2) tank, clear, metal screw cap closure in rear, embossed "U.S. ARMY" on top and "CANDY PACKED BY T. H. STOUGH CO., JEANETTE, PA." on side, L. 3⅛ in.; (3) touring car, clear, metal screw cap closure in rear, embossed "PACKED BY T. H. STOUGH CO., JEANETTE, PA" on cap, L. 3⅞ in.; c. 1940–1945.

Candy bottles (left to right): (1) limousine, clear, metal wheels, paper closure on top, L. 4 in., c. 1912–1914; (2) tank, two cannons on top, clear, paper closure on base, embossed "USA" on sides, L. 4⅛ in., c. 1940–1945.

Candy bottles (left to right): (1) automobile, clear, L. 4½ in.; (2) bus, clear, "Victory Glass, Inc., Jeannette, Pa" on paper closure at base, embossed "VICTORY LINES" over "V" on sides and "SPECIAL" on front, L. 5 in.; c. 1940–1945.

Candy bottles (left to right): (1) train engine, metal slide closure on base, clear, embossed "V. C. CO., J'NET, PA., USA, 888" on sides, L. 5⅞ in., c. 1920; (2) U.S. Army bomber, embossed "15-P-7" on one wing and "ARMY BOMBER" with a star on the tip of each wing, L. 4 in., c. 1940–1945.

Candy bottles (left to right): (1) telephone, clear, metal screw cap closure on base, H. 5 in., c. 1920; (2) Santa Claus's boot, clear, paper closure on top, H. 3⅛ in., c. 1945.

Candy bottles (left to right): (1) rabbit with ears laid back, string tie, clear, metal slide closure on base, embossed "1¾ oz AVD" on side, H. 4½ in., c. 1920; (2) rabbit eating a carrot, clear, paper closure on base, H. 4½ in., c. 1947.

Candy bottles (left to right): (1) lantern, clear, metal screw cap, embossed "J. S. Co." on side, H. 2⅜ in., c. 1940; (2) lantern, clear, metal screw cap, H. 2¼ in., c. 1950; (3) lantern, clear, metal screw cap, H. 3¼ in., c. 1940; (4) telephone, tin receiver, metal screw cap beneath receiver, W. (base) 1½ in., (receiver) 2½ in., c. 1950.

Candy bottles (left to right): (1) Liberty Bell with hanger, clear, metal screw closure on bottom, embossed "LIBERTY BELL" on side, H. 3½ in., c. 1910–1920; (2) upright piano, milk glass, metal slide closure on back, H. 3¾ in., c. 1920; (3) locomotive, clear, plastic screw cap on front, L. 4 in., c. 1950.

Candy bottles (left to right): (1) Kewpie by a barrel, metal press on lid, embossed "GEO. BORGFELDT & CO., N.Y. 2" and "KEWPIE" under barrel, H. 3¼ in., c. 1915; (2) and (3) hounds, clear, paper covering on base, H. 3 in., c. 1955.

Candy bottles (left to right): (1) Santa Claus, clear, metal screw closure on bottom, embossed "AVOR. 1 OX [sic] —V. G. USA" on back side, H. 4⅜ in., c. 1920; (2) suitcase, clear, metal handle, metal slide closure on base, L. 3¼ in., c. 1906; (3) baby bottle, clear, rubber nipple, H. 3¼ in., c. 1962.

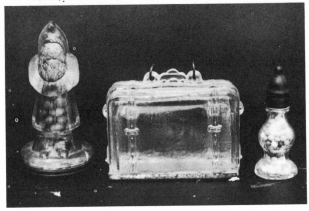

37

Milk Bottles

From the beginning of men's use of milk, large jars and later cans were used as containers for this precious fluid. For the most part these containers were large open-mouthed vessels and, of course, unsanitary.

The first use of a glass container for milk seems to be lost to recorded history. One rather tall bottle etched with a cow and the date 1866 is known to exist, but even if the date is accurate, this bottle could be considered at best only as an early attempt to use bottles for milk.

The first commercially successful milk bottles were not made until the early 1880s. Again, it cannot be absolutely stated who was the early maker but it is claimed that Alexander Campbell made the first delivery of milk in bottles in Brooklyn in 1878. Whose bottle he used remains a mystery. It is possible that the Warren Glass Works Company of Cumberland, Maryland, made their popular Warren Milk Bottle as early as 1881. In 1884 the Whiteman Milk Jar was patented; there seem to have been two types, one with "WHITEMAN, MAKER" embossed on the bottom.

The man who is often called the father of the milk bottle came on the scene in 1883. It was in that year Dr. Harvey D. Thatcher, a druggist from Potsdam, New York, patented a pail with a cover that was called a Milk Protector. Thatcher had a partner in this venture named Harry P. Barnhart. In 1884 Thatcher invented his first milk bottle. This container was also called the "Thatcher Milk Protector." Around the shoulder of this most famous of all milk bottles is embossed "ABSOLUTELY PURE MILK" and around the base "THE MILK PROTECTOR." The most striking feature of this glass container, however, is the embossment of a cow being milked by a Quaker farmer seated on a milking stool. The first of these bottles utilized a nickel-plated Lightning-type fastener. In 1886 Thatcher modified the bottle so that the metal closure was replaced with a glass one. The improved lid still operated on the Lightning principle. (An Italian firm, the Crownford China Company, has reproduced the Thatcher Milk Protector in several colors and in clear glass and is exporting them to the United States. These reproductions are easy to identify because they have porcelain stoppers which were never utilized on the original Thatcher bottles.)

By 1888 the Whitney Glass Works was manufacturing a bottle they called the Glass Milk Jar. In 1890, F. K. Ward produced what he called a Milk Preserving Jar. A. G. Smalley manufactured a quart milk bottle in 1896. This container had a nickel-plated handle around the bottle neck for easier handling.

Most of these early milk bottles used a Lightning-type closure that was nickel plated. For the most part the use of this type of closure was discontinued around 1900.

The changeover to paper caps began in 1889 when Thatcher introduced the Common Sense Milk Jar. The paper caps were inserted into a specially formed groove in the mouth of the bottle. This important improvement made the almost universal acceptance of the milk bottle a fact of life.

Even though there were a few square milk bottles as early as 1900, the round bottle retained its popularity until the round *squat* bottle was invented by Julian H. Toulouse in 1936. This shape was popular only a few years, until 1940 when Royden Blunt developed a square squat bottle that was readily accepted.

In the 1930s the Cream Top bottle was introduced and was popular for a time. This bottle featured a bulbous neck in which cream collected. The development and perfecting of homogenization did away with the use of this type of bottle by the late 1940s.

Throughout the relatively short history of the milk bottle there have been basically two methods of marking used. Almost from the beginning embossed lettering and designs were used on the majority. Most embossments were the result of an individualized plate inserted into a standard mold. In the mid-1930s applied color labeling (see Chapter 11) became financially practical and it began to replace embossed lettering.

Collectors interested in this relatively new specialty in bottle collecting will have no trouble building a sizeable collection at little expense. Because of the relatively small costs of the plates that were inserted in standard molds (one

company in 1902–1903 advertised one dollar per plate plus eight cents per letter) literally thousands of small dairies all over the country could afford to and did have personalized milk bottles produced. To the collector this means that a tremendous number of different bottles are available.

The comparatively few bottles made before 1900, utilizing the Lightning-type fasteners, are the difficult ones to obtain and are somewhat expensive, but the Common Sense type (circa 1900–1940) which used paper caps are quite numerous and easy as well as inexpensive to obtain.

Milk and milk product containers can be found in a wide variety of sizes ranging from two-inch miniature advertising bottles to one-gallon and sometimes larger milk bottles.

These bottles can also be located in a range of shapes. In addition to the plentiful round shape some square ones are available. The Cream Top variety and its imitators add variety in shape to a milk bottle collection—especially those with necks formed in a number of different faces. Then, there are the milk products bottles which come in unusual shapes.

Probably the most interesting to a milk bottle specialist are the beautiful embossed designs that can be found. Among the hundreds of unique designs are birds, stars, animals, people, and objects of all descriptions.

When it comes to color, milk bottles do have a definite lack, mainly because the buying public demanded that milk be sold in an absolutely clear bottle. Occasionally, however, a venturesome dairyman, realizing that milk resisted spoiling better in a dark bottle, sold his product in amber bottles. Amber bottles are not numerous but the average collector should be able to locate at least one for his collection. The only other color (except clear bottles that have reacted with the ultraviolet rays of the sun and turned amethyst) known to have been used in a milk bottle is green; this was only done once. The only known green glass milk bottle was patented in 1929 by H. Kart, of Buffalo, New York, and was manufactured by the Reed Glass Company for the owner of Alta Crest Farms in Spencer, Massachusetts. Because of legal action brought against Mr. Sagendorph, the owner of Alta Crest Farms, by the Springfield Milk Market, the bottle saw only limited use.

Co-related items include objects as large as milk cans or as small as trade tokens. Paper cups, cream spoons, opening devices, and a host of other items are readily available as well.

Bearing in mind that milk bottles have only recently been gathered by collectors, it is interesting to consider the following quotation from a 1925 periodical article:

The way of history teaches us that what is today [1925] a commonplace may be tomorrow an unobtainable and much desired antique with very apparent qualities of beauty.

The milk bottle, which is a rather recent contrivance, as turned out to the number of one hundred and sixty million in a single year by a single company. Truly this is the day and age of quantity production and standardization —the results of which are readily seen in the habit we have of considering all things so produced as serviceable necessities but otherwise valueless. *Perhaps the day may come when our well-known milk bottle will have become a rarity, bringing astonishingly high prices when found in excavations of old dairies or in old deserted houses* [italics added].

Bibliography

BOOKS

Kenyon, Harry C. *The Milky Way*. Ocean View, New Jersey: Evelyn Roth, 1969.

Rawlinson, Fred. *Make Mine Milk*. Newport News, Virginia: privately published, 1970.

PERIODICALS

Gallagher, Thomas F., II. "The Milk Bottle Through 85 Years," *American Dairy Review* (February, 1969), 50.

———, and Munsey, Cecil. "Milk and Its Containers," *Western Collector,* VII (July, 1969), 330–336.

Munsey, Cecil. "Milk Bottles Are of Historic Interest," *The Bottleneck,* III (January, 1968), 2–3.

Northend, Mary Harrol. "Valuable Old American Bottles," *The Dearborn Independent,* XXVI (December, 1925), 12–14, 24.

Rawlinson, Fred. "Bottles in the 'Moo' Category," *The National Bottle Gazette,* I (December, 1968), 23–24.

Reuter, E. "Speed in Process: Milk Dealers Bottle Exchange, Chicago," *Factory and Industry Management,* LXXVIII (August, 1929), 283–286.

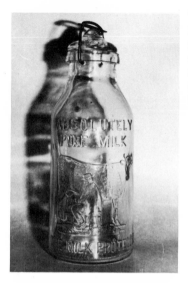

Thatcher Milk Protector milk bottle, clear, embossed "ABSOLUTELY PURE MILK, THE MILK PROTECTOR" and a cow being milked by a Quaker farmer seated on a milking stool, H. 9¾ in., 1886.

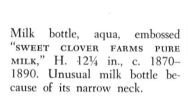

Milk bottle, aqua, embossed "SWEET CLOVER FARMS PURE MILK," H. 12¼ in., c. 1870– 1890. Unusual milk bottle because of its narrow neck.

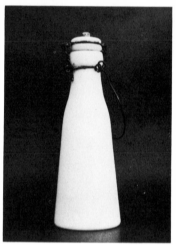

Milk container, white milk glass, H. 9 in., removable lid is white milk glass with hole in center to accommodate small cork, wire handle and closure, late nineteenth century.

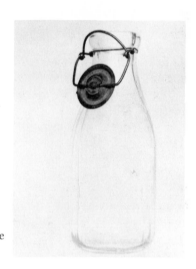

Milk bottle with Lightning type closure, H. 9½ in., c. 1890.

Milk bottle, clear, embossed "NEW ENGLAND DAIRY, W. B. HAGE, SAN DIEGO, CAL.", c. 1903. (Title Insurance Company, San Diego, Cal.)

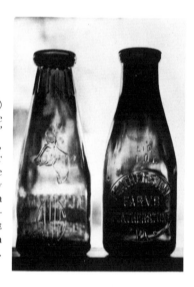

Milk bottles (left to right): (1) grass-green, embossed with the profile of a cow's head and "AHS" on one side and "MASS-A-SEAL, ONE QUART LIQUID, ALTA CREST FARMS, SPENCER, MASS," on the other side, H. 9½ in., 1929 (only company known to have used a green milk bottle); (2) dark amber, embossed "FEATHERSTONE FARMS, FEATHERSTONE, VA." in a circular frame on one side, H. 9½ in., c. 1921.

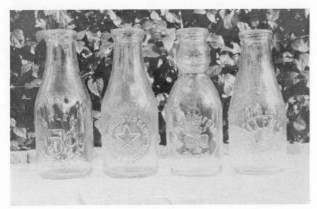

Milk bottles featuring unusual shapes and embossments (left to right): (1) eight-sided five cent deposit store bottle, (2) star, (3) cloverleaf, and (4) eagle. (Third from the left is a Pecora Baby Top bottle with the neck made in the shape of a baby's head.) H. 9½ in., c. 1915–1945.

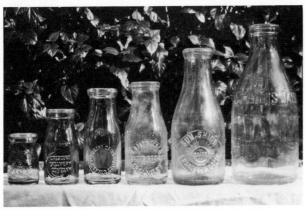

Left to right: milk bottles of unusual sizes, H. 3½ in., 5½ in., 6½ in., 6¾ in., 9½ in., and 11 in., c. 1920–1940.

Milk and dairy bottles of unusual shapes and sizes (left to right): (1) cylindrical wide-mouth dairy bottle, H. 4½ in.; (2) wide-mouth dairy bottle with cow's head and star embossment, H. 6 in.; (3) square milk bottle, H. 5¼ in.; (4) long-neck milk bottle, H. 7¼ in., c. 1920–1940.

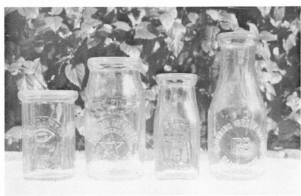

PART V

Unusual

Bottles

38

Fire Grenade Bottles

Early in the 1870s it became popular to have round glass bottles filled with carbon tetrachloride stationed at critical points in homes, businesses, trains, and other appropriate places. These bottles were designed to be thrown into fires, where the impact would shatter the bottle, spill the carbon tetrachloride, and extinguish the fire.

It is not known who was first to invent this ingenious method of extinguishing fires but it is known that the first American patent granted for a fire "extinguisher" was awarded to Alanson Crane of Fortress Monroe, Virginia, in 1863.

Another possibility for first honors is Thomas B. Atterbury of Pittsburgh, who was granted a patent in April of 1871 for a "Duck Bottle." It is possible that this bottle was a fire grenade. At any rate, in 1885 Atterbury sold a bottle patent to the Harden Hand Fire Extinguisher Company of Chicago. Harden was no newcomer to the business when he purchased Atterbury's invention; the first of his bottle fire extinguishers was patented August 8, 1871, and August 14, 1883. This fire grenade has been located in light- and cobalt-blue glass, ranging in size from five to seven inches. These early grenades were embossed "HARDENS HAND GRENADE FIRE EXTINGUISHER and THIS BOTTLE PATD. AUG. 8, 1871—AUG. 14, 1883"; they have either a vertical rib pattern or a diamond-quilted pattern molded into the glass. Another but similar type produced by this company is made in green glass and varies from six to eight inches in height. This grenade is embossed "HARDEN HAND GRENADE FIRE EXTINGUISHER STAR" in a star design on the top half of the face. A third type manufactured by Harden came in three separate sections which were held together by a wire. Each section was made in a different color glass: amber, clear, and cobalt-blue. This grenade is embossed "HARDEN'S IMPROVED FIRE EXTINGUISHER HAND GRENADE NEST SYSTEM, PAT. OCT. 1889.

Harden's grenades are the most common of all known types. Another large manufacturer of these extinguisher bottles was named Hayward. On the very same day (August 8th) in 1871 that Harden received his first patent, Hayward also received a grenade patent. While Harden operated from Chicago, Hayward's firm was located in New York City. Over the years Hayward manufactured two types: Hayward's Hand Fire Grenade, which was produced in golden amber, green, pale blue and smoke-colored glass; and Hayward Hand Grenade Fire Extinguisher, which came only in blue glass. Both types were approximately six inches in height.

In 1879 the American Electric Fire Extinguisher came on the market; this bottle is thirteen inches tall and was made in amber glass.

Another large firm involved in the manufacture of bottle fire extinguishers was Babcock. This company had factories in Elmira, New York, and in Chicago; their grenade was called Babcock Hand Grenade Non-Freezing, and was made in both amber and green glass. These bottles are seven to eight inches in height.

Other fire grenades of the period include the clear glass American Fire Extinguisher; the six-inch clear glass Boger Fire Extinguisher from Boston; the amber glass California Fire Extinguisher, which is approximately six inches tall and carries the embossment of a bear; the ten-inch tall Dash-Out, which was produced in amber glass and made in Chicago; the Diamond, which is made of amber diamond-patterned glass and is seven inches tall; the six-inch tall Harkness Fire Destroyer made in blue glass; the barrel-shaped amber Hazelton's High Pressure Chemical Fire Keg, which is eleven inches tall; the cobalt-blue Kalamazoo Automatic and Hand Fire Extinguisher and the Rockford Kalamazoo Automatic and Hand Fire Extinguisher, both of which are approximately eleven inches tall; the Magic Fire, which was made in amber glass; and the Y-Burn Winner, which is egg-shaped and made in blue glass. This is only a partial listing of the grenades that have been found.

Sizes, shapes, and colors in grenade bottles are indicative of those listed. The most common closure utilized on these bottles is a cork sealed with wax or cement; because of this closure some grenades are discovered today with their contents still intact.

A number of the fire grenades came in wire racks; the lucky collector who locates a rack usually includes it in his grenade collection. These

bottles are scarce because they were designed to be broken. Those that were not broken were usually discarded and replaced with a more modern fire fighting device. Their replacement probably began with the invention of the vaporized chemical fire extinguisher, first introduced in 1905 by the Pyrene Manufacturing Company of Newark, New Jersey.

Fire grenade bottles are not especially cheap because they are scarce; $10 to $100 is not unusual. Because of their shapes and bright colors most collectors feel they are worth the prices asked.

Bibliography

BOOKS

Ferraro, Pat and Bob. *A Bottle Collector's Book.* Sparks, Nevada: Western Printing & Publishing Co., 1966, pp. 63–67.

Freeman, Larry. *Grand Old American Bottles.* Watkins Glen, New York: Century House, 1964, pp. 350–351.

Kane, Joseph Nathan. *Famous First Facts.* New York: The H. W. Wilson Company, 1964, p. 256.

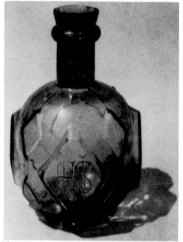

Fire grenade bottle, light amber, embossed "HNS" in monogram, H. 7 in., c. 1890.

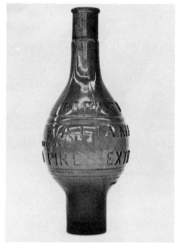

Fire grenade bottle, embossed "ROCKFORD KALAMAZOO AUTO-MATIC & HAND FIRE EXTIN-GUISHER," cobalt-blue, chimney-lamp shape, H. 11 in., c. 1890.

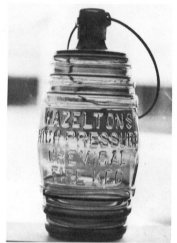

Fire grenade bottle, amber, embossed "HAZELTON'S HIGH PRESSURE CHEMICAL FIRE KEG" on side, H. 11 in., wire handle, c. 1890.

Fire extinguisher bottle, clear glass, embossed "DRI GAS FIRE EXTINGUISHER CHATTANOOGA, TENN., THROW CONTENTS [a sandy-looking substance] FORCIBLY AT THE BASE OF THE FIRE BY QUICK SWINGING MOTIONS," H. approx. 13 in., c. 1900.

Fire grenade bottle, peacock-blue, embossed "HARDEN'S HAND GRENADE FIRE EXTINGUISHER" on protruding band at middle of bottle, and "STAR" on a star in a circle, H. 6½ in., c. 1890.

Glass fire extinguisher of unknown origin. This type was hung throughout a building. Heat from a fire would melt the band and release the metal arm connected to the spring. The released arm would swing down and break the glass and release the fire-stopping fluid, H. 5 in., c. 1900–1920.

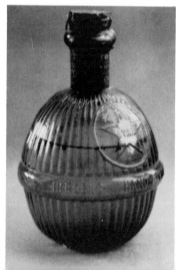

39

Witch Balls

Down through the ages glass has played an important part in superstition; everyone knows that breaking a mirror supposedly brings bad luck, and many are aware that looking at the moon through glass is supposedly an omen of ill fortune. This latter superstition originated at the time when glass was first used in churches. Occasionally some members of the congregation would stare out of the window during worship; this met with disapproval and soon was considered paganistic and a sign of impending ill fortune.

During the 1600s, when salt was a valuable commodity, it became standard practice to keep the substance in a round bottle called a *watch ball*. These balls were hung in the chimney to keep the salt dry. Perhaps because it was a misfortune to have the ball break, the hanging of a watch ball eventually came to connote warding off evil, and the balls were used for this purpose as much as for storing salt.

By the end of the seventeenth century the use of these unusual bottles had practically died out because they were expensive. This was due to the fact that they were considered effective in warding off evil only if the interior of the ball was silvered, and silvering was costly and dangerous to workers because it involved mercury.

During the late eighteenth century a new process was discovered by which two globes were blown, one inside the other, and the space in between was filled with a silvery solution. This innovation revived the practice of using watch balls to ward off evil spirits. In addition to being hung in fireplace chimneys they were hung in windows, and were popular enough to be sold at fairs, door-to-door by itinerant peddlers, and in stores.

The practice of hanging these balls in the window as well as the term "witch balls" seems to have originated at the Nailsea Glass Works near Bristol, England, whose workers were extremely uneducated and superstitious and used witch balls and other devices to ward off evil spirits.

The tradition of hanging witch balls throughout the house to protect the inhabitants from evil spirits was carried by English settlers to the colonies, where it flourished. Samuel Hopkins Adams in his book *Grandfather Stories* relates a story told by his grandfather about the use of witch balls along the Erie Canal in the mid-1800s:

> To protect themselves from these [evil] powers, the brothers had raised a Pennsylvania hex broom upon the prow of the lead raft and had hung their cabin windows with witch balls; blue, green, and amber, molded at the Mt. Vernon glass factory, in the Oneida hills.

This shows that witch balls were not only used in the United States, but were manufactured here. In fact, records indicate that when the glasshouse was opened in Millville, New Jersey, about 1820, one of their products was witch balls; and the McKearins, in *American Glass,* say, "Witch balls, as they are called, were made in abundance in practically all of the bottle houses."

While the popularity of witch balls was practically nonexistent in the United States by the beginning of the twentieth century, their use in England was continued until World War II.

Witch balls normally had a hole in the top, and a wooden peg was used as a closure. Later examples have a short neck and lip much like a bottle, and used a cork stopper for a closure. To the wooden peg or the cork a string was attached for handling purposes.

American as well as European witch balls were

made in a range of sizes to about seven inches in diameter and in a variety of colors.

Even though witch balls are scarce they still can be found in antique shops occasionally. Today, with many antiques being imported from England, the chances of a bottle collector's being able to obtain several examples of these unusual bottles for his collection are enhanced greatly.

Witch balls resemble Christmas tree ornaments in shape and color. Because of their similarity collectors often overlook these bottles; the difference is that witch balls are made of glass too heavy to hang on a tree.

Bibliography

BOOKS

Adams, Samuel Hopkins. *Grandfather Stories.* New York: Random House, 1955.

Hughes, Pennethorne. *Witchcraft.* Baltimore, Maryland: Penguin Books, Inc., 1965.

McKearin, George and Helen. *American Glass.* New York: Crown Publishers, Inc., 1968.

Moore, N. Hudson. *Old Glass—European and American.* New York: Tudor Publishing Co., 1939.

Witch ball, aqua with pale blue swirls (Nailsea Glass), 5 in. in diameter, c. 1700, made at the Nailsea Glass Works near Bristol, England.

Witch balls (left to right): amber, silver, and blue; 2 in., 7 in., and 2 in. in diameter; c. 1750–1850. (Ramon R. Willey, Gloucestershire, England)

Witch balls (left to right): (1) cobalt-blue, 4 in. in diameter, c. 1800; (2) amber, 2 in. in diameter, c. 1850.

40

Target Bottles

Trapshooting has been a popular sport for many years. Originally it consisted of releasing birds (usually pigeons) from a wooden trap and then shooting them as they attempted to fly away. In England during the early 1830s target bottles were invented, an improvement because live birds were a bother to handle, and were unpredictable and would fly in any direction. Further, public opinion was against the use of live birds in target shooting; the target bottle solved this problem as well.

Around 1850, Charles Portlock of Boston, Massachusetts, introduced the target bottle to American trapshooters. It was an immediate success and the shooting of live birds was eliminated almost entirely as a result. The early method of using target bottles was for one person to throw the bottle into the air while another person tried to break it by shooting it. Shortly after the target bottle became popular in America, Captain Adam H. Bogardus developed a mechanical throwing device, which further standardized trapshooting and helped to increase interest in the sport. Target-bottle shooting became widespread in sporting clubs throughout the country.

At first these interesting bottles were just plain rounded glass globes that were blown in a mold, designed more for utility than appearance; but by the 1860s bottles with ornamental patterns began to appear. The patterns were added not only to enhance the beauty of the product but to decrease the chance of a shot's glancing off the surface without breaking the bottle. In addition to patterns some were manufactured with embossments such as a hunter with a rifle and the company's name. The corrugated surface of the more elaborate bottles was quite beautiful and may account for the fact that some still survive.

At first target bottles were made in the common glass colors, i.e., light green and aqua, but as interest in the sport developed and it was discovered that more colorful bottles could more easily be seen by the shooter, they were produced in a wide

range of colors. Dark green, cobalt-blue, amber, and amethyst were not uncommon.

The shape of target bottles was a fairly well standardized globular one; the only irregularity was the small opening at the top which qualifies the container as a bottle. In size, target bottles range between two and three inches in diameter. The opening is about one-half inch in diameter; through it the bottles were sometimes filled with feathers, silk ribbons, confetti, or smoke, giving the marksman a real sense of satisfaction when he shattered it and providing visual proof of the hit.

Since these unusual bottles were designed to be broken they are quite a rarity and today's bottle collector will not often have an opportunity to obtain a specimen. During the approximately thirty years that these bottles were manufactured there were at least a dozen firms actively producing them; conceivably a collector could not only gather a sample of each firm's bottles but the variants in color, design, and so forth from each.

The era of target bottles ended with the invention of the so-called clay pigeon by George Ligowsky of Cincinnati, Ohio, patented in 1880.

Because they are rare, target bottles are sold for substantial amounts of money. The general range in price is from $30 to $80.

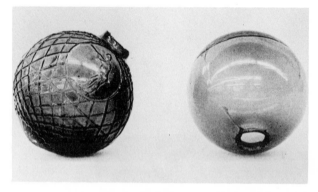

Target bottles (left to right): (1) amethyst, embossed with figure of man holding rifle, corrugated surface, H. 3 in., c. 1860–1880; (2) amber, H. 3 in., c. 1860–1880.

Bibliography

BOOKS

Freeman, Larry. *Grand Old American Bottles.* Watkins Glen, New York: Century House, 1964, pp. 351–352.

Kane, Joseph Nathan. *Famous First Facts.* New York: The H. W. Wilson Company, 1964, p. 628.

Maust, Don (ed.). *Bottle and Glass Handbook.* Uniontown, Pennsylvania: E. G. Warman Publishing, Inc., 1968, pp. 141–142.

PERIODICALS

"Glass Balls for Targets," *Antiques,* 1943, p. 275.

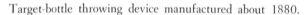

Target-bottle throwing device manufactured about 1880.

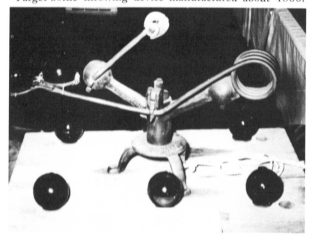

41

Glass Floats

Bottle collectors, especially those who have access to the shore of the Pacific Ocean, have recently taken an interest in the numerous glass balls that are found on beaches. These glass balls have been used by fishermen as net floats since the early 1900s.

Over the years fishermen from several countries, including Japan, Canada, and the United States, have employed glass floats on their nets, but today Japan is probably the only major country still using them. The farther away from Japan the collector lives the fewer floats are found; those collectors in the Philippines, Australia, and Hawaii are much more apt to find these glass balls on their shores than those living in North and South America.

Glass floats are found in a wide range of colors and sizes. The most common colors are varying shades of blue and green. The unusual colors include amber, amethyst, and red. In size, glass floats are as small as golf balls and as large as basketballs. Since floats are generally made by glass manufacturers who make other glass items, and color is of very little importance to fishermen, floats are often made from whatever glass is handy. This partially accounts for the wide range of colors. Size, however, is of importance to fishermen and they order by size according to their needs.

Sometimes glass floats are embossed with the fishing company's name if they have been made for a relatively large firm, and were specially ordered. Many Japanese floats have these emboss-ments (trademark or something written in Kanji) in the form of a seal that was apparently applied shortly after the ball was blown.

Most American and Canadian floats were made by automatic glassblowing machines, from about 1900 to 1950. The more prevalent Japanese floats were and still are mostly hand-blown in molds; some of the earliest ones were free-blown.

Glass floats are almost exclusively round and ball-shaped but some unusual ones have been used throughout the years. Pear-shaped floats are occasionally found and less often square or cylindrical floats are located.

Because of the collecting interest in glass floats and their use as decorator items, in recent years Japan has exported to the United States thousands of these glass balls. There seems to be no foolproof method for the collector to determine which of the balls were imported as decorator items and which were used on fishing nets.

At any rate, glass floats are of interest to the collector of bottles and do merit collecting consideration on this basis if on no other.

Bibliography

BOOKS

Wood, Amos L. *Beachcombing for Japanese Glass Floats*. Portland, Oregon: Binfords & Mort, Publishers, 1967.

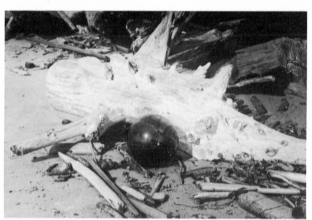

Glass float as typically found on beaches. (Mrs. M. Sharcott, Victoria, British Columbia)

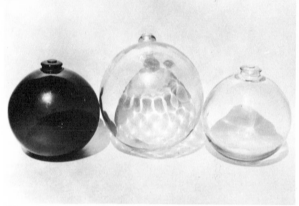

Glass floats made by automatic glassblowing machine; c. 1930–1950.

Large glass float in rope webbing by which it was attached to the fishing net.

Grouping of glass floats ranging in height from 3 in. to 12 in. (Mrs. M. Sharcott, Victoria, British Columbia)

Early twentieth-century glass float (left) compared with a float of the mid-nineteenth century (right).

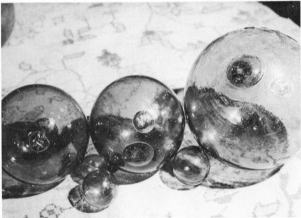

Glass floats, Japanese, each bearing an identifying seal written in Kanji. (Mrs. M. Sharcott, Victoria, British Columbia)

Glass float, 42 in. in circumference, Japanese, just after it was recovered from the ocean—note barnacles attached to rope webbing. (Mrs. M. Sharcott, Victoria, British Columbia)

PART VI

New
Bottles

42 Contemporary Bottles

Since the formal organization of bottle collecting in 1959 many manufacturers have produced containers that not only hold their merchandise, but are of interest to the collector of bottles; these may be defined as contemporary bottles. As interest in the hobby of bottle collecting grows, more manufacturers are becoming aware that the bottles they sell are almost as important to the consumer as their products—and in some cases more important.

The number of bottles made within recent years with the collector in mind is astounding; it seems safe to predict that the future will bring an even greater variety and quantity. Because of the number of contemporary bottles available only a sampling can be presented in this book, and text material is offered on only four of the companies currently producing bottles of interest to collectors.

Unlike other bottles, contemporary bottles are designed to appeal to the collector. The majority are figural (see Chapter 20) or historical (see Chapter 19). While some contemporary bottles are made of glass, most are produced in ceramic. The collecting market has become so large that some manufacturers of bottles have not bothered to put a product in their bottles, but place them on the market empty. Bottles sold by the Robert M. Silver Company, Famous Firsts, Ltd., and Wheaton Nuline Products Company are examples of this type.

Contemporary bottles are produced in a variety of sizes. In addition to pints, quarts, half-gallons, and gallons some of the most interesting are produced in miniature.

Colors are plentiful in contemporary bottles, which is to be expected since so many specimens are made in ceramic. In the glass bottles there are a range of colors, but embossments seem to be the most predominant characteristic of this type.

Closures on contemporary bottles, both ceramic and glass, are mostly of the cork variety. The use of the more practical screw caps has been rather limited, probably because of collecting resistance to this type of closure. Some of the more popular co-related items include labels, elongated coins commemorating some of the older Jim Beam bot-

tles, and the cardboard containers in which the bottles came (see Chapter 60).

Surprising as it may seem, rarity plays an important part in the collecting of contemporary bottles. Manufacturers who produce bottles with the collecting market in mind frequently claim limited production and the destruction of the original molds to assure collectors of future scarcity. Rarity is also a factor in the early offerings of some of the firms whose bottles are of current collecting interest. In some cases bottles produced before the popularity of the bottle collecting hobby were made in small quantities; these specimens command especially high prices.

The price of contemporary bottles depends almost entirely on supply, but some consideration should be given to original retail price and collector demand. Bottles made in limited quantities bring premium prices; and prices approaching $2000 are not unheard of for such specimens. Generally, however, prices of contemporary bottles start at several dollars and go as high as $200.

It seems likely that as the interest in collecting bottles mounts and examples of the older types become more scarce, the interest in contemporary bottles will increase.

Bibliography

BOOKS

Avery, Constance and Leslie, and Cembura, Al. *Bischoff, Kord, and Kamotsuru Bottles, Identification and Price Guide.* Portland, Oregon: Metropolitan Printing Co., 1969.

Decanter Collectors Guide. Kentucky: Pewee Valley Press, no date.

Fisher, M. I. *Liqueurs.* Westminster, England: Maurice Meyer, Limited, 1951.

Mebane, John. *The Poor Man's Guide to Antique Collecting.* Garden City, New York: Doubleday & Co., Inc., 1969.

Pictorial Bottle Review. Los Angeles: B. & K. Enterprises, 1969.

Umberger, Jewel and Arthur L. *Collectible Character Bottles.* Tyler, Texas: Corker Book Co., 1969.

Accardi Pellegrino (made in Italy), "Sicilian Gold," ceramic, white, red and black, H. 19 in. (left) and 12½ in. (right).

Angelita Blanca (made in Mexico), ceramic, white, H. 9 in.

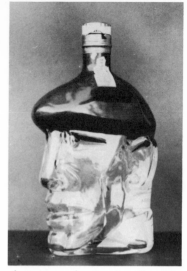

Armagnac (made in France), "French Apache Dancer," clear, red painted hat, H. 8¼ in.

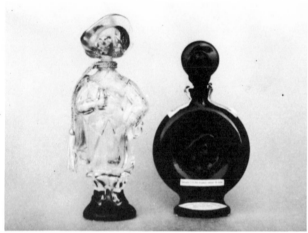

Armagnac (made in France) (left to right): (1) "Cavalier," clear, base painted black, H. 7 in.; (2) green, head of a cavalier embossed in a round frame on front side, H. 6¼ in.

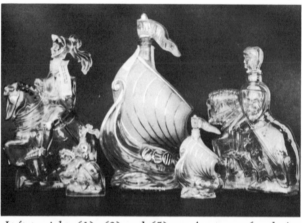

Left to right: (1), (2) and (5) are Armagnac (made in France), "Joan of Arc" (also called "Knight on Horseback"), clear glass with gold trim, H. 10½ in., 4¼ in., and 9¼ in.; (3) and (4) are Larsen (made in France), Viking ship *Invincible*, frosted glass with gold trim, H. 12 in. and 5¼ in.

Ballantine's "Golf Bag," ceramic, tan and brown, H. 12½ in., 1969.

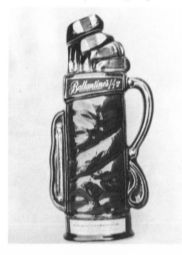

Ballantine, Epic Series, ceramic, heroic Greek or Roman figures in raised relief on a blue velvet-textured background (left to right): (1) Mercury; (2) discus thrower; (3) fighting gladiators; (4) charioteer; H. 9 in., 1969. (Harshe-Rotman & Druck, Inc., New York)

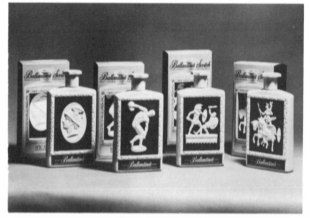

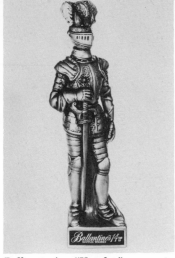

Ballantine's "Knight," ceramic, grey, H. 18 in., 1969. (Harshe-Rotman & Druck, Inc., New York)

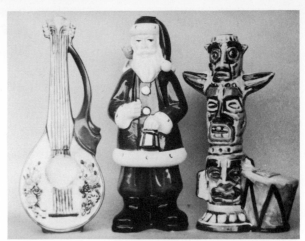

Bardi (made in Italy), ceramic (left to right): (1) mandolin, white with yellow, blue, and pink flowers, H. 12½ in.; (2) Santa Claus, red, white, and black, H. 12½ in.; (3) Alaskan totem pole with drum, multicolored, H. 11½ in.

Barsottini's "Tivoli Clock," ceramic, H. 15 in.

Barsottini's "Pisa's Leaning Tower," ceramic, grey and white, H. 13 in.

Barsottini's "Alpine Pipe," ceramic, H. 10 in.

Barsottini's "Paris Arc de Triomphe," ceramic, grey and white, ashtray top, H. 7½ in.

Barsottini's "Florentine Steeple," ceramic, grey and white, H. 15 in.

Barsottini's "Eiffel Tower," ceramic, grey and white, H. 15 in.

Barsottini's "Roman Coliseum," ceramic, grey and white, ashtray top, H. 6 in.

Barsottini's "Clowns," ceramic, gaily painted, H. 12 in.

Barsottini's "Antique Automobiles," ceramic, white with orange and brown trim, H. 6 in.

Barsottini's "Monastery Cask," ceramic, grey barrel, brown stand, H. 12 in.

Barsottini's "Florentine Canon," ceramic, white with orange flowers, L. 15 in.

"Beefeater" (made in England), ceramic, red and black, H. 21½ in.

Bischoff, ceramic, yellow, green, and black (left to right): (1) Chinese woman, H. 13 in.; (2) Chinese man, H. 13¾ in.; c. 1962. (Constance and Leslie Avery, Berkeley, Cal.)

Bischoff (left to right): (1) "Spanish Matador," blue, red, and black; (2) "Spanish Lady," purple and black; H. 14 in., c. 1961. (Constance and Leslie Avery, Berkeley, Cal.)

Bischoff, "Bell Tower," ceramic, white, red, purple, and black, H. 10 in., c. 1959. (Constance and Leslie Avery, Berkeley, Cal.)

Bischoff, "Christmas Tree," decanter and six matching glasses, green with red, blue, green, and clear glass "jewels," H. 13½ in., c. 1957. (Constance and Leslie Avery, Berkeley, Cal.)

Bischoff, "Bell House," ceramic, red, white, and green, H. 10 in., c. 1960. (Constance and Leslie Avery, Berkeley, Cal.)

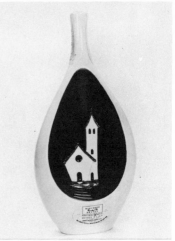

Bischoff, "Watch Tower," ceramic, white, red, blue, and green, H. 11½ in., c. 1960 (Constance and Leslie Avery, Berkeley, Cal.)

Bischoff's "Duck," Venetian glass, red, white, and blue, L. 12¾ in., 1964.

Bischoff's "Fish," Venetian glass, yellow, red, white, and blue, L. 11½ in., 1964.

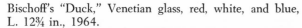

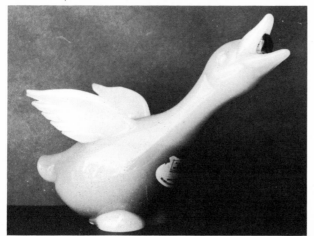

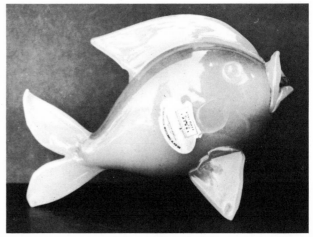

Bischoff's "Dachsund," Venetian glass, brown and white, L. 19 in., 1966.

Bischoff's "Clowns," ceramic, brightly colored, H. 14 in. (left) and 12¾ in. (right), c. 1963.

Bralatta (made in Italy), "Masks," black with yellow and white trim, cork in top, H. 4½ in. (left) and 10 in. (right). (Same bottle issued by Bischoff Company as "African Head.")

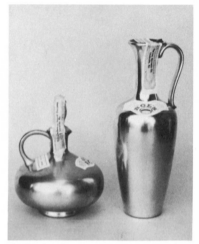

Bols (made in Holland), pewter (left to right): (1) H. 5 in.; (2) H. 8 in.; 1969.

Left to right: Bols (made in Holland), all Delft-type, blue and white, H. 8 in., 11 in., 5¼ in., and (on tray) 5 in. and 3½ in.

Bottles Beautiful (Famous Firsts, Ltd.) Never Before Series, "The French Telephone," white with purple and red flowers, gold movable dial and cradle, 1969. (Bottles Beautiful, New York)

212

Bottles Beautiful (Famous Firsts, Ltd.) Warrior Series
(left to right): (1) "Napoleon," white trousers, grey
coat and black hat and boots, H. 17¼ in.; (2) "Garibaldi,"
red hat and shirt, blue scarf and trousers, H. 17½ in.;
(3) "Bersaglieri," blue jacket, tan trousers, black hat and
boots, H. 17 in. (with 6-in. gold sword); (4) "Centu-
rion," white uniform, gold armor, H. 18¼ in.; 1969.
(Bottles Beautiful, New York)

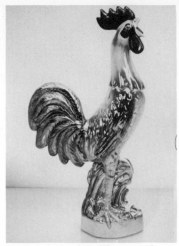

Bottles Beautiful (Famous Firsts,
Ltd.) Barnyard Series, "Ricardo,
the Rooster," brown body, grey
and brown tail feathers, red
comb, H. 15 in., 1969. (Bottles
Beautiful, New York)

Bottles Beautiful (Famous Firsts,
Ltd.) Barnyard Series, "Filomena,
the Hen," white body, gold and
brown tail feathers, red comb, H.
12½ in., 1969. (Bottles Beautiful,
New York)

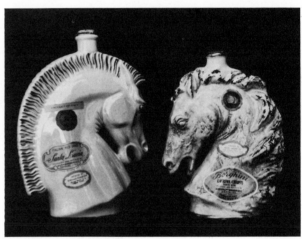

Borghini "Horses' Heads," ceramic (left to right): (1)
white, gold-trimmed mane, H. 10 in., 1967; (2) grey,
gold-trimmed mane, H. 9 in., 1968.

Borghini "Dogs" ceramic (left to right): (1) Pekingese,
grey and black, H. 8 in.; (2) Sad Eyed Hound, grey and
black, H. 9¼ in.

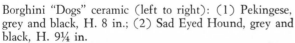

Borghini "Alpine House," ce-
ramic, brown roof, multicolored
walls, H. 9¼ in., 1969.

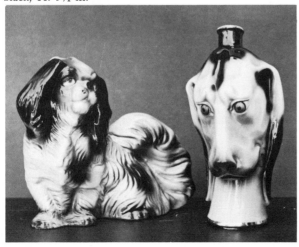

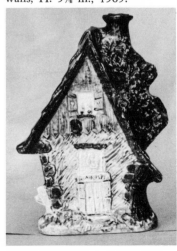

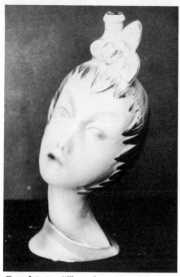

Borghini "Female Head," ceramic, pink flower in hair, H. 9½ in.

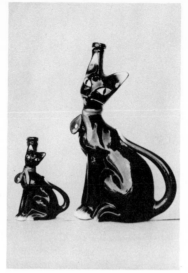

Borghini "Cats," ceramic, black with red ties, plastic whiskers, H. 6 in. and 12 in., 1969.

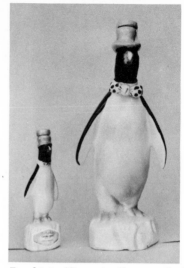

Borghini "Penguins," ceramic, black and white with blue hats and yellow ties, H. 6 in. and 12 in., 1969.

213

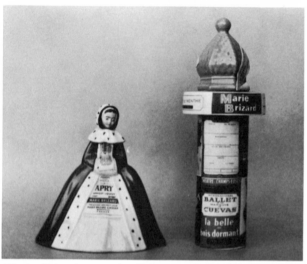

Marie Brizard, ceramic (left to right): (1) "Lady in Ermine Cape," blue cape, white dress, H. 7 in.; (2) "Kiosk," colorful signpost, H. 11½ in., 1968.

Marie Brizard, ceramic chessmen, dark brown, H. 8 in., 1962.

Left to right: Cabin Still, "Hillbillies," ceramic, multi-colored, H. 12 in., 8¾ in., 10¾ in., and 11¼ in., c. 1950–1970.

Cuervo (made in Germany), "Black Raven" on white stand, head removes to reveal cork stopper, H. 10 in.

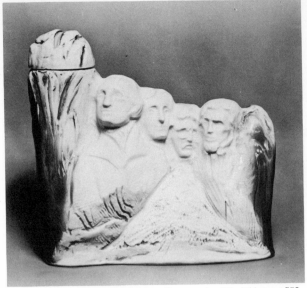

J. W. Dant, "Mt. Rushmore," ceramic, H. 7½ in., W. 8¾ in., 1969. (J. W. Dant Co., New York)

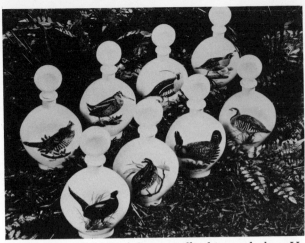

J. W. Dant, Field Bird Series, milk-white opal glass, H. 11 in. Pictures on one side are (top row, left to right): (1) ruffed grouse, (2) woodcock, (3) mountain quail, (4) California quail; (bottom row): (1) ringnecked pheasant, (2) bobwhite, (3) prairie chicken, (4) Chukar partridge; 1969. (J. W. Dant Co., New York)

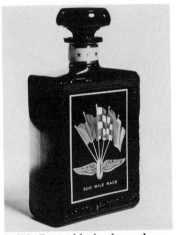

J. W. Dant, black glass, obverse picture of official insignia of Indianapolis 500, reverse embossment of an American eagle, H. 9 in., 1969. (J. W. Dant Co., New York)

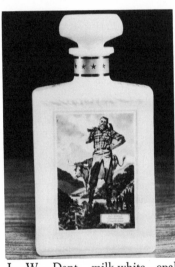

J. W. Dant, milk-white opal glass, obverse picture of Paul Bunyan, reverse embossment of American eagle, H. 9 in., 1969. (J. W. Dant Co., New York)

J. W. Dant, milk-white opal glass, picture of Boeing 747 on one side, H. 11 in., 1969. (J. W. Dant Co., New York)

J. W. Dant, cobalt-blue, obverse picture of Doughboy and Legionnaire, reverse embossment of an American eagle, gold foil-embossed medallion of "50th Anniversary of Legion" seal on stopper, commemorates fiftieth anniversary of American Legion, H. 11 in., 1969. (J. W. Dant Co., New York)

J. W. Dant, Americana Series, milk-white opal glass, obverse picture of Boston Tea Party, reverse embossment of American eagle, H. 9 in., 1968. (This bottle is of special interest because the eagle is facing sinister instead of dexter. One out of every twelve Boston Tea Party bottles were made this way by mistake, according to the manufacturer.) (J. W. Dant Co., New York)

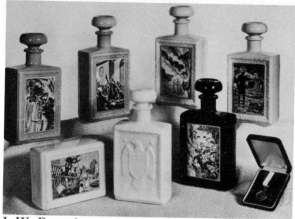

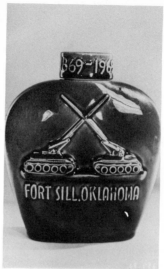

J. W. Dant, Americana Series, H. 9 in., all feature embossment of American eagle on the reverse and a picture of a famous American event on the obverse. *Top row, left to right:* (1) "Washington at the Delaware," light blue; (2) "Patrick Henry," tan; (3) *"Constitution* and *Guerrière,"* grey; (4) "Burr-Hamilton Duel," green. *Bottom row, left to right:* (1) "The Boston Tea Party," white; (2) embossment of the American eagle as shown on all bottles in the Americana series; (3) "The Alamo," black; 1969. (J. W. Dant Co., New York)

J. W. Dant, "Fort Sill Centennial Canteen," ceramic, dark brown, obverse embossed with eagle with shield and stars, reverse embossed with crossed 177-mm. tank cannons, commemorating the one hundredth anniversary of Fort Sill, Oklahoma, H. 7¼ in., 1969. (J. W. Dant Co., New York)

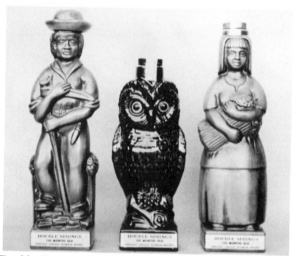

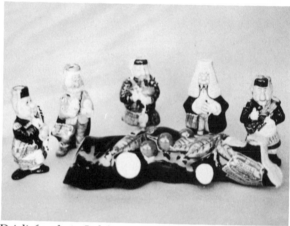

Double Springs, ceramic (left to right): (1) boy peasant, olive-green, H. 13¼ in.; (2) owl, dark brown, shiny glaze, H. 10½ in.; (3) girl peasant, olive-green, H. 13 in.

Drioli (made in Italy), ceramic (back row, left to right): (1) bagpiper, (2) jester, (3) bagpiper, (4) judge, (5) drummer; each H. 5 in., multicolored; (front): cherry tree branch, brown and red, L. 10½ in.

Dickel, "Powder Horn," amber, H. 15 in. and 13 in., souvenir bottle commemorating the reopening of Geo. Dickel Distillery. (Old Charter Distilleries Co., New York)

DeKuiper (made in Holland), Delft, H. 10½ in.

Ezra Brooks (left to right): (1) Tecumseh (a Naval Academy symbol of good luck—original figurehead of U.S.S. *Delaware*), gold bust, brown wood-like pillar, H. 13½ in., 1969; (2) Churchill commemorative, debossed "THE IRON CURTAIN SPEECH, MARCH 5, 1946, FULTON, MO." on podium, gold, H. 12 in., 1969; (3) Queen of Hearts (honors State of Nevada—symbol of Lady Luck); red, white, black, and blue, H. 16 in., ceramic, 1969.

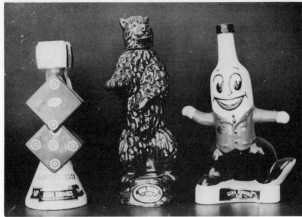

Ezra Brooks (left to right): (1) Harold's Club Lucky 7, red, white, and gold, H. 11¾ in., 1968; (2) Golden Grizzly, symbol of State of California, brown, H. 13½ in., 1968; (3) "Mr. Foremost," black, red, and white, H. 12¾ in.; ceramic, 1969.

Ezra Brooks (left to right): (1) dueling flintlock pistol, grey and brown, L. 15¼ in., 1968; (2) Iron Horse, black with gold and red trim, H. 8 in., L. 9½ in., ceramic, 1969.

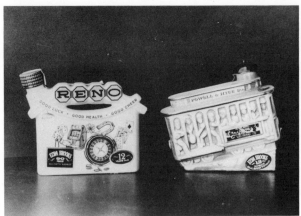

Ezra Brooks (left to right): (1) Reno Arch, white with multicolored decals, L. 8¼ in., 1968; (2) San Francisco cable car, grey and white, L. 7½ in., ceramic, 1968.

Ezra Brooks (left to right): (1) Zimmerman Hat, white, brown, and gold, L. 8 in., 1968; (2) cannon, brown and gold, L. 12 in., ceramic, 1969.

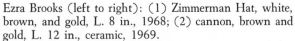

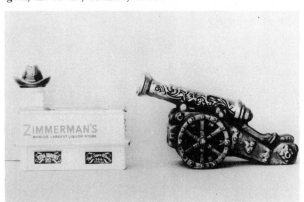

Famous Firsts' "The Spirit of St. Louis," L. 17 in., W. 21½ in., white body, yellow wheels, black tires and engine, silver propeller, 1969. (Famous Firsts, Ltd., New York)

Famous Firsts' "DeWitt Clinton Locomotive," L. 13½ in., black body, tan wheels, 24-carat gold trim on body, 1968. (Famous Firsts, Ltd., New York)

Famous Firsts' "Marmon Wasp," L. 16 in., H. 6½ in., bright yellow, 1968. (Famous Firsts, Ltd., New York)

Galliano (made in Italy), "Carabiniere," ceramic, black with white trim (left to right): H. 8¼ in., 20 in., 14 in.

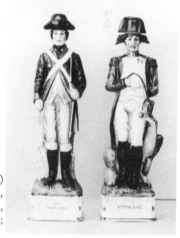

Grenadier (left to right): (1) Colonial soldier, red, blue, tan, and black; (2) Napoleon, green, white, red and black, H. 14 in.; ceramic; 1969.

Inca Pisco (made in Peru), glass painted black (left to right): (1) Huaco (copy of a ceramic vessel produced about 400 B.C. and used to store water and other liquids), H. 12 in., 1965; (2) Inca head, H. 10¾ in., 1965; (3) Inca god, H. 12¼ in., 1969.

Left to right: P. Hoppe (made in Holland), all Delft-type, blue and white, H. 9½ in., 10¼ in., and 7¼ in.

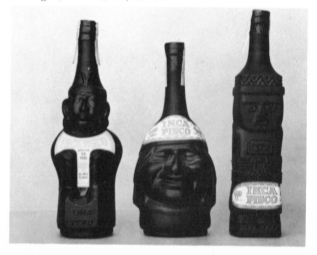

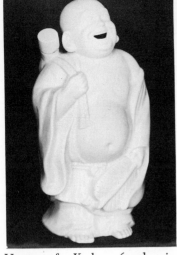

House of Koshu (made in Japan), "Sake God," bone china, white, H. 10 in. (Numano International, Inc., Los Angeles, Cal.)

House of Koshu (made in Japan), "Sake God," porcelain, reddish-brown, H. 10 in. (Numano International, Inc., Los Angeles, Cal.)

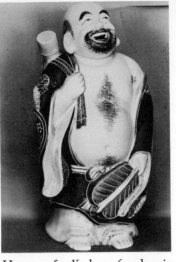

House of Koshu (made in Japan), Geisha girl, "Kiku" (Chrysanthemum), porcelain, blue and black, H. 13¼ in. (Numano International, Inc., Los Angeles, Cal.)

House of Koshu (made in Japan), Geisha girl, "Fuiji" (Wisteria), porcelain, maroon and gold, H. 13¼ in. (Numano International, Inc., Los Angeles, Cal.)

House of Koshu (made in Japan), Geisha girl, "Ume" (Plum Blossom), porcelain, red and gold, H. 12 in. (Numano International, Inc., Los Angeles, Cal.)

House of Koshu (made in Japan), Geisha girl, "Yuri" (Lily), porcelain, blue and pink with a red sash, H. 13¼ in. (Numano International, Inc., Los Angeles, Cal.)

House of Koshu (made in Japan), Geisha girl, "Sakura" (Cherry Blossom), porcelain, red and gold, H. 13¼ in. (Numano International, Inc., Los Angeles, Cal.)

House of Koshu (made in Japan), Geisha girl, "Violet," porcelain, purple, H. 13¼ in. (Numano International, Inc., Los Angeles, Cal.)

House of Koshu (made in Japan), "Pagoda," porcelain, lime-green, H. 14½ in. (Numano International, Inc., Los Angeles, Cal.)

House of Koshu (made in Japan), "White Lion Man," porcelain, white and black garments, white wig, H. 12 in. (Numano International, Inc., Los Angeles, Cal.)

House of Koshu (made in Japan), "Red Lion Man," porcelain, red robe, blue vest, red wig, H. 9 in. (Numano International, Inc., Los Angeles, Cal.)

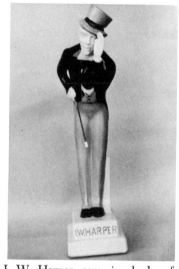

Irish Mist (made in Ireland), ceramic, green, red, black, and white, H. 19 in.

I. W. Harper, ceramic, shades of blue (also found in all white, and all grey), H. 16 in.

Kikukawa (made in Japan), "Hokusai" (Mount Fuji), porcelain, round flask, multicolored. (Numano International, Inc., Los Angeles, Cal.)

Kikukawa (made in Japan), "Toyokuni" (Kabuki actor), porcelain, round flask, multicolored. (Numano International, Inc., Los Angeles, Cal.)

Kikukawa (made in Japan), "Harunobu" (women), porcelain, round flask, multicolored. (Numano International, Inc., Los Angeles, Cal.)

Kikukawa (made in Japan), "Tsunodaru" (bucket), porcelain, red, H. 5 in. and 14 in. (Numano International, Inc., Los Angeles, Cal.)

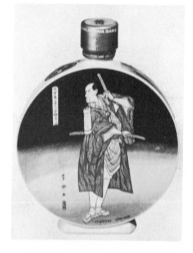

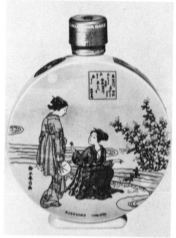

Kikukawa (made in Japan), "Utamaro" (a scene), porcelain, multicolored, oval flask. (Numano International, Inc., Los Angeles, Cal.)

Kikukawa (made in Japan), "Kokeshi" (Tomiko), porcelain, cylindrical body and round head, purple, H. 11 in. (Numano International, Inc., Los Angeles, Cal.)

Kikukawa (made in Japan), "Kokeshi" (Kumiko), porcelain, rounded body and head, red, H. 9 in. (Numano International, Inc., Los Angeles, Cal.)

Kikukawa (made in Japan), "Kokeshi" (Minako), porcelain, slender body, flaring out in bell shape at bottom, yellow-green, H. 14 in. (Numano International, Inc., Los Angeles, Cal.)

Kentucky Gentleman, ceramic, grey, H. 14 in.

Kentucky Gentleman (left to right): (1) Kentucky belle, pink, H. 13¾ in.; (2) frontiersman, tan, H. 14 in.; ceramic, 1969.

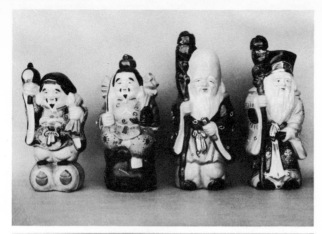

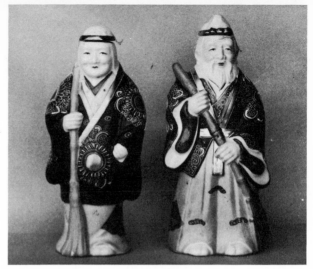

Kamotsuru (made in Japan), gaily painted porcelain (left to right): (1) "Joan," H. 9½ in.; (2) "Darby," H. 10 in.

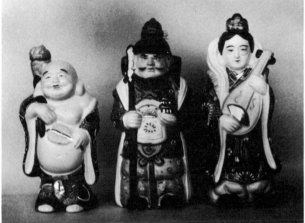

Kamotsuru (made in Japan), gaily painted porcelain (left to right, top to bottom): (1) "Daikoku," god of wealth and patron saint of farmers, H. 7¾ in.; (2) "Ebisu," god of fishermen and tradesmen, H. 9¼ in.; (3) "Fukuroku-jin," god of wisdom, H. 10½ in.; (4) "Jurojin," god of longevity, H. 10¼ in.; (5) "Hotei," god of wealth and wisdom, H. 9 in.; (6) "Bishamon," god of the military, H. 11 in.; (7) "Benten," goddess of art, literature, music, and eloquence, H. 10½ in.

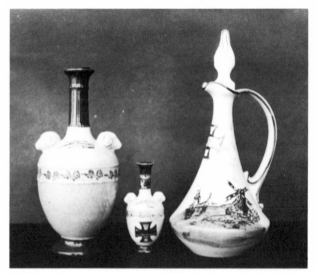

L'Abbé Françoise, ceramic (left to right): (1) and (2) Delft-like urns, beige, brown trim, H. 11 in. and 5 in.; (3) handled pitcher, blue and white, H. 11 in.

L'Abbé Françoise, ceramic (left to right): (1) choir boy, white and red, 10 in.. (2) and (3) Delft-like jugs, H. 4½ in. and 11 in.

L'Abbé Françoise's "Gondola," ceramic, black, L. 16 in.

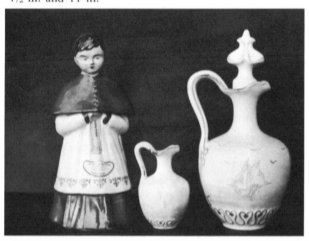

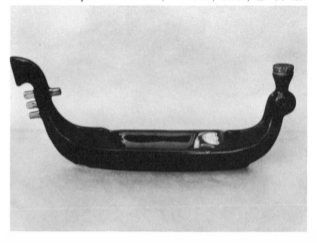

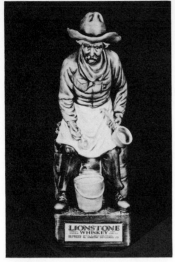

Lionstone, "Camp Cook," H. 13¾ in., 1969. (Lionstone Distilleries, Ltd., Lawrenceburg, Ky.) Photo by Birlauf & Steen, Inc., Denver, Colo.

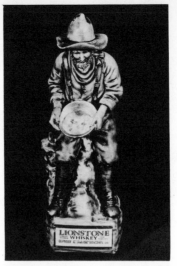

Lionstone, "Gold Panner," H. 13¾ in., 1969. (Lionstone Distilleries, Ltd., Lawrenceburg, Ky.) Photo by Birlauf & Steen, Inc., Denver, Colo.

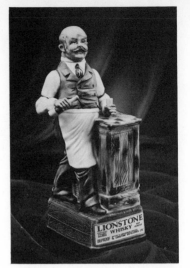

Lionstone, "Bartender," H. 13¾ in., 1969. (Lionstone Distilleries, Ltd., Lawrenceburg, Ky.) Photo by Birlauf & Steen, Inc., Denver, Colo.

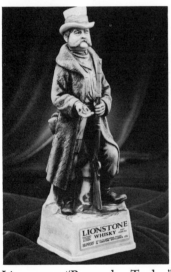

Lionstone, "Renegade Trader," H. 13¾ in., 1969. (Lionstone Distilleries, Ltd., Lawrenceburg, Ky.) Photo by Birlauf & Steen, Inc., Denver, Colo.

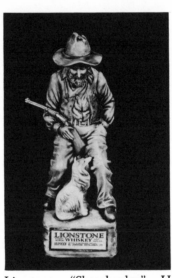

Lionstone, "Sheepherder," H. 13¾ in., 1969. (Lionstone Distilleries, Ltd., Lawrenceburg, Kentucky) Photo by Birlauf & Steen, Inc., Denver, Colo.

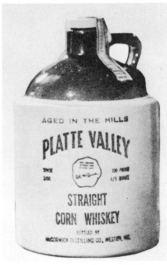

McCormick's "Platte Valley," pottery jug, tan bottom, dark brown top, dates back to at least the 1950's. (McCormick Distilling Co., Weston, Mo.)

McCormick's "Commemorative Barrel Decanter," ceramic, tan barrel with yellow barrel bands, black wrought-iron stand, L. 8 in. (including spigot), 1968. (McCormick Distilling Co., Weston, Mo.)

McCormick's "The Iron Horse, 'Jupiter 60,'" ceramic, black body, red and gold trim, 1969. (McCormick Distilling Co., Weston, Mo.)

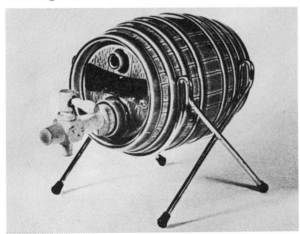

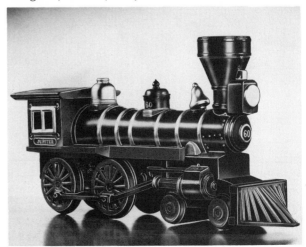

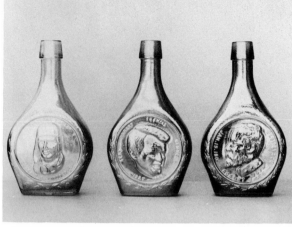

Nuline–Commemorative Decanters (left to right): (1) Charles A. Lindbergh, (2) Robert F. Kennedy, (3) Robert E. Lee; all iridescent blue, all H. 8¼ in.

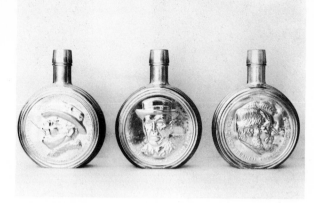

Nuline–Presidential Decanters (left to right): (1) Franklin D. Roosevelt, iridescent green; (2) Woodrow Wilson, iridescent blue; (3) Abraham Lincoln, iridescent topaz; all H. 7½ in.

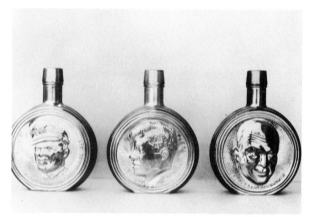

Nuline–Presidential Decanters (left to right): (1) Dwight "Ike" Eisenhower, (2) John F. Kennedy, (3) Dwight David Eisenhower; all H. 8 in.

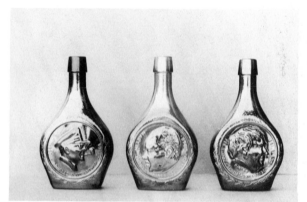

Nuline–Commemorative Decanters (left to right): (1) Douglas A. MacArthur, iridescent blue; (2) Martin Luther King, iridescent topaz; (3) Thomas A. Edison, iridescent blue; all H. 8¼ in.

Nuline (left to right): (1) "A. LANCASTER'S INDIAN VEGE-TABLE JAUNDICE BITTERS" embossed on side, blue, H. 8 in.; (2) "CHIEF WAHOO ELECTRIC TONIC" embossed on side, green, H. 8 in.; (3) "STRAUBMULLER'S ELIXIR, TREE OF LIFE, SINCE 1885" embossed on side, topaz, H. 8 in.; all 1968. (Wheaton Glass Co., Millville, N.J.)

Nuline (left to right): (1) "FRANK'S SAFE KIDNEY & LIVER CURE, ROCHESTER, N.Y." embossed on side, blue, H. 9 in.; (2) George Washington bust bottle, green, H. 9 in.; (3) Ball and Claw Bitters bottle, topaz, H. 9 in.; all 1968. (Wheaton Glass Co., Millville, N.J.)

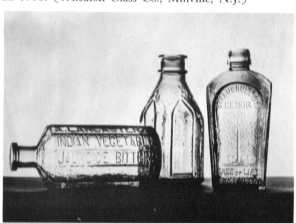

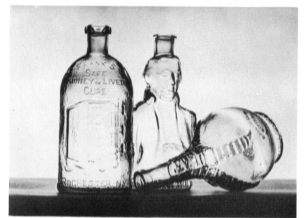

Old Taylor, shape of a castle, ceramic, grey and white, c. 1966.

Old Blue Ribbon, ceramic (left to right): (1) "River-queen," grey and white, gold trim, H. 10 in., 1968; (2) "Balloon," red and white, H. 9 in., 1969.

Orvieto (made in Italy), fish shape, glass, yellow, L. 16½ in.

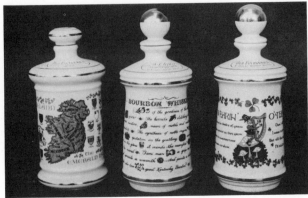

Old Fitzgerald (left to right): (1) "Emerald Isle," white porcelain with multicolored designs on all sides, H. 10 in., 1969; (2) "Weller Masterpiece," white porcelain with multicolored rebus design, H. 10 in., 1963; (3) "Leprechaun," white porcelain with multicolored design, H. 10 in., 1968.

W. P. Patterson, Ltd. (made in Scotland), ceramic, book shape, green with red stopper, H. 8 in.

Rybendes (made in Holland), all Delft-type, blue and white (left to right): (1) L. 4 in., (2) H. 4½ in., (3) H. 6 in., (4) H. 4 in., (5) H. 5 in., (6) H. 4½ in.; 1969.

Sandeman, "Don decanters," black (left to right): (1) Royal Dalton china, H. 10½ in.; (2) Wade china, H. 8¾ in.; (3) Royal Dalton china, H. 4½ in.

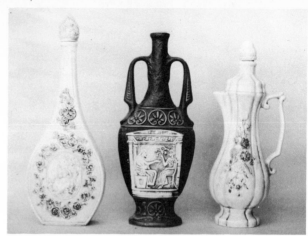

C. Serchi (made in Italy), ceramic (left to right): (1) antique white with blue flowers, H. 13½ in.; (2) black with white scene, H. 12½ in.; (3) antique white, hand-painted multicolored flowers, H. 12½ in.

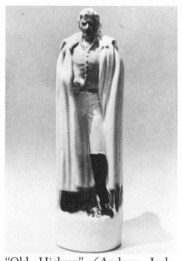

"Old Hickory" (Andrew Jackson), ceramic, H. 11 in., debossed "OLD HICKORY" under the figure and "OLD HICKORY DISTILLING CORP." on the base.

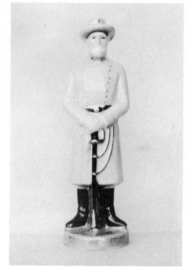

Southern Comfort, ceramic, blue, H. 11 in.

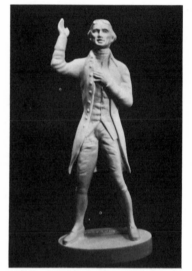

Robert M. Silver Co. (Cleveland, Ohio), "Builders of a Nation," Patrick Henry, bisque china, white, 1970. (Norma Silver) Photograph by L. J. Walczak.

Robert M. Silver Co. (Cleveland, Ohio), "Builders of a Nation," George Washington, bisque china, white, 1969. (Norma Silver) Photograph by L. J. Walczak.

Robert M. Silver Co. (Cleveland, Ohio), "Builders of a Nation," Benjamin Franklin and Thomas Jefferson, bisque china, white, 1970. (Norma Silver) Photograph by L. J. Walczak.

Whyte and Mackays (made in Scotland), "bagpiper," ceramic, red, H. 12½ in.

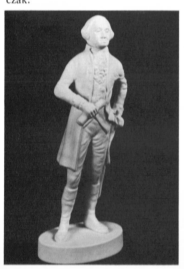

P. Viarengo (made in Italy) (left to right): (1) French poodle, glass painted black and red, head removes to reveal stopper, H. 9 in.; (2) rooster, glass painted black, gold, and grey, head removes to reveal stopper, H. 11 in.

P. Viarengo (made in Italy) (left to right): (1) gondola; glass painted brown, blue, red, and white, cork stopper, L. 13 in.; (2) pack mule, glass painted grey, brown, and blue, head removes to reveal a cork stopper.

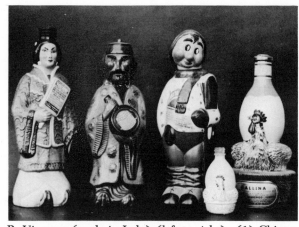

P. Viarengo (made in Italy) (left to right): (1) Chinese lady, glass painted black, brown, and blue, cork stopper in top of head, H. 11 in.; (2) Chinese man, glass painted red and green, pigtail on back of head, head removes to reveal cork stopper, H. 10¼ in.; (3) skier, glass painted red, white, blue, and green, head removes to reveal cork stopper, H. 11¾ in.; (4) chickens on a nest with egg, glass painted white, black, and yellow, H 4 in., metal screw cap (not pictured), H. 9 in. (cork stopper).

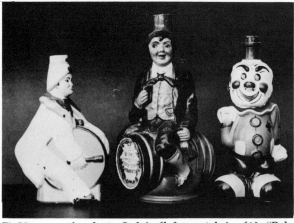

P. Viarengo (made in Italy) (left to right): (1) "Paly-cho" (clown with drum), glass painted white with blue and red trim, cork stopper in top of hat, H. 9 in.; (2) man on a barrel, glass painted green, yellow, and blue, cork stopper in top of hat, H. 12 in.; (3) clown, glass painted white, brown, and red, cork stopper in top of head, H. 9¾ in.

Perfume bottles (left to right): (1) Max Factor, Royal Regiment Grenadier Decanter, ceramic, red suit, blue hat, H. 8¼ in.; (2) Dana, French sailor, ceramic, white shirt and hat, blue trousers, red tassel on hat, H. 15 in.; 1969.

Perfume bottles, Faberge West (left to right): (1) boot, ceramic, bronze-like finish, H. 8 in.; (2) horse, ceramic, bronze-like finish, H. 10½ in.; 1969.

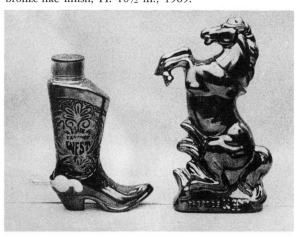

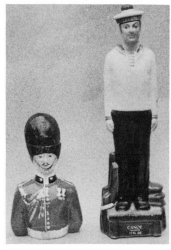

43

Luxardo Bottles

As early as 1366 in Zara, the capital of Dalmatia in what is now Yugoslavia, there was a cherry cordial called Rosalio Maraschino. From this early Italian liqueur evolved the famous Maraschino Luxardo. In 1821 Girolamo Luxardo built a factory in Zara and slowly, through experimentation, developed the Maraschino liqueur for which he became famous.

By 1833 Girolamo Luxardo was exporting his fine liqueur to many countries. The liqueur was shipped in a slender, long-necked, green glass bottle practically identical to the bottle still used today.

Growth throughout the years was steady under Girolamo's son Nicolò and his sons, Demetrio and Michelangelo; by 1918 when Zara was ceded to Italy by Austria the firm was one of the country's largest. In 1922 Michelangelo's sons Nicolò, Demetrio, Pietro, and Giorgio took over the business; by 1939 the plant employed 250 people and covered nine acres.

In 1943, during World War II, the Luxardo home was destroyed during an air raid. Of the four sons only Giorgio remained in 1947. He reestablished the industry at Torreglia, Italy. The necessary Marasca cherry trees were selected by the University of Florence. After the first planting of twenty thousand trees the farmers in the area were given thousands of two-year-old trees free with the agreement that the first crop would be sold to the Luxardo Company at a guaranteed minimum price.

With the reestablishment of the Luxardo Company has come other products. Some of the wines and liqueurs include apricot brandy, cherry brandy, Cherry Ardo, Kirsch Secco, Blackberry Ardo, Raspberry Ardo, Ardo Mint, and Lacrine D'Oro.

Luxardo was the first Italian firm to use ceramic containers for its products and as early as the 1930s some majolica amphoras were imported to this country. In all, about twenty-two different beautifully hand-decorated and glazed majolica amphoras were imported before World War II.

The Luxardo Company is almost as well known for its unusual and distinctive decanters as it is for its fine wines and liqueurs. Whether made of glass or ceramic, Luxardo decanters are hand made and hand decorated; they are inspired by ancient, Renaissance, and modern design.

At the beginning of each year, from three to six new decanters are selected; the most popular are used year after year. The company usually produces between ten and twenty different designs each year, with some of the previous year's being dropped and a few new ones added. Although popular designs may remain in the Luxardo line in Italy continuously they are not necessarily exported to the United States each year. American importers prefer to import different designs each year.

For many years Luxardo has employed the company of Archimede Seguso in Murano to produce its glass containers. Murano is a town on some small islands one mile east of Venice. Venetian glass has been produced in Murano since 1291; in fact almost all of the world-famous Venetian glass has come from these islands.

One of the main reasons that Murano has retained its fame for hundreds of years was the discovery of a method of making perfectly clear glass that is free of impurities. Actually it was a secret that was rediscovered after being lost during the Middle Ages. This glass is called *cristallo* and is even used for the colorful figural animal decanters designed for Luxardo.

Some of these decanters include a green dolphin with flakes of gold infused in the glass, an amber "Cucciolo" (puppy), a green and amber duck, and fish of green and gold, alabaster, and ruby. Other glass specialties include a cocktail shaker, a doughnut bottle, a clock bottle, and a "wobble bottle" that rocks back and forth.

Majolica is Italian earthenware coated with an opaque metallic glaze with a tin base. It is this tin glaze that separates majolica from other kinds of ceramic ware. The name was first used in Italy in the fifteenth century for the lustered Valencia wares shipped in Majorcan trading ships. This glossy, brilliantly colored earthenware is still produced today and is used extensively by the Luxardo Company for its containers. All Luxardo bottles of majolica are glazed both inside and out to prevent leakage. The external and internal glazing qualify these vessels as porcelain and they are sometimes advertised as such.

Some of the most famous Luxardo bottles are the majolica amphoras. Amphoras are earthenware vessels dating from the early days in Greece; they have a handle on either side of the neck, usually rising nearly to the level of the mouth. They were used for the storage of grains, wine, honey, and oil, and either rested on a base or ended in a point so they could be stuck in the ground. Well over thirty different Luxardo amphoras and urns have been imported to the United States since the early 1950s. Many of these are direct copies of amphoras uncovered in the ruins of the early Romans.

The majolica figurals are, perhaps, the most well known of the Luxardo bottles. Again drawing from the inspiration of history, these bottles come in such designs as the Sphinx and the Egyptian. Other majolica figurals bear names like "Calypso Girl," "Tower of Fruit," "Cherry Basket," "Slave Girl," and so forth. Over thirty different styles of majolica figural bottles were exported to the United States over the years.

Luxardo has also produced a majolica specialties series; the bottles are unusual because they are useful as well as decorative, e.g., Burma ashtray, coffee carafe, apothecary jar, and Burma pitcher.

Some of the most unusual of the majolica bottles made for Luxardo come in the Surrealist Series. These containers are named "Gazelle Surrealist," "Duck Surrealist," "Swan Surrealist," and

so forth, but as might be expected, they are really quite abstract and only the original designers can be positive that the bottles in this grouping look like the object they are named after.

During the late 1930s, as already mentioned, about twenty-two different majolica amphoras were imported to the United States; the next period of significance to the collector was between 1952 and 1962, when many glass and ceramic Luxardo bottles were brought to this country. Starting ·in 1968, Luxardo bottles were again brought to the American marketplace. The Luxardo bottle collector can expect to find some of the bottles imported in recent years but those of the 1930s are extremely scarce and for the most part unobtainable. The very dedicated collector could possibly obtain from abroad those bottles that were not imported, but it would obviously take some doing.

The sizes, shapes, and colors of Luxardo bottles, it can be emphasized, occur in a wide range in each category. *Luxardo Bottles* by Constance Avery and Al Cembura will provide visual verification of this variety of size, shape, and color.

Generally speaking, Luxardo bottles range in price from $15 to $50, which seems to be reasonable compared to similar containers from other firms. Of course, the older bottles are commanding much higher prices commensurate with their age and rarity.

Luxardo closures are mostly the traditional cork. Embossments also rate very little consideration; the major characteristic of Luxardo bottles is their unusual shapes which qualify them as figural containers (see Chapter 20).

Bibliography

BOOKS

Avery, Constance, and Cembura, Al. *Luxardo Bottles, Identification and Price Guide*. Portland, Oregon: Metropolitan Printing Co., 1969.

PERIODICALS

Avery, Constance. "The Luxardo Story," *Western Collector*, VI (September, 1968), 39–43.

"Glassworks of Murano," *American Architect* (Boston), V (1878), 127.

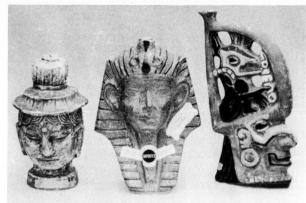

Luxardo (left to right): (1) "Buddhist Goddess," majolica, grey and green, H. 8 in., 1961; (2) Sphinx, majolica, grey, H. 9½ in., 1961; (3) "Mayan," majolica, reddish-brown, yellow, black, and white, H. 11 in., 1960.

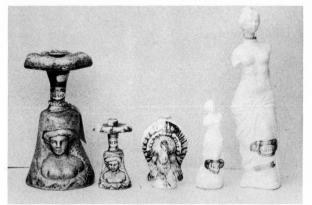

229

Luxardo (left to right): (1) and (2) Paestum (incense burner), majolica, shades of brown, H. 9 in. and 4½ in., 1959; (3) turkey, majolica, brown, red, and yellow, H. 4¾ in., 1961; (4) and (5) "Venus di Milo," majolica, white, H. 5¾ in. and 12¼ in., 1959.

Luxardo (left to right): (1) "Alabaster Goose," translucent, blue-green, base crystal, H. 15½ in., 1960; (2) "Alabaster Fish," soft white with light beige head, crystal base, H. 13 in., 1960.

Luxardo (left to right): (1) dolphin, green glass, fin forms the stopper, H. 16½ in., 1959; (2) "Plump Fish," shades of ruby-red, H. 7 in., L. 11½ in., 1960.

Luxardo (left to right): (1) "Tower of Flowers," majolica, pastel flowers (blue, brown, white, yellow, and pink), H. 22¼ in., 1968; (2) "Egyptian Urn," majolica, brown, gold, and white, H. 14½ in., 1959; (3) "African Urn," majolica, brown, blue, yellow, and grey, H. 13½ in., 1960.

Luxardo (left to right): (1) "Babylon Urn," majolica, green and gold, H. 13¾ in., 1960; (2) "Jogan Buddha," majolica, brown, H. 12½ in., 1961; (3) "Burma Pitcher," majolica, black, white, green, and gold, H. 12½ in., 1960.

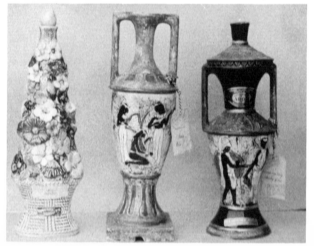

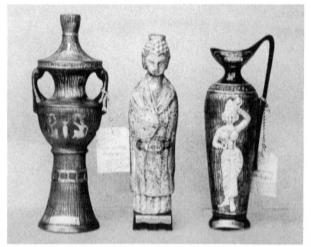

Luxardo (left to right): (1) fish, green and gold, H. 10 in., 1960; (2) puppy, amber, crystal base, H. 12 in., 1960.

Luxardo, "Alabaster Candlesticks," rose and white, H. 12½ in., 1961.

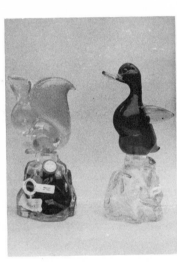

Luxardo (left to right): (1) squirrel, translucent amethyst glass, crystal base, H. 11½ in., 1968; (2) duck, body dark green, wings and lower part of body amber, crystal base, H. 12¾ in., 1960.

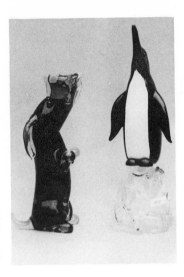

Luxardo (left to right): (1) Scotch terrier puppy, amber and green, H. 11½ in., 1961; (2) penguin, black and white, crystal base, H. 15½ in., 1968.

Luxardo (left to right): (1) Bacchus, green, H. 11 in.; (2) cannon, brown, brass wheels, L. 12½ in.; (3) sailing vessel (*Santa Maria*), shades of brown, H. 12½ in.; 1969.

Luxardo, horse, crystal on black quartz base, H. 11¾ in., 1969.

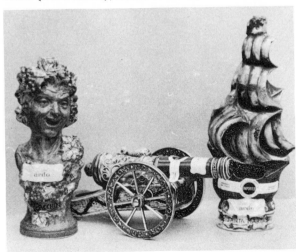

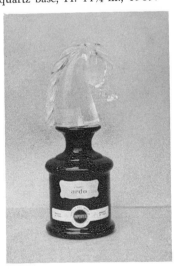

44

Garnier Bottles

The P. Garnier Company, of Enghien, France, has been making use of unusual bottles since 1899. Probably not very many early Garnier bottles are available to today's collectors but, nevertheless, they should be considered.

The Garnier Company has been producing fine liqueurs under the direction of members of the Garnier family since 1859. Production and development of Garnier bottles have been affected by the events of history. There were no bottles issued during the First World War, for example; and shortly thereafter Prohibition greatly slowed production and completely stopped importation into this country; World War II again limited production. Only a few figural bottles were issued before World War I; none during, but a few after. During Prohibition only a few were issued; but by 1939 Garnier was issuing a duck, a clown, a parrot, a penguin, a greyhound, a cat, a clown head, an elephant, a marquis and a marquise, a series of glass miniatures, several pottery bottles, blown crystal animals, and a series called Humoristiques which consisted of miniature pottery animals that contained one tenth of a pint of liqueur. In 1939 they also issued other bottles, including a set of three glass decanters and a series of pin-shaped porcelain figurals called Skittles.

After World War II production again picked up, and since 1949 many Garnier bottles have been produced and imported to the United States.

A book called *Just Figurals: A Guide to Garnier* by Jeri and Ed Schwartz, is an enormous help to collectors. Until this book was published, because of the sporadic issuing of these bottles and the age of the company, collectors had a difficult time identifying and collecting Garnier bottles. One factor that may help in identification is that they are currently being manufactured in Italy and are marked in various ways indicating they are Garnier bottles, whereas they used to be made in France, where the company is located.

Because of the contents—liqueurs—Garnier bottles come in a wide range of sizes, and shapes of all description are available. As with most ceramic bottles, there is a variety of colors available in Garnier containers. Standard closures are cork, which on the figural bottles is often concealed in part of the bottle shape.

The pricing of Garnier bottles is very difficult but in general they range from $15 to over $100. The newer the bottle the less it should cost. The pre-World War II bottles will, no doubt, be toward the high end of the price scale. Until the recent interest in bottle collecting, Garnier bottles were regularly discarded. Perhaps growth of interest will lead to the recovery of examples when dumps of the 1930s are excavated.

Bibliography

BOOKS

Schwartz, Jeri and Ed. *Just Figurals: A Guide to Garnier*. Privately published, 1969.

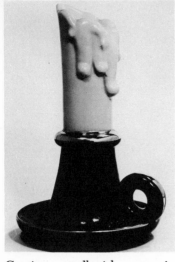

Garnier, candlestick, ceramic, yellow candle, brown base, H. 10¾ in., 1952. (Constance and Leslie Avery, Berkeley, Cal.)

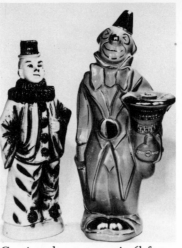

Garnier, clowns, ceramic (left to right): (1) blue and white (also made in green and white), H. 10 in., 1939; (2) green and gold, H. 13½ in., 1955. (Constance and Leslie Avery, Berkeley, Cal.)

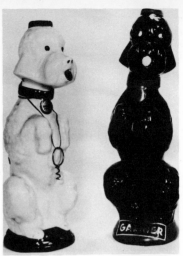

Garnier, poodles, ceramic, white and black, H. 9½ in., 1955. (Constance and Leslie Avery, Berkeley, Cal.)

Garnier, goose, ceramic, off-white, outlined in gold, L. 15 in., 1955. (Constance and Leslie Avery, Berkeley, Cal.)

Garnier, ceramic (left to right): (1) chalet, brown roof, white chimney and walls, blue banister, H. 8½ in., 1955; (2) chimney, unusual detail shows flame in fireplace and candle on mantle, H. 9 in., 1956.

Garnier, ceramic (left to right): (1) violin, white with colorful floral decorations, H. 15 in.; (2) Pegasus (horse), black with gold mane, H. 12¾ in., 1958.

Garnier, ceramic (left to right): (1) snail, grey, brown trim, H. 6½ in., 1959; (2) soccer shoe, black, white trim, H. 8 in.

45

Avon Bottles

Many of the world's bottle collectors started their quest for bottles by gathering the unusual current offerings of Avon Products, Inc., of New York. Collectors' interest in these bottles began in 1965 when the firm produced an attractive stein decanter and a boot containing men's cologne. Coincidentally, Avon spurred collector interest by naming their line of unusually shaped bottles the Collector's Series.

The Avon Company was founded in 1886 by David H. McConnell, a twenty-eight-year-old book salesman. To spur an interest in the books he was peddling he had a druggist make up small vials of perfume that he could give to his prospective customers, who were mostly housewives. McConnell's sales rose as he had hoped but he discovered that there was more of an interest in his perfume than his books. He rented space in a downtown Manhattan building and began to manufacture a line of perfumes under the name "California Perfume Company."

After he had accumulated a stock of fragrances he hired a number of women, many of whom were housewives, to sell his product door to door. McConnell's revolutionary idea for merchandising perfume was an immediate success.

By 1894, David McConnell expanded his business by building a plant in Suffern, New York. By 1905 he had over ten thousand representatives throughout the country.

In 1930, McConnell renamed the company Allied Products and named one of his perfumes Avon. The perfume became popular under the romantic name, so much so that people began to ask for his products by the name Avon. With this in mind he again changed the firm's name, in 1939, to Avon Products, Inc.

In 1954 business had grown to the point where Avon products were exported to other countries. Today the company employs over 350,000 "Avon Ladies" (some are men) and does business not only in every corner of the United States but in well over two dozen foreign countries. It has been said that Avon is the largest cosmetics company in the United States, larger in fact than its two closest competitors combined.

An Avon bottle collector must know something about the company's policies to be as effective as possible in gathering these containers.

Every two weeks customers are offered new products and a "special." These specials are either new bottles or old ones that are being offered at a reduced price. In addition to sometimes being able to obtain a new bottle at a reduced price a collector can occasionally purchase an old bottle that has been unobtainable for some time. Another money-saving thought for the bottle collector is to select the container desired with the least expensive contents; sometimes several products come in the same container.

Bottles usually are sold on a regular basis for about six months and then taken off the market. Sometimes they are reissued as specials at a later date; sometimes they are never reissued.

The bottles are usually quite elaborate and are designed by the company's packaging group. All containers are produced in the East by various glass manufacturers with all of each type being made by a single manufacturer. The completed containers are shipped to and filled in various parts of the country. At least one third of Avon's total line of bottles is redesigned each year, giving the collector quite a variety to collect.

The major characteristic of Avon bottles is their shape. These bottles are almost always figurals (see Chapter 20). Avon bottle shapes include a clock, a gun, a stein, a bell, steer horns, a barrel, a duck, a dagger, automobiles, a dolphin, boots, a horse, a key, a pipe, books, and so forth. There are well over one hundred shapes with more being issued all the time.

In addition to having unusual shapes, these bottles are colorful. Some of the colors are flashed on clear glass and can be scratched off, and some are actually colored glass.

As a rule, embossments and closures are of little consequence on these contemporary containers. Embossments are practically nonexistent, and the closures are standard threaded types. Quite often, however, the cap of an Avon bottle will be part of the entire shape and important from that standpoint.

The sizes of Avon bottles do vary but in general they are all small. This is because they were manufactured to contain cosmetics which traditionally are sold in small quantities.

Related material for the Avon collector usually consists of the boxes in which the bottles originally came, and the catalogues in which they were advertised. For the more persistent collector there are the early advertisements, sales pamphlets, and so forth.

At this time Avon bottles are in one of the most inexpensive bottle categories. These containers range in price from $2 to $50 for some of the very rare items. Prices for the older bottles will, no doubt, rise as interest increases. One of the best books dealing with Avon bottles is *Western Collectors' Handbook and Price Guide to Avon Bottles,* which pictures most of the bottles and offers a complete price guide.

Originally, the collecting of Avon bottles was restricted to the figural containers that were produced as early as 1965, but as the interest has grown, collectors are seeking out the earlier containers. These early bottles were, for the most part, cosmetic bottles and jars of standard shapes. There has also been an interest in the line of plastic bottles that were first issued during the latter part of 1968. These fascinating containers were made mostly for children's cosmetics and are shaped like cartoon characters (the "Peanuts" and Walt Disney characters and others), ice cream cones, shoes, a variety of animals, and the like.

This speciality is probably the only one in which the collector can collect by sitting at home in his armchair and waiting for the doorbell to ring and the Avon representative to say, "Avon calling."

Bibliography

BOOKS

Holmberg, Millicent, and Munsey, Cecil. *Western Collectors' Handbook and Price Guide to Avon Bottles.* San Francisco, California: Western World Publishers, 1969.

PERIODICALS

"Avon—Calling You?," *Old Bottle Magazine,* II (February, 1969), 12–19.

Wiseburn, Jack. "Avon Calling," *Western Collector,* VI (November, 1968), 35–39.

Avon bottles (left to right): (1) clear, icicle-shaped fluted flacon etched with delicate crisscrossing, one dram capacity, 1967; (2) "Bell," clear, gold metallic handle, H. 4 in., 1968; (3) "Petit-Fleur," clear, H. 2½ in., 1969; (4) "Petite Snail," clear, H. 1½ in., 1968; (5) "Key Note," clear, L. 5½ in., 1967.

Avon bottles (left to right): (1) "Boot," amber glass, silver metallic top, H. 7 in., 1965; (2) "Miss Lollypop Majorette Boot," clear, red cloth tassle, H. 4¾ in., 1967; (3) "Leather Boot," brown plastic-covered glass boot, H. 6 in., 1967; (4) "Classic Decanter," milk glass, H. 11 in., 1969; (5) "Gavel," amber glass head, brown plastic handle, H. 10¾ in., 1967.

Avon bottles (left to right): (1) "Christmas Tree," metallic red (also comes in metallic gold, green, or silver), H. 7 in., 1968; (2) "Christmas Sparkler," metallic green (also comes in metallic gold, silver, red, and purple), H. 4 in., 1967; (3) "Golden Angel," metallic gold, pleated cone-shaped body, embossed metallic gold foil wings and white plastic screw-type head closure, H. 5½ in., 1968; (4) "Christmas Sparkler," metallic gold (also comes in metallic red, green, or blue), H. 4 in., 1968.

Avon bottles (left to right): (1) "The Swinger," black with silver clubs and red club covers, H. 7 in., 1969; (2) "Snoopy," plastic, white with blue hat, H. 5½ in., 1969; (3) "Town Pump," opaque, black glass, metallic gold plastic handle, H. 8 in., 1968; (4) "Legendary Hero," frosted glass, H. 6 in., 1967; (5) "Weather or Not," light amber, H. approx. 7 in., 1969.

Avon bottles (left to right): (1) "Touring T," smoky grey glass, L. 6½ in., 1969; (2) "The Straight Eight," green glass, black plastic trunk, L. 6 in., 1969; (3) "Sterling Six," amber glass, black plastic spare tire screw-type closure, L. 6 in., 1968.

Avon bottles (left to right): (1) "Pony Post," green glass, fluted column, H. 10 in., 1966; (2) "Daylight Shaving Time," replica of pocket watch, metallic gold, white face, black numerals, H. 6 in., 1968; (3) "Mallard Decanter," emerald-green glass, H. 7½ in., 1967; (4) "8 oz. Stein," replica of old-fashioned Bavarian beer mug, silver-like finish, H. 6¼ in., 1965; (5) "Opening Play," gold and black, H. 4 in., 1968.

Avon book-shape decanters, "Classics," with metallic screw caps, clear, H. 5½ in., 1969.

Avon bottles (left to right): (1) "Western Choice," clear, metallic silver plastic screw-type closures on horns, each horn is a separate bottle, L. 8½ in., 1967; (2) "Pipe Dream," amber glass, brown plastic holder, H. 7 in., 1967; (3) "Defender," light amber, brown plastic simulated wood cradle, L. 8½ in., 1966.

Avon bottles (left to right): (1) "Scimitar," embossed metallic gold with ruby-red bejewelment, L. 10 in., 1968; (2) "A Man's World," embossed metallic gold, brown plastic stand, H. 4 in., 1969; (3) "Viking Horn," amber glass with metallic gold screw cap, L. 7 in., 1966.

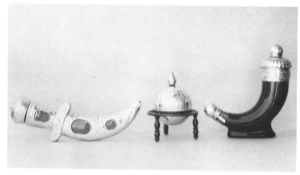

46

Jim Beam Bottles

For the collector of modern bottles the ceramic and glass bottles of the James B. Beam Distilling Company are of prime interest. These modern bottles date from 1953, but the company that inspired their creation was started at least 150 years before the first of their revolutionary decanters appeared on the market.

The founder of the company was Jacob Beam, a whiskey distiller from Virginia and Maryland. Beam moved to Kentucky in 1788 and shortly thereafter he began his own distillery. By 1795 his distillery was firmly established and his fame widespread.

To continue the family tradition, Jacob's son, David, entered the business, and his son, David M. Beam followed suit. In 1880, David M. Beam's son, Jim (the famous Colonel James B. Beam), entered the business and continued its management until well into the 1940s.

Today, T. Jeremiah and Carl Beam (fifth-generation Beams) and Baker and Booker Beam (sixth-generation Beams) continue to manage the historic distilling company.

It was in 1952 that the James B. Beam Distilling Company decided to try a revolutionary new package for their whiskey. Their first effort was a glass cocktail shaker decanter which was released for the 1953 Christmas season. The sales of this new package were so great that the company has continued to produce other glass specialties.

In 1955, to commemorate their 160th anniversary the company issued the first of their Executive Series. Each year since there has been a new ceramic bottle in this series; they are hand-crafted, hand painted, and almost all are decorated in 22-karat gold.

Also in 1955 the Beam Company issued the first of its Regal China Specialties, an ivory ashtray bottle. These, the Glass Specialties (from 1953), and the ceramic Executive Series and Regal China Specialties (from 1955) were readily accepted in the gift market; as yet, however, there was little collector interest.

In 1956 two new series were added to the

rapidly expanding Beam line of unusual ceramic bottles. The Political Series, consisting of donkey and elephant bottles, was a big hit. In response to a demand by large retailers a Customer Specialties Series, beginning with a Foremost Liquor Stores of Chicago bottle, was initiated in the same year.

A duck and a fish bottle were produced in 1957 to begin the popular ceramic Trophy Series. The above-mentioned six series sold well for the Beam Company and encouraged them to expand even more with unusual packaging.

Beginning in 1958 a State Series was introduced with Alaska and Hawaii bottles. At irregular intervals, ceramic bottles commemorating the various states are issued. These bottles have been so popular that some were reissued to satisfy customer demand.

In 1960 the Beam Company initiated its eighth series, ceramic bottles designed to commemorate centennials. The first of this Centennial Series was the Santa Fe bottle.

Beam bottles had little resale value as collectors' items until approximately 1967, when bottle collectors took an interest in Beam's glass and ceramic containers. Clubs were formed, and today there is at least one Jim Beam bottle club in almost every state. Several of these clubs have even been honored with their own club bottles.

Since their first unusual bottle in 1952, the James B. Beam Distilling Company has produced over two hundred bottles that collectors are clamoring to obtain. Each year adds more of these glass and ceramic containers to the collector's shelves.

The major characteristic of Jim Beam bottles seems to be price. It is quite fantastic to realize that these bottles range in price from $5 to $2000. In all of bottle collecting there are no bottles so young that command so many dollars.

Even though the glass bottles issued by the Beam Company are found in a beautiful range of colors and shapes, they are not nearly so popular with collectors as are the other seven ceramic series.

The ceramic bottles are figural bottles (see Chapter 20)—most are shaped like an animal, a state, a person, or a landmark. The containers are brightly decorated in almost every color possible and are heavily embossed with a number of words and designs. Some are painted with gold and all are made of Regal China by a small factory in Illinois devoted exclusively to the production of Beam bottles.

Beginning in 1957 the Wheaton Glass Company, of Millville, New Jersey, has produced all of the Jim Beam glass bottles.

Most Beam bottle collectors rely on a book by Constance Avery and Al Cembura entitled *Beam Bottles: Identification and Price Guide.* This book pictures each of the Beam bottles and gives pertinent information about them and their prices. Because of the large number of bottles issued each year the book is revised and reissued annually.

In addition to the various club newsletters devoted to the discussion of collecting Jim Beam bottles, there is at least one monthly publication devoted to the pricing of these bottles.

The interest in Beam and its bottles is so big that men's tie tacks and ladies' lapel pins are being sold as related items. Commemorative coins have also been issued. These and related advertisements may all be included in the Jim Beam bottle collection.

Bibliography

BOOKS

Avery, Constance, and Cembura, Al. *Beam Bottles: Identification and Price Guide.* Berkeley, California: Wagner Printing Co., issued annually.

PERIODICALS

Cembura, Al. "The Jim Beam Story," *Western Collector,* IV (May, 1966), 27–29.

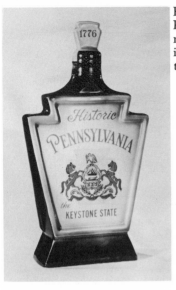

Beam's State Series, "Historic Pennsylvania, the Keystone State," multicolor, Regal China, H. 11½ in., 1967. (James B. Beam Distilling Co., Chicago, Ill.)

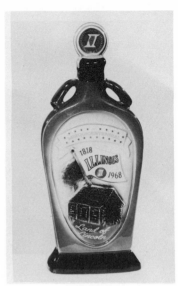

Beam's State Series, "1818—Illinois—1968," Regal China, H. 12¾ in., 1968. (James B. Beam Distilling Co., Chicago, Ill.)

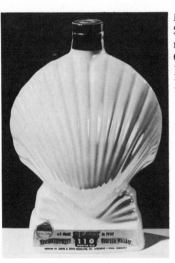

Beam's State Series, "Florida Shell," iridescent pearl (also made in iridescent bronze), Regal China, H. 9¾ in., 1969. (James B. Beam Distilling Co., Chicago, Ill.)

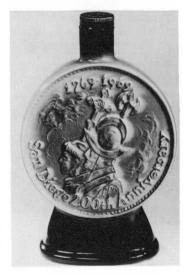

Beam's Centennial Series, "San Diego 200th Anniversary," mustard color, Regal China, H. 10 in., 1968. (James B. Beam Distilling Co., Chicago, Ill.)

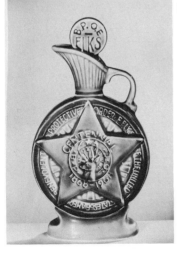

Beam's Centennial Series, "Elks," brown and gold, Regal China, H. 11 in., 1969. (James B. Beam Distilling Co., Chicago, Ill.)

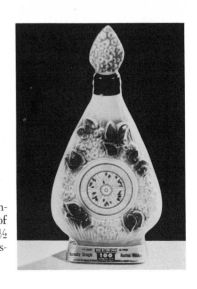

Beam's Centennial Series, "Lombard," off-white and shades of lavender, Regal China, H. 12½ in., 1969. (James B. Beam Distilling Co., Chicago, Ill.)

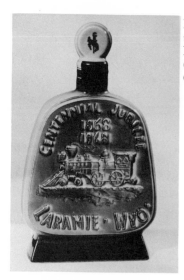

Beam's Centennial Series, "Centennial Jubilee, Laramie, Wyo.," Regal China, H. 10½ in., 1968. (James B. Beam Distilling Co., Chicago, Ill.)

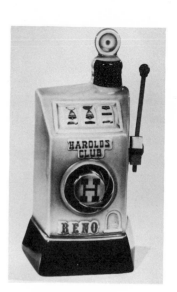

Beam's Customer Specialties, "Grey Slot Machine," grey bottle with words "Harold's Club" and "Reno" in blue letters, pinwheel is gold with black letter "H" in center, Regal China, H. 10 in., 1968. (James B. Beam Distilling Co., Chicago. Ill.)

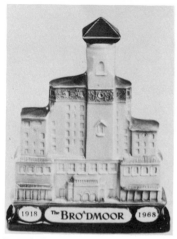

Beam's Customer Specialties, "The Broadmoor," pinkish brown with darker shades of brown on roof, Regal China, H. 10 in., W. 8 in., 1968. (James B. Beam Distilling Co., Chicago. Ill.)

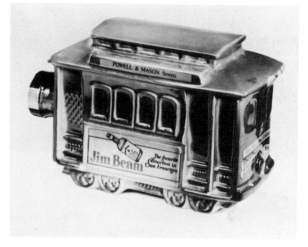

Beam's Regal China Specialties, "Cable Car," avocado-green and gold, Regal China, H. 4½ in., L. 7 in., 1968. (James B. Beam Distilling Co., Chicago, Ill.)

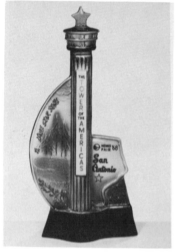

Beam's Regal China Specialties, "Hemisfair," grey and blue with blue star on top, H. 13 in., 1968. (James B. Beam Distilling Co., Chicago, Ill.)

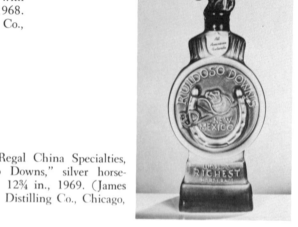

Beam's Regal China Specialties, "Ruidoso Downs," silver horseshoe, H. 12¾ in., 1969. (James B. Beam Distilling Co., Chicago, Ill.)

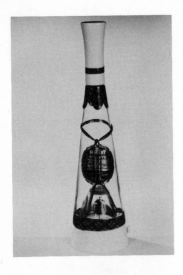

Beam's Glass Specialties, "Dancing Scot," clear glass, Scotsman has red plaid shirt, green kilt, and bright tartan, H. 17 in., 1964–1969. (James B. Beam Distilling Co., Chicago, Ill.)

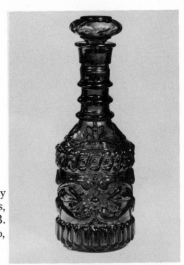

Beam's Glass Specialties, "Ruby Crystal Decanter," amethyst, glass, H. 11½ in., 1967. (James B. Beam Distilling Co., Chicago, Ill.)

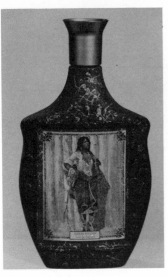

Beam's Glass Specialties, "Indian Maiden," Collectors' Edition Volume III, blue suede-like covering, H. 10½ in., 1968. (James B. Beam Distilling Co., Chicago, Ill.)

Beam's Glass Specialties, "Hauling in the Gill Net," Collectors' Edition Volume III, blue suede-like covering, H. 10½ in., 1968. (James B. Beam Distilling Co., Chicago, Ill.)

Beam's Glass Specialties, "Boy with Cherries," Collectors' Edition Volume IV, leather-like covering, 10½ in., 1969. (James B. Beam Distilling Co., Chicago, Ill.)

Beam's Glass Specialties, "The Guitarist," Collectors' Edition Volume IV, leather-like covering, 10½ in., 1969. (James B. Beam Distilling Co., Chicago, Ill.)

PART VII

Collecting Bottles

47

How to Obtain Bottles

The methods of obtaining bottles are many and varied. In this chapter some of the most common methods will be mentioned and examined. The suggestions offered herein are not intended to be the last word on the subject but only guidelines for the collector.

By the mid-1800s Americans began to discard the tradition of saving and reusing their glass and ceramic containers; as years passed more and more bottles found their way to the dumping areas. These trash heaps of the past are perhaps the most abundant and inexpensive source of antique bottles. Trash was most often dumped under buildings, in outhouse pits, and, of course, in areas specially set aside for dumping. A cursory examination beneath buildings will quickly reveal whether such areas were used for discarded items, but locating outhouse pits and old trash heaps is usually more difficult.

Depending upon what has happened over the years, dumps may lie under a few feet of earth or be at or near the surface. Dumps at or close to the surface are easily located by visible bits of broken glass, pieces of metal, and tin cans. Dumps covered with earth are harder to locate. Digging is certainly one of the most direct methods of determining if a suspected area was used as a dump, but an easier way is to scan the area with a metal detector. Another effective method consists of pushing a long steel rod into the ground; the probe will make a sound if it strikes glass.

Outhouse pits, almost without exception, are covered with several feet of soil. These pits were quite frequently used for the disposal of trash in addition to their normal use. Here again the metal detector or steel probe may be useful. One of the best methods, however, in an area in which an outhouse may be suspected to have been located is to examine the area for a depression in the ground. Over the years the contents of the outhouse pit decompose and compress, and the pit area often sinks noticeably.

Once a dump or outhouse pit is located the next step is to excavate it to recover the items of interest. The most common tools are a round-pointed shovel, a hoe, and a potato rake. Because of the composition of a trash pile, a pick is seldom required. Digging carefully is necessary to reduce the amount of breakage, and sifting the dirt often results in the locating of small bottles and objects such as coins.

Another area that is only recently being searched is the ocean. Many seventeenth- and eighteenth-century bottles are being recovered from shipwrecks (see Chapter 14). The ocean always has been a vast dumping ground, and the majority of the bottles found on the ocean floor were merely discarded in these watery dumps. Scuba diving seems to be the best method of obtaining bottles from the ocean. As more and more collectors become proficient in the skill of diving, more currently rare bottles will, no doubt, be found.

Once overlooked completely, the land and sea dumps of the twentieth century are gradually interesting the collector, partly because bottles of the twentieth century are capturing more attention and partly because the larger dumps are easier to locate. Pre-1900 bottles are not only scarce because of increased interest, but the small and scattered dumping areas of the nineteenth century are becoming increasingly hard to find.

Another major method of obtaining bottles is by purchase. Quite often a collector reaches a point where it is almost impossible to obtain certain bottles without buying them. Buying is practically the only means of obtaining some of the contemporary bottles.

Bottles are available for sale in antique shops, antique shows, bottle shops, bottle shows, swap meets or flea markets, liquor stores (for contemporary bottles), private collections, and auctions. Another marketplace for both old and new bottles is found in the various antiques and bottle collectors' periodicals, some of which are almost exclusively devoted to advertisements of items for sale.

Trading is another prime source of bottles.

Many collectors and dealers are always receptive to proposed trades. The periodicals often devote sections to articles offered for trade.

Whether buying, selling, or trading, a successful collector must be aware of current values. There are, of course, books available which claim to be price guides; these publications usually show a sketch or photograph of a number of bottles, perhaps with their color and/or size, and offer a suggested value. These price guides are probably more popular than they are useful; prices vary constantly, so no matter how accurate a guide is when it is published it becomes outdated almost immediately upon being offered for sale. It would seem more logical to use current periodical advertisements as a price guide. Such literature is revised weekly, bi-weekly, or monthly as the publication is issued; what better guide for current value could there be?

There have been heated discussions among collectors regarding the methods of obtaining bottles, with some collectors advocating only digging and some only buying. It seems that whether a collector obtains his bottles by digging, buying, or trading is of little consequence and what is of importance is the fact that he is interested and does collect.

Blumenstein, Lynn. *Bottle Rush U.S.A.* Salem, Oregon: Old Time Bottle Publishing Co., 1966.
————. *Redigging the West.* Salem, Oregon: Old Time Bottle Publishing Co., 1966.
Davis, Marvin and Helen. *Old Bottle Collecting for Fun and Profit.* Ashland, Oregon: Artisan Press, 1966.
Fike, Richard E. *Guide to Old Bottles, Contents and Prices.* 2 vols. Ogden, Utah: privately published, 1966 and 1967.
Johnson, Robert J. *The Bottle Game Called "Collecting."* Rock Hall, Maryland: privately published, 1969.
Kenyon, Harry C. *Jersey Diggins,* Vol. I. Newfield, New Jersey: The Old Barn, 1969.
Rawlinson, Fred. *Old Bottles of the Virginia Peninsula, 1885 to 1941.* Newport, Virginia: FAR Publications, 1968.
Seamans, Berna, and Robb, Mertie. *Colorado Bottle History.* Denver, Colorado: privately published, 1969.
Sellari, Carlo and Dot. *Eastern Bottles, Price Guide.* 2 vols. Dunedin, Florida: Area Printing, 1969 and 1970.
Tibbitts, John C. *How to Collect Antique Bottles.* Santa Cruz, California: The Heirloom Press, 1969.

Bibliography

BOOKS

Adams, John P. *Bottle Collecting in New England.* Somersworth, New Hampshire: New Hampshire Publishing Co., 1969.
Bailey, Shirley R. *Bottle Town.* Millville, New Jersey: Shirley R. Bailey, 1968.
Bates, Virginia, and Chamberlain, Beverly. *Antique Bottle Finds in New England.* Peterborough, New Hampshire: Noone House, 1968.
Black, Ruth. *Bottle Stoppers.* Auburn, California: privately published, 1968.

PERIODICALS

Gorey, M. "Notes on Bottles," *Hobbies,* LIII (August, 1948), 109.
Hale, Mary Eileen. "Being Down in the Dumps Can Be Fun," *Northwestern University Alumnus,* XXXII (Winter, 1970), 24–29.
Keiser, J. P. "When You're on Spring Jaunts There Are By-Roads and Bottles," *Hobbies,* XLV (May, 1940), 55.
Kendrick, Grace. "History in Glass," *Nevada Highways and Parks,* XXIX (Fall, 1969), 54–55.

48

Cleaning Bottles

While there are almost as many techniques of cleaning bottles as there are collectors, there are two basic methods: chemical and mechanical.

Chemical

The following is a list of the most popular and effective chemical cleaners: soap, oven cleaner, vinegar, ammonia, oxalic acid (powder), toilet bowl cleaner, hydrochloric (muriatic) acid, caustic soda and soap, tile cleaner, drain cleaner, sink cleaner, tri-sodium phosphate, and paint remover.

These chemicals are produced by various commercial companies and can usually be purchased in grocery, drug, and hardware stores.

WARNING! Never mix a chlorine bleach with an acid or acid-producing substance such as vinegar or toilet-bowl cleaner because such a mixture will produce a poisonous chlorine gas. Similarly, chlorine bleach when mixed with ammonia or lye will produce a highly irritating gas. A good rule to follow is: never mix chemical cleaners unless you are *sure* the chemicals will complement each other and not produce dangerous gases or neutralize each other.

Mechanical

There are countless mechanical devices, commercial or otherwise, that can be used to aid in the cleaning of bottles. Some of the most popular include: a wide variety of brushes in varying sizes and lengths, an assortment of wires, steel or brass (soft) wool; eggshells, carpet tacks, gravel, unpopped popcorn or uncooked rice, and lead shot; the latter six are used on internal portions of the containers.

Methods

Before attempting to clean bottles the collector needs two basic pieces of equipment: a fairly large plastic container and rubber gloves, for protection from some of the chemicals used.

The best way to begin the cleaning of most bottles is with an extensive soaking in water for several days. Never put a glass vessel into an ex-

tremely hot or cold medium; glass may break under rapid changes in temperature.

After soaking, a cursory examination of the bottle will show whether a good hard scrubbing in soap and water will suffice or whether stronger chemicals should be used. A good rule when deciding which of the listed chemicals to use is: the more stubborn the stain, the stronger the chemical should be.

The various mechanical devices may be used in any combination with one chemical at a time. Wires and brushes may be bent to reach corners within the bottle. Steel wool and other objects may be attached to wires. The eggshells, carpet tacks, gravel, unpopped popcorn, uncooked rice, or lead shot may be put into the bottle with soap or some other cleaner and shaken vigorously until the stain has been removed. The individual will undoubtedly think up new techniques of his own.

It is possible that some of the chemicals and mechanical devices described will permanently stain or scratch bottles. Each collector will have to experiment to learn the limits of the methods and the bottles to which he applies them.

Regardless of which chemical cleaner is used it is best to complete the cleaning of a container with a good washing in soap and water, and a rinse in clear water. One of the best devices for drying bottles is a board with varying lengths of doweling placed in drilled holes. Recently cleaned bottles may be placed upside down over the appropriate size dowel and left to dry.

Bibliography

BOOKS

Wagoner, George. *Restoring Antique Bottles.* West Sacramento, California: Gorman's Stationery, 1967.

PERIODICALS

"Cleaning Old Bottles," *Hobbies,* LI (March, 1946), 54.

49

Restoring, Repairing, and Altering Bottles and Labels

The restoration and improvement of antiques has long been accepted by many collectors; to discard something of historic value because it is damaged seems a bit extreme to them. There are other collectors who refuse to own objects that have been tampered with in any way. Each collector has a right to his opinion.

Only when restored or improved bottles and labels are misrepresented as being in original condition is a wrong being committed. This is not to say that restored or improved objects should not be sold or traded but, rather, that such objects should be honestly represented and valued under such conditions.

As the hobby grows and the supply of available bottles and labels dwindles it may well be that in many cases the only way a collector will be able to obtain examples of some of the rarer types will be by accepting restored or improved bottles and labels.

The same thoughts can be applied to altered bottles. There are numerous ways of altering bottles; it is not beyond the skills of some collectors to grind away chips, lettering, and other unwanted embossments. Neither is it impossible to change a bottle from a less desirable color to a more desirable one with the aid of glass stains. Still another possibility is the addition of highly desirable embossments to otherwise plain bottles with the skillful use of resin.

Restored, repaired, and altered bottles and labels are potential joys or sorrows; it depends entirely on the collectors and dealers involved and their morals or lack of them. The founder and first president of the Antique Bottle Collectors Association put it wisely in this way:

> The restoration of very old antiques including the paintings of the masters is an art in itself and a dignified profession. The art and antique treasures of today are much more abundant for more people to enjoy only because of the restoration and repairs. It would be a pity if only "perfect" specimens had been kept. So, and I emphasize this, restoration of antique bottles is ethical and necessary.
>
> JOHN C. TIBBITTS

Improvement of Bottles

Glass bottles, after long exposure to moisture, will begin to deteriorate. The collector who gathers

245

the older glass bottles often acquires specimens in varying stages of corrosion (see Chapter 12 on sick glass). While in some cases this corrosion is quite attractive and the collector would want to keep and display the bottle as it was discovered, there are some cases in which the corrosion is only slight and appears to be only a stain. Such stained bottles can be improved in any one of several ways:

1. Oil in almost any form will temporarily improve the appearance of a dull bottle. The worse the stain the more oil it will require to hide it. Collectors use baby oil, lemon oil, lotions, and so forth. One of the most effective oiling techniques, however, is an Almond Stick. This is a tightly wrapped cloth that is saturated with petroleum distillates. With time any oil will evaporate and a new coat will be required.

2. To obtain a very hard and durable finish on a stained bottle many collectors have successfully used casting resin. When properly applied to the surface of a bottle this substance will dry absolutely clear and give a shiny and lasting finish. This chemical is often called liquid glass and is very similar to the material used on fiber glass boats. Correctly mixed, casting resin is brushed on the outside surface of the bottle; like oil, when used on the interior of the container it must be poured in and the container turned until the entire inside is covered.

3. A relatively new process that holds great promise is "tumbling." Rock collectors, for many years, have polished their finds by tumbling them with water and a polishing compound in a rotating cylinder. Bottle collectors have tried this with some success. It would seem good advice, however, to hold a "wait and see" attitude about this method. When and if the technique is perfected detailed instructions will be published in one or more of the periodicals serving the hobby.

Restoring Bottles

With the development of a substance called casting resin has come the reality of adequately restoring partially destroyed ceramic and glass bottles. Casting resin is a clear and workable liquid plastic; when allowed to dry it becomes a very hard and glasslike material.

Collectors of bottles quite frequently find specimens that have chips, holes, lost or broken handles, or are cracked. All of these flaws in bottles can be effectively repaired with casting resin.

Of all the injuries to bottles, chips in the lips are the most frequently encountered. Older bottles utilizing cork closures were often chipped on the lip, since such sharp devices as ice picks were used to remove the cork. To repair such chips a mold is made around the chipped area with masking tape, and the mold is filled with casting resin. After it has dried, the filled area is sanded with a very fine sandpaper and a coat of thinned resin applied. On colored glass bottles the appropriate coloring must be added to the resin.

Holes in bottles are a common problem. Often holes are knocked in bottles when they are thrown away or by the tools used for their recovery from the dump. The larger the hole the more difficult it is to repair. Perhaps the most difficult part of repairing a hole in a bottle is the placement of the masking tape mold. Using a length of wire, masking tape is placed over the hole from the inside of the bottle. As soon as the tape is in place the hole is filled with resin and allowed to dry. As in the repair of chips the dried resin is sanded and then covered with a brushed-on coat of thinned resin to bring back the original glass appearance. If the removal of the tape on the inside of the bottle leaves a dull finish, this can be eliminated by pouring thinned casting resin into the bottle and rotating the bottle until the inside is covered.

Casting resin can also be used as a glue to reattach broken handles or reassemble broken bottles. After the pieces are put back together and dried the bottle is then sanded and coated with thinned resin.

One of the major uses of casting resin in restoring bottles is the replacing of necks. Broken necks are probably the most frequent damaged condition encountered in bottles. Many bottles are broken except for the necks, however, so the interested collector should save both bottles with broken necks and necks from broken bottles. When a matching set has been acquired, the two can be joined to make a whole bottle.

The procedure for joining whole necks to whole bottle bodies is not as complicated as it might seem. The first step is to cut off the broken part of both the bottle and the neck. This necessary cut can be made by a diamond-impregnated lapidary saw.

After the cuts have been made, place masking tape around the inside of the body of the bottle, leaving a small portion extended above the cut edge. Apply resin to the surface to be glued and slip the new neck down over the projecting tube of masking tape. Allow the joined pieces to dry, then

sand the outside and remove the tape from the inside. Coating the bottle with thinned resin should complete the process and give the collector a whole bottle.

Altering of Bottles

It is doubtful if altering bottles except for personal pleasure is ethical. Because of this, specific methods will not be discussed in detail. It is good to remember that there are many ways in which a bottle can be made into something it really is not. The various methods discussed will only be a few of the most common; new techniques are being perfected all the time. It behooves the interested collector to read current bottle literature to keep abreast of these methods.

One of the easiest and most common alterations is accomplished through grinding and polishing. Frequently the only thing that separates an inexpensive bottle from an expensive one is embossed lettering. Although most embossments are highly desirable, some are not. A good example is the warning embossed on whiskey bottles from the 1930s to the 1960s (see Chapter 25). Many liquor bottles embossed "FEDERAL LAW PROHIBITS THE SALE OR RE-USE OF THIS BOTTLE" would be highly desirable if this embossment did not date them as being made since the 1930s. It is very easy to carefully grind away this lettering and polish the bottle so that the grinding will not show. Other grinding might be done to eliminate threads which date some bottles.

Just as some embossments can be eliminated to enhance a bottle's value, so can embossments be added for the same reason. Through the clever use of casting resin desirable embossments can be added to otherwise plain and uninteresting bottles. A good example again is whiskey bottles. These bottles were produced in basic shapes; the most desirable ones are those embossed with lettering or designs that associate them with a particular firm. By reproducing specific embossments a plain whiskey bottle can be transformed into a very rare and desirable spirits bottle. In at least one case a very knowledgeable collector paid approximately $1200 for just such an altered bottle.

An otherwise common bottle can be made more valuable by altering its color by one of several methods. By far the easiest technique is to paint a bottle with glass stain. Another method, called flashing, can be used; this involves dipping the container into a batch of colored glass. Color alterations are easily detectable by scratching the container with a sharp object—real colored glass will not scratch, but stained or flashed colors can be removed by scratching.

One other common alteration deals with bottles that could have had bare iron pontil marks (see Chapter 10). Bottles made after the period of bare iron pontils can be made to appear a number of years older by painting their bottoms with a paint that resembles the iron oxide left by a bare iron pontil.

As already indicated, it is doubtful if altering bottles except for personal pleasure is ethical.

Removal and Improvement of Paper Labels

Soaking seems to be the best method to remove labels from bottles. Place the bottle in a container of warm water until the label is submerged. Allow the label to soak ten or fifteen minutes, then slip it off the bottle, place it face down on clean paper, and allow it to dry. To avoid curling, a weight of some sort may be placed on the drying label. If the label is a brightly colored one add a little salt to the water to prevent the colors from spreading. If the glue on the label does not dissolve in plain water use a little vinegar or dilute acetic acid.

Improvement of labels is a delicate subject, since some collectors view any attempt to improve the appearance of labels as some sort of fraud. In the following suggestions there is no idea of altering a label but only of overcoming, in a small way, the harm it may have suffered through careless handling or age and of preventing further damage.

1. *Removal of Creases.* Light folds or creases that do not break the paper fibers may be removed completely, but when the fibers are broken the line or fold will always show. Soak the label in warm water until it is thoroughly softened, place it face up on a hard, smooth surface, cover with blotters, and press until dry. An electric iron may be used for the pressing.

2. *Removal of Dirt.* Usually all that dirty labels need is a light wash with a mild soap. Place the label in the palm of the hand and with one finger or a stubby brush—a worn shaving brush is excellent—wash with a little suds, taking care to brush toward the edges. If the dirt is obstinate add a drop of ammonia to the suds. In every case soak the label in clean water before pressing.

3. *Removal of Mildew.* Mildew and stains caused by fungi may be removed or bleached by painting the stained places with a very weak solution of chlorine bleach. Try a solution containing

one or two drops in a teaspoonful of water. If this is not effective, increase the chlorine bleach a drop at a time until the bleaching action is obtained. Then wash or soak the label to remove all traces of the chemical.

Another method is to soak the affected label in a hot bath of salted milk.

4. *Removal of Grease and Oil.* Spots of oil may be removed by dipping the label two or three times in boiling water.

Also, dry-cleaning solvent will remove grease and oil. Place the label on a blotter and wet the entire surface with the fluid. Then blot up the liquid and repeat without allowing the label to dry out between the treatments. After removing as much of the oil or grease as possible place the label in a bath of clean water.

Ether is another chemical which can be used to remove grease.

Still another method is to vaporize the grease or oil with a very hot iron. The label must be protected with blotters to prevent scorching and to absorb the oil vapor.

5. *Closing Small Tears.* Use Scotch Magic Mending Tape on the back of the label. This relatively new tape will not yellow or become brittle.

6. *Reconstructing Pieces.* Collectors often find labels in various stages of ruin. Many collectors are able to join such pieces, making a reconstructed label.

7. *Lacquering.* Use Workable Fixatif spray coating to preserve labels from fingerprints and other damage. This product, made especially for artists, dries crystal clear while providing a protective coating; it is available at most art supply stores.

Bibliography

BOOKS

Wagoner, George. *Restoring Antique Bottles.* West Sacramento, California: Gorman's Stationery, 1967.

PERIODICALS

Fountain, John C. "Warning to All Bottle Collectors," *National Bottle Gazette,* I (May, 1969), 30.

Munsey, Cecil. "Removal and Improvement of Paper Labels," *The Bottleneck,* II (September, 1967), 2–3.

50

Dating Bottles

When it comes to methods of dating bottles and related items, history has not been very kind to collectors. As yet it has failed to reveal very many of the dates that would be valuable in determining the exact age of many bottles. Of course, continuing research is gradually discovering secrets of value; and as long as there are those interested enough to devote the necessary time, effort, and patience to the needed research, more and more valuable information will be disclosed.

Perhaps one of the big reasons facts regarding glass manufacturing techniques and production are so scarce has to do with the traditionally secretive way in which glass factories operated; competition forced each glasshouse to try to keep its formulas and innovative methods to itself. As a result, not many written or printed documents have survived.

Most of what is used today to date bottles and related items is based on research that has been conducted within the last one hundred years. Much of the information is based on assumption and logic and at best is general. This is not to say that today's methods of dating bottles are useless but rather that they are crude. Even crude methods, however, are better than no methods at all.

The following charts are offered as a summary of the "facts," presented in the chapters throughout this book, that may be useful in dating bottles. They are the results of the best research currently available. For in-depth discussions of each, the reader should study the appropriate chapters.

Basically the charts concern themselves with two things that help today's collector assign a tentative date to his bottles: (1) manufacturing methods and the periods during which they were employed; and (2) types of bottles, based mostly on what they contained, and the periods during which they were used.

The dates offered *are not* to be considered absolute but do serve as general indications of when specific manufacturing methods were employed and specific types of bottles were used.

DATING CHART

Techniques, Tools, and Tool Marks

	100 B.C.	100 A.D.	1300	1400	1500	1600	1700	1800	1900	1970

Blowpipe

Free-blown bottles

Hand blowing (free-blown and mold-blown bottles)

Automatic glassblowing (Owens machine)

Dip mold

Dip mold in America

Hinged molds (brass)

Hinged molds (iron)

Hinged shoulder-height mold with embossing (side seam disappears at or just above shoulders of bottle)

Full-height post-bottom mold (seam down side and around bottom of bottle)

Full-height bottom-hinged mold (seam across bottom of bottle)

Full-height blow-back mold (seams all the way to the top—with top ground) HAND BLOWN

Plate mold (circles or rectangular seam around embossment)

Full-height three-part mold with dip-mold body (three seams on shoulder of bottle)

Turn mold (lines or grooves around body of bottle)

Full-height cup-bottom mold (seams down side and around outside of base above bottom of bottle)

Full-height blow-back mold (seams all the way to the top) MACHINE BLOWN

Seam around top of bottle

Blowpipe pontil scar (ring-shaped scar on bottom of bottle)

Solid iron bar pontil scar (solid scar on bottom of bottle)

Bare iron pontil scar (reddish-black mark on bottom of bottle)

Bare iron pontil scar (white mark on bottom of bottle)

Snap (no scar on bottom of bottle and sometimes marked on side of body)

Suction machine cut-off scar (large irregular circle on bottom of bottle)

Machine-made valve mark (small circle less than one inch in diameter on bottom)

Laid-on ring(s)

Smooth laid-on ring(s)

Fire polishing

Fire polishing—extremely smooth (glory hole)

Embossments in America

Lipping tools

Decoration

Gilding

Diamond-point engraving rediscovered in the West

Enameling

Engraving

Overlay

Glass cutting

250

DATING CHART

| | 100 A.D. | 1400 | 1600 | 1800 | 1970 |
| | 100 B.C. | 1300 | 1500 | 1700 | 1900 | |

Staining
Etching
Applied color labeling

CLOSURES

Cork in America
Screw lids
Screw lids (period of greatest production)
Inside screw threads
Inside screw threads (period of greatest production)
Gravitating stopper
Codd ("marble") stopper
Lightning stopper
Hutchinson stopper
Baltimore Loop Seal
Paper caps
Crown cork

GLASS COLORS AND STYLES

Manganese as a decolorizing agent
 (sun-colored purple bottles)
Selenium as a decolorizing agent
 (sun-colored light amber bottles)
Arsenic as a decolorizing agent (clear bottles)
Venetian glass from the town of Murano
French glass
English glass
Venetian cristallo glass
Black glass (in America)
Lead glass
Caspar Wistar (glass production)
Henry William Stiegel (glass production and decoration)
Thomas W. Dyott (Dyottville Glass Works)

BOTTLE TYPES

Case gin bottles
Whiskey bottles (pre-Prohibition)
Whiskey bottles (post-Prohibition)
"FEDERAL LAW FORBIDS SALE OR RE-USE OF THIS BOTTLE"
 embossed on whiskey bottles
Beer bottles (pre-Prohibition)
Beer bottles (post-Prohibition)
Decanters (American)
Bar bottles
Chinese snuff bottles (period of greatest production)
Snuff jars (free-blown and mold-blown)
Drugstore bottles (unembossed)

DATING CHART

	100 B.C.	100 A.D.	1300	1400	1500	1600	1700	1800	1900	1970

Drugstore bottles (embossed)

Bitters bottles

Bitters bottles (period of greatest production in America)

Pottery jugs (American)

Pottery beer bottles (in America)

Patent and proprietary medicine bottles

Patent and proprietary medicine bottles (in America)

Pure Food and Drug Law (modified patent and proprietary medicine claims)

Squat wine bottles from England and Holland

Seal bottles (separately applied seals)

Wine bottles (Bordeaux, Burgundy, Rhine-shape)

Soda water bottles

Blob-top soda water bottles

Round-bottom soda water bottles

Demijohns (in America)

Carboys

Historical and pictorial flasks

Figural bottles

Figural candy bottles

Ink bottles of glass (American)

Figural ink bottles (in America)

Poison bottles of unusual shape, color, and embossment

Milk bottles

Barber bottles

Nursing bottles (American)

Chinese pottery and glass bottles (in America)

Mineral water bottles

Perfume bottles

Fruit jars

Witch balls (in America)

Target bottles

Fire grenade bottles

Glass floats (in America)

COLLATERAL ARTICLES

Insulators (threadless)

Insulators (threaded)

Encased postage

Private-die proprietary revenue stamps (Civil War)

Private-die proprietary revenue stamps (Spanish-American War)

Periodical advertising (period of greatest use)

Trade cards (period of greatest use)

Barbed wire (period of greatest production)

51

Cataloguing a Bottle Collection

Recorded information about a collection is valuable whenever the collector needs to recall when, where, how, and for how much a specimen was acquired.

One of the most popular record-keeping devices is the card file. Card catalogues have replaced notebooks and similar record-keeping books because they are easier to keep up to date by adding new cards and discarding old ones. Each card can be numbered according to a corresponding number taped to or marked on a specific bottle. On each card can be recorded such information as type of bottle, date acquired, where acquired, condition of bottle, book reference (if any), cost, value, possible selling price, manufacturing process, shape, color, height, and a sketch, if desired.

Because such things as cost, value, and possible selling price are information of a private nature a collector may wish to use a coding system for these facts. One of the simplest and most effective coding devices is to select any one or two words which contain ten letters, no one of which is a duplicate of another. Starting with zero, assign consecutive numbers through nine to each of the letters in the word or words. Example: QUICK TRADE = 01234 56789. Using the letters corresponding to the numbers any amount of money a bottle would cost, is worth, or would sell for can be written in code, e.g., $16.75 would be UR.AT.

To make the recording of data on a card even easier it is possible to have cards printed with the necessary categories. This leaves the collector only the task of filling in the appropriate blank spaces.

52

Displaying Bottles

To be fully appreciated, a bottle collection must be properly displayed; this is a discovery the collector of bottles quickly makes. In the home the most common method of showing a collection is to place the bottles in rows on a series of shelves. Such a method is an effective way to display a bottle collection—especially if the shelves are in a window which provides natural backlighting for the colorful bottles. The currently popular adjustable shelves offer an opportunity for variations in the distance between shelves, and this variety adds much to a display of bottles. A variety of bottle sizes, shapes, and colors provides much in the way of displaying beauty.

In addition to shelves in windows there are, of course, shelves on walls, which are especially good for showing bottles of ceramic, relatively colorless glass, and extremely dark glass bottles which do not display well with backlighting. Free-standing shelves are nice for both colorful bottles and specimens with embossments on more than one side. Used as room dividers, free-standing shelves are a fine way to present a collection of bottles.

Artificially lighted cabinets are often overlooked as a place to effectively show off a bottle collection. Perhaps the most attractive cabinets are those featuring glass sides and front, so the bottles can be seen from different angles.

Whether displaying in a cabinet or on a free-standing shelf, wall, or window shelves there are several basic points to consider. Small groupings of bottles usually are more attractive than just bottles lined up along a shelf. Grouping by colors, sizes, or shapes adds variety and beauty to a display. A mixture of colors, sizes, or shapes is just as effective as grouping if such a display is not overcrowded.

Displaying parts of a collection throughout the

home in small but tasteful centers of interest provides an excellent opportunity to exhibit co-related items, and can enhance almost any room. Often collectors display bottles specifically related to a room, e.g., medicine bottles in the bathroom, perfume bottles in the bedroom, fruit jars in the kitchen, and so forth. These displays may be located on tables, bookcases, and other pieces of furniture.

One of the most interesting and unusual innovations in displaying in small interest centers is flower arranging with bottles. *Bottle Beauty* by Pauline Rosen is a book devoted to flower arranging with bottles; many collectors have discovered a new dimension in bottle collecting with the aid of this book.

The home is not the only place in which a collector is challenged to show off his bottles to best advantage. The bottle show not only provides him with the opportunity to display for the general public but the opportunity to do it in competition. The same techniques and principles discussed in conjunction with home displaying can be applied to the public display as well. The chief difference is that there is more to consider in a public display than just attractive arrangement. While arrangement is always a prime factor, display category, bottle rarities, educational value, and so forth, are also important.

Since much displaying for the public is restricted to the flat surface of a table, height variations become very important. One of the most effective methods of creating height variety is by placing individual or groups of bottles on blocks or similar objects. Often these blocks, after being placed on the table, are covered with an attractive cloth.

Just as in the home, a small public display is often more effective than an overcrowded grouping of bottles. Many experienced show participants maintain that displays should have a focal point. Such a focus is not restricted to bottles; many winning displays feature an unusual piece of furniture or some co-related item. One cobalt-blue bottle in the midst of a milk glass display is an example of a good focal point. An old kitchen stove surrounded by fruit jars is an example of a piece of furniture serving as the focal point. A mechanical device is often employed to catch attention; a slowly rotating platform upon which a particularly interesting bottle has been placed is an example of this idea.

The ways of display are only limited by the imagination and taste of the displayer; perhaps the best way to build displaying skill is to observe closely both private and public displays and try to imitate and improve upon them.

Bibliography

BOOKS

Rosen, Pauline. *Bottle Beauty*. Placerville, California: Pioneer Press, 1968.

PERIODICALS

"Bottles of Colorful Beauty," *American Home*, LXIV (November, 1961), 32–33.

Rosen, Pauline. "Displaying Your Bottles," *Western Collector*, VI (October, 1968), 42–43.

————. "The Petals of Pauline," *Western Collector*, VII (December, 1969), 568–570.

————. "The Petals of Pauline," *Western Collector*, VIII (January/February, 1970), 14.

————. "The Way to Display," *Western Collector*, VII (March, 1969), 145–146.

Miscellaneous nineteenth-century bottles displayed by Robert Terry at show held by Antique Bottle Collectors of Colorado in 1969.

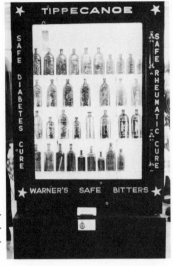

Warner Safe Remedies in simulated safe display by Robert Shipley at show held by Antique Bottle Collectors of Colorado, 1969.

Display of Bardi "Dueling Pistol" (made in Italy), glass covered with simulated leather, gold trim, L. 15 in.

Display of Stiegel bottles at bottle show held by Southern Nevada Antique Bottle Club in 1969.

Display of "dueling pistols," Garnier, Barsottini, and Avon.

Display of violin bottles and banjo bottle (left to right): (1) amber, hand blown, musical notes embossed on reverse, H. 9½ in.; (2) clear, H. 8½ in.; (3) blue, H. 8 in.; (4) amethyst, H. 9¾ in.; (5) cobalt-blue, H. 8 in.; (6) blue, musical notes embossed on reverse, H. 9½ in.

Display of "dueling pistols," all Barsottini (made in Italy), brown, ceramic, plastic coverings, cork stoppers, L. 10½ in.

Bottle display by Mrs. Winnie Morris, Texas Longhorn Bottle Club Show and Sale, Dallas, Texas, August 1969.

Simple floral grouping using pontil scar on base of umbrella ink bottle as focal point. A Jamaica Ginger bottle filled with lilies and foliage completes the arrangement. (*Western Collector,* San Francisco, Cal.) Arrangement by Pauline Rosen; photograph by Malcolm Kurtz.

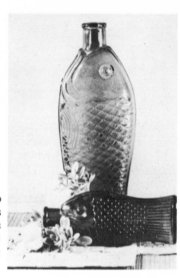

Reflections of the ocean using two cod-liver oil bottles and succulents on two woven mats. (*Western Collector,* San Francisco, Cal.) Arrangement by Pauline Rosen; photograph by Malcolm Kurtz.

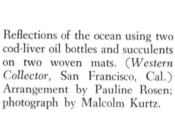

Patio setting, consisting of orange and copper zinnias, coral and yellow red-hot poker blooms with a wicker-covered demijohn, Buffalo Brewing Co. beer bottle, and amber snuff bottle, on a straw placemat. (*Western Collector,* San Francisco, Cal.) Arrangement by Pauline Rosen; photograph by Malcolm Kurtz.

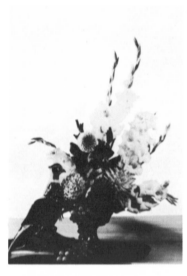

Autumn floral arrangement using Jim Beam pheasant, dahlias and gladioli. (*Western Collector,* San Francisco, Cal.) Arrangement by Pauline Rosen; photograph by Malcolm Kurtz.

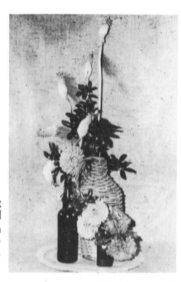

53

Transporting
Bottles

Many collectors have had the unhappy experience of breaking a valued bottle because of improper transporting practices. In the following few paragraphs *some* of the many effective methods of transporting bottles from one place to another will be discussed.

Packing the fragile bottles is the most important point; care in handling properly packed bottles is a necessity and needs no discussing. Probably the most common packing material is newspaper. Whether packing bottles in bags or boxes newspapers are an excellent material to use. Best results are obtained by taking individual sheets of the paper and wadding them up and surrounding the bottles with them.

Another packing material that is effective is popped corn. This processed corn is easy to use and when completely surrounding a bottle it affords excellent protection.

Socks are effective insulators. Many collectors save their wornout socks for use in this way. The average sock will easily stretch to accommodate most bottles.

Cardboard boxes are the most popular containers in which to transport bottles. Most grocery and liquor stores will provide the collector with these free of charge. Many of the readily available boxes come with separations that aid in the packing of bottles, but if these are not available, separations can be made from cardboard milk cartons; these fit nicely into the average cardboard box.

The cardboard box used with any of the packing materials discussed will give the collector the needed protection against breakage while bottles are being transported. No doubt each collector will experiment and find the methods most suitable for his particular situation.

54

What Else to Do with Bottles

Bottles that are damaged, broken, or otherwise of no value from a collecting standpoint can be used as the focus for a variety of arts and crafts.

Quite frequently when collectors acquire their bottles by excavating the trash heaps of the past they find broken bottles. Some collectors gather the more unusual and colorful pieces of bottles and make various useful articles from them. One such idea is to take a relatively valueless common bottle and cover it with a slow-drying putty. Into the putty broken parts of other bottles can be pressed until the bottle is completely covered. The bottle makes an attractive decanter. Another similar project involving broken parts of bottles is to make a lamp of the colorful pieces. One of the simplest ways of doing this is to place the broken pieces in three or more panels of properly prepared casting resin. Once the panels of resin embedded with bits of broken bottles have dried they can be fashioned into a variety of lamps.

Sometimes basic bottle shapes can be seen to resemble a variety of things. It is often fun, with the aid of papier-mâché, to actually try to create the object imagined. An example is a bottle that is larger at the shoulders than at the base. Such a bottle bears a resemblance to a soldier. A collector could add a ball of clay in the shape of a head to the top of the bottle and cover the entire structure with papier-mâché. After sanding the dried papier-mâché and appropriately painting it, a very realistic figurine of a soldier can be obtained. The number of things that can be made with the aid of papier-mâché in this way are almost countless.

Many collectors feel badly about leaving damaged bottles in the dumps. They carry them home and turn them into a variety of useful objects. Probably the most popular are glasses. Bottles with damaged necks and the like can very successfully be made into attractive drinking glasses. The cutting of glass to make things has been made relatively simple with the recent marketing of inexpensive tungsten carbide blades that fit a standard hacksaw. Another method of cutting glass is to scribe the glass with a common window glass cutter and then place a small wire around the scribed line; the wire is then attached to a small electric train transformer. When the transformer is turned on the wire becomes quite hot and neatly breaks the glass as scribed. Bottles thus cut generally need polishing to smooth the sharp edges. Appropriate grinding wheels may be obtained from lapidary shops. Because of the nature of the cutting processes there is a certain amount of danger involved in glass cutting. A collector wishing to try it should make sure that he knows exactly what he is doing before he attempts to cut glass.

Another interesting activity involves the use of a ceramic kiln or furnace. Bottles or pieces of bottles can be readily melted in a kiln. Such melted bottles make unusual, beautiful, and useful items. Perhaps the easiest and most popular of such items are ash trays. By placing a bottle on its side in a kiln and heating the kiln the bottle will collapse and form an attractive ash tray. Depending upon the temperature the bottle will melt into the desired shape in a matter of minutes to over an hour. The trick to successfully melting a bottle is to turn off the kiln just before the bottle has reached the desired shape. To prevent the heated bottle from exploding it should be allowed to cool slowly in the turned-off kiln for at least twenty-four hours.

Another interesting project involving the use of a bottle is a terrarium—a garden in a bottle. Generally a clear glass, aqua, or light green bottle is selected for maximum visibility. The basic principles of this type of gardening are conservation of moisture, protection against sudden changes in temperature, and provision for light. To establish a garden in a bottle, clean gravel should first be placed in the container; to this an inch or two of sand should be added; and then finally soil should be added. The tedious part is placing the plants in the bottle—this is accomplished with the aid of two long sticks or wires. The plants used in a terrarium should be slow growing and of similar types. After the garden is established, it requires little care.

There are, of course, many more things that can be done with bottles. The ideas presented are only some of the more obvious ones; the collector can, no doubt, think of many other entirely differ-

ent approaches or modifications of those presented here.

Bibliography

PERIODICALS

Aably, P. "Bottle Dolls," *School Arts,* LII (February, 1953), 197.

Asher, Shirley. "Latest Glass Cutting Methods Evaluated," *Old Bottle Exchange,* I (April, 1968), 29–32.

Beard, A. B. "Bottle Dolls," *St. Nickolas,* XXXIV (October, 1907), 1122–1126.

"Curious Bottles Made by a Convict," *Scientific American,* LXXX (March 11, 1899), 155.

"Cutting Bottles by Electrical Wire," *Popular Mechanics,* LVII (February, 1932), 303.

Gari, R. "Things One Can Make from the Humble Bottle," *School Arts,* XXV (October, 1925), 109–111.

Heydorf, H. R. "Novelties from Old Bottles," *Popular Science,* CXXIX (July, 1936), 78.

"Industry Built on New Uses for Old Bottles," *Popular Mechanics,* LX (November, 1933), 703.

"J. W. Hope Builds a Bottle House," *Rotarian,* LIX (November, 1941), 61.

Kenah, E. F., "Bottle Your Garden," *American Home,* XXXV (March, 1946), 84–86.

"Look What They Did with a Bottle," *Popular Science,* CLX (February, 1952), 186–187.

Munsey, Cecil. "Mini-Garden in a Bottle," *Western Collector,* VI (November, 1968), 41–42.

Palmer, F. N. "Hobby Hitching Post: Transforming Glass Bottles," *Rotarian,* LXXXVII (November, 1955), 66–67.

Rice, C. M. "How to Make Lighting Fixtures from Bottles," *Industrial Arts Magazine,* XVII (September, 1928), 332.

Richards, M. C. "Bottle Gardens of Sari Dienes," *Craft Horizons,* XXII (September, 1962), 24–25.

Strand, H. P. "Electrically Cut Bottles Form Unusual Containers," *Popular Science,* CXLVI (February, 1945), 202–203.

Truebig, J. N. "Making People Out of Bottles," *School Arts,* LVIII (January, 1959), 23–24.

Wieda, A. "Decanters Made from Bottles," *Industrial Arts and Vocational Education,* XXXVIII (October, 1949), 327.

Williams, B. E. "What's in a Bottle? Bead Bottles," *Hobbies,* L (July, 1945), 117.

Contemporary whiskey bottle covered with parts of broken antique bottles embedded in putty.

Lamp made with pieces of broken bottles embedded in plastic.

Bottle covered with papier-mâché to represent a soldier.

Bottle covered with papier-mâché to represent a fish.

Ashtray made from melted beer bottle.

Drinking glass made from whiskey bottle.

Bud vase made from stretched amber screw-top medicine bottle, 1969.

Terrarium two days after initial planting.

Terrarium two months after initial planting.

Partially melted glass bottle.

55

The Bottle Club

Part of the fun involved in collecting anything is being able to communicate and socialize with others of similar interests. One of the best means of talking with other collectors is at club meetings.

Forming a Bottle Club

When several bottle collectors discover their shared enthusiasm for collecting, the idea of forming a club is usually discussed.

Communicating with other interested collectors in the area is usually the first step in forming the desired organization. To locate unknown collectors who might be interested in forming a club an advertisement in the local newspapers is very effective. Such an advertisement should include a brief description of the purpose, date, time, and location of the initial meeting.

At the first gathering elect a temporary chairman and secretary. Led by the chairman establish the following three committees: (1) A committee to locate a monthly meeting place if the size of the group warrants it; if it does not, then this committee can schedule future meetings in the homes of the members. If and when a special meeting place is needed, schools, libraries, community centers, banks, savings and loan associations, and other firms generally offer the use of their facilities at little or no cost. (2) Another committee can discuss the type of activities desired at future meetings. Some of the most popular types of meeting activities include speakers, discussions, displays, club digs, picnics, dinner meetings, pot luck dinners, open house tours, demonstrations, slide lectures, films, skits, drawings, sales, and field trips. (3) The third committee should draw up club bylaws; these are the rules by which an organization can operate most efficiently and effectively. A good set of bylaws will include the name of the club, the purpose, type of membership (open or closed), a listing of the officers (usually a president, vice-president, secretary, treasurer, and a board of directors), details concerning the elec-

tion of officers (including the directors, who are not technically officers), duties of the officers (explained specifically), meeting dates (usually once a month), dues, committees, and a set of rules for amending the bylaws as needs arise.

At subsequent meetings the proposed bylaws can be presented, changed if not satisfactory, and then adopted. After the bylaws have become the official rules by which the group has agreed to operate, the permanent officers should be elected.

An active and growing club will soon feel the need to reduce the amount of time-consuming business discussed at the general meeting. This can be done effectively by arranging to hold a separate business meeting of the officers and directors. Two weeks before the regular monthly meeting is probably the best time for such a meeting. These meetings provide the opportunity to conduct much of the routine business of the club so that the general meeting can be reserved for the more enjoyable activities.

One of the important aspects of a hobby, and a goal of almost all serious collectors, is to learn more about the items they collect. Most realize that knowledge not only enhances the pleasure of collecting but also gives the collector an effective collecting tool. In addition to informative club activities, reading the literature related to bottle collecting is an excellent means of acquiring knowledge. A club will, therefore, wish to form a library. The group should select a librarian and allot regular amounts of money to him for the purchase of books and magazine subscriptions. Some books and magazines may be donated by members, authors, and publishers. Books in a club library are usually loaned to members on a one-month basis.

Every successful club needs funds for such things as rent, newsletter publication, library purchases, and other items necessary to running the organization. There are numerous ways in which a club can raise money to meet these financial obliga-

tions. Some of them include annual dues, sales, auctions, and selling club-related items such as badges. The important things to remember regarding fund raising are: (1) Select fund-raising projects that will benefit club members first and make money for the club second. (2) Keep fund-raising programs to a minimum necessary to insure normal growth; it is of little value for a club to have a big bank account unless the savings are being held for some specific reason.

Publishing the Club Newsletter

It is usually only several months after a club is formed that there is felt the need for a newsletter; the larger the club the greater the need. The newsletter is needed to disseminate information such as meeting date, time, location, special events, and so forth. Usually a club just starting a newsletter will restrict itself to fulfilling these basic needs. As the club grows, however, it will want to, and be able to afford to, expand its coverage to include items of interest to as many of its members as possible. This expansion should be a slow, well-thought-out process; care should be exercised in selecting items to add. Items of general interest should be given first priority, i.e., lists of new members and changes of address, upcoming shows and sales, current listings from the club library, a list of the latest periodical literature available, etc. As the club grows it will want to include articles on specific bottles, companies, etc. A question and answer column might be added next, followed by a miscellaneous selection of information from the bottle collecting community including, perhaps, interesting letters to the editor.

When a club decides that it is ready and can support a newsletter the question of an editor always arises. In some clubs there will be several who are willing to do the job while in others no one will be willing to undertake the responsibility —the latter is, of course, unusual. The people responsible for making the selection of an editor

(usually the club officers) should be very careful and consider several things before they make a choice: Is he responsible? Does he have the time? Does he have the enthusiasm? Most important of all, however, does he have an axe to grind? A club must be very careful that the editor they choose does not use the newsletter for his own purposes. It is every club's responsibility to make the editor aware that, unlike a newspaper, a newsletter does not usually have an editorial policy. Any club that fails to make this clear to their editor will, undoubtedly, run into trouble ranging from complaints to lawsuits.

The actual production of the club newsletter is very important, probably the one area most overlooked. Every newsletter should be typed. Selecting a name for the publication is another important consideration (the trend has been toward using bottle collecting jargon in the title.) A masthead should be designed and should include the newsletter's title, volume and issue number, name and address of the club, dues, and names and addresses of the officers. The use of columns should be considered; shorter lines are easier to read. Pages should be single spaced with double or triple spaces between articles. Each page should have the name of the publication, the issue date, and, of course, the page number. Standardization of these features is important; each club should develop a format for the editor to follow. Certain features should appear in relatively the same section of the newsletter each month. Further, each item of production should be accomplished in a consistent manner from month to month.

Printing is very important. The two most popular and least expensive methods will be discussed here. Ditto or spirit duplicating is very popular because it is fairly easy to accomplish. Spirit duplicating machines are relatively inexpensive, costing generally less than a hundred dollars. Ditto masters come in a variety of colors but purple is usually selected because it prints more readable copies. (With this process a clever person can print in several colors.) The one serious drawback in this process is that it is limited to about two hundred readable copies under ideal conditions. Mimeographing is the other popular process of newsletter reproduction. A mimeograph machine is more expensive than a ditto machine and more messy since actual ink is used. But it does have the advantage of being able to produce copies by the thousands. Only one color may be used at a time. Usually black is selected because of the trouble involved in changing ink color on the machine. With both of the processes discussed, it is difficult but possible for pages to be printed on both sides of good-quality paper.

Assembling the finished newsletter is worthy of consideration here. It is always disappointing to see an otherwise excellent newsletter ruined by the way it is assembled. Pages should be in order and neatly gathered. Stapling seems to present the biggest difficulty. One staple in the upper left-hand corner is probably sufficient. Use of this technique allows the reader to read the newsletter as he would a letter. Staples down the side or across the top are superfluous and make reading a chore when going from one page to the next.

Preparing the newsletter for mailing can be accomplished in several ways. Some clubs have found it practical to include in the assembling process a cover sheet upon which the addresses and postage can be placed. This is not necessary, however. Costs may be reduced by leaving space on the reverse of the last page of these mailing essentials. The finished newsletter is usually folded from top to bottom. The two most popular methods of sealing the folded newsletter are stapling and using transparent tape; both methods are equally effective. Addressing the finished newsletter can be done in any one of several ways. One method (and the least expensive but most time-consuming) is to address by hand. Another method is to type labels; the expense involved is

not great. With carbon paper a several months' supply of labels can be typed at one time. Still another method is to type the mailing list on a ditto or stencil and reproduce it on sheets of gummed paper available at any printing shop. The printed sheets are then cut into individual labels.

There are several methods of mailing available to clubs. The Post Office Department has provisions for second class bulk mailing but few clubs are large enough to take advantage of this. Most clubs will have to decide between mailing their newsletter first class or third class. There are advantages and disadvantages to both methods. First class costs more than third class, but undeliverable first class mail is forwarded if possible or returned. Undeliverable third class mail is discarded, unless the sender has indicated he will pay for its return by marking the piece with "RETURN POSTAGE GUARANTEED." Having undeliverable newsletters returned has one distinct advantage: Mail returned by third class has the addressee's forwarding address on it; a mailing list can be kept current with this information.

The Bottle Show

Eventually almost every well-established club will entertain the thought of having a public display of their collections. A bottle show is a big undertaking and certain things should be considered before the attempt is made. For example: (1) Does the club have enough collections? (2) Can the group afford the expense of staging a show? (3) Is the club in a location that would be conducive to a successful show? (4) Will the general public and the collecting public support the show?

By definition a show is an exhibition but in bottle collecting the term "show" has come to include other things. Each group must decide what type of show it desires. Some shows include a sale, some an educational program, and some a social activity such as a dinner. One, a combination, or all of the above are possible.

A club contemplating a bottle show should plan far ahead. The most important person is the show chairman. The group should select their show chairman carefully with an eye toward one who can lead. The successful chairman must realize his is a job of coordination and delegation of the work involved.

The group must select a date that does not conflict with other shows geographically close enough for it to matter. The location, too, is important; a club should select the best place they can afford that is easily accessible to those who will attend.

After the decision to have a show, the type, date, location, and selection of a chairman, the next step should be the selection of the chairman's assistants:

1. **Display chairman:** This person must plan the display area. He must take care of the rental of tables and display cases. Reservations must be taken and confirmations made as well.

2. **Sales chairman:** The responsibilities of this job are almost identical to those of the display chairman, but the sales chairman also collects fees paid by the partcipating sellers. Such fees could be a percentage of sales, a set fee for a specified amount of space, or a combination of both—this is for each club to decide.

3. **Program chairman:** This assignment includes deciding on the type of program and locating the participants. This person must also plan the scheduling.

4. **Publicity chairman:** This job includes not only making the public aware of the forthcoming event but supervising the printing of posters and other advertising materials. Posters, giveaway cards, and all other forms of advertising should include such information as type of show, date, time, location, sponsoring organization, and an information address. A good publicity chairman will see to it that the show is as widely advertised as possible in trade journals, magazines, newspapers, and on radio and television.

5. Raffle and door prize chairman: He must locate the bottles to be given away and arrange for tickets.

6. Awards chairman: This assistant arranges for the awards to be purchased and obtains suitable judges. He must also see to it that all involved are aware of the rules for displaying that have been selected by the club.

7. Security chairman: This job consists of planning the security for display and sales areas. Twenty-four-hour protection is a necessity. Depending upon the availability of funds, professional guards can be employed, or arrangements made to have a crew of members provide the necessary protection.

8. Hospitality chairman: This responsibility includes arranging for the greeting and registration of guests as they arrive, selling of tickets if an admission charge is levied, passing out literature, enrolling of new members, and accomplishing the many tasks that are best taken care of at the entrance to the show.

9. Refreshments chairman: This person is responsible for the planning and supervising of the selling of refreshments during the show.

10. Building chairman: This job consists of organizing volunteer members into a team whose responsibility it is to arrange chairs, tables, display cases, and other portable items.

After making all the preliminary decisions and delegating the workload the next steps are based mostly on teamwork. The general chairman should meet periodically with all of his assistants and attempt to tie all of their efforts together. As a team they should report on their progress to the membership of the club at the regular monthly meetings.

Whether large or small, limited or extensive, the club and its activities are the backbone of bottle collecting.

Bibliography

PERIODICALS

Munsey, Cecil. "The Antique Bottle Show," *The Old Bottle Exchange,* I (April, 1968), 22–26.

———. "How to Publish a Bottle Club Newsletter," *The Old Bottle Exchange,* I (March, 1968), 14–18.

———. "How to Start and Operate a Bottle Club," *The Old Bottle Exchange,* I (February, 1968), 22–25.

PART VIII

Collateral Articles

56

Advertisements
and Advertising Items

The collector of bottles very seldom limits his collection to just bottles; items related to the bottles he collects are often included. Since most bottles contained a commercial product of some kind it is not surprising to find a great variety of advertisements and advertising items that are directly related to these bottles.

In America, the first major group of advertising forms were signboards, tavern signs, notices, and the like. Newspaper and periodical advertisements became a popular means of promoting bottled products and other items during the eighteenth century. Other important methods of advertising included invoices, bills of lading, handbills, broadsides, leaflets, tickets of admission, posters, trade cards, and encased postage stamp coins. For the collector of bottles the latter two items are among the most important, and separate chapters have been devoted to them (see chapters 57 and 59). Still other interesting advertising items (mostly of the nineteenth and twentieth centuries) include glasses, mugs, knives, bottle openers and corkscrews, serving trays, pitchers, coffee pots, plates, bowls, tokens, almanacs, and a host of other items.

The vast majority of collectible advertisements and advertising items go back not much further than the 1870s. It was during this period that the mass media gave birth to modern advertising as we know it today. Until the 1870s any form of advertising was considered an effective method of promoting a product, but after this period, manufacturers came to realize that periodical advertising was their most powerful promotional tool. Advertising from the late 1800s to the present time is a complete study in itself. One of the best books available on the subject, which traces the development of the modern advertising industry in great detail through its formative years, is *They Laughed When I Sat Down* by Frank Rowsome, Jr.

By 1900 few publications could survive financially without paid advertising. This means that there are many early advertisements extant today for the collector to acquire.

Perhaps the most famous of the early advertising geniuses was Phineas Taylor Barnum. P. T. Barnum's promotions are, by now, legendary and too lengthy to include here. Let it suffice to say that his unique promotional methods set examples that were followed for many years and in some cases are still imitated today. (It is interesting to note that one of Barnum's few promotional failures was in marketing a grease to grow hair on bald heads.)

The phenomenal development of advertising during the last half of the nineteenth century can almost exclusively be attributed to the patent and proprietary medicine industry (see Chapter 15). In the decades following the Civil War this industry, through advertising, was the principal support of most magazines and newspapers. It is almost impossible to imagine the different ways in which the medicine business promoted its products. In the two decades from 1870 to 1890 there was produced by the various medicine companies at least *one* advertising almanac for every *two* Americans. *Hostetter's Illustrated U. S. Almanacs* were printed in seventeen languages—fifteen million copies were produced in one year. J. C. Ayer in one year printed twenty-five million almanacs in twenty-one languages. Dr. R. V. Pierce's book, *The People's Common Sense Medical Adviser,* a book with over a thousand pages, was reprinted sixty-six times in thirty years. One pill was advertised in the same issue of a newspaper thirty-seven times. Over forty million dollars was spent to advertise Lydia E. Pinkham's Vegetable Compound.

Patent and proprietary medicine vendors went to remarkable lengths to advertise their nostrums. P. H. Drake chopped down an entire mountainside so that he could advertise his Plantation Bitters to passengers of the Pennsylvania Railroad in letters four hundred feet tall. Another medicine

vendor purchased a Mississippi stern-wheeler and painted his product's name on the side in letters so large (twelve feet tall) they could be seen for three miles. Still another medicine manufacturer bought a steamship, painted advertisements for his product on it, and let it float dangerously near Niagara Falls as a promotional stunt.

Of a less spectacular but more collectible nature are the many items either given away free or sold for nominal amounts of money by firms selling products that were packaged in bottles. These items themselves were not necessarily directly related to the product being promoted but more often than not carried an advertising message of some kind. These miscellaneous advertising items, often called advertiques, were generally useful in nature and were saved as a result.

As time passes, the less durable advertisements and advertising items of the late nineteenth and early twentieth centuries are becoming harder to obtain. This fact, coupled with the growing interest by bottle collectors to include such articles in their collections, is raising prices. Still, it is possible to obtain very desirable items for a few dollars; yet it is not unusual for some of the rarer items to sell for well over $100.

Bibliography

BOOKS

Freeman, Larry. *Victorian Posters.* Watkins Glen, New York: American Life Foundation, 1969.

Hornung, Clarence P. *Handbook of Early Advertising Art.* New York: Dover Publications, Inc., 1956.

Mayborn, Curtis, compiler. *Those Wonderful Old Advertisements.* Dallas, Texas: Highlands Historical Press, Inc., no date.

Munsey, Cecil. *Would You Believe.* San Diego, California: I.P.S., a division of Neyenesch Printers, Inc., 1968.

Penland, Bell. *Bottles, Corks and Cures.* Virgilia, California: Belee Corp., 1963.

Rowsome, Frank, Jr. *They Laughed When I Sat Down.* New York: McGraw-Hill Book Co., 1959.

Sutphen, Dick. *The Mad Old Ads.* New York: McGraw-Hill Book Co., 1966.

Watkins, Julian Lewis. *The 100 Greatest Advertisements.* New York: Moore Publishing Co., 1949.

PERIODICALS

Gaylord, Bill. "Advertiques I: A Look into Mirrors," *Western Collector,* VI (March, 1968), 16–21.

———. "Advertiques II: Glasses—Name Your Poison!" *Western Collector,* VI (May, 1968), 20–24.

———. "Advertiques III: Beer Trays," *Western Collector,* VI (July, 1968), 23–27.

———. "Advertiques IV: Tokens for the Trader," *Western Collector,* VI (September, 1968), 16–20.

———. "Advertiques V: Tobacco Tins," *Western Collector,* VI (November, 1968), 7–10.

———. "Advertiques VI: Trivia," *Western Collector,* VII (January, 1969), 17–20.

———. "Advertiques VII: Showcases," *Western Collector,* VII (April, 1968), 170–173.

———. "Advertiques VIII: Ceramic and Pressed Glass Advertiques," *Western Collector,* VII (June, 1969), 255–258.

———. "Advertiques IX: Stationery Items," *Western Collector,* VII (August, 1969), 354–357.

———. "Advertiques X: Opener Advertiques," *Western Collector,* VII (October, 1969), 454–458.

———. "Advertiques XI: Fun and Games," *Western Collector,* VII (December, 1969), 546–550.

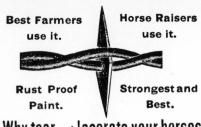

Best Farmers use it. Horse Raisers use it.

Rust Proof Paint. Strongest and Best.

Why tear and lacerate your horses

by using **barbarous** Barb Wire? when you can get the **Kelly Improved Yielding Barb** almost as cheap. A pound will stretch **one-sixth farther** than any other in building your fence. **ABSOLUTE SAFETY** is guaranteed for your horses. Send direct to the manufacturer for it. Address

KELLY BARB WIRE CO.

228 LAKE ST., CHICAGO.

Advertisement for Kelly barbed wire.

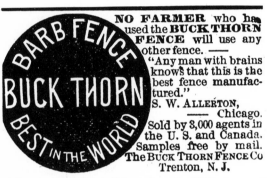

NO FARMER who has used the **BUCK THORN FENCE** will use any other fence. —— "Any man with brains knows that this is the best fence manufactured." S. W. ALLERTON, —— Chicago. Sold by 3,000 agents in the U. S. and Canada. Samples free by mail. The BUCK THORN FENCE CO Trenton, N. J.

Advertisement from November 1, 1887, issue of *Farm and Home* magazine, for Buck Thorn barbed wire.

It CURES THE HURT

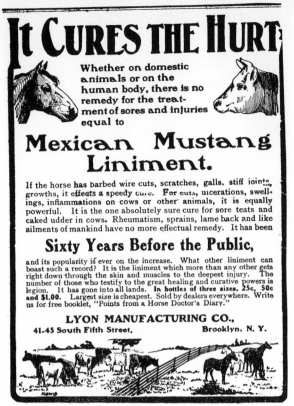

Whether on domestic animals or on the human body, there is no remedy for the treatment of sores and injuries equal to

Mexican Mustang Liniment.

If the horse has barbed wire cuts, scratches, galls, stiff joints, growths, it effects a speedy cure. For cuts, ulcerations, swellings, inflammations on cows or other animals, it is equally powerful. It is the one absolutely sure cure for sore teats and caked udder in cows. Rheumatism, sprains, lame back and like ailments of mankind have no more effectual remedy. It has been

Sixty Years Before the Public,

and its popularity is ever on the increase. What other liniment can boast such a record? It is the liniment which more than any other gets right down through the skin and muscles to the deepest injury. The number of those who testify to the great healing and curative powers is legion. It has gone into all lands. **In bottles of three sizes, 25c, 50c and $1.00.** Largest size is cheapest. Sold by dealers everywhere. Write us for free booklet, "Points from a Horse Doctor's Diary."

LYON MANUFACTURING CO.,

841-45 South Fifth Street, Brooklyn, N. Y.

Advertisement from a 1903 issue of *Hoard's Dairyman* for Mexican Mustang Liniment.

Early 1900s periodical advertisement for Coca-Cola (note detachable coupon at bottom).

Early 1900s beer bottle, tray, and mug from San Diego Brewing Co. (Bruce C. Aschenbrenner, San Diego, Cal.)

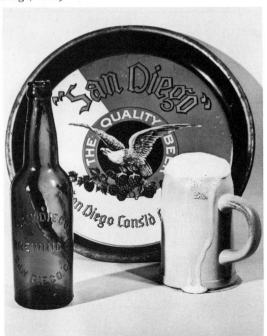

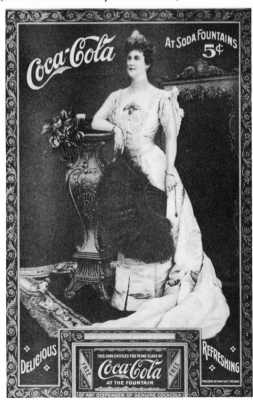

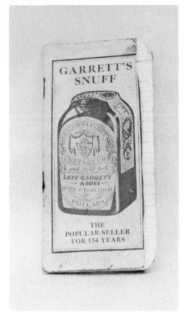

"World's Smallest" almanac (1¼ in. x 2 in.) issued in 1896 by the Piso Company of Warren, Pennsylvania, makers of Piso's Cure for Consumption and Piso's Remedy for Catarrh.

Note pad advertising Garrett's Snuff, c. 1910.

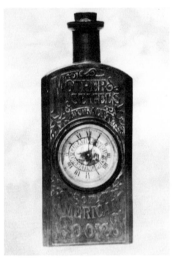
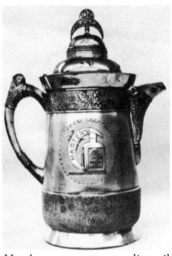

Early nineteenth century advertisement for tobacco and snuff.

Late nineteenth-century metal replica of proprietary medicine bottle with clock embedded in body of bottle, H. 7 in., probably English.

Hot beverage server, sterling silver, insulated, distributed as an advertising item by the manufacturers of Harter's Wild Cherry Bitters, c. 1880–1900.

Sword-shaped bottle opener advertising Coca-Cola, c. 1925.

Pocket knife advertising Coca-Cola, c. 1930.

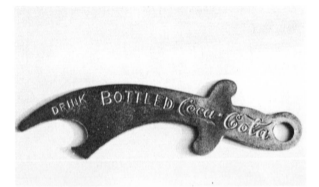

270

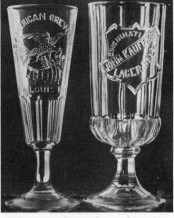

Midwestern beer glasses featuring embossments advertising breweries, c. 1900–1920.

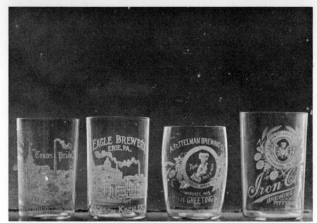

Four beer glasses etched with advertisements for breweries, c. 1900–1920.

Poster advertising White Horse whiskey, c. 1900. (John C. Fountain, Amador City, Cal.)

Poster advertising Kessler's whiskey, c. 1880. (John C. Fountain, Amador City, Cal.)

Poster advertising Carroll rye and P. Morville's AAA whiskey, c. 1890. (John C. Fountain, Amador City, Cal.)

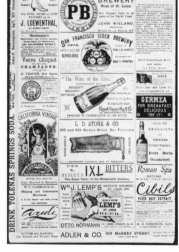

Page from a late 1800s San Francisco city directory advertising various bottled and other prod-

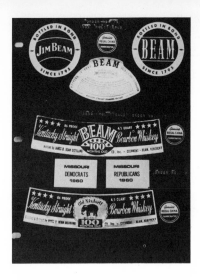

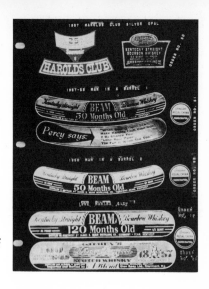

Pages from an album containing a collection of labels from Jim Beam whiskey bottles.

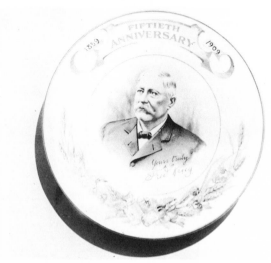

Obverse of plate commemorating the fiftieth anniversary of Fred Krug Brewing Co., 1909.

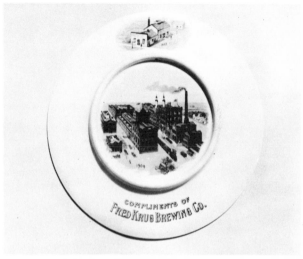

Reverse of plate commemorating the fiftieth anniversary of Fred Krug Brewing Co., 1909.

Booklet distributed by the Mellin's Food Company on baby care, c. 1890.

Calendar issued by B. Brandreth & Sons, Sing Sing, N.Y., makers of Allcock's Porous Plasters and Brandreth Pills, 1886.

Labels used on patent and proprietary medicine bottles between 1883 and 1898; and after 1900. These labels do not resemble the original private-die proprietary revenue stamps used by the companies represented.

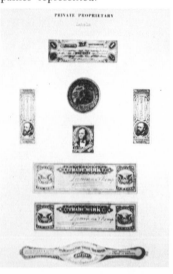

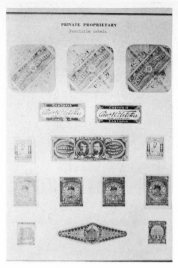

Facsimile labels (labels used on patent and proprietary medicine bottles between 1883 and 1898; and after 1900). These labels resemble the original private-die proprietary revenue stamps used by the companies represented.

Miscellaneous selection of almanacs typical of those given away by many patent and proprietary medicine companies during the last half of the nineteenth century.

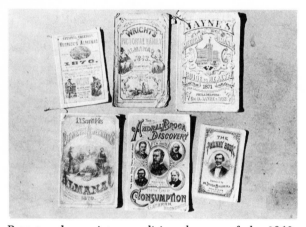

Patent and proprietary medicine almanacs of the 1860–1870 period.

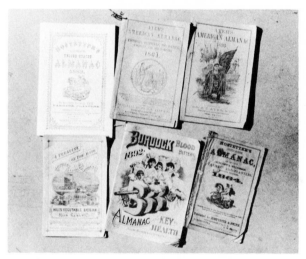

Miscellaneous selection of almanacs typical of those given away by many patent and proprietary medicine companies during the last half of the nineteenth century.

Three almanacs typical of the early 1860s.

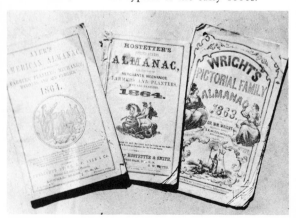

Advertisement (enlarged) for candy-filled figural bottles (toys) from Montgomery Ward and Company. Fall–Winter 1930–1931 catalogue.

Advertisement (enlarged) for candy-filled figural bottles (toys) from Sears, Roebuck and Company. Fall–Winter 1928–1929 catalogue.

Tatter, distributed by the Lydia E. Pinkham Co., 3 in. x ¾ in., c. 1890–1910.

Reverse side of tatter bears picture of Lydia E. Pinkham.

Table plate distributed by the Moxie beverage company, approximately 9½ in. in diameter, c. 1920.

Assorted tableware distributed by the Moxie beverage company (left to right): (1) cup and saucer, H. 2½ in.; (2) sugar bowl, H. 3½ in.; (3) creamer, H. 4¼ in.; (4) plate, H. 6¼ in.; c. 1920.

Periodical advertisement for Hires Rootbeer, c. 1895.

Selection of labels used on Hires Root Beer bottles throughout the years. (*Soft Drinks* magazine, New York—formerly the *National Bottlers' Gazette*)

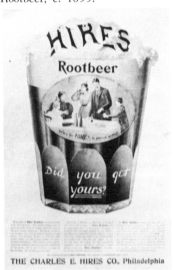

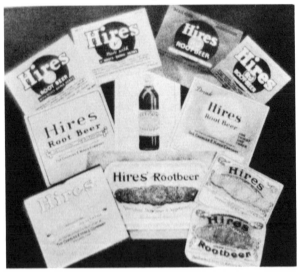

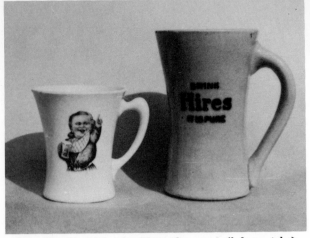

Mugs distributed by the Hires Company (left to right): (1) ceramic, white, hand-painted picture of a chubby-faced child holding a similar mug, H. 4 in.; (2) ceramic, tan, stenciled "Drink Hires, It Is Pure" on side, H. 6⅛ in., c. 1890–1920.

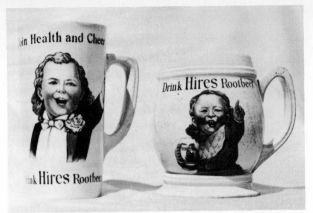

Mugs distributed by the Hires Company (left to right): (1) ceramic, white, hand-painted picture of a child holding a similar mug in left hand, lettered "Join Health and Cheer Drink Hires Root Beer," H. approx. 6 in.; (2) ceramic, white, hand-painted picture of a chubby-faced child holding a similar mug in right hand and lettered "Drink Hires Root Beer," H. approx. 4 in., c. 1890–1920.

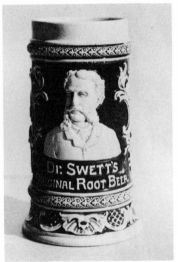

Dr. Swett's Original Root Beer mug, H. 6 in., c. 1900.

Card advertising the Seven Sutherland Sisters as singers and musicians. This card dates to about 1880; several years before the group began selling hair grower and related products.

Glass paperweight advertising Fleming's Old Export Whiskey, length 4 in., c. 1890–1910.

Miniature milk bottles given away by dairies as advertising items, c. 1950.

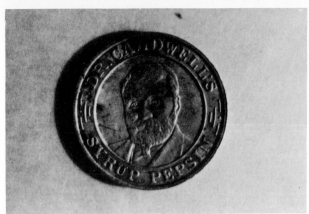

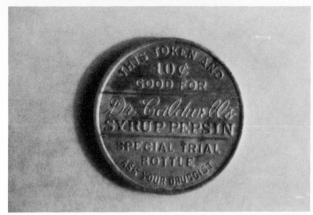

Trade token, embossed "DR. CALDWELL'S SYRUP PEPSIN" on one side and "THIS TOKEN AND 10¢ GOOD FOR DR. CALDWELL'S SYRUP PEPSIN SPECIAL TRIAL BOTTLE, ASK YOUR DRUGGIST" on other side, c. 1860–1870.

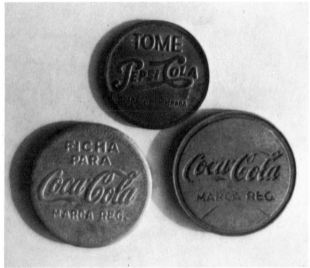

Miscellaneous trade tokens.

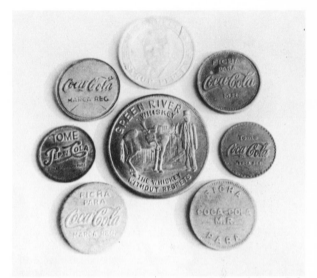

Trade tokens distributed by the Pepsi Cola and Coca-Cola Bottling Companies for one free drink of soda, c. 1930.

Letterhead from Rumford Chemical Works, Providence, R.I., 1870; lists articles manufactured by the firm.

Receipt from Altschul Distilling Co., Springfield, Ohio, 1900.

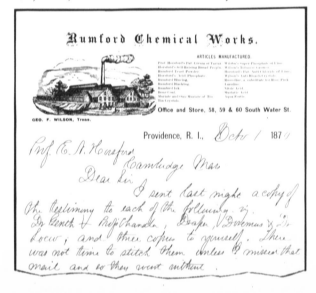

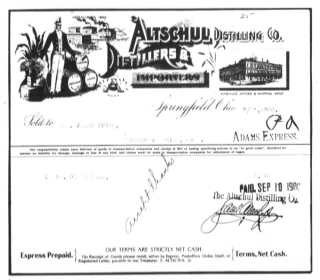

276

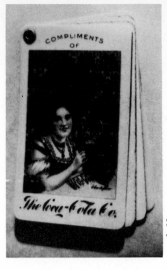

Scorecard, distributed by the Coca-Cola Bottling Co.; reverse side shows the number of gallons of Coke sold in 1901, 2½ in. x 1½ in., 1902.

Pocket mirrors distributed by the Coca-Cola Bottling Co., 3 in. x 1¾ in., c. 1900–1920. (Bruce C. Aschenbrenner, San Diego, Cal.)

Bottle opener, H. 3¼ in. Given away free to customers as an advertising item, c. 1900.

Corkscrew, folds down into metal container in the shape of a bottle, L. 2¾ in., with 2⅛ in. corkscrew, c. 1910.

SEVEN SUTHERLAND SISTERS'

Hair Grower
AND
Scalp Cleaner

Always have been, are today, and will continue to be perfect preparations for the production and maintenance of bountiful, soft, lustrous hair. Being sold by over 28,000 dealers should be evidence of their popularity and merit.

Ladies should always remember—

"It's the Hair—not the Hat"

That makes a woman attractive

Late nineteenth-century proprietary medicine advertisement.

Sutherland Family
—OF—
SEVEN SISTERS.

SARAH SUTHERLAND, Hair 3 feet long.
VICTORIA " " 7 "
ISABELLA " " 6 "
GRACE " " 5 "
NAOMI " " 5$\frac{1}{2}$ "
DORA " " 4$\frac{1}{2}$ "
MARY " " 6 "

H. Bailey, Manager

Sutherland Sisters' Hair-Grower.

Will Grow Hair; will stop Hair falling out; will cure Dandruff, &c.

Sutherland Sisters' Head & Scalp-Cleaner.

THEIR OWN PREPARATIONS.

For Sale by Sutherland Sisters, and all Druggists.

Address all orders to Sutherland Sisters,

LOCKPORT, N. Y.

CINCINNATI, O., March 2nd, 1884.

Having made a chemical analysis of the Hair-Grower prepared by the Seven Long-haired Sisters, I hereby certify that I found it free from all injurious substances, being entirely composed of Vegetable preparations. It is beyond question the best preparation for the Hair ever made—and I cheerfully indorse it.

J. B. DUFF, M. D., Chemist
Late Vice-President Louisiana College of Pharmacy and Medicine.

Reverse of trade card advertising a proprietary medicine, c. 1885.

278

Booklet entitled *Prize Animals and Their Records* produced by the Perry Davis & Sons Company of Providence, Rhode Island, in 1890. This 4 in. x 3 in. publication contains much information about prize animals and an abundance of advertising for Perry Davis' Pain Killer.

Bookmark distributed by E. W. Hoyt and Company of Lowell, Massachusetts, manufacturers of Hoyt's German Cologne. H. 4½ in., c. 1890.

Miniature beer bottle (salt shaker) distributed by Acme Breweries of San Francisco to advertise Acme Beer; amber, H. 3 in., c. 1930–1950.

Miniature Coke bottles, some still containing liquid, heights range from 3½ in. to 1½ in.; ruler in front of bottles was another item distributed by the Coca-Cola Bottling Co., name shown on reverse, c. 1920–1960.

Title page from a revised edition of *Microbes and The Microbe-Killer* by William Radam, 1895.

Periodical advertisement for putting Hutchinson stoppers into soda water bottles.

Mineral water mug, ceramic, tan, stenciled "Saratoga Springs, N.Y.," on side, H. 4 in., c. 1880.

Advertising match holders, pottery (left to right): (1) debossed "HABERLE BREWING CO.," H. 4½ in., c. 1880–1890; (2) debossed "AMERICAN BREW. CO., ROCHESTER," H. 3 in., c. 1890–1910; (3) debossed "CRYSTAL SPRING BREWING CO.," H. 5 in., c. 1880–1890. (*Western Collector,* San Francisco, Cal.) Photo by Ralph Bond.

Left: One of a set of four paper dolls distributed by Lautier's Extracts of New York; *right:* one of a set of sixteen paper dolls (each representing a different country) distributed by the J. A. Pozzoni Pharmacal Company of St. Louis, Missouri. H. 6 in. and 5 in., c. 1890. These dolls are made in two pieces and when assembled will stand by themselves.

Change trays distributed by the Coca-Cola Bottling Company; top round tray, 5⅝ in.; center round tray, 4½ in.; remaining oval trays 6⅛ in. x 4¾ in.; c. 1900–1920.

Poster distributed by The Eberhardt & Ober Brewing Company, Allegheny, Pa., 33 in. x 47 in., c. 1890.

Only known photograph of the *Maid of the Mist* (a 52-foot steamer belonging to the city of Niagara Falls) which was leased by John Hodge, president of the Merchant's Gargling Oil Co., of Lockport, New York, to sail dangerously near the edge of Niagara Falls as an advertising stunt. The stunt was accomplished on September 6, 1883. Hodge paid the city only $200 for the use of the ship and no doubt received many thousands of dollars worth of advertising. (Alan and Ann Spear, Lockport, N.Y.)

57

Trade Cards

By the 1870s many American manufacturers, including those whose products were packaged in the bottles being collected today, were doing business on a nationwide scale. These firms were in need of a truly national advertising medium. Advances in graphic arts, specifically the perfecting of inexpensive methods in color lithography, prepared the way for the trade card boom which was in full swing until around the turn of the century.

The resulting chromolithographed trade or advertising cards were reproduced in astronomical quantities. Companies flooded the country with their representative bits of cardboard by inserting them in packages at the factory, mailing them to prospective customers, passing them out door to door, and handing them out to customers over the counters of retail stores.

Basically the cards had a full-color picture on one side with the sales pitch printed on the other. The colorful sides can be broken down into two general categories: (1) stock floral, scenic, or comic colored pictures on cards that were to be imprinted later with the message and name of the merchant (these cards had no relationship to any particular product) and (2) cards that associated the picture side directly with the product advertised in printed detail on the other side.

These cards were not only an effective advertising innovation but can truly be considered a form of American folk art. Thousands of Americans avidly collected and saved these cards; they were exchanged with friends, pasted in albums (many of which are found today), or kept in a drawer in the parlor and studied by the entire family on long winter evenings.

Much of America's cultural history can be found on trade cards. The clothes that were worn, the foods that were eaten, the medicines that were taken, the products that were used, the songs that were sung, and the jokes that were told are all recorded on these pasteboard advertising cards of the past.

Some of the most unusual of these cards were ingeniously designed to fold or move in some way. These "mechanical cards," as they were called, most often showed before-and-after scenes stressing the need for the product advertised.

Trade cards came in unusual sizes and shapes but generally were postcard size.

Even though readily available they are not especially inexpensive. Recent interest has driven prices from the nickel and dime range to a range of from fifty cents to several dollars.

Bibliography

BOOKS

Carson, Gerald. *One for a Man, Two for a Horse.* Garden City, New York: Doubleday & Company, Inc., 1961.

Landauer, Bella C. *Early American Trade Cards.* New York: William Edwin Rudge, 1927.

Young, James Harvey. *The Toadstool Millionaires.* Princeton, New Jersey: Princeton University Press, 1961.

PERIODICALS

Maccoun, Bill. "Collecting 19th Century Trade Cards," *Western Collector,* IV (July, 1966), 5–7.

McLaughlin, William G. "Trade Cards," *American Heritage,* XVIII (February, 1967), 48–63.

Early trade card (c. 1740) advertising *"Daffy's and other Elixirs, and all other public Midicines [sic], Pills, Tinctures, Snuffs"* (3½ in. x 5½ in.).

Trade cards, 1882: (left) written in English; (right) written in Spanish. Trade cards, almanacs, and other advertising literature were often issued in several languages.

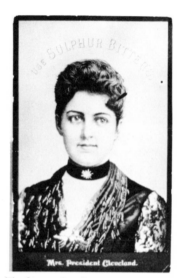

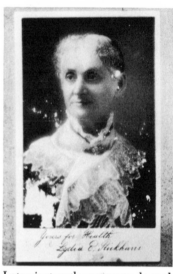

Stand-up trade card by the Mellin's Food Company depicting a marble statue, "Maternity," property of Mr. Mellin, the óriginator of Mellin's Food, 1890. Mellin's Food was supposed to be good for "infants, growing children, invalids, and the aged."

Trade card advertising Sulphur Bitters, c. 1885. Unusual in that it features the wife of President Grover Cleveland.

Late nineteenth-century trade card featuring an actual photograph of Lydia E. Pinkham on the obverse and information about Lydia E. Pinkham's Vegetable Compound on the reverse.

Unusual trade cards of the 1880s. When held to the light a message printed on the back shows through and the baby's and lady's eyes open: (1) Mellin's Food; (2) Bovinine.

Unusual trade cards of the 1880s. (Left) obverse; (right) reverse. When held to the light the lady's eyes appear to open and she looks at a bull standing in the field. Holding to the light also reveals the statement, "My Life Was Saved by BOVININE."

Late-nineteenth-century trade card advertising the An-heuser Busch Brewing Assn., of St. Louis, Missouri.

Late-nineteenth-century trade card advertising Quincy Brewing Co., of Quincy, Illinois.

Late-nineteenth-century trade card advertising Merchant's Gargling Oil.

Late-nineteenth-century trade card advertising Merchant's Gargling Oil.

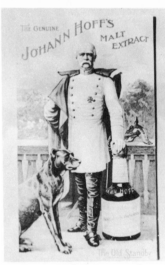

Late-nineteenth-century trade card advertising Johann Hoff's Malt Extract.

Late-nineteenth-century trade card advertising Merchant's Gargling Oil Liniment.

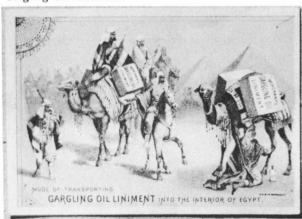

Miscellaneous grouping of trade cards, c. 1880–1900.

Miscellaneous grouping of trade cards, c. 1880–1890.

Miscellaneous grouping of trade cards, c. 1880–1890.

Miscellaneous grouping of trade cards, c. 1880–1890.

58

Private-Die Proprietary Revenue Stamps

To help defray the tremendous costs of the Civil War, the federal government planned a series of excise taxes. Schedule "C" of the Revenue Act of 1862 required that revenue stamps be affixed to a variety of items including patent and proprietary medicines and perfumery to indicate prepayment of taxes.

The act allowed the merchants being taxed to have dies engraved and plates made, at their own expense, from which the government would print revenue stamps. These stamps are appropriately called private-die proprietary revenue stamps. In just the patent medicine area alone 143 companies took advantage of the opportunity to have their own personalized stamps.

At the beginning of the taxing period the private-die stamps were not much different from the regular government revenue stamps that were used by merchants not wishing to go to the extra trouble and expense of obtaining their own personalized stamps, but as time passed the stamps got larger, more colorful, and most unusual in shape. Some even carried portraits of the merchants themselves. These stamps are of prime interest to today's bottle collectors.

The 1862 act was repealed in 1883, but it was revived during the Spanish-American War (1898–1900).

Reluctant to give up their unusual stamps, which in many cases had become trademarks, some of the manufacturers continued to use imitation stamps between and after the two taxing periods. These have come to be known as facsimile labels and are of as much interest as the genuine stamps.

These attractive items are of special significance to the collectors of medicine and perfume bottles.

Bibliography

PERIODICALS
Munsey, Cecil. "Discovery of Coins and Stamps," *Western Collector*, VI (May, 1968), 39–43.

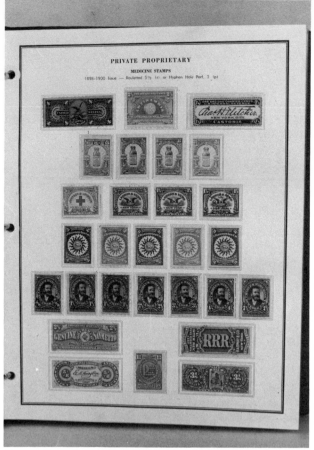

Private-die proprietary revenue stamps, 1898–1900.

Private-die proprietary revenue stamps used on bottles of perfume during the period from 1862 to 1883.

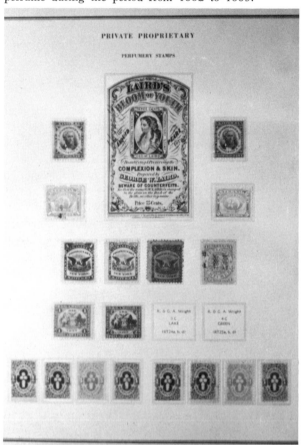

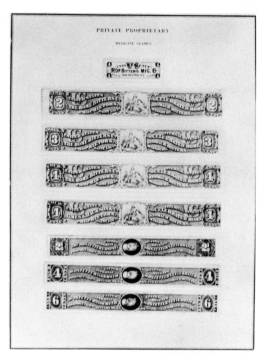

Private-die proprietary revenue stamps, 1862–1883.

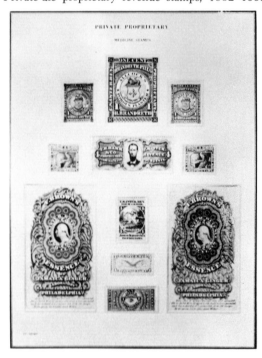

59 Encased Postage Stamps

Until 1857 foreign coins were legal tender in the United States and their use helped prevent a shortage of U.S. coins. New laws outlawing foreign coins, the recalling of large cents by the federal government, coins held in reserve by banks, and hoarding by individuals brought about a critical shortage by 1860. On the eve of the Civil War there were not ten coins per person in circulation in the United States. To meet the demand for small currency, tokens, postage stamps, and paper currency were all used. In 1862 Abraham Lincoln signed the Postage Currency Bill which allowed the printing of postage stamps on cards (very much like the postcard of today) which could be used for currency.

About a month after the Postage Currency Bill was signed, a Boston businessman named John Gault patented his design for a postage stamp case. This invention was a small brass case with a mica front. The two metal parts of the case were pressed together by a machine that made flat buttons. Gault's encased postage stamp currency was made by Scovill & Co., button manufacturers of Middlebury, Connecticut.

The metallic postage currency of Gault was popular but was made for only a few months because the Post Office Department refused to sell him the necessary postage stamp; he was competing directly with their postage stamp cards. A November 1862 advertisement in the *New York Daily Tribune,* however, evidences the fact that Gault was able to stay in business to that date at least, after his supply of stamps had been officially cut off in August of 1862.

Gault's encased postage stamp coins were issued in denominations of one to ninety cents. What attracts bottle collectors to these pieces are the advertisements embossed on their reverse. In the few months he was in business, Gault convinced thirty-five firms to use his unusual form of advertising. Those coins of special interest to the collector of bottles include specimens with advertisements for Ayer's Cathartic Pills, Ayer's Pills, Ayer's Sarsaparilla, Brown's Bronchial Troches, Burnett's Cocoaine Kalliston, Burnett's Cooking Extracts, Drake's Plantation Bitters, and Sands Ale.

Encased postage stamp coins have been sought after by stamp and coin collectors for many years; this and the fact that Gault manufactured them for only a few months accounts for the fact that they are extremely hard to find, and when a collector is offered the opportunity to purchase a specimen, he usually has to pay from fifty dollars to over two thousand dollars for it.

Bibliography

BOOKS
Slabaugh, Arlie R. *Encased Postage Stamps, U. S. and Foreign.* Chicago: Hewitt Bros., 1967.

PERIODICALS
Munsey, Cecil. "Discovery of Coins and Stamps," *Western Collector,* VI (May, 1968), 39–43.

Photograph of encased postage stamp coin issued through the courtesy of the Drake's Plantation Bitters Company in 1862. (Chase Manhattan Bank Money Museum of New York City)

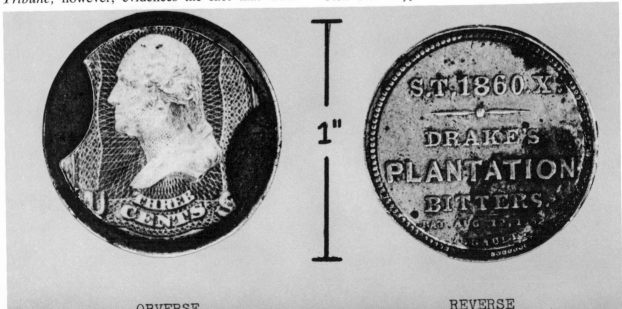

OBVERSE REVERSE

60

Co-related Items

Canning implements (sterilization tongs), used to remove lids from boiling water (top) and (bottom) used to remove jars from boiling water, c. 1890.

Co-related items are very difficult to categorize because their identification is largely an individual matter; what may appear to be an item related to bottles for one collector may not be defined as such by another collector. The best method of identification, it seems, is to rely on individual judgment. The items pictured in this chapter are examples of what some people include in their collections as co-related items. There are, of course, many additional articles that could qualify for inclusion in this chapter; the object here, however, is to offer only ideas of what may be considered co-related items.

Another approach toward the defining of co-related items could be the exclusion of related items that were made originally to advertise a bottled product; other articles thought to be related to bottle collecting would by definition qualify as co-related items.

The price and rarity of co-related articles depends almost entirely on the item. As in most collecting, age, condition, supply, and demand are among the most important factors to be considered. In general, co-related items are not as expensive as the associated bottles.

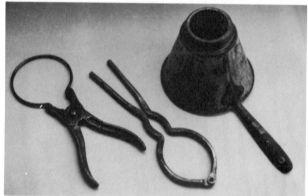

Canning implements (left to right): (1) and (2) are metal wrench-type tools for removal of fruit jar lids, (2) is embossed "WIZARD JAR WRENCH" on handle; (3) metal funnel; c. 1890.

Miscellaneous assortment of canning accessories (left to right): (1) fruit-jar rings, manufactured by Schacht Rubber Mfg. Co., 1900; (2) Zubian Sealing Wax and (3) Pontius' Sealing Wax, both manufactured by the Dicks-Pontius Co., Dayton, Ohio, c. 1870.

Bibliography

BOOKS

Bressie, Wes and Ruby. *101 Ghost Town Relics*. Portland, Oregon: Old Time Bottle Publishing Co., 1969 (reprint).

Davis, Marvin and Helen. *Bottles and Relics*. Medford, Oregon: Gandee Printing Center, Inc., 1969.

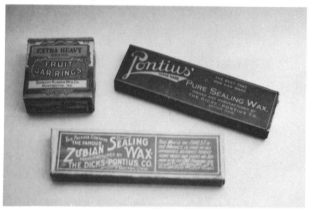

Canning implement: Clamp to hold hot jar while screwing fruit jar lid tightly closed, c. 1890.

Cream Top spoon used to dip cream from bulbous-necked milk bottles, c. 1930.

Top: "Modern Top," designed to fit bulbous-necked milk bottles. The hinged rubber portion is inserted into the cream-filled bottle neck and holds the milk in the body of the bottle while the cream is poured off, c. 1942. *Bottom:* Paper lid lifter; sits over the lid of a paper-capped milk bottle and when the knob is turned, two hooks on the underside catch the paper lid; then it is easily lifted off, 1912.

Postcard sent to customers in 1899 by the Antikamnia Chemical Company, of St. Louis, Mo. Customers who filled out and returned these cards received samples of the proprietary medicines advertised.

Envelope used in 1892 by Charles N. Crittenton Medicine Co. of New York, green paper.

Envelope used in 1889 by the Merchant's Gargling Oil Co.

Postcard mailed by John L. Thompson Sons and Co., vendors of proprietary medicines, 1889.

Attractively designed bank check issued by the Humbold Brewing Co., of Eureka, California, in 1912; printed in green, black, brown, and yellow. (*Numismatic Scrapbook,* November 1969) Photograph by Christensen and Stone, Temple City, Cal.

Envelope used by the J. C. Ayer (proprietary medicine) Co. in 1887.

1908 Sears, Roebuck & Co. catalogue (reprint) containing many bottled products. (Gun Digest Publishing Co., Chicago, Ill.)

1895 issue of *The Ladies' Home Journal,* 16½ in. x 11¼ in. Typical magazine of the late nineteenth century in which advertisements for bottled products can be found.

Wooden insulator peg (pole type), L. 10 in., c. 1900.

Wooden insulator peg (crossarm type), L. 8 in., c. 1880.

Porcelain sign used by the Interstate Telegraph Company (note insulators on telegraph pole), same wording on both sides, 15 in. x 14½ in.

Porcelain caps typical of those used during the last half of the nineteenth century on whiskey bottles in bars. These caps had corks glued in them and were reused indefinitely on bottle after bottle.

Miscellaneous selection of items sold by The Owl Drug Co. (left to right): *front row:* razor blades, dental floss, aspirin, cold-cream jar; *middle row:* measuring glass, bottle top, white milk glass cream jar, clear pill bottle; *back row:* herb tea, Seidlitz powders, sulphur ointment, shaving brush, throat pastilles; c. 1900–1930.

Inkwell, featuring two bottles that turn back to close (left) and turn forward to open (right), c. 1870.

Vapo-Cresolene lamp, box in which it came, and bottle; lamp H. 6 in.; bottle H. 3½ in., embossed with dots and "VAPO CRESOLENE CO."; c. 1900.

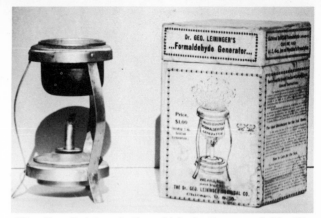

"Dr. Geo. Leininger's Formaldehyde Generator," H. 4⅝ in., c. 1910.

Elongated coins (pennies) depicting Jim Beam bottles (left to right): *top row:* 1967, Kentucky Black Head; 1955, Royal Porcelain–Executive; 1968, Princess–Executive; *middle row:* 1957, The Fish; 1968, Broadmoor Hotel; 1958, Grey Cherub; 1968, San Diego Centennial; *bottom row:* 1958, Grey Cherub; 1968, Grey Slot Machine–Regal China Specialties; 1965, Harold's Club Pinwheel; 1959, Oregon–Statehood; 1961, The Pheasant. (Danny B. Crabb, Van Nuys, Cal.)

Cigar store Indian.

The same salt and pepper shakers as in photo at left, compared with their real ceramic and glass counterparts. (Gary Eichhorn, Missoula, Mont.) Photographs by Gordon Laridon.

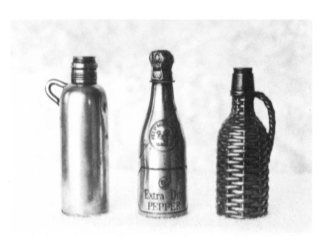

Bottle-shaped salt and pepper shakers issued in 1888 by the Meriden Silver Plate Co., silver, H. 3½ in. (left to right): replica of ceramic mineral water bottle, glass ale bottle, and wicker-covered demijohn.

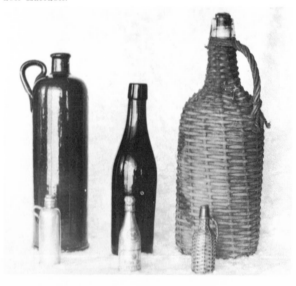

61

Barbed Wire

During the late 1800s, as Americans began to move west and settle, one of the biggest problems they encountered was fencing their land. In the East there had been an abundance of stones and wood from which to build fences, but west of the Mississippi these items were not plentiful. In 1867, the first U.S. patent for a fence with "defensive points" or barbs was issued. By 1897 over six hundred types of wire had been manufactured, and the whole country was using barbed wire in preference to other fencing.

Today's collectors of bottles often search the remote areas of our country for the old home sites of the past. The dumps of these home sites are a prime source of old bottles, but the collecting habit often urges the bottle collector to salvage other relics of the past; among the most popular of these are the many unusual types of barbed wire.

Barbed wire is customarily collected in eighteen-inch lengths and mounted on boards. Along with other relics, barbed wire is frequently displayed at bottle shows.

There is more of a relationship between barbed wire and bottles, however, than just the fact that they are often found in the same remote areas. Searching old newspapers and periodicals for advertisements related to bottles, the collector often discovers advertisements for barbed wire. The claims of barbed wire manufacturers of the late

292

1800s are second only to those made by the nostrum vendors of the same period. Perhaps the most important link between bottles and barbed wire is the bottles of medicine produced to repair the damage often caused by barbed wire. Among the most famous of these bottled products are Mexican Mustang Liniment, Elkay's Wire-Cut Liniment, Haller's Barb Wire Liniment, and Dr. L. D. LeGear's Screw Worm Killer.

Some barbed wire specimens are quite rare and are expensive. Prices of the usual eighteen-inch specimens range from $1 to $100.

Bibliography

BOOKS

James, Jessie. *Early United States Barbed Wire Patents.* Privately published, 1966.

McCallum, Henry D. and Frances T. *The Wire That Fenced the West.* Norman, Oklahoma: University of Oklahoma Press, 1965.

PERIODICALS

Munsey, Cecil. "Cuts and Cures," *Relics,* II (Winter, 1968), 20–22.

Barbed wire (left to right): Glidden Patent steel barbed fencing; Bronson barbed wire; Sterling barbed wire; two-barbed fence wire; Chicago barbed wire; Kelly steel barbed wire; an unknown brand; Cleveland barbed wire; a wire of unknown origin made by bending a horseshoe nail around the main wire and then holding it in place by winding a small wire upon it; Brinkerhoff steel strap and barb (blunt, the barbs are five to six inches apart); Brinkerhoff steel strap and barb; American barbed wire fence; Allis' Patent; Lyman Mfg. Co. barbed fence; Iowa four-pointed barbed steel wire; Quadrate barbed fence; Spiral steel barbed cable fence; steel barbed cable fence; and three-pointed Stone City steel barbed wire.

62

Insulators

In about 1967 there was a sudden surge of interest in insulators on the part of bottle collectors. As newly discovered specimens were located, the excitement grew until several thousand types and variants were known.

The interest has grown to the point where some people have completely given up bottle collecting in favor of building an insulator collection. For the most part, however, insulators remain an arm of bottle collecting and insulator collections are almost always included in bottle shows.

Insulators are not especially old; they go back only to the early 1840s. When Samuel F. B. Morse invented his first telegraph set in 1835 there was little interest. After several small improvements he applied for a patent in 1837; the patent was granted in 1840. To prove the worth of his invention, Morse asked Congress for money to build a telegraph line between Washington and Baltimore. In 1843 he was granted $30,000 to do the job.

Ironically, Morse's original plan called for an underground cable which is only now becoming practical and popular. After nine miles of underground cable had been laid it was found that insulation between the wire and the lead pipe would not work. Morse decided that he would string his telegraph wire between poles. Ezra Cornell (who later endowed Cornell University), an inventor, originally hired to develop a plow to aid in the laying of the underground cable, suggested the use of glass insulators to avoid the same insulation problem encountered with the underground cable.

Cornell's insulators were quite different from those later developed. A thick square of glass was set into a corresponding notch in the crossarm on the telegraph pole. The wire was wrapped with cotton cloth and covered with shellac. Another square of glass went on top with a wooden cover to hold the whole thing together and keep the wire in place.

Cornell's complicated insulators were modified to resemble a bell-shaped glass cap. These insulators were hollow so that they would fit over wooden pegs on the pole. A groove in the glass provided a place for tying the wire.

Before the glass insulator was accepted as being one of the best methods of insulation many other materials were tried. One of the most absurd was made by Ezra Cornell himself. Almost ruining his reputation as an inventor, Cornell developed an insulator made of iron and brimstone. When wet, this device became a perfect conductor of electricity.

The bell-shaped glass insulator did have one major defect: it was difficult to keep on the wooden peg. Many methods of keeping insulators on the pegs were tried, but none were successful until Louis A. Cauvet, a New York carpenter, invented an insulator with interior threads in 1865. The interior glass threads matched similar threads on the wooden peg.

Cauvet took his invention to James M. Brookfield, owner of the Bushwick Glass Works in Brooklyn. Brookfield immediately bought the patent and began to manufacture threaded insulators much like the one still used today. Brookfield changed the name of his company to Brookfield and made insulators until 1920. The company made nearly one hundred different types of insulators during its approximately fifty-five years in the business.

In 1871, Robert Hemingray began making and marketing insulators turned out on a hand-operated press. Hemingray insulators were made in two steps, with the threads being molded after the body was poured. Hemingray insulators of an improved type are still being manufactured; the only interruption was around 1900 when a flood washed out the plant in Covington, Kentucky. The plant was moved to Muncie, Indiana, and production continued. Over the years approximately seventy-five different designs were manufactured.

With the invention of the telephone in March, 1876, by Alexander Graham Bell came a new need for insulators. Thomas Edison's invention of the light bulb in October, 1879, brought further interest and a greater need for insulators. By the early 1900s there were many insulator manufacturers ministering to the needs of a growing nation that was rapidly becoming an electrical one. After World War I, there was a surge of new companies joining the already large number in existence; each of these firms produced one or more types, which accounts for the thousands of types being collected and catalogued today.

By the 1940s, insulator manufacturers were greatly reduced in numbers by mergers and the recent Depression. In fact, by far the majority of insulators produced during and since the 1940s were manufactured by two firms, Owens-Illinois

Glass Company, which produced Hemingray Insulators, and the Armstrong Cork Company, which purchased the Whitall Tatum Co. in 1938 and produced insulators under that name until 1946 and then started manufacturing insulators under the name "Armstrong's."

Insulators were and still are made of both glass and ceramics. They can generally be classified by their users. One of these users is the power companies, the second is communications firms (telephone and telegraph). However, classification according to users is often artificial because companies failed occasionally and existing lines were purchased by other firms not necessarily in the same geographical area; this is especially true of the communications firms.

Although there are many insulator styles, some are more common than others; these include the *pony,* which is the smallest of insulators. Another interesting style is the *transposition,* which is unusual because it consists of separate upper and lower sections. The lower section is open at the top to allow the longer-than-usual pin to extend up into the upper section. Other transpositions are one-piece in construction; but all transposition styles are constructed to hold more than one wire. The two-piece model was invented in 1889 by A. S. Hibbard and the one-piece was developed by F. M. Locke in 1894. The *petticoat* and *double petticoat* are interesting variations in styles. The double petticoat was invented in 1883 by S. Oakman of Boston; this style features a flaring outer skirt over an inner one. The purpose of the petticoats is to provide two air spaces between the insulator and the pin below the threads. The *saddle groove* (sometimes called a *Mickey Mouse*), also an Oakman invention, was patented in June, 1890. This style is appropriately named because the top has a depression resembling a saddle (or ears). Other styles include the *exchange, tall line, carrier circuit* and *signal.*

Disregarding the very large glass and ceramic insulators used on high tension lines the majority of glass and ceramic insulators are only three to four inches in height and their weight will range from about half a pound to two pounds.

Even though insulators vary little in size there is a great number of shapes or styles within the one basic and encompassing umbrella shape. Embossments are numerous also and include variety in lettering and design.

Color is of prime importance to the insulator collector. The common colors in glass insulators are aqua and varying shades of green. The unusual and rare colors are amber, cobalt-blue, white (milk glass) to a certain extent, and golden iridescent (carnival-type glass). There has been widespread talk of red insulators but as yet none have been located that are really made of red glass; those presented as red were flashed red and were easily identified by scratching some of the red flashing off. In ceramic insulators brown is the common color. Less common are grey, white, blue, and green.

Some of the very earliest types are extremely rare; especially those of the threadless variety. Because of their durability, threaded glass insulators produced in mass are still being utilized today sixty or so years after they were manufactured, and are available in limited numbers. Those produced by small companies or for small companies that were not in business for long periods of time are, of necessity, less plentiful.

Prices for insulators range from $1 to $100 on the average. Threadless specimens would probably command more than $100.

Bibliography

BOOKS

Cranfill, Gary G., and Kareofleas, Greg A. *The Collectors' Guide for Glass Insulators* (Revised Edition). Sacramento, California: privately published, 1969.

Hill, James L., and Pickett, Edward. *An Insulator Book for Collectors.* Oregon: The Mail Printers, 1968.

Milholland, Marion C. *Glass Insulator Reference Book.* U.S.A.: Olympic Publications, Inc., 1967.

Saccoman, Frank. *Insulators . . . Just Insulators.* U.S.A.: privately published, 1967.

Stuart, Lynn R. *Stuart's Insulator Guide.* U.S.A.: privately published, 1968.

Woodward, N. R. *The Glass Insulator in America.* Texas: Press of Premier, 1967.

PERIODICALS

McClellan, Claire T. "The Insulator Story, Part I," *Western Collector,* V (May, 1967), 16–19.

————. "The Insulator Story, Part II," *Western Collector,* V (June, 1967), 16–21.

————. "The Insulator Story, Part III," *Western Collector,* VI (March, 1968), 39–43.

Insulator, green/aqua, embossed "W. E. MFG. CO., PATENT DEC. 19, 1871" on one side and "W. U." on another side, H. 4¼ in.

Insulator, green/aqua, embossed "E. C. & M. CO., S. F." (Electrical Construction & Maintenance Co., San Francisco) on side, flat top, H. 4¼ in., c. 1860–1870.

Insulators (left to right): (1) green/aqua, embossed "HEMINGRAY, MADE IN USA" on side, drip points pointed and close together, H. 4½ in. (embossing painted for photographing); (2) purple, embossed "C. N. W. TEL. CO." on side, H. 4¼ in.; (3) clear, embossed "4-W BROOKFIELD, 55 FULTON ST., N. Y." on one side near the top and "PAT. FEB. 22, 1870/PAT. JAN. 25, 1870/PAT. JAN. 14, 1870" on another side, H. 4¼ in.

Insulator, green/aqua, embossed "CAL. ELEC. WORKS, PATENT" on side, flat top, H. 4¼ in. Embossing painted for photographing.

Insulators (left to right): (1) dark olive-green, diamond shape embossed on one side (trademark of the Diamond Glass Co.) and "12" embossed on another side, H. 3½ in., c. 1880–1910; (2) amethyst, embossed "B. T. CO. OF CANADA" together with a diamond shape on two sides (trademark of the Diamond Glass Co.), H. 3½ in., c. 1880–1910; (3) light aqua, embossed "W. BROOKFIELD, 45 CLIFF ST., N.Y." on crown, H. 3½ in., c. 1880; (4) olive-green, diamond shape embossed on side (trademark of Diamond Glass Co.), H. 3½ in., c. 1880–1910.

Insulators (left to right): (1) green/aqua, embossed "HEMINGRAY-43" on one side and "MADE IN USA" on another side, drip points round and close, H. 4¼ in. (embossing painted for photographing); (2) smoky grey, embossed "CALIFORNIA" on side, H. 4½ in.; (3) green/aqua, embossed "HEMINGRAY" on one side and "PATENTED JUNE 17, 1890, MAY 2, 1893" on another side, drip points large and pointed, H. 5 in.; (4) green/aqua, embossed "HEMINGRAY NO. 2 CABLE" on one side and "PAT. MAY 2, 1893" on another side, drip points small, round, and close, H. 3½ in. Embossing painted for photographing.

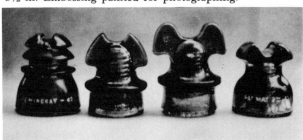

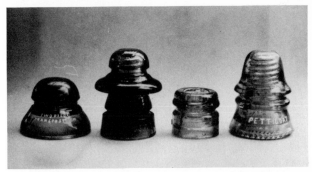

Insulators (left to right): (1) and (3) aqua, embossed "TWO PIECE TRANSPOSITION" on side, H. (top) 2¾ in. and (bottom) 2½ in.; (2) dark aqua, embossed "TRANS-POSITION" on one side, H. 4¼ in.; (4) aqua, embossed "PETTICOAT" (Hemingray Insulator Co.) on one side and "PAT. MAY 2, 1892" on another side, H. 4 in. Embossing painted for photographing.

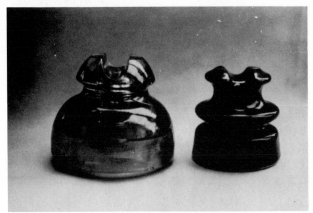

Insulators (left to right): (1) green/aqua, embossed "FRED M. LOCKE, VICTOR, N.Y., DEC. 5, 1896" on side, H. 4½ in.; (2) brown, ceramic, embossed "LOCKE HIGH TOP 77 USA" on side, H. 4 in., c. 1895–1910.

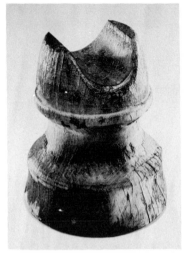

Insulator, wood (Lignum Vitae), unembossed, machine made, high voltage, used on lines which supplied power for electric streetcars in San Francisco, H. 4 in., c. 1900. (*National Bottle Gazette*, Amador City, Cal.) Photo by Frank Saccoman.

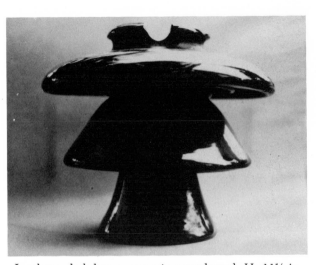

Insulator, dark brown, ceramic, unembossed, H. 11½ in., W. (base) 7½ in.

Insulator, green/aqua, two-piece transposition, H. (top) 2¾ in. and (bottom) 2½ in.; shown with wooden insulator pin. Embossing painted for photographing.

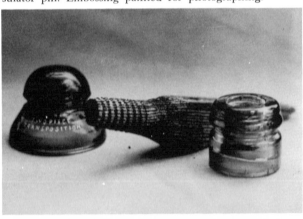

Insulator, amber, embossed "HEMINGRAY-109" near top on one side and "MADE IN USA" on another side, high voltage, steel bar goes through center, H. 3½ in. Embossing painted for photographing.

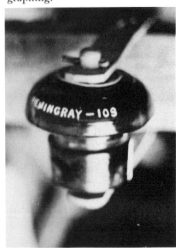

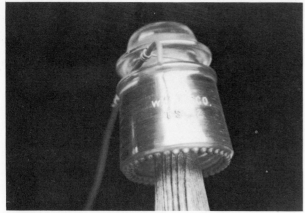

Insulator, carnival glass, embossed "W.U.T. CO., TS-2" (Western Union) on side, H. 4½ in. Embossing painted for photographing.

Insulator, aqua, embossed with "H" and overlapping "I" and "CO.," and "HAWLEY, PA. U Ƨ A" (note reversed "S") on side, H. 4¼ in. Embossing painted for photographing.

Insulator, blue/aqua, embossed "HEMINGRAY-62" on side, drip points round and close together, H. 4 in. Embossing painted for photographing.

Insulator, white milk glass, embossed "MAYDWELL-20" on side, drip points round and wide apart, H. 3¾ in., c. 1935–1940. Embossing painted for photographing.

Insulator, carnival glass, embossed "PYREX T. M. REG. U.S. PAT. OFF." on one side and "MADE IN USA 441" on another side, H. 8 in., W. 8½ in.

Newsletter Bibliography

Within organized bottle collecting there are over one hundred clubs and many of these publish monthly newsletters. Not only do these publications provide one of the most effective means of communication between clubs and individuals about current activities, but they are often an excellent source of factual information about bottles and related history.

The following is a list (alphabetically by name of publication) of the club newsletters consulted in the preparation of this book:

The Applied Lip. Finger Lakes Bottle Collectors Association, Ithaca, New York.

The Applied Lip. Memphis Bottle Collectors Club, Memphis, Tennessee.

Applied Seals. Genesee Valley Bottle Collector's Association, Rochester, New York.

Backache Bulletin. Modesto Old Bottle Club, Modesto, California.

The Bimal Bulletin. The Canal Zone Bottle Collectors Association, Balboa, Canal Zone.

Bits and Pieces. Empire State Bottle Collectors Association, Syracuse, New York.

Bitters and Sweets. Mid-State Antique Bottle Collectors, Inc., Orlando, Florida.

The Blister. Arizona Treasures Unlimited, Inc., Phoenix, Arizona.

The Blowpipe. San Antonio Antique Bottle Club, San Antonio, Texas.

Botellas Antiquas de Tucson. Arizona Territory Antique Bottle Club, Tucson, Arizona.

The Bottle Blurp. M. T. Bottle Club, Encinitas, California.

Bottle Bug Bulletin. Antique Bottle Collectors of Hawaii, Hawaii.

Bottle Bulletin. Antique Bottle Club of Orange County, Santa Ana, California.

The Bottle Busters' Bugle. Cheyenne Antique Bottle Club, Cheyenne, Wyoming.

The Bottle Digger's Dope. Minnesota's First Antique Bottle Club, Minneapolis, Minnesota.

The Bottle Examiner. Oregon Bottle Collectors Association, Aurora, Oregon.

Bottlemania. Chief Solano Bottle Club, Vallejo, California.

The Bottleneck. San Diego Antique Bottle Club, Inc., San Diego, California.

Bottle Nooz. San Bernardino County Historical Bottle Club, Bloomington, California.

The Bottleologist. Sequoia Antique Bottle Society, Visalia, California.

The Corker. Golden Gate Historical Bottle Society, Berkeley, California.

Cracked Glass. High Country Antique Bottle Club, Alamosa, Colorado.

Digger's Digest. Gold Diggers Antique Bottle Club, Gold Hill, Oregon.

Digger's Dirt. Reno Sparks Antique Bottle Association, Reno, Nevada.

Dump Diggers Gazette. Antique Bottle Collectors of Colorado, Inc., Denver, Colorado.

El Buscador. Santa Barbara Bottle Club, Santa Barbara, California.

Ezra Brooks Heritage Gazette. Ezra Brooks Specialties Club, Los Angeles, California.

The Fractured Flask. Emerald Empire Bottle Club, Eugene, Oregon.

The Ghost Town Echo. Washington Bottle Collectors Association, Seattle, Washington.

The Glass Eye. Georgia–Carolina Empty Bottle Club, Augusta, Georgia.

The Glassblower. Northwestern Bottle Collectors Association, Santa Rosa, California.

The Glasshopper. The Glasshoppers Figural Bottle Association, Harbor City, California.

Hangtown Bottle-eer. Hangtown Bottle-Necks, Camino, California.

Jim Beaming the News to You. Jim Beam Bottle and Specialties Club, San Leandro, California.

The Kickup. Utah Antique Bottle Club, Ogden, Utah.

The Label. San Jose Antique Bottle Collectors Association, San Jose, California.

The Lady's Leg. Gem Antique Bottle Collector's Association, Boise, Idaho.

The Milking Parlor. Milkbottles Only Organization, Newport News, Virginia.

The Mold Mark. Bishop Belles and Beaux Bottle Club, Bishop, California.

Mold Marks and Remarks. Antique Bottle Collector's Association, Fresno, California.

Mound City Empties. St. Louis Antique Bottle Collector's Association, St. Louis, Missouri.

Newsletters of: Bottle Bugs, Lawndale, California; The Endless Mountain Antique Bottle Club, New Albany, Pennsylvania; Greater California Antique Bottle Club, Sacramento, California; Horsetooth Antique Bottle Collectors, Inc., Ft. Collins, Colorado; Iowa Antique Bottleers, Ottumwa, Iowa; Juniper Hills Bottle Club, Valyermo, California; The Milwaukee Jim Beam and Antique Bottle Club, Milwaukee, Wisconsin; Nebraska Antique Bottle and Collectors Club, Lincoln, Nebraska; Peaks and Plains Antique Bottle Club, Colorado Springs, Colorado; Southeastern New England Antique Bottle Club, Mystic, Connecticut; The Texas Longhorn Bottle Club, Dallas, Texas; Suncoast Antique Bottle Collectors Association, St. Petersburg, Florida; Queen Mary Beam and Specialties Bottle Club, Long Beach, California.

The Onion. Bay Area Historical Bottle Collectors, Apollo Beach, Florida.

On the Beam. Beam Bottle Club of Southern California, Los Angeles, California.

The Pack Rat. Mineral County Antique Bottle Club, Hawthorne/Babbitt, Nevada.

Platte and Prairie Bottle News. Northeastern Colorado Antique Bottle Club, Ft. Morgan, Colorado.

The Pontil. Antique Bottle Collectors Association, Sacramento, California.

The Punkin Seed. Southern Nevada Antique Bottle Collectors, Las Vegas, Nevada.

Stopper. Humboldt Antique Bottle Club, Arcata, California.

The Whittle Mark. Los Angeles Historical Bottle Club, Los Angeles, California.

Glossary

Advertiques: early advertising items.

Amphora: a two-handled oblong vessel used by the ancients for holding wine or other liquids.

Annealing: the gradual cooling of hot glass in an oven or lehr.

Apothecary: a person who both prescribes and manufactures drugs.

Applied color labeling: a method of decorating a bottle by applying glass with a low melting point to a bottle through a metal screen and then baking it in a muffle.

Baltimore loop seal: a bottle closure.

Banana ink bottle: a side-spouted ink bottle.

Batch: a mixture of the raw glassmaking materials ready for the melting pot.

Battledore: a wooden paddle used to flatten portions of a bottle as it is being hand blown.

Bitters: a patent or proprietary medicine containing alcohol; sold without a prescription.

Blob top: a bottle with a rounded bloblike lip; found frequently on early soda and mineral water bottles.

Block: a wooden dipperlike device cut out on one side and used during free blowing to give symmetrical form to a bottle in its early stages.

Blow-back mold: a full-height mold with a bulblike formation cut into the neck of the mold to facilitate severing the completed bottle from the blowpipe.

Blow-over: a seam mark caused when a bottle is blown in a dip mold until the shoulder expands over the top of the mold.

Blowpipe: a two- to six-foot-long hollow iron tube used to blow glass.

Bocca: an opening in the side of the furnace through which the pot is placed in the furnace; the batch is put into the pot, and the gather is taken.

Calabash: a gourd-shaped flask.

Canning jar: See Fruit jar.

Carboy: a large cylindrical bottle normally holding one to ten gallons of liquid.

Case bottle: an octagonal bottle used to contain gin and designed to pack easily in a case.

Chair: a wooden bench with slanting arms at which the gaffer works.

Chestnut flask: a free-blown and semiflattened flask.

Cloisonné bottle: a bottle (usually a Chinese snuff container) covered with soldered metal bands between which powdered enamel is placed and fired.

Closure: the device used to seal a bottle, e.g., cork, cap, stopper, etc.

Codd stopper: a bottle closure.

Co-related item: an article directly or indirectly related to bottled products.

Cork: a tree bark used as a bottle closure.

Cristallo: Venetian crystal glass.

Crown cork: a bottle closure.

Crucible: See Melting pot.

Cucumber ink bottle: a side-spouted ink bottle.

Cullet: broken glass included in a mixture of raw materials ready for the melting pot.

Cup-bottom mold: A full-height mold with a cup indentation in the bottom plate.

Cure: a patent or proprietary medicine sold as an all-purpose remedy.

Cutting: a method of decorating a bottle by cutting with an iron wheel, a stone wheel, and a willow wheel in that order.

Decolorizing: the process of making glass clear by the addition of manganese, selenium, or arsenic to the batch.

Demijohn: a large bladder-shaped bottle normally holding one to ten gallons of liquid.

Dip mold: a one-piece mold open at the top.

Dunmore: a free-blown squat wine bottle.

Empontilling: the act of attaching a rod to the bottle-bottom so that it can be held during the finishing process.

Enameling: a method of decorating a bottle by painting it with a mixture of lead, tin, and an oxide, and then firing it in a muffle.

Encased postage stamp: Civil War emergency coin in the form of a token upon which embossed advertisement was placed.

Engraving: a method of decorating glass by cutting with a copper wheel.

Etching: a method of decorating glass by using hydrofluoric acid.

Ethical medicine: a prescribed medicine, as opposed to a patent or proprietary medicine.

Finish: the last step in the formation of a bottle, the development of the lip.

Finishing: the completion of the neck and mouth of a bottle.

Finishing mold: the mold on the Owens automatic glassblowing machine into which the gather is dropped and blown into a completed bottle form.

Fire grenade: a glass bottle fire extinguisher designed to be thrown into a fire and broken.

Fire polishing: the reheating of a finished bottle to obliterate marks left by tools or molds and to obtain a smooth surface.

Flashing: a method of coloring glass by dipping it in a batch of colored glass.

Flux: a substance (soda) which promotes fusion in glass.

Free-blown: glass formed by blowing and manipulation with tools, *without* the aid of a mold (in contrast to hand-blown glass).

Fruit jar: a jar in which food is preserved.

Fulgurite: a long slender glass tube formed by lightning striking sand.

Gaffer: a master blower; head of a shop.

Gall: a scum that rises to the top of a batch and is skimmed off to insure high-quality glass.

Gather: the blob of hot glass gathered on the end of a blowpipe before blowing.

Gatherer: the assistant to a gaffer who accumulates the gather on the blowpipe.

Gathering mold: the mold on an Owens automatic glassblowing machine that receives the gather from the melting pot.

Gemel bottle: two separate bellows-shaped bottles fused together.

Gilding: a method of decorating a bottle by fixing gold to the outside of the bottle.

Glass float: a glass ball used by a fisherman to support his net.

Glasshouse: a glass factory.

Glory hole: a small furnace used for the frequent reheating necessary during blowing and fire polishing.

Graphite pontil: an inaccurate term used to describe the mark on the bottom of a bottle held by a solid iron-bar pontil.

Gravitating stopper: a bottle closure.

Half-post: a bottle redipped after partial blowing and then blown to completion.

Hand-blown: glass formed by blowing and manipulation with tools, *with* the aid of a mold (in contrast to free-blown glass).

Hinged-bottom mold: a full-height mold hinged across the bottom.

Hinged shoulder-height mold: a dip mold hinged down the side.

Historical flask: a flask embossed with portraits, emblems, symbols, or inscriptions.

Hobble skirt bottle: one of the nicknames given the 1915 Coca-Cola bottle.

Hutchinson stopper: a bottle closure.

Igloo ink bottle: a side-spouted ink bottle.

Inside screw (thread): a bottle closure accepting a threaded stopper.

Kick-up: the bottom of a bottle pushed up into the interior during construction; common on wine bottles.

Kings bottle: a free-blown squat wine bottle.

Laid-on ring: a string of glass laid around the outside of the neck of a bottle.

Lehr (leer): the annealing oven or furnace where glass is gradually cooled.

Lead glass: glass made with flint instead of sand, potash instead of soda, and twenty-five percent lead oxide.

Lightning stopper: a bottle closure.

Lime: an oxide of calcium used in glassmaking to reduce solubility.

Liquid bread: beer.

Liquid glass: a casting resin used in the repairing and restoring of bottles.

Mae West bottle: one of the nicknames given the 1915 Coca-Cola bottle.

Marble bottle: *See* Codd stopper.

Marble stopper: *See* Codd stopper.

Marver: a metal slab upon which a gather of glass is rolled.

Master ink bottle: a bulk container for ink.

Melting pot: the large clay pot in which a batch is melted.

Metal: glass in either its molten or hard state.

Mickey Mouse insulator: *See* Saddle groove.

Muffle: a small furnace.

Mull: an implement used to contain and pulverize snuff.

Nostrum: a worthless patent or proprietary medicine.

Obsidian: a glass created by volcanoes.

Off-hand: *See* Free-blown.

Onion bottle: a free-blown squat wine bottle.

Opalescence: *See* Sick glass.

Overlay: a method of decorating a bottle by cutting through one or more purposely applied layers of glass.

Parison: an inflated gather.

Patent medicine: a medicine that has been pat-

ented and is sold without a prescription.

Pattern mold: a dip mold with a design cut into it.

Petticoat insulator: an insulator featuring a flaring outer skirt of glass over an inner one.

Pharmaceutist: an early term for pharmacist.

Pictorial flask: a flask bearing a purely decorative motif.

Pig bottle: *See* Codd stopper.

Plate mold: a full-height mold designed to receive a plate into which lettering and/or design has been cut.

Pontie: *See* Pontil.

Pontil: a long solid or hollow rod used to hold the bottle during the finishing process.

Pontil scar: the scar left by the pontil on the completed bottle.

Pony insulator: the smallest type of insulator.

Post: *See* Snap.

Post-bottom mold: a full-height mold with a post on the bottom plate.

Private-die proprietary revenue stamp: a revenue stamp required on many bottled products, 1862–1883 and 1898–1900.

Proof: an arbitrary measurement of alcoholic strength in which pure ethyl alcohol is rated 200.

Proprietary medicine: an unpatented medicine sold without prescription.

Pucellas: an iron tonglike tool for shaping glass.

Pumpkinseed bottle: an oval whiskey flask.

Punte: *See* Pontil.

Puntellium: *See* Pontil.

Punty: *See* Pontil.

Round-bottom bottle: a soda or mineral water bottle with a rounded bottom.

Sabot: *See* Snap.

Saddle groove insulator: an insulator with a depression in the top.

Salt glaze: an orangepeel finish on pottery containers achieved by throwing salt into the kiln during firing.

Screw cap: a bottle closure.

Seam: a mark on a bottle caused by glass assuming the shape of the mold where the two halves meet.

Servitor: the glassblower who is first assistant to the gaffer.

Shop: a gaffer and his helpers; a gatherer, a servitor, and a boy.

Show-window bottle: a highly decorated bottle used for show in drugstores.

Sick glass: glass that has corroded through excessive and long exposure to moisture.

Silica: sand.

Snap: a spring cradle-type device which replaced the pontil as a holding tool.

Specific: a patent or proprietary medicine sold as a single-purpose medicine.

Squat: a free-blown squat wine bottle.

Staining: a method of coloring a bottle by dipping it in a stain.

Suction machine cutoff scar: a mark left on the bottom of a container made by the Owens automatic glassblowing machine.

Sun-colored glass: glass containing manganese that has reacted to the ultraviolet rays of the sun by turning purple or amethyst.

Tap-hole jar: an English term for an inside-screw bottle.

Target bottle (ball): a glass ball designed to be shot at by sportsmen.

Teakettle ink bottle: a side-spouted ink bottle.

Terrarium: a garden in a bottle.

Three-part mold: 1) a full-height mold with three hinged vertical parts; 2) a full-height mold with a dip-mold body and a two-part shoulder section.

Tiger Whiskey bottle: a bulbous pottery bottle that held rice wine from China.

Tool: *See* Pucellas.

Torpedo bottle: a soda or mineral water bottle with a torpedo-shaped bottom.

Trade card: an advertising card.

Transposition insulator: an insulator designed to hold more than one wire.

Turn mold: a process by which a blown bottle is spun in the mold before removal to erase seam markings.

Umbrella ink bottle: a conical eight-sided bottle.

Watch ball: *See* Witch Ball.

Weathering: a process by which glass suffers damage from the forces of nature.

Wetting off: marking the neck of a hot bottle with water so that it can easily be broken from the blowpipe.

Whittle marks: wavy, dimpled, or hammered marks on a completed bottle caused by blowing the container in a cold mold.

Wistarburg: a free-blown squat wine bottle.

Witch ball: a glass ball hung in homes to protect against witches.

Index

(Page numbers in italics refer to illustrations)